American
Antique Decoration

ELLEN S. SABINE

WITH DRAWINGS BY THE AUTHOR

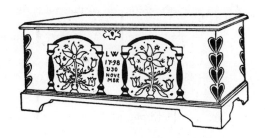

VAN NOSTRAND REINHOLD COMPANY
NEW YORK CINCINNATI TORONTO LONDON MELBORNE

Combined edition first published in 1982
Copyright© 1956 by Van Nostrand Reinhold Company Inc.
Library of Congress Catalog Card Number 81-51277
ISBN 0-442-28423-2

Printed in the United States of America

Van Nostrand Reinhold Company Inc.
135 West 50th Street, New York, NY 10020

Fleet Publishers
1410 Birchmount Road, Scarborough, Ontario M1P 2E7

Van Nostrand Reinhold Australia Pty. Ltd.
480 Latrobe Street, Melbourne, Victoria 3000

Van Nostrand Reinhold Company Ltd.
Molly Millars Lane, Wokingham, Berkshire, England
RG11 2PY

Cloth edition published 1958 by D. Van Nostrand
Company
Second cloth impression 1967
Bonanza cloth reprint edition published 1971 by Crown
Publishers

16 15 14 13 12 11 10 9 8 7 6 5 4 3 2

Introduction to the Combined Edition

Ellen Sabine has long been recognized as one of the foremost authorities on American decorative patterns. Her three books, *American Folk Art, American Antique Decoration,* and *Early American Decorative Patterns,* are acknowledged classics in the field. Out of print for many years, the recent resurgence of interest in American cultural history has prompted the publishers to reissue these books in one compact volume. It is hoped that their renewed accessibility, together with the convenience of easy reference, will be helpful to craftspeople, collectors, historians, and designers.

Foreword

For the amateur artist, the hobbyist, or the lover of antiques this book will prove to be a valuable guide to the old-new art, known as American Antique Decoration. The author, Ellen Sabine, defines the techniques, enumerates the materials, and describes the procedures in such simple, easy-to-understand words that the reader will be enticed to begin, and encouraged to perfect, the skills which re-create this early American art.

While Mrs. Sabine clearly explains each step in the process of creating a beautiful object, she anticipates the problems and pitfalls and sets forth all the requisites for successful achievement. Her informal directions are detailed, enabling the student to progress with confidence from the simplest to the most elaborate work.

For several years Mrs. Sabine has shared her artistic knowledge and skill with many hundreds of students in her classes at Central Branch YWCA in New York City. Her explicit directions and her love for this art form have brought the joy of new creative experiences to these students. She tells her students that practice is essential in learning a new skill, and she reminds them that "All the practice in the world is of no use if you keep thinking that you'll never be able to do it."

Now this knowledge and skill are placed at your disposal in this book. You will be inspired and encouraged to try your hand and brush. As you work, you may find it helpful to heed this bit of philosophy which Mrs. Sabine is in the habit of saying to her students. "Keep in your mind's eye a picture of yourself as doing beautifully whatever it is you want to do. This mental attitude of success, coupled with practice, is the only recipe (I know of) that can make an artist of you or anyone, and if followed implicitly it will assure success!"

CLARICE L. HAINES
Director of Adult Education
Central Branch, Y.W.C.A.
New York, N. Y.

iv

Preface

It has always been a marked characteristic of human beings that they have sought to decorate their immediate surroundings. In certain parts of the world there are caves the walls of which were decorated by men of prehistoric times, and some of the surviving work shows a high standard of artistic skill. Weapons and utensils were similarly painted and carved.

With the coming of houses and other advances of civilization the scope for decoration was correspondingly enlarged. Even when machines of iron and steel arrived on the scene, they were frequently decorated in an elaborate manner, of which many an old sewing machine is an example.

Although the forms of decoration may change as time goes on, the urge to decorate never entirely disappears. Modern living, which is increasingly altering our ways in so many respects, calls no less than earlier times for the compensation of decoration. Dreary indeed would be a purely utilitarian world from which every "unnecessary" adornment was banished! If, then, one is asked, "Why decorate?" the answer must surely be, "Because we like it." Immense as are the changes which the industrial age has brought about, it has left the realm of artistic expression little affected. There the machine is no substitute for the human hand and eye, and the urge to artistic creation cannot be satisfied by the most ingenious touch-of-a-button invention. That is why people constantly seek out creative handicrafts. They refuse to let their personalities be submerged by the merely mechanical and automatic.

If a thing of beauty is a joy forever, it is doubly so to the person who created it. To be an artist in American Antique Decoration, one need not be an artist in the full sense, a professional who devotes all his faculties to art and undergoes years of training. A keen desire to learn and to do will carry the amateur far in this field.

There exists for our use a vast storehouse of fascinating designs, taken from old pieces of furniture and other household objects. These designs are as much a part of our national heritage as the Declaration of Independence. To use them is not an "escape into the past," for they are already a part of us and of our traditions. Most of them are truly beautiful, and a conscious appreciation of their worth and importance is an inspiring and enriching experience for anyone.

It is true that we decorate because we like it. But a beautifully decorated home gives something more than immediate pleasure to the eye. It has far-reaching effects on the people who live there, encouraging thoughts

and feelings of well-being and contentment. Since the subconscious mind is always influenced by its surroundings, it is wisdom to make those surroundings beautiful. This book offers guidance to those who wish to use American Antique Decoration in beautifying their homes, and it will also be found helpful by the collector and restorer of antiques.

ACKNOWLEDGMENTS

My grateful thanks are tendered to Mrs. Eda Baum, Mrs. Wesley S. Block, Jr., Mrs. Grosvenor Farwell, Miss Katherine Hatch, Mrs. Edward Herndon, the Index of American Design (National Gallery of Art, Washington, D.C.), Mrs. George E. Jones, Mrs. Alan Kissock, Mrs. John G. McTernan, the Metropolitan Museum of Art (New York), Mrs. Victor Mravlag, the New York Public Library, the Queens Borough Public Library (Jamaica, N.Y.), Mrs. W. Mason Smith, Jr., Miss Nadine Stein, Mrs. Louis Stevenson, Mrs. Arthur S. Tompkins, and Mrs. Marion Wood for their kind permission to use designs and for supplying information; to Mrs. Roderick D. MacAlpine for special help on many occasions; to my sister, Miss Hilda Borcherding, for the photographs; to Mr. Richard Gray for aiding in their production; and to my husband for assisting in the preparation of the manuscript. Finally, I would like to record the immense debt which all who are engaged in this field owe and will always owe to the late Esther Stevens Brazer, and to the Esther Stevens Brazer Guild of the Historical Society of Early American Decoration, which was founded in her memory.

E. S. S.

Contents

General Index at end of book

1 Techniques and Their History

Five main techniques are employed in American Antique Decoration, namely, Country Painting, Freehand Bronze, Stenciling, Floating Color, and Gold Leaf. Each of these will be dealt with later in a separate chapter, and here we shall give them a brief preliminary survey. With the exception of stenciling, all of them are rated as freehand techniques. But although the freehand techniques are carried out without the aid of a stencil, the designs are first traced on the surface to be decorated, and so you have an outline to follow when you begin to paint.

Country Painting was used in the old days to decorate the many household articles made by the tinsmith. From about 1740 English tinplate was imported and was made here into trays, various boxes, candle holders, coffee pots, tea pots, canisters, tea caddies, and many other things. Such items formed part of the stock of country peddlers, who were welcome visitors to every farm and village, for they brought not only their tinware and other goods, but, no less important, the news and gossip from other places.

It was not long before it was discovered that decorated pieces sold more readily than undecorated ones. The painted surfaces were not only more attractive, but they prevented rusting. This early painting technique was used also, though to a less extent, for the decoration of chairs, chests, wooden boxes, and other household articles.

Country painting is good for the soul. It is gay and colorful; its very simplicity of arrangement and its flat, posterlike colors seem to be a healthy antidote for the complexities of modern living. It is always delightful to do and delightful to live with. It seems to fit in almost anywhere.

Freehand Bronze painting is a method of applying bronze powders over an underpainting that is partly dry. Sometimes the entire pattern is covered with the powder, and sometimes only highlights, thus leaving portions of the underpainting to show and to form part of the design. Details of line and color are added later.

Freehand bronze is a more sophisticated type of decoration than country painting. It is often found in conjunction with gold leaf, and sometimes with stenciling. Occasionally two or three different shades of bronze powders were used.

It is a very old technique and undoubtedly originated in the East. Many eighteenth-century European and American pieces show Oriental influence in their delicacy of design and treatment. Freehand bronze was used a

1

great deal on trays and furniture. Since, however, it required considerable skill and ample time, new and more rapid methods of decoration became more popular, and early in the nineteenth century it more or less ceased to be employed.

Stenciling is one of the most satisfying and fascinating of the old techniques. Its main development was during the period from about 1815 to 1850, and it was used on Boston rockers, Hitchcock and other chairs, pianos, wardrobes, trays, mirrors, cornices, chests, beds, boxes, and many other domestic pieces. The earlier examples are often elegant and formal. The designs include beautifully cut motifs and delicate shading and evince great artistry of arrangement. As the years went on, however, economic necessity drove the stencilers to devote less time to their work and to employ simpler designs and methods. This trend continued until the work done around 1850 was often quite crude.

Stenciling can be used with great effect in our homes today. One can decorate as simply or as intricately as one pleases, and once a stencil is cut, the speed with which it can be used in decorating an object is remarkable. There are few styles of room in which stenciling does not seem appropriate. A simple leaf repeated to form a border around the edge of a modern table, for example, never fails to add interest and charm.

Floating Color is a method used to produce a subtle blending of colors which can be achieved in no other way. Generally it is used in the painting of flowers or fruits that require a soft blending of transparent colors over an underlying pattern of opaque color. These colors are actually floated on a mixture of varnish and linseed oil. The result of these glazes is to produce a depth and a glow that are most pleasing.

Examples of floating color are found on old lace-edge and Chippendale trays and on some rectangular ones. This technique was also used on furniture and other household articles. As it required considerable skill, it is generally found to have been used on the finer pieces, often in conjunction with gold leaf. No one should attempt to do floating color who has not had considerable practice in country painting.

Gold Leaf. The sheer beauty and elegance of gold leaf put it in a class apart. Early eighteenth-century England used it to imitate the expensive lacquer ware imported from the East. From this period have come down very elaborate gold leaf trays which were imported by the American colonists. Naturally, it was not long before American artists too began to decorate with gold leaf, and they used it until well into the nineteenth century. In the domain of furniture, chairs in particular were decorated with gold leaf, sometimes for the whole design, as on Sheraton fancy chairs, and sometimes only for parts of the design, as on the finer type of Hitchcock chairs. It was used also with notable effect on rockers, tables, highboys, etc.

2

The application of gold leaf requires a certain skill in applying the underpainting, and also in the handling of the gold leaf itself. However, as in other fields, patience and a degree of practice will be well rewarded and will result in good technique. An effect of splendor combined with good taste is given to the home which contains objects adorned with gold leaf.

2 Materials and Their Care

The following are the essential materials required for American antique decoration work, together with some comments on their care.

Tube Colors: (a) Japan Colors in tubes of Vermilion (light), Chrome Green (light), Chrome Yellow (medium), and Lamp Black.

(b) Artists' Oil Colors in small tubes of Alizarin Crimson, Prussian Blue, Burnt Sienna, Burnt Umber, Raw Umber, Yellow Ochre, and Indian Yellow or Yellow Lake. Also a medium-sized tube of Titanium White or Superba White. Note that the Alizarin Crimson, Prussian Blue, Indian Yellow, and Yellow Lake differ from the others in that they are transparent colors.

The Japan colors were originally ground in Japan and were used in the West by the old coach painters. They are opaque and dry and give a flat, smooth surface. The tubes should be handled carefully, as they crack easily, with the result that the paint soon dries and becomes useless.

Keep the caps on all tubes when not in immediate use. If a cap sticks, do not try to unscrew it by a degree of force that will twist the tube. Instead, hold the cap for a few seconds only in the flame of a match. The warmth will cause it to expand, and using a cloth to protect your fingers, you can invariably unscrew it.

Bronze Powders: Palegold Lining, Deepgold, Aluminum (silver), and Fire.

Gold Leaf: 1 book of mounted pale gold.

Tracing Paper: 1 roll, thin and very transparent, 21 inches wide.

Frosted Acetate: 1 roll, medium weight. This is a transparent plastic sheet, one side of which is slightly frosted so that it will take paint. Its transparency enables one directly to copy a pattern underneath it without having first to trace an outline.

Black Drawing Ink.

Crow-quill: A fine-pointed pen.

Drawing Pencils: H, 2H, and 4H.

Architect's Tracing Linen: 1 yard. Although the old stencilers used paper, stencils for the projects in this book will be made from architect's linen, the kind that has a shiny undersurface. This sturdy fabric will last almost indefinitely, provided it is properly cared for. It should be kept away from all forms of moisture, which dissolves the starch lining and renders the linen useless for stenciling purposes. Cut stencils should be kept in wax paper envelopes, which can be made from wax paper sheets,

4

folded and secured with cellophane tape. They should be kept lying flat. Immediately after using stencils, clean them on both sides with Carbona cleaning fluid and a soft cloth. They dry in a few minutes.

Stencil Scissors: These are cuticle scissors, but with *straight* blades. They may be obtained from various sources. Very small embroidery scissors may be used if they are specially sharpened.

Don't try to cut stencils with an inadequate pair of scissors; it takes all the joy out of an otherwise delightful pastime.

Mohair: You will need a piece about 9 by 12 inches of this high-piled upholstery fabric to use as a "palette" for holding the bronze powders. Overcast or blanket-stitch the edges to prevent fraying. The bronze powders are placed along the lengthwise center fold, as shown in Plate 4. When not in use, the palette should be folded in half lengthwise, rolled up tightly crosswise, and secured with a small elastic band. The high pile and the tight rolling will keep the different-colored powders from mixing.

Velvet: 3-inch wide satin-backed black velvet ribbon is used to apply the bronze powders. Three or four pieces, each 4 inches long, should be prepared. On each piece, sew the two rough edges together to form a cylinder with both selvage ends open. These are known as "velvet fingers." Keep one for freehand bronze, one for gold stenciling, and one for aluminum powder.

Black Paper: For stenciling this may be prepared by tacking ordinary shelf paper in convenient lengths to sheets of newspaper, using small pieces of masking tape at the corners. Give the shelf paper two thin coats of flat black paint, allowing at least 24 hours for each coat to dry. For directions on thinning the black paint, see Chapter 3. Black paper is used for copying stencil patterns and for practice work.

Varnish: Varnish is used as a medium for mixing tube colors in the painting of designs, for finishing coats on a decorated piece, and for stenciling. It should be noted, however, that not every varnish is suitable for stenciling, particularly some of the heavier kinds.

Varnish should never be stirred. The ½ pint size is handiest. So long as the can has not been opened, the contents will keep in a perfect state. On contact with the air, the spirits begin to evaporate, and once the varnish has definitely begun to thicken, it should not be used. Since it cannot be retrieved, proper care should be taken from the first to ensure that no needless waste occurs. It is obvious that the cover should be kept on the can when it is not in use. But be sure that the cover is on *tightly*— step on it to make quite sure. When a can is one-third used, it is a good plan to pour the rest of the varnish into small bottles with good screw caps, since the air in the can, even though it is tightly closed, will thicken the varnish.

Primer: A high-grade metal primer paint which dries quite smooth and thus requires very little sandpapering should be used. It should be stirred thoroughly before using and may be thinned with turpentine.

When you have finished applying a coat of paint, wipe off the rim of the can with a cloth. Then pour a little turpentine on top of the paint in the can, just enough to cover the surface, letting it float there. This will prevent a skin forming. Then replace the lid and press it down tightly. The next time you open the can, simply mix the turpentine in with the paint, and it will probably thin it just enough for use.

Flat Black Paint: Makers are apt to change paint composition from time to time, but currently these are good: Sapolin and Sherwin Williams.

Brushes: (a) For applying coats of varnish and background paints, ordinary one-inch flat bristle brushes as sold in paint stores at a nominal price can be used. Some decorators, however, prefer to use better-quality brushes for this work and find them worth the extra cost. In any event, it is of the first importance to keep the brush in perfect condition.

To clean a varnish brush, first wipe it off thoroughly with newspaper. Then douse it up and down in a dry cleaning fluid such as Energine, letting it stand in the fluid about 15 minutes, with enough fluid to cover the hairs. After this, wash the brush thoroughly in soap and water, and rinse it well. Shake out the surplus water, and shape the brush carefully. Stand it up in a jar to dry undisturbed. The dry cleaning fluid can be kept in a screw-top jar, and used again and again.

To clean a paint brush, wipe it off thoroughly with newspaper, and then clean it in turpentine, letting it stand in the spirit 10 or 15 minutes. Wash the brush thoroughly with soap and water, and rinse. Shake out the surplus water, and shape the brush. If you intend to use the brush again the next day, it need not be cleaned, but may be left standing overnight in turpentine, or in plain water, with just enough of the fluid to cover the hairs.

(b) For painting designs, we require: (1) *Square-tipped ox-hair rigger or showcard brushes* #4 or #5. Hairs should be ⅝ to ¾ inch long. Buy two for convenience. (2) *Square-tipped camel's-hair quill brushes,* #0 and #1. Hairs should be ¾ inch long. (3) *Striper.* This is a square-tipped quill brush with hairs about 1½ inches long, and about the thickness of a #1 quill. It is used without a handle.

To clean these brushes, wipe them gently with a cloth, and then douse them up and down in turpentine. Let them stand in the fluid about 15 minutes, so that any paint that has worked up into the ferrule is soaked out. Then wash thoroughly in soap and water, and rinse. Shake out surplus water, shape carefully, and stand up in a jar undisturbed until they are dry.

Turpentine: 1 quart.
Steel Wool: #000.

Sandpaper: #000 or very fine.

Crude Oil: Pint bottle from paint store.

Decorator's Masking Tape: 1 roll.

Trichloroethylene is a dry-cleaning fluid that may be used for making erasures when painting patterns on frosted acetate or when decorating objects. One small can or bottle is enough, as a little on a cloth will do the job. But be sure to read the warning on the label. It seems to be the dry cleaning fluid least harmful to health, but even so use it only in a well-ventilated room, and very sparingly. Don't inhale the fumes and don't use it to remove spots of paint, etc., from your skin. For that use a little, very little, turpentine, or better, soap and water.

Energine: 1 bottle. This is a dry cleaning fluid sold in most stores.

Linseed Oil: 1 small bottle from an artist supply store.

Powdered Pumice: 2-oz size from a drugstore.

Magnesium Carbonate: 1-oz cake usually available at a drugstore.

Rusticide, for removing rust, is sometimes obtainable from local hardware or paint stores.

Bottle Caps: Start saving bottle caps about 1 inch in diameter and ½ inch high—for example, those that come on catsup bottles. Bottle caps make convenient-sized receptacles for the varnish used in painting designs.

Empty Jars and Bottles: Collect some small jars or bottles, about 2 or 3 inches deep, which have good, airtight screw tops. These will be needed for holding varnish, Carbona Cleaning Fluid, "slow varnish," etc. Bronze powders which come in packets are handled more conveniently if they are transferred to small bottles or jars. Cold-cream jars and others of similar type are useful for holding the mixed background colors.

Newspapers: Always have plenty of newspapers on hand. You will need them to spread over your work tables, to wipe brushes, and to use as "palettes" in painting designs.

LIST OF SUPPLIERS

Many artist supply stores carry items that the American antique decorator can use. The following list of some of the suppliers is included for your convenience. Several of them carry trays.

Priscilla Hauser
P.O.B. 45730
Tulsa, OK 74145

Be Crafty
8383 University Boulevard
Des Moines, IA 50311

Vera Petrie
P.O.B. 132
Nisswa, MN 56468

Ceramichrome
P.O.B. 427
7155 Fenwick Lane
Westminster, CA 92683

Margaret's Decorative Painting
4609 South Village Parkway
Topeka, KS 66609

Flair-Craft
P.O.B. 3494
Kimberling City, MO 65686

Leisure Services
P.O.B. 2763
Kansas City, MO 64142

Art & Craft Studio
293 Pascack Road
Westwood, NJ 07675

Fernandez
4110 West Town & Country Road
P.O.B. 2032
Kettering, OH 45429

American Handicrafts Company
1011 Foch
Fort Worth, TX 76107

Houston Art & Frame
2520 Drexel Drive
Houston, TX 77027

Duncan Enterprises
5673 East Shields Avenue
Fresno, CA 93727

Grumbacher
460 West 34th Street
New York, NY 10001

Ladybug Products
150 Enterprise Avenue
Box 8007
Trenton, NJ 08650

Magic Art Schools
Box 525
Bellflower, CA 90706

Malco Distributing Company
3825 Industry Avenue
Lakewood, CA 90712

Martin Weber Company
Wayne & Windrim Avenues
Philadelphia, PA 19144

Colonial Handcraft Trays
Route 211
New Market, VA 22844

Binney & Smith
1100 Church Lane
Box 431
Easton, PA 18042

Create-a-Finish
Cooper Road
Box B
West Berlin, NJ 08091

Dahlcraft
1564 Copenhagen Drive
Solvang, CA 93463

Delta Technical Coatings
11015 East Rush Street
Box 9326
South El Monte, CA 91733

Union Instrument Company
1447 East Second Street
Box 907
Plainfield, NJ 07061

American Metalcraft
4545 West Homer Street
Chicago, IL 60639

World Wide Enterprises
Box 873
Murray, KY 42071

Nashco Products
1015 North Main Avenue
Scranton, PA 18504

Premier Manufacturing Company
Box 220
Arvada, CA 80001

The Quilt House
5784 South Pennsylvania Avenue
Cudahy, WI 53110

St. Louis Crafts
44 Kirkham Industrial Court
St. Louis, MO 63119

TACC Industries
Box 125
Riverdale, NJ 07457

Wolff Products
Route 2, Box 258
Nashville, IN 47448

Mulligan's Craft Supply Company
825 Route 88
Point Pleasant, NJ 08742

Palmer Paint Products
1291 Rochester Road
Troy, MI 48084

Shiva
4320 West 190th Street
Torrance, CA 90509

3 Preparation of Tin for Decoration

This chapter and the next one deal with the preparation of actual objects for decoration. The beginning student, however, need not spend time on them, but may turn straight on to Chapters 6 to 10 which impart the techniques of decoration. When practice and skill have been acquired in these techniques, the time has come for trays and other articles to be prepared for decoration, and this and the next chapter should receive due attention.

1 Removing Old Paint or Varnish

The work of preparing a surface for decoration is as important as the decoration itself. The first step is to remove all old paint or varnish, for which purpose any good brand of paint and varnish remover will do. To reduce the chance of inhaling the fumes, work with the windows open. Read and follow the directions on the can, and have plenty of rags and old newspapers close at hand.

2 Removing Rust

In its initial stages rust is invisible to the naked eye, and therefore all tinware should be treated for rust whether it is observed or not. For this purpose, Deoxidine #624 is recommended. Deoxidine not only removes rust, but also cleanses the metal and minutely etches the surface, with the result that paint will adhere better. Proceed as follows.

(a) Dilute one part of Deoxidine with three parts of cold water, mixing only enough for the job in hand. Apply the solution to the tin surface with a paint brush, and leave it on for 5 minutes.

(b) Rub the surface with steel wool, and then apply the solution again for 5 minutes. Rub again with steel wool.

(c) Rinse the article thoroughly in cold water, and dry it well. The yellowish color that may appear is not rust.

(d) Apply the primer paint without delay once the article is completely dry.

If the tray or other article is badly rusted, several applications of Deoxidine solution may be necessary. This is particularly true of old articles into which the rust has eaten deeply. In restoration work, when as much as possible of the original paint is to be retained, it is safe to apply Deoxidine to the rusted parts, as it will not harm the surrounding paint.

3 *Before Painting a Surface*

The painting of a surface falls into two main parts, primer painting and flat background painting, which are described in turn in sections 4 and 5 which follow. But before applying any coat of paint, whether primer or background color, it is essential to note these three directions:

(a) Stir the can of paint carefully with a stick until the contents are thoroughly mixed. Avoid slopping the paint over the rim of the can, and do not stop stirring until it is *completely* mixed. It may take 10 minutes.

(b) Dust off the surface with a lintless cloth, making sure no particle of dust remains. Just before applying the paint, rub the palm of your hand over the surface, picking up any minute particles in the corners.

(c) Never paint a second coat until the first one is at least 24 hours old, and unless it feels completely and thoroughly dry. Wait if it feels the least bit sticky, even if you have to wait a week because of bad weather.

4 *Primer Painting*

A tin surface must always be given one or two coats of primer paint before the background color is applied, or the latter will not adhere properly. Any color will do for this primer. The primer paint should be applied *immediately* after the tin surface has been treated for rust. Spread plenty of newspapers on a table or other working surface, and be sure the paint has been thoroughly mixed.

In applying the primer to a tray, first paint the underside of the flange or border, leaving the central surface untouched. Then turn the tray over, and holding it balanced on your left hand, paint first the top side of the flange, and afterwards the *floor* of the tray, using long strokes the full length of the tray floor.

Don't flood the tray with primer, but use just enough to cover the surface. Don't go back to retouch any of it. Paint it, and leave it. Last of all, hold the tray high and check the underside for any drippings. Finally, set the tray down on a tin can placed on a spread newspaper, and let it dry for 24 hours. When applying the second coat, paint the floor of the tray in the opposite direction. After the second coat is thoroughly dry, sandpaper it to remove any tiny "pinheads."

The bottom of the tray is left unpainted until the rest of the tray is completely finished, including its decoration and the finishing coats of varnish. Then the bottom is rubbed off with turpentine and is given two coats of flat black paint.

5 *Flat Background Painting*

A properly painted background, whether black or any other color, should be a completely flat or dull surface, feeling smooth and free from

10

ridges when the hand is run over it. If you can feel any ridges, your paint was not sufficiently thinned with turpentine. To rectify this by sandpapering the surface until it is smooth may take a great deal of time and hard work; therefore apply the paint correctly in the first place and you will save yourself trouble later on. With this preliminary word of caution in mind, the following directions should be carefully studied and followed.

The paint should be thinned with enough turpentine to make a very watery mixture. Usually there is not enough room in a fresh can of paint for the necessary amount of turpentine to thin the paint properly. Procure a small empty jar, and pour into it about a quarter of an inch of turpentine. After stirring the can of black paint until it is thoroughly mixed, dip out one or two brushfuls, and add them to the turpentine in the jar. Mix with the brush. The resulting mixture should be quite thin and watery.

After dusting the surface, apply the thinned black just as you did the primer coat. Because of the thinness of the paint, the first coat will not completely hide a white undercoat, but do not go back to touch up. Leave it, and let it dry for 24 hours at least. Then apply the second coat. There should be at least three coats; four are preferred. In each case, paint the floor of the tray in the opposite direction to the previous coat, so as to contribute to an even result.

Sandpaper the last coat *very lightly* with a square inch or so of fine sandpaper. A little piece of sandpaper can be controlled better than a large one, and there is less likelihood of using too heavy a hand. Sandpaper chiefly the floor of the tray, avoiding the edges and other "vulnerable" parts, such as the bumps on a chippendale tray.

Allow the paint to harden for at least a week before doing a design on it. A longer period of waiting, such as a month, can be recommended, especially when a freehand gold or gold leaf design is to be applied.

6 Tin Boxes

Paint only the outside of a tin box. The inside is not usually painted, but is merely oiled from time to time to keep it from rusting.

7 "Mass Production"

Mass production in the usual sense of the term is not applicable to American antique decoration! But I use the expression to convey to learners the value of the economical use of time and effort. Practically never do I paint only one object at a time. By a little planning ahead you can generally arrange to carry several articles through the routine from Deoxidine to background painting. Then you can please yourself when you want to decorate them. Similarly, when the time comes to apply the finishing coats of varnish, it is very economical to wait until you have several pieces to do.

4 Preparation of Wood for Decoration

Old Wood

The re-decoration of old chairs, boxes, chests, cupboards, tables, etc., is one of the most satisfying ways of using American antique decoration techniques. Countless plain pieces have thus been converted into things of beauty; some which were thrown out with the rubbish have been rescued and turned into objects of admiration and envy.

The steps in the preparation of old wood for decoration are these:

(a) Remove the old paint or varnish as described in section 1, Chapter 3.

(b) Fill in all holes and cracks with plastic wood. Let it dry.

(c) Obtain a smooth surface by sandpapering the flat parts, and by rubbing the turned parts and any carving with steel wool.

(d) Apply three or four thin coats of flat background paint as described in section 5, Chapter 3.

(e) Again use the sandpaper and steel wool, but this time only *very lightly*, and keeping well away from all edges. To rub the painted edges would entirely remove the paint from them.

New Wood

In the case of new wood, the process of preparation is as follows:

(a) Sandpaper well, first using fairly coarse paper, and then the finer kind. Use steel wool on the turned parts and carving.

(b) Fill in crevices with plastic wood. When it is dry, sandpaper again.

(c) Apply a coat of shellac to seal the wood. Let it dry for 24 hours.

(d) Sandpaper again.

(e) Apply three or four coats of thin background paint in the way previously described (section 5, Chapter 3).

(f) Sandpaper very lightly, avoiding rubbing the edges.

Graining

A simple grained background was sometimes used on painted furniture, in order to imitate expensive woods. Occasionally it was used on boxes. The graining was generally done over a dull red painted background, or over a stained walnut one. There is more than one method of graining. The following is the one which I personally prefer.

First, apply the dull red background color in the usual three or four

12

thin coats of flat paint as described in Chapter 3. The color may be bought as Venetian Red or obtained by mixing Brown with Vermilion.

When the background color is thoroughly dry, apply a coat of thin black paint. The graining effect is done lengthwise along the wood and is achieved by immediately pulling a crumpled piece of old muslin across the wet surface. In the case of a large piece of furniture, do the graining in suitable sections. Have several small pieces of muslin on hand. When one piece becomes too full of paint, take a fresh piece. Let the work dry for 24 hours.

On a stenciled chair, the main slat is not grained, but is painted black.

5 Mixing Colors

Background Colors

For these use good-quality, flat indoor paints. Do not use glossy enamels. Pratt & Lambert's Sta Blac *Flat* Enamel gives an excellent dull black surface when it is sufficiently thinned with turpentine. Always remember to mix paint thoroughly before using.

Most of our other background colors have to be obtained by mixing, and for this work it is necessary to save small screw-top jars, such as cold-cream jars. It is important when mixing a color to be sure there is enough left over for touching up after the decoration has been completed, and the jars serve to keep the colors fresh.

In mixing for a background color, mix the pigments first, and then add the turpentine to get the proper watery consistency. For this reason, mix a relatively small quantity of the thick color, allowing for the fact that you will have a much larger quantity after the turpentine has been added.

Antique Black

To obtain this, put a little flat black in a clean jar, adding to it some Raw Umber and White. The best way to go about this is to squeeze a little of each of the two last-named colors on to an old saucer, and to dissolve them by mixing in some of the black with a showcard brush. When no lumps remain, add the mixture to the jar of flat black, and stir well with a small stick. Test the color on a piece of paper, using the showcard brush. Keep mixing and adding until the proper shade has been reached. Antique black is really off-black, that is, a very dark, soft, charcoal color. It is very effective with country patterns.

Light Colors

Use flat white paint as a base for all light colors, adding Japan or oil colors to get the desired color. Always allow for the darkening effect of the finishing coats of varnish and, of course, for any antiquing you may intend to do. Among the most used light background colors are these:

Off-white: White with a little Raw Umber added.
Cream: White with a little Yellow Ochre added.
Pale antique yellow: White, Japan Yellow, and Raw Umber.
Pale apple green: White, Japan Yellow, Raw Umber, and a touch of Prussian Blue.

14

Medium Colors

Use the nearest color flat paint, and tone with tube colors, as for example:

> *Venetian red:* Vermilion, Burnt Umber, and White.
> *Olive green:* Green, Burnt Umber, and Yellow Ochre.

Asphaltum

A background which falls into a class by itself is "asphaltum," as we call a mixture of asphaltum or asphalt and varnish. It is a semi-transparent background used over bright tin and is difficult to apply satisfactorily. Old examples invariably show more or less streakiness, and therefore beginners need not be unduly discouraged by the results of their first attempts.

If the tin has darkened with age or use, no longer presenting a uniformly shiny surface, apply a coat of clear varnish. When this is tacky, apply aluminum or chrome powder with a velvet finger, and then burnish it by applying extra pressure. This will give a simulated shiny tin surface. Wait 24 hours. Then wash off all loose powder under running cold water, pat the surface thoroughly dry with a lintless cloth, and apply a coat of varnish to protect the surface. Let it dry for another 24 hours.

Asphalt can be bought in a tube. It should be mixed in a saucer with varnish, to which is added a little each of Alizarin Crimson and of Burnt Umber. The quantity used of these oil colors determines the color of the asphaltum, and the quantity of varnish determines its transparency.

Apply the mixture with a varnish brush, working quickly. Do not go back and repaint any part of it. If you have enough of the mixture on your brush as you apply it, the streakiness will more or less disappear when the asphaltum settles. Use discarded tin cans to experiment with in applying the mixture, and to find out what shade of background you like best. Asphaltum must be allowed to dry for at least a week.

Color Key for Painted Patterns

The following are more or less standard colors, ones that recur again and again in American antique designs. Here they are arranged in convenient groups: first the reds, then the greens, then the blues, and so on. The method by which the different shades are obtained is added. Rarely do we use bright color fresh from the tube. Indeed, with the exception of Vermilion, all the bright colors must be toned down by the addition of Yellow Ochre or one of the browns in order to obtain those beautiful, soft, antique shades of color that are such a joy to live with. Mix the colors with the showcard brush, using varnish as the medium. Of course, the colors must be mixed completely, so that no lumps of pigment remain.

15

Prefixed to each color is the letter or letters by which it is indicated in the black-and-white drawings in this book.

V	bright red	Japan Vermilion.
S	salmon pink	Japan Vermilion, Yellow Ochre, and a touch of White.
A	dark red overtone	Alizarin Crimson, with a touch of Burnt Umber and enough varnish to make a semi-transparent rich dark red.
G	country green	Japan Green, with a touch of Burnt Umber.
LG	light country green	Japan Green with a little Japan Yellow, and a touch of Burnt Umber.
DG	dark country green	Japan Green, a touch of Raw Umber and Prussian Blue.
YG	yellow green	Japan Yellow, a little Japan Green, and a touch of Raw Umber.
B	medium blue	Prussian Blue, with a little Raw Umber and White.
LB	light blue	White with a little Prussian Blue and Raw Umber.
DB	dark blue	Prussian Blue, with Raw Umber and a touch of White.
RU	dark brown	Raw Umber.
BU	medium brown	Burnt Umber.
BS	reddish brown	Burnt Sienna.
Y	mustard yellow	Japan Yellow, with Burnt Umber added a little at a time until you get the color you want. For a greenish mustard, use Raw Umber. For an orange mustard, use Burnt Sienna.
W	off white	White with a touch of Raw Umber. For white overtones, use enough varnish to make the mixture semi-transparent.

6 Country Painting

The first step towards proficiency in country painting is to learn its typical brush strokes. Take a double sheet of newspaper and fold it into eighths so as to make a handy "palette." Newspaper is used because it has the advantage of absorbing superfluous oil in the paint. Next you will need the following: a small bottle cap filled with varnish; a tube of Japan Vermilion; a square-tipped show card brush for mixing; a square-tipped camel's-hair quill brush for painting; some tracing paper; a small jar half full of Carbona Cleaning Fluid for cleaning brushes. With these items you can proceed to practice the brush strokes.

Place a piece of tracing paper over Plate 1. Squeeze out a little color on the newspaper, and dipping out some varnish with the showcard brush, mix it with a small quantity of color. The mixture should contain enough varnish to make it manageable, and yet it must not be so thin that it spreads once it has been painted.

Take up the quill brush and dip it into the paint mixture, loading the brush its full length, not just the tip of it. Now hold the brush as illustrated in Plate 1. Hold it as vertically as possible, with the wrist off the ground, and the hand resting lightly on the tip of the little finger. Rest the forearm on the table edge.

Paint the broad stripe as seen through the tracing paper, and observe how the brush flattens out to a knife-edge now that it is lowered. Next, slowly raising the brush, pull it off to one side, using the knife-edge to end the stroke on a hairline.

Now go on to paint the rows of brush strokes in the illustration, starting at the broad end of each stroke, and gradually raising the brush to end on a hairline. Paint each stroke slowly and deliberately. If your stroke finishes too thick, either you had too much paint mixture on the brush or you did not raise the brush enough. Too much paint on the brush may also cause the strokes to spread a few minutes after you have painted them.

Except for very small strokes, reload the brush for each stroke, always reloading to its full length. With practice you will learn to load the brush instinctively with just the right amount of paint for the size of stroke you desire.

For a stroke that starts on a point and ends on a point, flatten the brush on the newspaper palette, and then holding the brush high, begin the stroke; lower the brush to do the broad part of the stroke, and finally lift it to complete the stroke. For a thin line or vein, flatten the brush on

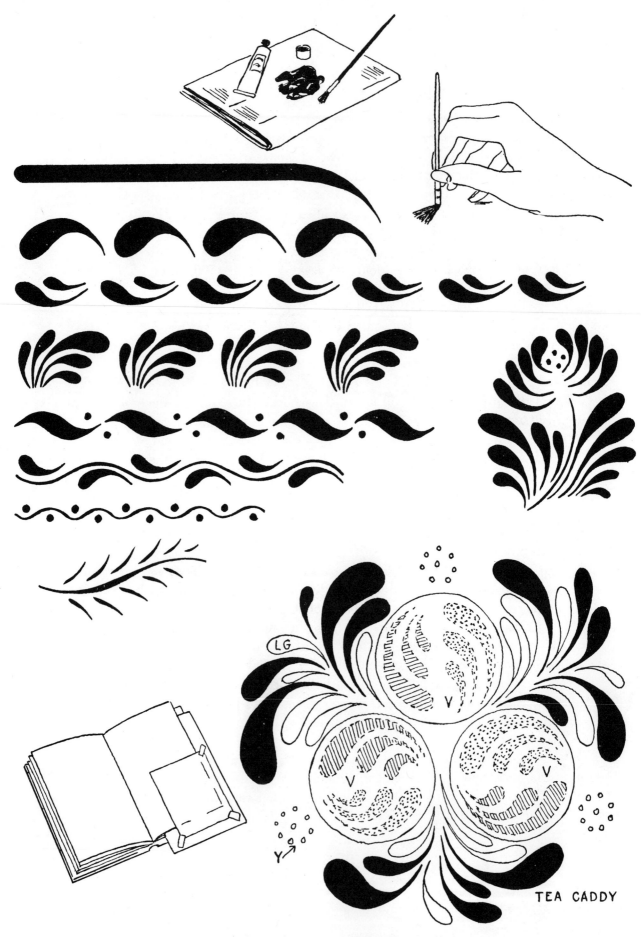

PLATE 1 PRACTICE YOUR BRUSH STROKES

the newspaper and then paint with the knifelike edge. For a dot, round the brush on the newspaper, and then holding the brush high, paint the dot with the end of the brush.

Whenever the paint begins to thicken, clean the brush in Carbona. Squeeze out a little fresh paint, and mix with varnish on another part of the newspaper.

Don't hesitate to turn your work round to any convenient angle that suits the particular stroke you are doing; turn the work upside down if necessary. A good stroke is the result of patience and practice. By practicing half an hour every day for a week or two you should have a fair command of the brush.

Tea Caddy Pattern on Plate 1

To make a copy of this pattern, cut a piece of frosted acetate large enough for the design, and attach it at three corners to a piece of thin cardboard, using for the purpose small pieces of decorator's tape. Slip this contrivance into the book in the manner shown in the drawing in the lower left-hand corner of Plate 1, which will have the effect of bringing the tea caddy pattern under the acetate. By painting the pattern directly on the acetate you will get not only a color record of it, but also valuable practice. The stages are these:

1. On a newspaper palette squeeze out a little Japan Vermilion. Using the showcard brush, dip several brushfuls of varnish out of the bottle cap, and mix them with a small quantity of the color. Paint the three large "flowers" marked V, disregarding the overtone strokes. The paint should be opaque, but yet contain sufficient varnish for it to dry smooth and flat. Clean the brush by wiping off the excess paint on a rag, and then dipping it in Carbona.

2. Squeeze out a little Japan Green and a tiny bit of Burnt Umber. With the showcard brush mix some Green, adding a speck of Burnt Umber to tone down the Green a little. With this "country green" mixture, paint those "leaves" which are shown black in the illustration, using your quill brush for this purpose.

3. Squeeze out a little Japan Yellow and add a touch of it to the green mixture, making a much lighter and yellower green. With this mixture, paint the leaves, which are shown white in the illustration.

4. Clean the showcard brush, and use it to mix a little Yellow with a touch of Burnt Umber. With the cleaned camel's-hair quill brush, paint the dots. Remove the cardboard and acetate from the book, and set it aside to dry for 24 hours.

5. To paint the shaded and the dotted overtones on the vermilion flowers, do not put the acetate back over the illustration. These are done by eye, using the illustration as a guide. On a clean newspaper palette mix

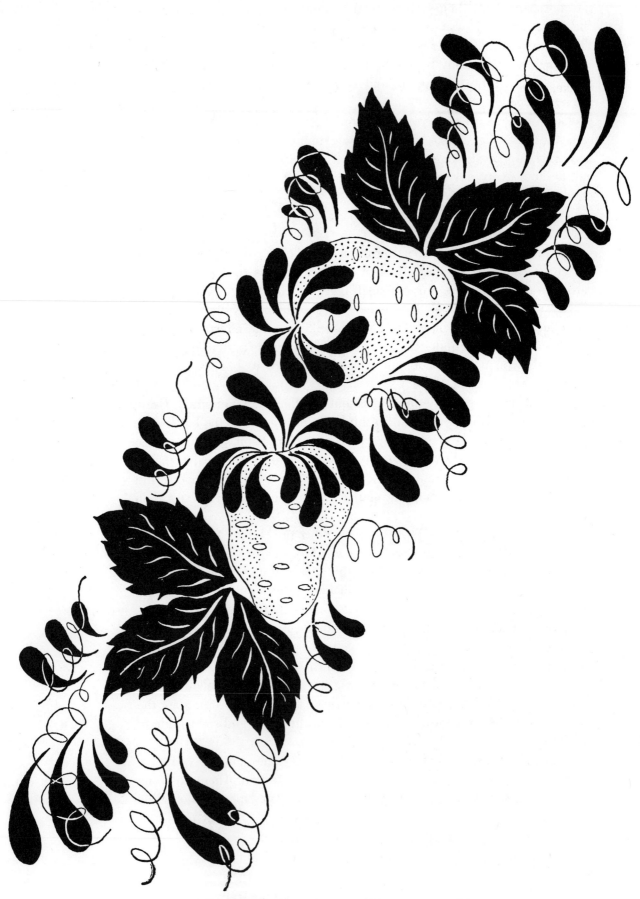

PLATE 2 STRAWBERRY CHAIR: YELLOW BACKGROUND

several brushfuls of varnish with some Alizarin Crimson and a touch of Burnt Umber, making a rich, dark, semi-transparent red. With this mixture, and using the quill brush, paint the dotted overtone strokes on the flowers. Use only one stroke for each overtone. If you make a mistake, wipe it off with a clean cloth at once, before it has time to set.

6. For the shaded overtone strokes in the illustration, mix some varnish with a little White and add a touch of Raw Umber to make a semi-transparent white overtone. When this is painted on the vermilion flower, it will take on a faintly pinkish tone. Set aside to dry for 24 hours.

Strawberry Chair on Plate 2

To make a copy of this pattern, cut a piece of frosted acetate and place it over the illustration, as described above for the tea caddy pattern. Proceed as follows:

1. On a newspaper palette mix some varnish and Japan Vermilion, and paint the whole area of the two strawberry shapes, covering the overlapping leaves, the shading, and the seed marks. Remove the acetate from the book and let it dry for 24 hours.

2. On either side of each strawberry are dotted areas which are done in semi-transparent dark red, made by mixing some Alizarin Crimson with varnish and adding a touch of Burnt Umber. With one or two strokes of the showcard brush, apply this mixture to the berries, taking care not to go over the edges, as it would show on any pale background color. Don't fuss over it. Do it once and leave it.

Immediately take a camel's-hair quill brush, dip it in the varnish, and wipe off some of the varnish on the newspaper palette, at the same time flattening the brush. Now, with one stroke, draw the flattened brush along the inner edge of the dark red overtone, with the brush partly on the red and partly off. This will blend and soften the edge of the dark red, giving the berry a softly shaded look.

If you use too much varnish on the blending brush, it will spread and disturb the smooth appearance of the dark red. Practice will enable you to know just how much to use each time.

3. Twenty-four hours later, mix some Japan Green with a touch of Burnt Umber, and paint all the leaves and brush strokes which are black in the illustration. Wait 24 hours.

4. Mix some Japan Yellow with a touch of Raw Umber, and using enough varnish to make the mixture slightly transparent, paint the seeds on the berries and the veins in the leaves.

5. With Japan Black, paint the curlicues, using a fine quill brush.

To Decorate a Chair

Before proceeding to decorate a chair with this pattern, you should study the instructions as to preparation and background color which are given in Chapters 4 and 5. The pattern was taken from a chair that was painted a pale antique yellow. This color can be made by mixing White with Japan Yellow, adding a little Raw Umber, and thinning with turpentine to a very watery consistency. Apply three or four coats.

Striping

See Chapter 14 as to the general method of striping. The striping on the chair was done in two colors. The broad stripe, about ⅛ inch wide, running around the main slat and the seat, was in a transparent dark red, made by mixing Alizarin Crimson and a touch of Burnt Umber. This was also used to accent some of the turnings. See Plate 19. The fine striping on the side back posts, the seat (just inside the red stripe), the smaller slat, and on some of the turnings, was done in country green to match the leaves, and was about $\frac{1}{16}$ inch wide.

Position of Chair

The most convenient way to decorate a chair is to lay it on its back on a table, and to work upside down. Turn the pattern you are copying upside down too. This method of procedure applies to stenciling as well as to freehand painting.

7 Freehand Bronze

Freehand bronze painting is the term used to describe a method of applying various metal powders to a pattern without the use of a stencil. The word "bronze," when used in this connection, covers a large variety of metal powders which give the effect of gold and silver as well as bronze. It was, no doubt, in imitation of the splendid but expensive process of gold leaf decoration that "gold" metal powder was first used, and the use of other metallic colors naturally followed.

For this work an absolutely dry background of flat paint is essential; otherwise the loose bronze powders will stick to the background. The design is painted freehand with a varnish mixture, and when it is tacky it is burnished or shaded with the metal powders.

To Copy a Tray Border

A good way to learn freehand bronze is to copy on to a sheet of frosted acetate the simple tray border shown at the top of Plate 3. Proceed as follows:

1. Place the acetate over the design.
2. On a newspaper palette, and using the ox-hair brush, mix some Japan Vermilion with a little varnish. Using the quill brush, begin by painting the first flower, then its three large leaves, and then its smaller leaves. Paint the overall surface of the flower, going over all the details and shaded areas. Proceed to the other flower and its leaves in the same order. Apply the paint evenly, avoid leaving any overly wet places, and do not go back and repaint any part. Paint it and leave it. Your work should present a flat, even surface. In working along, keep a watch on the areas already painted, and, as they begin to dry, apply pale gold powder with a velvet finger, using a small circular motion and a very light touch. Continue in this way, painting and applying the powder to the drying areas.

The secret of success is to apply the powder at just the right stage of dryness. If you do it too soon, the surface of the paint will be roughened and some of the hairs of the velvet will stick to it. If you wait too long, the surface will be too dry for the powder to stick. The flowers and large leaves will take longer to reach the proper stage than the smaller parts of the design.

When you have finished applying the last of the gold powder, lay the pattern aside to dry for 24 hours.

TRAY BORDER

BOX

SMALL OVAL TRAY

PLATE 3 FREEHAND BRONZE

3. Next day, gently wipe off the excess gold powder with a cloth. Then draw the details with pen and ink. Allow half an hour for drying.

4. Apply Burnt Umber shading on the areas marked with fine parallel lines. A thin mixture of varnish and Burnt Umber is used. Allow the work 24 hours to dry.

Excess Bronze Powder

It is sometimes difficult, after the 24-hour drying period, to wipe off the excess powder from a tray or other object. In the case of a metal object, such as a tray, the excess can be washed off by running cold water over it. If you are working on an article made of wood, it is better to wipe it well with a damp sponge, after which the surface may be dried by patting it with a linen towel. If powder still remains, paint it out with the original background paint.

The finer bronze powders, such as the lining powders, tend to stick in the wrong places if the opportunity is given them. They give a more beautiful surface than the coarser powders, but need to be used with the greatest care. If we bring a little patience and perseverance to this work, the most gratifying results will be attained.

To Copy the Box Pattern

1. Put a sheet of frosted acetate over this pattern in Plate 3. Using a quill brush, paint in all the black parts with a mixture of Japan Vermilion and varnish. When the work is tacky, apply the gold powder. Let it dry for 24 hours.

2. Wipe off the excess gold powder. Paint the white areas with a mixture of Titanium White, a touch of Raw Umber, and a little varnish. Allow 24 hours to dry.

3. The dotted lines in the design indicate areas of transparent colored overtones, which are applied with one or two strokes of the quill brush. Do not fuss over this—do it and leave it. If the first application is not right, instantly wipe it off with a soft cloth, and do it again.

The red (marked with an A) is made of varnish mixed with a little Alizarin Crimson and a touch of Burnt Umber. The blue (B) is a similar mixture of varnish with a little Prussian Blue and Raw Umber. The chartreuse green (C) is obtained with Indian Yellow and a touch of Prussian Blue.

To Copy the Small Chinese Tray

1. Put a sheet of frosted acetate over this pattern in Plate 3. With Japan Vermilion paint in the black parts excepting the details on the heads. When tacky, apply the gold powder. Wait 24 hours.

2. Wipe off excess powder. Paint in the heads with a pale flesh color

obtained by mixing White with a little Indian Yellow and a touch of Alizarin Crimson. While the work is still wet, work in a little more crimson on the faces. By adding still more crimson to the flesh color, make a deep rose, and use it to paint in the three balls. Wait 24 hours.

3. Give the entire sheet of acetate a coat of varnish, and when it is almost dry, cloud in a little pale gold powder to indicate faintly the ground. Wait 24 hours.

4. With pen and ink, draw in the faces and hair, and the details of the clothes. This is done after the application of the varnish, so that if any mistakes are made they can easily be erased without affecting the other parts of the design.

8 Stenciling

Stenciling is done on a partly dry, varnished surface, by applying bronze powders through a stencil. Black is the usual and typical background color, as this gives depth and roundness to the shaded leaves, fruits, flowers, etc. When stenciling is found on light-colored chairs (such as an apple green or a salmon pink), the main slat carrying the stenciled design is painted black.

Tracing Stencils

Our stencils are made out of architect's tracing linen, which is semitransparent, enabling the design to be traced directly on it. The tracing is done on the dull side of the cloth by means of a crow-quill pen and black drawing ink. In Plate 5 are shown the units for an old Boston Rocker pattern, the black parts being the areas that are to be cut out.

In tracing each unit on linen, allow an inch of linen around the unit. The larger units should be on separate pieces of linen, but the smaller ones may be traced two on a piece so long as care is taken to allow an inch of space in between. For example, figures 5 and 6 of Plate 5 may both

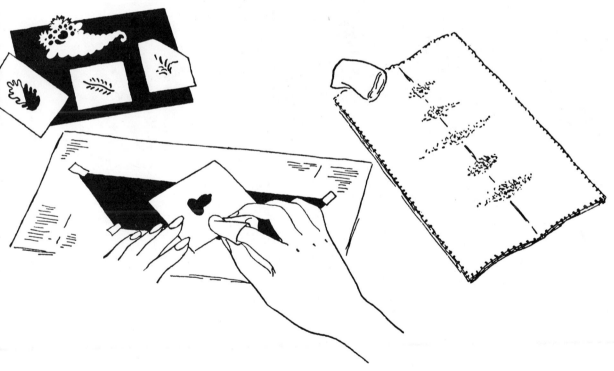

PLATE 4 STENCILING WITH BRONZE POWDERS

27

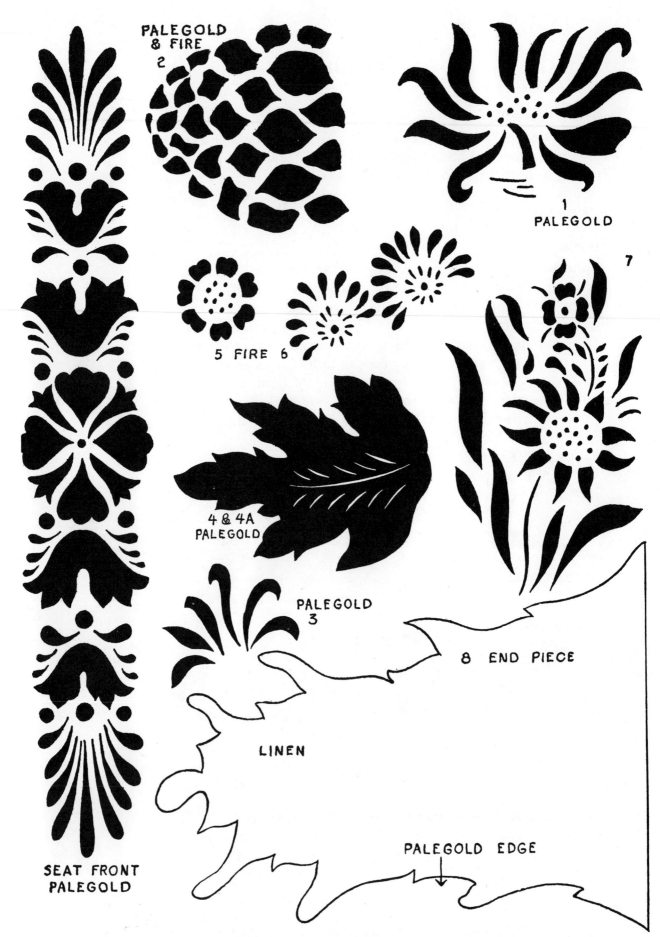

PALEGOLD
& FIRE
2

1
PALEGOLD

7

5 FIRE 6

4 & 4A
PALEGOLD

PALEGOLD
3

8 END PIECE

LINEN

SEAT FRONT
PALEGOLD

PALEGOLD EDGE

PLATE 5 STENCILED BOSTON ROCKER

be traced on one piece of linen but with an inch of linen between them and, of course, one inch of linen all around the outside of them.

Note that in the case of figure 4 *two* stencils are required, one for the leaf and one for the veining.

Notice that figure 8 is different from the others in that, instead of being cut out, the unit is a piece of linen with a cut-off edge. Hence there is no one-inch margin to consider.

Cutting Stencils

It is important to have the proper scissors (see page 5), a comfortable chair, and a good light over your shoulder. Be comfortable and be relaxed. A black cloth on your lap will make it easier to see the job and at the same time will serve to catch the scraps that fall.

During the actual cutting, take care not to stretch the edges of the linen. Do not pierce the cloth directly on the line, but rather inside it. For a stem running to pointed ends, pierce the cloth in the middle, and cut towards the point. A tiny dot is cut by piercing the linen with the point of the scissors, and then taking five or six tiny cuts around, using only the very points of the scissors. In a unit composed of many pieces, such as figure 7, cut the smallest pieces first, gradually working up to the largest ones last. When the stencils have all been cut, number the pieces in ink to correspond with the numbers of the figures in Plate 5, and write on each the color of bronze powder which is to be used with it.

Black Paper

The pattern should be stenciled on black paper before doing it on a rocker. Cut a piece of black paper about 20 by 5 inches, and tack this to a larger piece of clean newspaper, using tiny bits of masking tape at the corners. A beginner would do well to practice stenciling a pattern several times on black paper, as it is much easier to throw away a mistake on paper than to clean off and re-do a black surface on a piece of furniture.

Varnishing

Carefully dust off the surface to be varnished, and assemble all the necessary equipment before opening the varnish can. You will need plenty of newspapers to spread down, the varnish brush, a paint rag, and the brush bath. The latter is a jar half full of Energine.

Do not shake or stir the can of varnish. Flick your brush to get rid of any loose hairs or dust particles. Dip the hairs of the brush about one half their length into the varnish, and holding one end of the black paper down with the left hand, begin to apply the varnish. Press the brush down

29

all the way, and use long strokes the full length of the paper. Work with the light falling across the paper so you can see that every bit of surface is being covered. Work quickly and surely, taking more varnish only as you need it, but never flooding the surface. Now hold the black paper down at the top, and without taking any more varnish, go over the surface in the crosswise direction, thus making sure that there is an even distribution of varnish.

If you have used too much varnish and the surface seems very wet, wipe the brush off on some clean newspaper and then quickly pick up the excess varnish. Last of all, with a very light touch, and using only the tip of the brush, pick up any tiny bubbles on the surface. Set the paper aside to dry in a dust-free place. Follow the same procedure when you come to varnish a tray or a chair slat.

The weather and the amount of varnish used will determine how long it will take for the varnished surface to reach the proper tacky stage for stenciling. It generally takes about 45 minutes to an hour, but on a wet day it would take longer. The proper tacky stage is reached when the surface is sticky to the touch, but yet the fingertip leaves no mark on the surface.

Stenciling

While the varnish is drying, assemble your stencils, and check them to be sure you have all of them. Set up your mohair palette with tiny mounds of palegold and fire powders, as illustrated in Plate 4. Wrap the velvet "finger" (see page 27) around your forefinger as shown in the illustration, drawing the folds tightly to the back of the finger, and holding it in place with the third finger. The tiny working surface of velvet on your fingertip should be smooth, and only about one quarter of an inch in diameter. If your finger happens to be larger than that, stencil with the side of the fingertip.

When the black paper has reached the proper tacky stage, begin to stencil by placing stencil 1 in position on the black paper, using Photo. I between pp. 22-23 as your guide. With the velvet "finger" pick up so little palegold that it is barely visible, and then with a light *circular* touch apply the powder around the outer edges of the leaves where they are brightest, taking up more powder as needed. After the brightest parts are stenciled, go over them with a little more pressure to burnish them, and then go lightly over the rest of the unit to achieve a shaded and rounded effect. Lift the stencil.

If you pick up too much powder on the velvet, just tap it on a clean part of the mohair, and the high pile will take it off instantly. If you apply too much powder to the black surface, there is no way of taking it up again; hence work cautiously.

Place stencil 2 in position and apply the palegold brightly at the very top of the pineapple. Then with a clean part of the velvet pick up some fire powder and go back over the palegold, working on down the fruit and fading out to *deep black* before you reach the leaves of stencil 1. It is the quick transition from very bright gold shading to fire and then to deep black that gives roundness to the fruit. Next, stencil 3 is done in palegold, very bright at the outer edges, fading quickly to black before you get to the pineapple.

Do stencil 4 in palegold, very bright around the edges of the leaf, leaving the center black; after which the veins are done in palegold. Then flower stencil 5 is done in fire, one at a time, followed by stencil 6, also in fire. Stencil 7 is then added, one on either side. Last of all, stencil 8 is carried out on the ends of the slat. The stencil is used for one end, after which it is cleaned on both sides with turpentine, and then reversed to stencil the other end. Palegold is used for both 7 and 8.

Always remember when stenciling to apply the powder with a light circular motion of the velvet. Do not dab it on Also, after the brightest parts have been stenciled, go over them again with a little more pressure to burnish them.

When you have finished stenciling a pattern, immediately clean the stencils on both sides with Energine or Carbona, using a soft cotton cloth. They dry in a few minutes. Let the stenciled pattern dry for 24 hours.

9 Floating Color

The rose on the Queen Anne style tray is a typical floating color rose. It is done in three stages, each stage being allowed to dry thoroughly before the next one is painted. The characteristic subtle blending of color is produced by floating the color on the second stage. For this process, you will need a small bottle of "slow varnish," which is composed of one part linseed oil and two parts varnish. This you can mix yourself. Be sure to label the bottle, so as not to confuse it with ordinary varnish.

Incidentally, do not attempt to do floating color work until you have had a fair amount of practice in country painting.

To copy the Queen Anne tray center, slip a piece of frosted acetate over the drawing in Plate 6. In the original pattern, the leaves and stems were all in gold leaf, the application of which will be dealt with in Chapter 10. Meanwhile, satisfactory results can be obtained by using palegold bronze powder as already described in Chapter 7 (Freehand Bronze). Proceed as follows:

1. On a newspaper palette, mix some varnish with a little Japan Vermilion, and paint the leaves and stems. First do the larger leaves, then the next larger, and so on, down to the thin stems. When the proper tacky stage has been reached, apply the palegold powder. Wait 24 hours.

2. Dust off the excess powder.

3. Disregarding all details, paint the overall area of flower A with a subdued orange, made by mixing Japan Vermilion, Yellow Ochre, and White. Using a creamy white, produced by mixing White with a little Raw Umber and Yellow Ochre, paint the overall shapes of the other two large flowers (B and C), the bluebells (D), and the small flowers and buds. Remove the acetate from the book, and let it dry for 24 hours.

4. On a newspaper palette squeeze out a little Alizarin Crimson, Burnt Umber, Prussian Blue, Raw Umber, and Indian Yellow. Dust off the surface of the pattern.

For flower A, dip the showcard brush into the bottle of slow varnish, and apply a coat of the mixture over the entire flower, but just short of the outer edge all round, since the varnish will spread a little of its own accord. Do not flood it on, but use just enough to cover the area comfortably.

Wipe off your brush on a rag to get rid of most of the slow varnish, and pick up a little *dry* Alizarin Crimson and a speck of Burnt Umber on the tip of the flattened brush. With a light touch, brush in the red on the shaded (broken-line) areas of flower A, adding a bit more pigment just

32

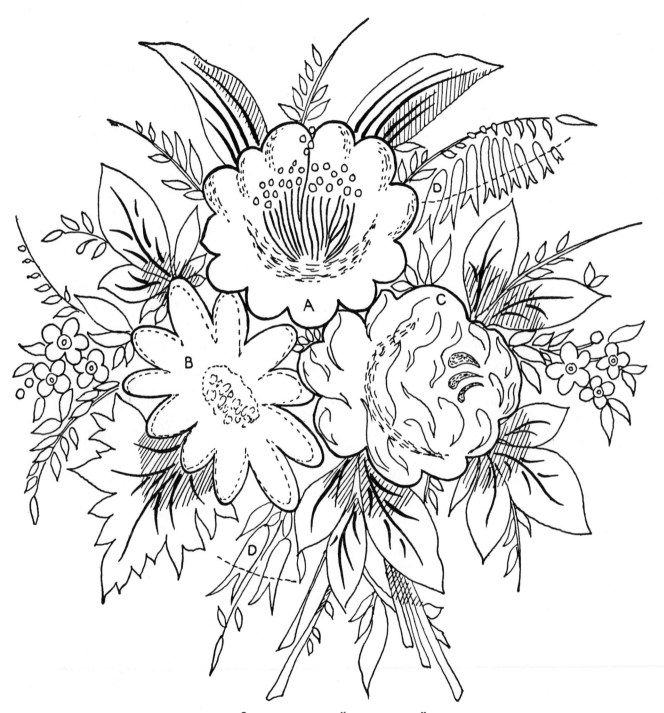

PLATE 6 CENTER FOR "QUEEN ANNE" TRAY

under the stamens. Work quickly. Do not fuss over the streaks. After a few minutes of standing, the transparent color should have blended in with the slow varnish.

5. Clean the brush, and apply a coat of slow varnish to the rose C. Wipe the brush on a rag, and brush a little Indian Yellow all over the flower until you have a smooth transparent yellow tone. Then pick up a speck of Alizarin Crimson plus Burnt Umber, and lightly brush this pinky color under the "cup" of the rose, here and there around the edges, and also in the "heart" of the flower. Pick up a little more pigment, and darken the areas under the cup and in the heart of the rose.

6. With a clean brush, apply slow varnish to the bluebells D, treating both groups as units. Wipe off the brush on a rag. Pick up a speck of Prussian Blue and a tiny speck of Raw Umber, and apply a transparent deep blue to the lower third of the flowers. Using an even lighter touch than before, continue by fading the color off to a paler and paler blue, and finally to nothing, letting the white underpainting show at the top end of the bells. This completes the floating color on this pattern.

Note that anything with slow varnish in it needs at least a week to dry. It is not dry until every hint of stickiness is gone. However, after a day or two the other parts of the pattern may be painted.

7. With a thin mixture of Alizarin Crimson and Burnt Umber, apply a transparent red overtone to the flower B, leaving some of the white underpainting showing around the edges. Wipe off the brush a little, pick up a little *dry* Burnt Umber and work in a darker area at the center.

Paint the centers of the small white flowers with transparent red. Paint the veins of the leaves with Burnt Umber.

8. After the slow-varnish areas are thoroughly dry, dust off the surface. Using hardly any varnish at all, mix a little White with a touch of Raw Umber to get a thick off-white for accentuating the edges of the petals on the rose C, known as the "veiling." Paint one petal at a time, immediately taking a second brush with a little varnish on it, and using it to blend and soften the inner edge of each white stroke.

With a somewhat thinner mixture of off-white, paint the stamens on flower A and the centers of the small white flowers. For flower B, take the off-white brush, wipe it off a bit on the newspaper palette, and with this "dry" brush put in the strokes on the dark center.

Using a transparent green, made by mixing varnish with a little Indian Yellow and Prussian Blue, paint the shaded areas on the larger leaves and stems. Each time, apply the green with one or two strokes of the brush, and then taking a clean brush with a little varnish on it, immediately blend the edge of the color, so that it blends off nicely into the gold. Do not wait to do the blending until after all the green has been applied. Each patch of green must be blended off at once as it is painted. Let the work dry for 24 hours.

34

10 Gold Leaf

Gold leaf comes in two kinds of little booklets. In the one the leaves are mounted on tissue paper, and in the other they are unmounted. If you are learning to lay gold leaf without the personal guidance of a teacher, it is best to obtain the mounted kind, which is easier to handle than the other. Cut a piece of cardboard the size of the booklet, and lay the booklet on it, thus keeping the leaves flat, which generally facilitates handling.

Flat Background

As with freehand bronze painting, gold leaf work calls for an absolutely dry background of flat or dull paint; and preferably one that has been left a month to harden thoroughly.

To Prevent Sticking

Gold leaf has a tendency to stick in places where it is not wanted. To counteract this tendency, take some whiting, or Bon Ami cleansing powder, on a wet cloth, and go lightly over the surface. When it has dried, the resulting application is seen as a very faint film of white powder. Then transfer the design with magnesium carbonate, as described in Chapter 11. You can paint right over the white film. Later on, after the gold leaf has been applied and is dry, the film can be wiped off with a damp sponge.

Underpainting

The simplest way to start applying gold leaf is to lay a solid gold border. For practice, place a sheet of frosted acetate over the section of this rectangular tray border shown in Plate 7. With a mixture of varnish and Yellow Ochre oil color, paint the background of the broad band on which the flowers, etc., appear, working quickly and evenly, with no areas wetter than others. Let the light fall across your work, so that you can be sure to cover every bit of surface as you go along. Guard against having an excess of varnish in the painting mixture, for that will make it spread. On the other hand, too much Yellow Ochre will result in a lumpy surface. With the same mixture, paint in the background for the three narrow gold stripes, namely, the one along the outer edge of the flange and the two inside the broad band which lie on the floor of the tray. Set the work aside until it is somewhat drier than is appropriate for stenciling, but is still tacky to the touch.

WHITE STRIPE

SOLID GOLD LEAF BAND

WHITE STRIPE

WHITE

RED

WHITE

GOLD LEAF

SMALL RECTANGULAR TRAY

GOLD LEAF PEN TRAY

MUSTARD YELLOW STRIPE

PLATE 7 GOLD LEAF TRAYS

Laying Gold Leaf

Note that, when laying gold leaf, it is important to see that the tissue paper does not touch the painted surface.

The proper tacky stage having been reached, pick up a mounted piece of gold leaf, holding it by the tissue paper with both hands, and with the gold side down. Hold it just above the painted border until you know exactly where you want it, and then lay it down on the tacky surface.

With a clean piece of velvet, press it down gently. Then lift up the tissue, and, with the remaining gold, go on to the next section, slightly overlapping the leaf as you apply it. Continue in this way until the gold on the tissue has been used up. With the fragments that may still remain, go back and touch up any small areas that, for one reason or another, did not get covered. A few hours after this part of the work is completed, gently remove all loose gold leaf with a clean piece of velvet. Let the work dry for 24 hours.

It would be a decided waste of gold leaf to practice the whole tray border on frosted acetate. By completing the border on an actual tray, you will get the best kind of practice.

Touching Up

After the gold leaf on a tray is 24 hours old, any places that are still without gold on them should be touched with clear varnish on a quill brush. But don't flood it on. Dip the brush in varnish, and wipe off a little on the newspaper palette before touching up. When the spots are tacky, which such tiny areas may become in a few minutes, lay the gold leaf. The whole job should then dry for a week.

Protective Coat of Varnish

Dust off the surface of the tray, making sure to remove not only dust but all stray bits of gold leaf as well. Then, before going on with the rest of the design, apply a coat of varnish to the tray as a protection for the gold leaf. After the varnish has dried for 24 hours, go over it very lightly with #000 steel wool, applying just enough pressure to take off the high gloss. This will give a good working surface for pen lines and any further painting.

Completion of the Small Rectangular Tray Pattern

Put a sheet of frosted acetate over Plate 7.

On a newspaper palette mix a little Japan Vermilion with varnish, and paint the center flower. With a mixture of off-white, paint the white flowers, and also the interlacing border design at the left. With a mixture of transparent deep green, made by mixing varnish with a little Indian Yellow and Prussian Blue, paint the shaded leaves. Wait 24 hours.

With Japan Black and a little varnish, paint the black accents on the leaves and the black flower centers. With a mixture of off-white, paint the stripes on either side of the gold leaf band area. Allow 24 hours to dry.

Gold Leaf Pen Tray

Besides the small rectangular tray, Plate 7 includes the pattern for a gold leaf pen tray. This provides more advanced practice in laying gold leaf. Proceed by the following stages:

1. Prepare the tray with three or four coats of flat black in the usual way. See Chapter 3.

2. Apply a thin film of whiting to prevent sticking as described earlier in this chapter.

3. Make a tracing of the pattern from Plate 7, and transfer it to the tray.

4. With a mixture of Yellow Ochre and varnish, and disregarding all superimposed details, paint the parts of the design which are to be gold in the following order, namely: the larger fruits, the smaller fruits, the leaves from the largest down to the smallest. This order ensures that, as far as possible, all will reach the proper tacky stage at the same time. Omit the tiny flowers, the buds, the stems, and the "whiskers," none of which are to be in gold. Then paint the end pieces, which are entirely in gold. When the proper tacky stage has been reached, lay the gold leaf. Wait one week.

5. Dust off the tray, and apply a coat of varnish to protect the gold. Let the work dry for 24 hours.

6. Rub very gently with the steel wool #000 to remove the gloss. Dust off thoroughly.

7. With a crow-quill pen and black ink, put in the lines and dots on the fruits and large leaves. Wait half an hour for the ink to harden.

8. Using a showcard brush, mix a little Burnt Sienna with varnish to make a transparent brown, and paint the shaded areas on the fruits, each time blending the edges at once with a clear varnish brush. Paint the tiny flowers and buds in off-white. Paint the stems and "whiskers" in mustard yellow. Let the work dry for 24 hours.

9. With Vermilion, paint the dots on the buds, and the circles on the flowers. The center dots on the flowers are done in black. Wait 24 hours.

10. With mustard yellow, paint a stripe around the edge of the tray.

11. Finish the tray in the usual way. (See Chapter 15.)

38

II To Transfer a Design

Before a freehand design is painted on a tray, chair, or other object, an outline of the design should be transferred to the painted surface. The first step is to make a careful tracing of the design on tracing paper, including everything except the superimposed details, which can be added later by eye. Use a well-sharpened H or 2H pencil.

To Transfer to a Dark Background

1. Rub a cake of magnesium carbonate on the back of the tracing. Then, with your fingertips, rub this well into the paper. Blow off the excess powder.

2. Place the tracing, white side down, in position on the surface to be decorated, making sure the design is exactly where you want it. Then retrace the design with a well-sharpened 4H pencil.

It is not generally recommended that a tracing be taped down with masking tape while the design is being transferred. If this course is followed, however, use no more than two very small bits of tape, and be careful to wipe away any stickiness with Carbona Cleaning Fluid when the tape is removed. Taping down is, of course, not practicable on an uneven surface, such as a Chippendale tray border, where a tracing unavoidably shifts as you work. In this case, one can trace only an inch or two, after which the tracing must be readjusted.

To Transfer to a Light Background

1. On the back of the tracing, go over the pencil lines with a blunt H pencil. Do not use a soft pencil as it will smudge and spoil a light background.

2. Place the tracing right side up in the desired position on the painted surface, and retrace the design with a 4H pencil.

Home-made "Carbons"

Much of the time involved in the above-described process can be saved by using home-made "carbons." They can be used over and over again. (Commercial carbon papers generally are not suitable.)

A white "carbon" is made conveniently with a sheet of tracing paper about 6 by 12 inches. Rub the magnesium carbonate on one side of it, rubbing it well into the paper, and then blowing off the excess. With this sheet the necessity of putting magnesium carbonate on the backs of design

39

tracings is done away with. You merely hold the tracing in position on the painted surface, and slip the "carbon," white side down, under the tracing. Holding both tracing and "carbon" in place with one hand, retrace the design, moving the "carbon" along when necessary. When not in use, fold the "carbon" in half, with the white inside.

A pencil "carbon," for use on light backgrounds, can be made in a similar way. Rub a piece of tracing paper all over one side with an H or 2H pencil.

12 To Enlarge or Reduce a Design

The method of enlarging a design will be explained step by step, taking the leaf shown in Plate 8 as the example.

1. Trace the leaf in the upper left-hand corner on a sheet of tracing paper large enough to contain also the enlarged size you want.

2. Draw a rectangle around the leaf that just boxes it in and touches it on all four sides. Use a small right-angled triangle or a postcard to get right angles at all the corners: Draw with a well-sharpened 2H pencil.

3. Extend the right-hand side of the rectangle downwards several inches, and extend the bottom line several inches out to the right.

4. Using a ruler, draw a line diagonally from the upper left-hand corner to the lower right one and beyond, as in the illustration.

5. Measure either the width or the height of the larger size that you want, and complete the larger rectangle. Use the triangle or the postcard to get right angles at the corners, and be sure the diagonal already drawn passes through the lower right-hand corner. This insures that the enlarged size will be in the same proportion as the original.

PLATE 8 ENLARGEMENT OF A DESIGN UNIT

41

6. With the ruler, divide the sides of the smaller rectangle in half, then in quarters, and then in eighths. Do the same with the larger rectangle. If the design is more complicated than our present example, divide the sides into sixteenths or even thirty-seconds.

7. Rule in the lines and number them, as shown in the illustration.

8. You will observe that the outline of the smaller leaf is crossed by the dividing lines at certain points in the little square. Where these points occur place a dot in the corresponding place on the larger square. Watch the numbers to be sure you are in the corresponding square each time. When all the dots are in, join them up with lines of the same character as those in the original.

9. If the finished leaf looks a little stiff, put a fresh piece of tracing paper over it, and retrace it. While doing this you have an opportunity to improve the drawing.

To *reduce* a design, turn Plate 8 upside down, and go through the same procedure, but this time you will be starting with the larger unit and ending up with the smaller size.

13 To Adapt a Design

Sometimes it happens that we want to use a particular pattern on a surface whose proportions do not correspond to it. The surface may be a little longer or a little shorter in one direction or another than was the case with the original from which the pattern was taken.

For example, the Gold Leaf Box Pattern in Plate 38 is 6 by 8¾ inches, and it was desired to use it on a box which was 5¼ by 8⅛ inches. Since the proportions were roughly the same, the pattern might have been reduced to fit the box. However, it was preferred to use the leaves and acorns in their original size. This was achieved by following these directions:

1. On a sheet of tracing paper, rule off an area the exact size of the surface you want to decorate. Rule a second line around the edge to complete the width of the stripe.

2. Mark the center of each side of the original pattern and of each side of the new size.

3. Since the main motifs of this pattern are at the centers of each side, put the center of one long side of the new size over the corresponding center of the pattern, and trace the main motif, which is the cluster of leaves and acorns. Do the same with each of the other three sides.

4. Then place the corresponding corners of the new size over the pattern, and trace the corner motifs.

5. Since there will not be room for the whole design, it will be necessary to leave out some of the tiny sprays, or an acorn; or to reduce the size of a leaf here and there. The important things to remember are to keep the main motifs intact, and to make the necessary changes where they will neither be noticed nor affect the balance of the design as a whole.

Conversely, should our pattern be somewhat smaller than the available working surface, we should have to add an acorn, a leaf, or a tiny spray somewhere between the main center motifs and the secondary corner motifs.

It is not advisable to adapt patterns to sizes that are a great deal larger or smaller than the original, as the composition or balance is almost sure to suffer as a result.

14　Striping

Striping is an important part of practically every decorating job. Examine almost any decorated article of the eighteenth or nineteenth century, and you will find that the design includes a painted fine-line stripe. Nothing will impart a "professional" touch to your work more than a well-executed bit of striping.

At first, this may seem difficult to achieve, but the fact is that striping is easily learned. It requires a certain amount of practice, but it is practice which steadies the hand, and you will soon gain a facility with the brush.

The proper brush for this work is a square-tipped camel's-hair, or badger hair, quill brush, with hairs about 1½ inches long, and about #1 in thickness. It is used without a handle, and in the act of striping, the brush is always pulled towards you. See Plate 19.

Begin by half-filling a bottle cap with varnish. Using a showcard brush, mix in with the varnish a little Japan Yellow and a touch of Burnt Umber, until the color is a fairly thin mustard yellow. With the brush, lift out some of the mixture on the newspaper palette. Dip the striper into the mixture on the palette, moderately loading it the full length of the hairs. Pull it back and forth on the newspaper to get the feel of the brush.

Practice striping first on a piece of back paper, always pulling the striper towards you. The stripe should be semi-transparent, about ¹⁄₁₆ inch or less in width, with the black paper partly showing through it to give it a slightly greenish cast. Some of the old trays have a hair-line opaque yellow stripe, which is obtained by adding to the mixture a little White or a little more Japan Yellow.

Students may find it helpful to practice striping on a raw tray, and thus get the feel of working on an object. The tin can easily be cleaned off with Carbona. With a striper adequately loaded with paint, you should be able to stripe one side of a tray without replenishing the brush.

In striping a chair slat with sharp corners, carry the stripe right to the edge of the slat each time. Then touch up the corners with the background paint when the stripe is dry.

These painted fine-line stripes, as distinct from the broader bronze stripes, are done on a glossy or varnished surface that is thoroughly dry. The glossy surface not only keeps the stripe from developing a fuzzy edge, but also permits corrections which, however, must be done at once, either with a clean cloth or by means of Carbona. If your hand seems to stick as you stripe, put a little talcum powder on the fingertips.

The broader bronze stripes are done on a flat painted surface and are painted in the same manner as a freehand gold pattern. The stripe is painted in a mixture of Japan Vermilion and varnish; when it is tacky, the gold powder is applied with velvet.

On a stenciled tray or chair it is easier to paint the bronze stripes before you do the stenciling, as you still have the flat paint surface on which to work. When the stripes are thoroughly dry, and all loose powder has been carefully removed with a damp sponge, the surface may be varnished for stenciling.

Some beginners like to cut a stencil for the broad gold stripes and stencil them on in the usual way, but there are many jobs where this course is not practicable. Moreover, a stenciled stripe is apt to have a rigid, stilted look. There is nothing to equal a well-executed hand-painted stripe, and with practice you will be able to do it.

15 Antiquing and Finishing

To achieve the effect of the finish found on most old pieces, we apply at least six coats of varnish after the decoration has been completed. On trays and table tops, for which a heat-proof and alcohol-resistant surface is always desirable, the last two coats should be of Super Valspar varnish, procurable in most paint stores.

Some of the coats of varnish may be toned with oil pigments to give an antique color, and this process we call antiquing. The varnish so tinted must remain completely transparent, and therefore only a very little color should be used to make it. Otherwise unsightly streaks will appear on the decorated surface. For most purposes we use Burnt Umber or Raw Umber, but Indian Yellow, Black, or Prussian Blue are occasionally used. Antiquing is generally done with the first coat, or the first two or three coats, depending on the depth of color you want. Since most beginners tend to over-antique, it is well to act on the principle that a little antiquing goes a long way.

It is important to do all varnishing in an atmosphere free from dust. Clean the room first, and allow the dust to settle. Close the windows, and while the varnish is drying keep traffic away from the room for the first three or four hours.

Varnish should be applied in a warm room, one in which the temperature is 70 degrees or more. The varnish itself should be at least that warm, and so should the object to be varnished. To achieve this, let each stand in the room for some time before the varnishing is begun. They may be placed near a radiator to raise their temperature a little. Varnish applied to a cold surface, or in a cold room will "crawl."

Taking a tin tray as our example, we will now go step by step through the procedure of finishing and antiquing it.

First Day

Dust the tray carefully and place it on clean newspapers. Decide where to put the tray to dry after it has been varnished, and spread newspapers there with a can or other firm object in the middle on which the wet tray may finally be rested. Just before beginning to varnish, wipe the tray with the palm of your hand to remove any remaining lint or dust particles, especially from the corners.

On a clean newspaper palette squeeze out a little Burnt Umber. Using your one-inch varnish brush, dip out four or five brushfuls of varnish,

46

and mix with them on the palette a touch of Burnt Umber. Try it out on a clean piece of paper to test the color, which should not be much darker than the clear varnish itself. Work quickly because varnish thickens on contact with the air.

If it is the right color, that is, a very pale brown, start to varnish the tray at once, first doing the underside of the flange, then the edge, then the top side of the flange, and finally the floor. Don't flood the varnish on, as it will only run down and settle in the corners, where it cannot dry properly. Spread it out, and work with the light falling across your work so as to enable you to see that every bit of surface is covered. Then use the brush in the crosswise direction to ensure an even distribution.

Work quickly, and mix more varnish and Burnt Umber as you need it. In doing so, keep a sharp watch lest any brown streaks appear, for that would mean that you have added too much color to the varnish. Last of all, hold the tray high, and pick up with the brush any varnish drippings from the under side. Set the tray down on the prepared stand, and leave it to dry for 24 hours.

Second Day

Dust off the tray, and apply the second coat of varnish, adding a touch of Burnt Umber if you want a darker color. Dry for 24 hours.

Third Day

Dust off, and then apply the third coat of varnish. Dry for 24 hours.

Fourth Day

Cut some very fine sandpaper into 1½ by 3½ inch pieces, and fold them in half, with the sand outside. Sandpaper the surface with these small pieces. Starting on the floor of the tray, sandpaper diagonally, first from upper left to lower right, and next from upper right to lower left. Work on small sections in turn. When one hand is tired, use the other, and by thus changing back and forth you will save time and not become fatigued.

Although sandpapering has to be thorough, you must be careful not to do it too long or to press too hard, for you may go right through the coats of varnish. Once the floor of the tray has been sanded, do the flanges, keeping away from the edges, where the sandpaper can very easily take off both varnish and paint. Naturally, this caution must be observed in dealing with any kind of object, large or small.

Sanding being completed, dust off the tray. If any sand particles are stuck in the corners, it means you used too much varnish previously, and that it was unable to dry properly. In such a case, you will have to wait another 24 hours for the varnish to dry, after which the corners may be sanded out.

Apply the fourth coat of varnish, and allow it to dry for 24 hours.

Fifth Day

Sandpaper the surface as described above. Dust off thoroughly. Apply a coat of Super Valspar varnish. This is a heavier varnish than the previous coats so that you must work quickly and vigorously to brush it all over the surface before it starts to set. Let it dry for 24 hours.

Sixth Day

Instead of sandpaper, use steel wool #000, rubbing on the diagonal again. In dusting off, be sure to get all the remnants of steel wool out of the corners. Apply the second coat of Super Valspar, and let it dry for 48 hours.

Final Rubbing

In the center of the tray place about a teaspoonful of powdered pumice. Take a soft cotton flannel cloth, and put a little crude oil on it. Dip the oiled cloth into the pumice, and begin to rub a small section of the tray, say, about five inches square, at a time. There is no need to rub long, for the high gloss of the varnish comes off immediately. If you rub too much, you will give the tray a dull, lifeless finish, whereas the proper effect is that of a satiny gleam. This is achieved very quickly and without strenuous effort. Use enough crude oil to keep the rubbing moist.

When you have gone over the whole tray, rub off the remains of the oil and pumice with a clean flannelette cloth, and let the surface dry. In about fifteen minutes inspect the surface, and if any bright glossy spots are visible, give them a rubbing as before. Wipe off again with a clean cloth. This satiny finish needs no furniture polish to preserve it. All it needs is the application now and then of a damp cloth.

48

16 Restoring Decorated Articles

The restoration of decorated antiques should be undertaken only after one has studied many original pieces and has acquired considerable skill in all the painting methods. Obviously a higher degree of practical experience and skill is required for the restoration of valuable antiques than for reproducing them. The following paragraphs give an outline of the procedures.

The first point to be considered is whether the decoration is genuinely old, and the second is whether it has sufficient merit to justify restoration. Experience is the best guide. Worth-while decorations are recognized by their sure and expert brushwork, their evidence of beautifully cut stencils, and their well-balanced designs.

Cleaning

A piece which is to be restored should be washed gently and judiciously with mild soap and water so as to remove surface dirt. Rinse and dry. For any white stains or thick coatings of old shellac, use denatured alcohol, but only a little at a time. Watch closely its effect on the decoration. If any color comes off on the cloth, stop at once. Work only on a small section at a time. A white film may be left, but this will disappear when a coat of varnish is applied.

If there is a coat of paint over an original decoration, it must be removed slowly and carefully. Sometimes a continued application of soap on a damp cloth will do. In other cases rubbing small sections at a time with denatured alcohol is effective. Or the coating may be removable by chipping it off bit by bit with a small knife. In all cases judgment and discretion must be exercised if the decoration below is to be preserved.

Rust

For removing rust spots, use the Deoxidine solution in the regular way. This will not harm paint, but in rubbing the spots with steel wool, rub the surrounding paint or decoration as little as possible. Rinse and dry. Then apply a coat of varnish as a protection against further rust. Dry 24 hours.

Partial Restoration

Whenever possible, keep the original decoration, touching in only where the decoration and background are missing. Match the colors as

closely as you can. Bronze powders may be mixed on the newspaper palette with a little varnish and oil color. Let the touched-up parts dry for 24 hours, and then "antique" them with transparent overtones, to match the original.

Complete Restoration

When a decoration is too far gone to be restored, make a careful and complete copy of it on frosted acetate. This is done by first making an accurate tracing on frosted acetate of everything that is even faintly visible. Sometimes all one can see of the original gold scrolls are faint impressions on the black paint. Next, put a fresh piece of frosted acetate over this tracing, and make a complete painted copy. Supply any missing sections from research or imagination.

Having thus prepared your pattern, you can proceed to remove the old finish entirely from the article and start the work of restoration on the raw metal.

Pitted Areas

Sometimes the floor of an old tray is badly pitted where the paint has been chipped off. To deal with such areas, take some thick sediment from the bottom of a can of flat black, and mix it with enough powdered pumice to make a heavy paste. Add a few drops of varnish. Use this compound as a filler, smoothing it on with a small palette knife or your finger. Let this dry several days, and then sandpaper it. For a colored background, use the appropriate color instead of flat black.

Restoration of a Stenciled Design

To restore a stenciled design, proceed as follows:

1. Trace the design carefully on frosted acetate.

2. Placing the architect's tracing linen over the acetate, trace the outlines of the missing sections. Cut stencils for these.

3. Varnish the tray or other surface, and, when it is tacky, stencil the missing parts, matching the bronze powders as closely as possible. Let the work dry for 24 hours.

4. Using varnish toned with a little oil color, apply a transparent overtone to "antique" the newly stenciled parts, and to make them match the original parts as far as possible. Use as little varnish as you can, so that it will not form a ridge around the edges when it settles. When desirable, flatten or smooth out the edges of the varnish patch with the tip of your finger.

Another method is to give the whole tray a coat of varnish; then, immediately wiping most of the varnish off the brush, pick up the smallest bit of dry color on the brush, and lightly go over the newer parts

until you obtain the color you want. Sometimes it is necessary to use a smaller brush in applying the color. The process requires considerable skill to put the color just where you want it and to avoid streakiness.

5. Finish the article in the usual way with several coats of varnish.

Golf Leaf Restoration

To match gold leaf truly is very difficult, if not impossible. However, since restoration is better than neglect, we should try to do the best we can. Make a tracing of the original pattern, and supply the missing parts. Transpose these to the prepared surface. Then apply the gold leaf in the usual way over a mixture of varnish and Yellow Ochre. Let the gold leaf dry for a week, after which apply a protective coat of varnish. When this is dry, use transparent-colored overtones over the newly laid gold leaf to match as closely as possible the color of the old metal.

Restoration of Old Painted Chests and Boxes

These usually have an oil finish, that is, the designs were painted with colors mixed with turpentine and linseed oil. This sort of finish requires an oiling once a year to keep it in good condition. First, clean the surface by washing it carefully and gently. Wait 24 hours, and then oil the surface with raw linseed oil, applied on a soft cloth. Give the oil at least a week to soak in, and meanwhile keep the dust from settling on it.

If any parts of the design need restoring, this should be done with Japan and oil colors, mixed with Turpentine, linseed oil, and a few drops of Japan Dryer to hasten the drying. Any colors containing linseed oil require at least a week to dry thoroughly. It is important to remember this when imposing one color on another.

17 Adapting Used Furniture

Not everyone possesses decorated antiques, but it is nearly true to say that everyone possesses used pieces of ordinary furniture which, instead of being discarded, could be transformed by painting and decorating into admired and still useful adjuncts to the home. For example, a chest of drawers, if the drawers work smoothly, and the piece is of good proportions, should never be abandoned. Make it instead an object lesson in the value of American antique decoration.

A chair pattern often makes a good decoration for a chest of drawers. The main design is used on the top drawer and the accessory units, such as those in Plates 27 and 40, being added to suit the construction of the piece. Tiny borders, applied around the edge of each drawer, are sometimes most effective, and may be all that is needed. Any striping should be in mustard yellow if applied to our usual black background color. The freehand bronze chair pattern in Plate 16 might be used for a chest of drawers having a pale yellow or off-white background, in conjunction with brown and black striping.

For a cabinet with two small doors, the watering can pattern would be good. Coffee tables, end tables, and bookcases might be decorated effectively with some of the borders in Plate 26. In this kind of work there is an opportunity to use judgment and decorate according to the shape and size of the furniture. Of course, we must always resist the temptation to over-decorate.

Country patterns are very suitable for kitchen furniture and fittings and likewise for porch and outdoor furniture.

Gold leaf decorations make for elegance, invariably attracting more attention than the other techniques. For this very reason particularly careful attention should be given to their application. As a suggestion, the large oval tray pattern in Plate 37 would look very fine around the edge of a simple but really well-designed coffee table. Such a splendid pattern, however, would be quite out of place on many pieces. Suit the pattern to the character of the object.

Additional Patterns

The instructions which accompany the following drawings are kept as short as is consistent with clarity. Needless repetition is avoided. It is a simple matter to refer back to the chapters on background painting, on gold leaf, and on the other fundamental processes whenever they are mentioned and it is found that the memory needs to be refreshed.

18 Pennsylvania Chest

This pattern is taken from a pine chest made in Berks County, Pennsylvania, and dated on the front, 1798. The chest measures 48 inches long, 23 inches high, and 21 inches deep. Study the drawing on the title page of this book in order to determine how much to enlarge the pattern for your own purpose. The proportions of the chest to which the pattern is to be adapted will be your guide.

To prepare an old chest for decoration, remove the existing paint and varnish, and apply a coat of shellac. When this is dry, sandpaper the surface.

Before any painting is done, the outline of the pilasters and the arches (not the floral design) should be transferred to the front of the chest. Place the chest on its back so that you can do the work comfortably.

The background of the two panels formed by the pilasters and arches should now be painted in a dull ivory, made by mixing White, Yellow Ochre, and a touch of Raw Umber.

The background of the rest of the chest is in a light brown, made by adding a little White to Burnt Sienna. Mix it in a small jar with a showcard brush. Use tube oil colors, and add very little varnish, thus keeping the mixture quite thick. As you use it, lift out small quantities at a time on to the newspaper palette. Apply the color to the chest with a damp sponge, a little at a time and not too much in any one place. Allow the natural wood to show through and give to the whole surface the effect of a texture. Wait 24 hours.

Referring to the title page sketch, paint the black parts of the pilasters and arches, and the black parts of the corners, in a brown similar to that used for the background, but this time use a darker shade. This will be achieved by using a little less of the White with the Burnt Sienna. Let the work dry for 24 hours. Paint the remaining parts of the pilasters in Japan Vermilion. Allow 24 hours for drying.

For the designs on the ivory panels, with Japan Black, paint all the parts there shown in black. Use this color also for the initials and the date between the panels in the event that you wish to include them. Wait 24 hours.

All the dotted areas are to be painted in Japan Vermilion, and this should be thinned with varnish so that when the color is applied over the

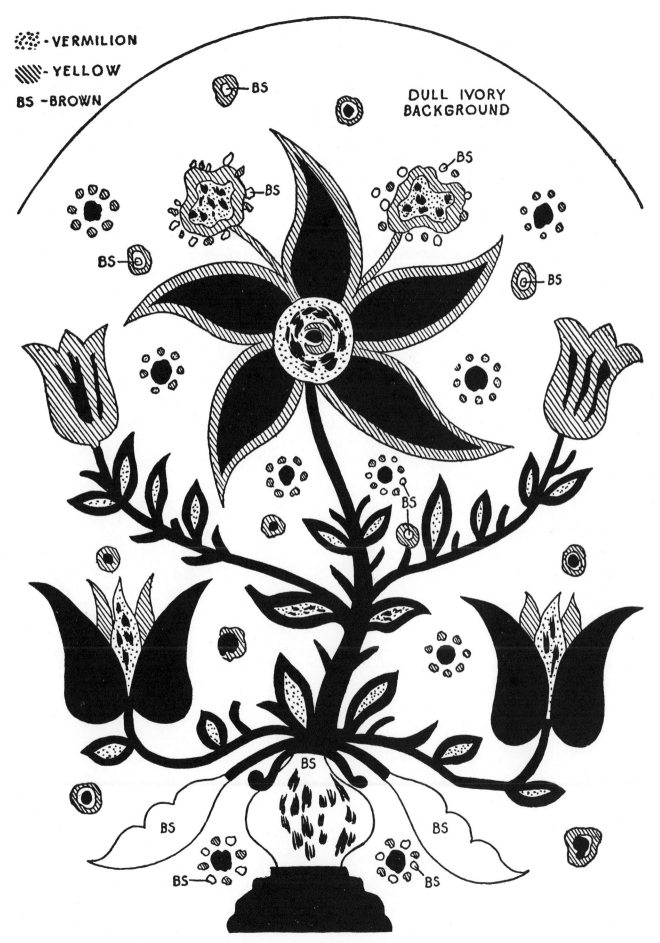

PLATE 9 PENNSYLVANIA CHEST

black "speckles" in the center of the main flower, in the lower tulips, and elsewhere, the speckles will show through the red, and appear brownish. Wait 24 hours.

Mix Japan Yellow and a little Burnt Sienna to make a rich, warm, mustard yellow, adding enough varnish to make this also slightly thin. With this mixture, paint all those parts which are diagonally shaded. Paint right over the black markings in the upper tulips. These markings will show grayish through the slightly transparent yellow. With a thicker mixture of the same yellow, paint the outlines around the hearts at the corners of the chest.

The parts marked BS are painted with the same light brown which was used for the sponged background process, and this also should be slightly thin so that the black spreckles on the vase show through a little.

Old Pennsylvania chests were not painted with varnish or given finishing coats of varnish. If an old chest is being restored and needs no more than a little touching up here and there, it is desirable to mix your colors with turpentine and linseed oil, as was done by the old decorators. But to keep paint of that kind in good condition it is necessary to rub it over with raw linseed oil once a year. Therefore, if you are starting from the very beginning on an old chest, you will probably prefer to use varnish in mixing the colors and to finish up with the six coats of varnish generally recommended. That kind of finish not only wears better, but once it is applied it needs little or no attention.

19 Coffee Pot

The original coffee pot illustrated was painted with a background of asphaltum, but the pattern is just as effective on a black background, which besides is much easier to apply. A practice copy of this pattern being desirable, put a piece of frosted acetate over Plate 10. The large circular area behind the design is in off-white, but this may be omitted on the acetate copy.

1. With Japan Vermilion, paint the large over-all areas marked V, without regard to the dotted and shaded areas, and the other details on them. To avoid misunderstanding, refer to the small drawing in the left-hand bottom corner of Plate 10, where it is made plain that the entire areas marked V are to be painted Vermilion, leaving the colors indicated by the dotting, shading, etc., to be superimposed later, as described lower down.

With a country green mixture, paint all the solid black areas, representing the leaves.

With a soft medium blue, paint the two flowers and the fruit marked B, again ignoring details and shaded areas.

Similarly disregarding the presence of the cross-hatched area and the details, paint the single fruit at the bottom, marked Y, with a light mustard yellow. Wait 24 hours.

2. Mix Alizarin Crimson and a touch of Burnt Umber with enough varnish to make a rich, dark, semi-transparent red, and paint all the finely dotted areas.

With Japan Vermilion, apply a broad stroke or two on the cross-hatched area of the yellow fruit at the bottom, blending off the inner edge with a clear varnish brush. Wait 24 hours.

3. With a thin, semi-transparent, mustard yellow, paint the shaded areas on the three vermilion flowers and on the upper half of the large center stem. Do likewise with the shaded areas on the blue flower at the lower left, and on the blue flower at the upper left, in the latter case blending off the edge all around. Apply the yellow also to the blue fruit, blending off the inner edge, and to the small shaded leaf at the extreme left of the drawing. Wait 24 hours.

4. With Japan Black, paint all the leaf veins, the tiny clusters of dots,

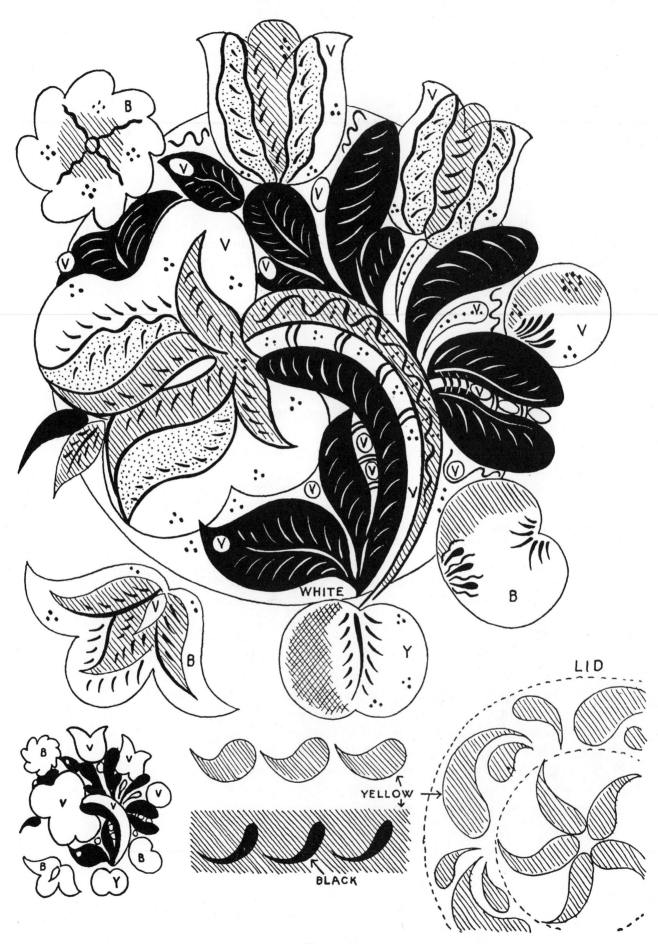

PLATE 10 COFFEE POT

the heavy black outlines, and all the other details shown in black in the drawing. Similarly outline the green leaves.

To decorate the coffee pot, prepare the background with three or four coats of the usual flat black, or, if desired, with asphaltum (see page 15).

1. Make a tracing of the design, including the large circular area. This has a diameter of 5⅛ inches and should be drawn with a compass. Transfer the circle first to the coffee pot. Remove the tracing, and paint the circular area in off-white. Wait 24 hours.

2. Transfer the rest of the design to the coffee pot.

3. Proceed to paint the pattern as described above. The brush-stroke border and the strokes on the lid are in mustard yellow. Let dry 24 hours.

5. Paint the hairline striping in mustard yellow, according to the construction of the coffee pot.

6. Finish the piece in the usual way.

20 Sugar Bowl

The original background was asphaltum, but unless you have had a good deal of practice in applying asphaltum, it is advisable to prepare the sugar bowl with a flat black background in the usual way.

1. Take a sheet of tracing paper long enough to go entirely around the bowl. Hold it against the bowl, and trace the line of the top edge, marking where the ends meet. This will give you a curved line for the upper edge of the border. Using a ruler, mark off a number of points below the line at a distance equal to the width of the border. Join the points by a second curved line, parallel to the first. You now have a border area which will go exactly around your bowl. If you are putting the design on a canister instead of a bowl, the border is more easily made, since the parallel lines will be straight.

In either case, the next step is to trace the motifs from Plate 11, rearranging them a little if necessary to ensure a continuous sequence without any noticeable join. Trace also the brush-stroke border. Make a separate tracing for the lid pattern.

2. Transfer the border area to the bowl or canister. Transfer the four circular areas on the lid. Paint both border and circular areas throughout in off-white. Wait 24 hours.

3. Transfer the rest of the design to the bowl.

4. With Japan Vermilion, paint the whole area of the fruits marked V, covering the details and the shading up to the curved right-hand edge of the fruit. Paint the strokes marked V on the lid.

With a country green mixture, paint the large leaves which are black in the drawing.

With a soft medium blue, paint the strokes marked B on the lid. Wait 24 hours.

5. With a semi-transparent mustard yellow, paint the shaded areas on the border, blending off the inner edge. Paint the brush-stroke border and the shaded brush strokes on the lid. Wait 24 hours.

6. With Japan Black, paint all the veins, clusters of dots, and the details on the fruit.

7. Striping at the top and bottom edges of the bowl and around the edge of the lid is in mustard yellow.

8. Finish in the usual way.

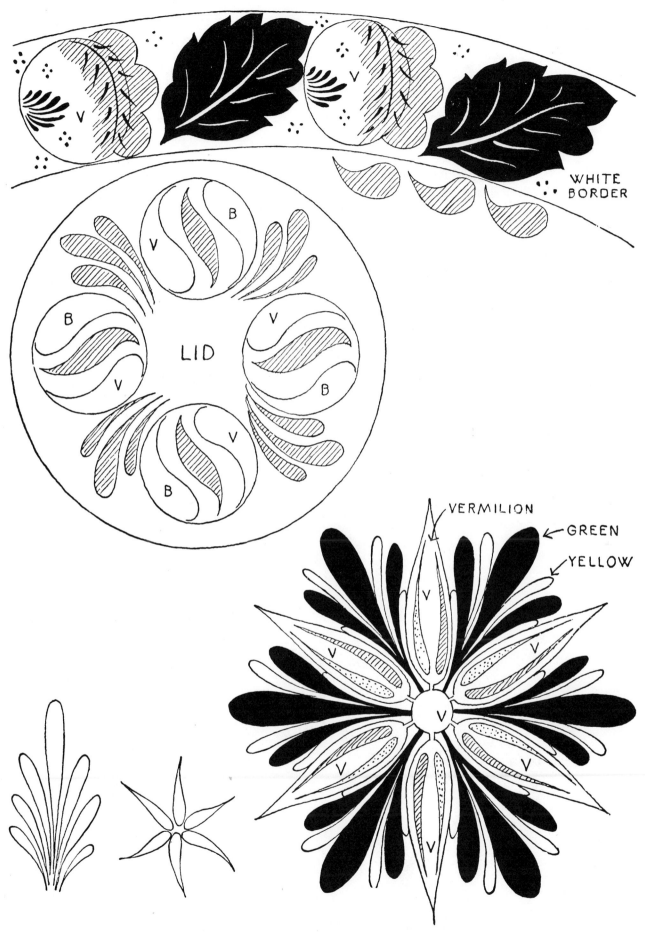

WHITE
BORDER

LID

VERMILION

GREEN

YELLOW

PLATE 11 (UPPER) SUGAR BOWL; (LOWER) COFFEE POT

21 Coffee Pot Pattern Applied to Box

This design was taken from an old coffee pot and in the illustration is shown applied to a round flat box. It can, of course, be applied to other suitably shaped objects. The original background was black. To paint the design, proceed as follows:

1. With Japan Vermilion, paint all the petals marked V, including their shaded and dotted areas.

With a country green mixture, paint the areas which are black in the illustration. Allow 24 hours to dry.

2. Mix Alizarin Crimson and a touch of Burnt Umber to make a transparent dark red, and paint the dotted brush strokes.

With a semi-transparent mixture of off-white, paint the shaded brush strokes. Wait 24 hours.

3. Paint the remaining brush strokes a mustard yellow. In the drawing these are the white areas, apart from those marked V.

4. Striping is in mustard yellow.

22 Coffin Tray

Coffin trays, or country octagonal trays, were made in this country by the local tinsmith and were generally decorated with the gaily colored designs we have come to know as country painting. Gold leaf was more or less unknown to the country tinsmith, although, from about 1820, many of his wares were stenciled with bronze powders.

Plate 12 shows the pattern for the coffin tray. To carry out the work, proceed as follows:

1. Paint the tray flat black in the usual way.

2. Make a tracing of the design from Plate 12, and transfer it to the tray.

3. Mix some Japan Vermilion, Yellow Ochre, and White to make a salmon pink, and with this mixture, paint the flowers and the buds (marked S) and likewise the stems. Cover the shaded and dotted areas as well as the white parts of the flowers and buds.

With a mixture of country green, paint all those leaves (G) which are black in Plate 12. Wait 24 hours.

4. Mix Alizarin Crimson and a touch of Burnt Umber to make a semi-transparent dark red, and apply this to the dotted areas on the flowers and buds, using only one stroke each time.

With a semi-transparent mustard yellow, paint the highlights on the leaves as indicated by the dotted white lines.

With a somewhat thicker mixture of mustard yellow, paint all the white leaves (Y); the cross-hatching at the center of the flower on the right; and the border strokes. Wait 24 hours.

5. With a semi-transparent off-white, paint the shaded strokes on the flowers and buds. Wait 24 hours.

6. Give the tray a coat of varnish to provide a glossy surface for striping. Wait 24 hours.

7. Add the striping in mustard yellow.

8. Finish the tray in the usual way.

PLATE 12 COFFIN TRAY

23 Deed Box

The fruit border is painted on a band of off-white that goes around the sides of the black painted box.

Refer to Plate 13. With Japan Vermilion, paint the over-all areas of the fruits and berries marked V.

With a light country green mixture, paint the leaves marked LG. Wait 24 hours.

With a light mustard yellow, paint the shaded areas on the vermilion fruits and berries, blending off the edges with varnish. Wait 24 hours.

Using Japan Black, paint the brush-strokes on the fruits, the tiny clusters of dots, and the leaf veins.

The brush-stroke designs and border on the cover of the box, and the striping are all done in light mustard yellow.

BLACK

WHITE

LG

LG

LG

LG

LG

LID

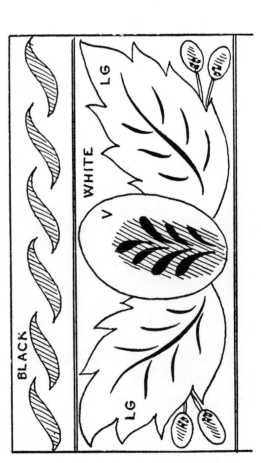

WHITE

BLACK

LG

LG

LG

PLATE 13 DEED BOX

24 Cedar Wood Box Pattern: Lamp

1. Refer to Plate 14. With Japan Vermilion, paint the outer section of the tulip and the buds (V), covering the details and the dotted areas.

With a country green mixture, paint the leaves and stems, shown in solid black in the drawing.

With a yellow green mixture, paint the scrolls at the top (LG). Wait 24 hours.

2. With a mixture of Alizarin Crimson and Burnt Umber, paint the dotted strokes on the vermilion flowers and buds.

Using a light mustard yellow, paint the horizontally shaded areas of the tulip. Fill the space between with a cross-hatching of yellow lines as in the drawing. The dots at the points of the buds are also to be done in yellow (Y).

With a light blue mixture, paint the small bands on the buds (LB).

Paint the leaf veins in Burnt Umber.

25 Tea Caddy

1. Using off-white, paint the overall areas of the flower and the detached "buds." See Plate 14. Cover the dotted areas as well as those which are blank in the drawing.

With a light country green mixture, paint the leaves and stems shown black in the drawing. Wait 24 hours.

2. Paint the dotted areas on the flower and on the "buds" with a mixture of Alizarin Crimson and Burnt Umber.

Paint the ring of dots and the circular center of the flower with Burnt Sienna. These are cross-hatched in the drawing.

Paint the remaining leaves and stems (diagonally shaded) and the scrolls or tendrils in a light mustard yellow.

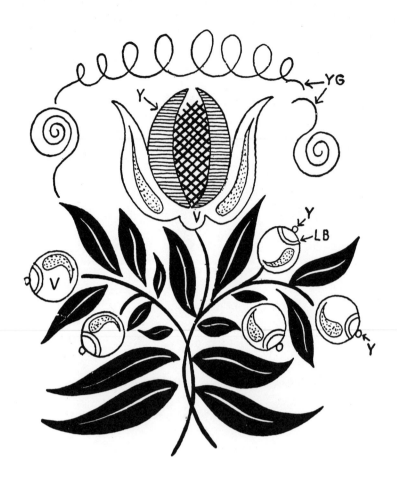

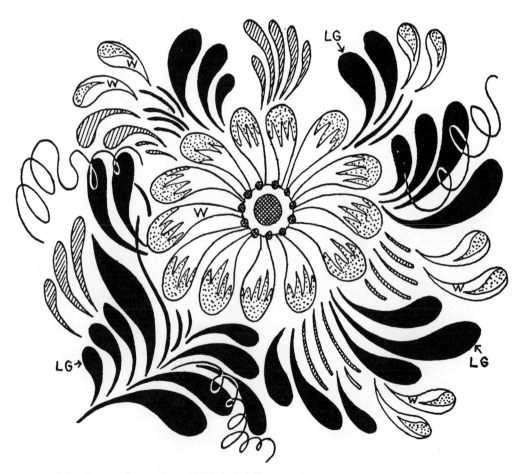

PLATE 14 (UPPER) CEDAR WOOD BOX; (LOWER) TEA CADDY

26 *Small Rectangular Tray*

To make a practice copy of the floor design, place a sheet of frosted acetate over Plate 15, and proceed as follows:

1. With a mixture of medium blue, paint the flower and the two buds.

With a bright country green mixture, paint the leaves, stems, and the calyx on each bud. Wait 24 hours.

2. Mix some Prussian Blue and Raw Umber to make a transparent blue, and apply this to darken one side of each flower petal and bud, blending off into the lighter half with varnish. Apply the same mixture to make the darker side of each leaf and calyx. Let the work dry for 24 hours.

3. To a thin mixture of off-white add a touch of Prussian Blue and Indian Yellow to give it a slightly greenish tinge, and, keeping the brush rather dry, apply this to the lighter side of each petal and bud, blending off the internal edge with varnish. Immediately pick up some dry White to add a white highlight to the wet surface. Do the complete operation on one petal at a time.

Using a bright mustard yellow, apply this to the lighter side of each leaf and each calyx. Blend off the inner edge, and on some of the leaves add a touch of *dry* yellow to the wet surface as a highlight. Wait 24 hours.

4. Paint a small dab of Vermilion on the center of the flower. Wait 24 hours.

5. Paint the stamens a mustard yellow, and add a touch of it on the vermilion.

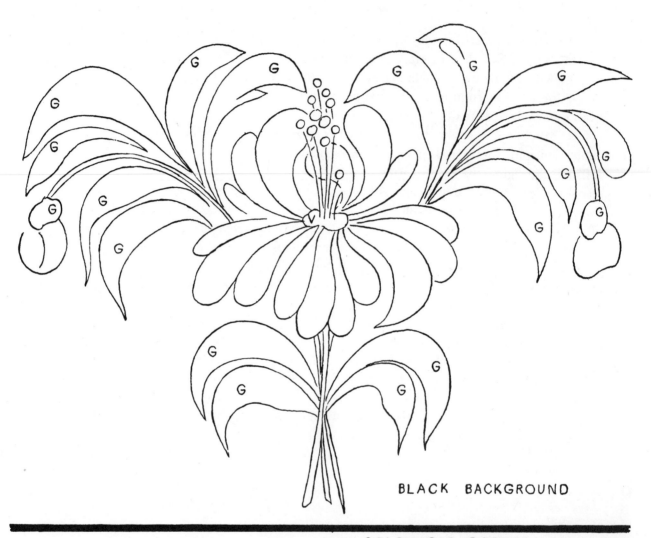

BLACK BACKGROUND

GOLD LEAF BORDER

PLATE 15 SMALL RECTANGULAR TRAY—9″ × 12″

27 Chair Pattern in Freehand Bronze

The background color on the original chair was a soft, pale, antique yellow, made by taking flat white paint and adding Japan Yellow and a little Raw Umber. The pattern is done in palegold powder on a black underpainting.

To make a copy of the pattern, proceed as follows:

1. From Plate 16 trace the outline of the main design on tracing paper. Mount the tracing on white cardboard so that the lines can be seen easily, and put a piece of frosted acetate over it.

2. Trace, cut, and number the stencil units 1, 2, 3, 4, and 5.

3. With a mixture of Japan Black and varnish, paint the design, doing first the large main area, then the grapes, the separate brush strokes, and the tendrils. Let it dry until it has reached the proper tacky stage for stenciling.

4. Place the pear stencil (1) in position, and apply the palegold powder, making the highlights very bright. Leave the parts around the edges dark. Lift the stencil.

5. Place the leaf tip stencils (4 and 5) in position, and apply powder, making the highlights very bright.

6. Next, stencil the cherries and plums (2 and 3).

7. Without using a stencil, apply the gold highlights on the large leaves, small leaves, grapes, lower end of pear, small leaf strokes, and tendrils. Let the work dry 24 hours.

8. Using a mixture of Japan Black and varnish, paint the outlines of the fruit, the fruit details, highlights on the grapes, leaf veins, the lower edges of the brush-strokes, and any other black accents needed. Wait 24 hours.

The striping on the chair consists of two bands of black, one broader than the other, and of a band of transparent umber, as shown in the middle of Plate 16.

STRIPING

STENCILS

PLATE 16 CHAIR PATTERN IN FREEHAND BRONZE

28 Stenciled Hitchcock-Type Chair

1. Prepare a Hitchcock-type chair with three or four coats of flat black.

2. Refer to Plate 19. The broad black stripes on the side back posts and on the small back slat are to be done in palegold, as are also the turnings marked in black on the front legs and the front rung, on the seat front, and on the chair back. Paint all these parts with a mixture of varnish and Japan Vermilion, and when the surface is tacky, apply the palegold powder with a velvet finger. Let the work dry for 24 hours. Then wipe off the loose powder with a damp sponge.

3. Trace and cut the stencil units shown in Plate 17, making separate stencils for the veins of the leaves. Number the units in ink to correspond with the numbers in Plate 17, and also write on each the name of the colored powder or powders to be used with it. Of course, the stenciling of this pattern should be practiced several times on black paper before the decoration of an actual chair is undertaken.

4. Varnish the main slat of the chair, the two side back posts, the seat front, and the hand grip.

5. When the varnished surface of the main slat is ready for stenciling, proceed to stencil in accordance with the pattern. The best position for the chair during stenciling is to have it lying on its back on the work table. To take full advantage of this position you should stencil upside down, with the pattern from which you are copying also turned upside down.

Stencil border unit (1) in palegold on each side of the slat.

Place the bowl (3) in position, and the leaf (2) in position on top of it. Holding the leaf in place, remove the bowl. Stencil the leaf in palegold, very bright around the edge, shading quickly to black in the center. Lift the stencil and put the bowl back in place, stenciling it in palegold, very bright at the center, shading off slightly at the side, and leaving some black all around the leaf (2).

Place (4) in position in the center, and stencil first the brightest part at the top in palegold; then shade in a little fire powder, but quickly let it go to black. Place (5) in position, and complete the peach. Stencil the second peach.

Proceed in numerical order with the rest of the units in the main

73

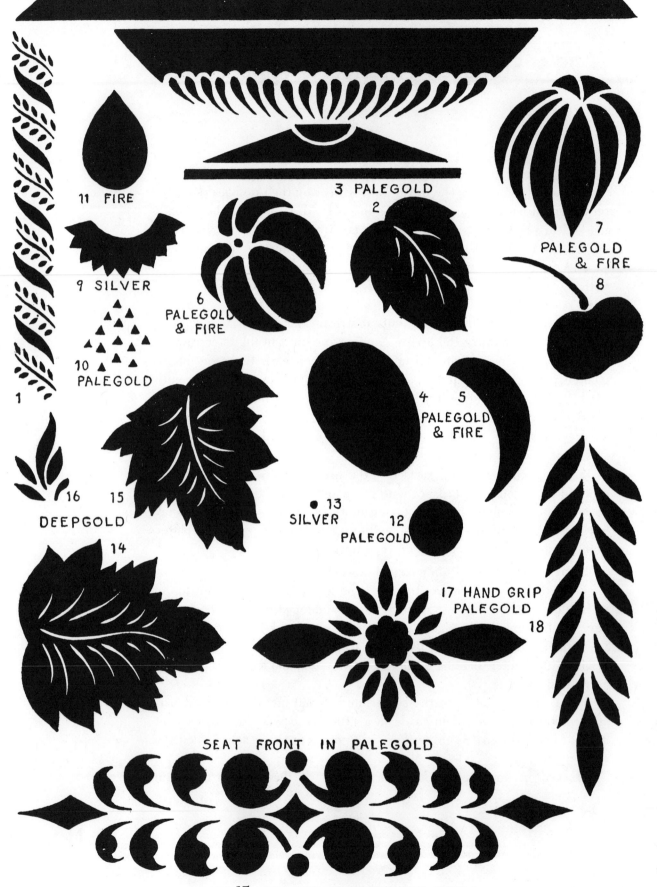

11 FIRE

3 PALEGOLD

2

7
PALEGOLD
& FIRE

8

9 SILVER

6
PALEGOLD
& FIRE

10 ▲ ▲
PALEGOLD

1

4 5
PALEGOLD
& FIRE

● 13
SILVER

12
PALEGOLD

16 15
DEEPGOLD

14

17 HAND GRIP
PALEGOLD

18

SEAT FRONT IN PALEGOLD

PLATE 17 STENCILED HITCHCOCK-TYPE CHAIR

slat, always referring to the photograph for the light and dark areas. The veins are all in deep gold.

Plate 19 shows where the accessory units are placed on the side back posts, the handgrip, and the seat front. All are in palegold. Let the work dry for 24 hours. Then wipe off any loose powder with a damp sponge.

6. Apply a coat of varnish to the entire chair to provide a glossy surface for the striping. Allow 24 hours to dry.

7. The hair-line striping is done in mustard yellow, and its placing more or less depends on the construction of the chair. In the example in Plate 19, there is a fine stripe around the edge of each slat, one to outline the flattened areas on the side back posts, others around the edge of the sides of the seat, on the seat front, and on some of the turnings, as shown by the fine pen lines.

8. Finish the chair in the usual way.

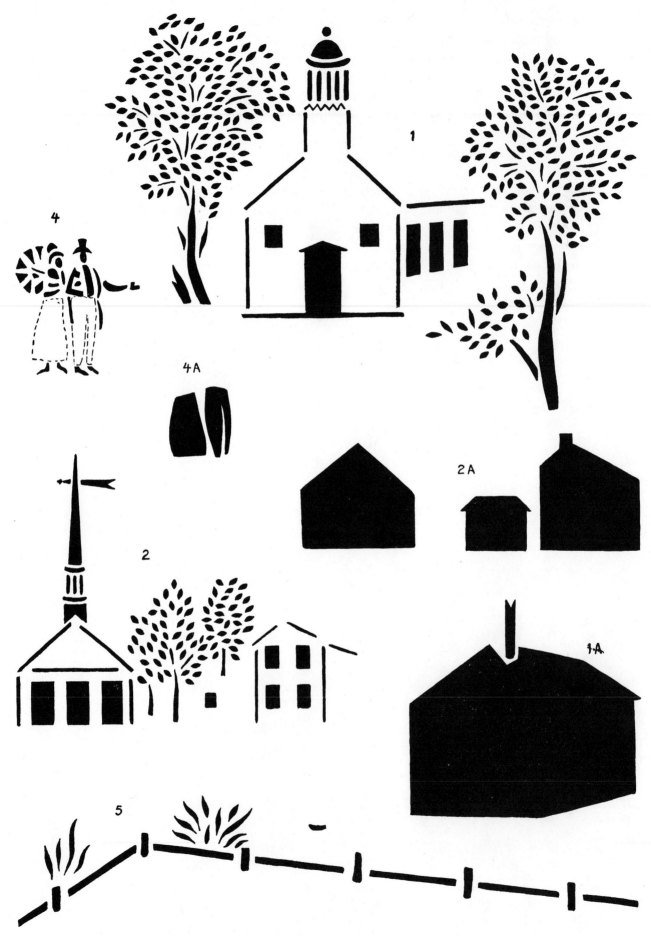

PLATE 18 STENCILED VILLAGE SCENE—SECTION A

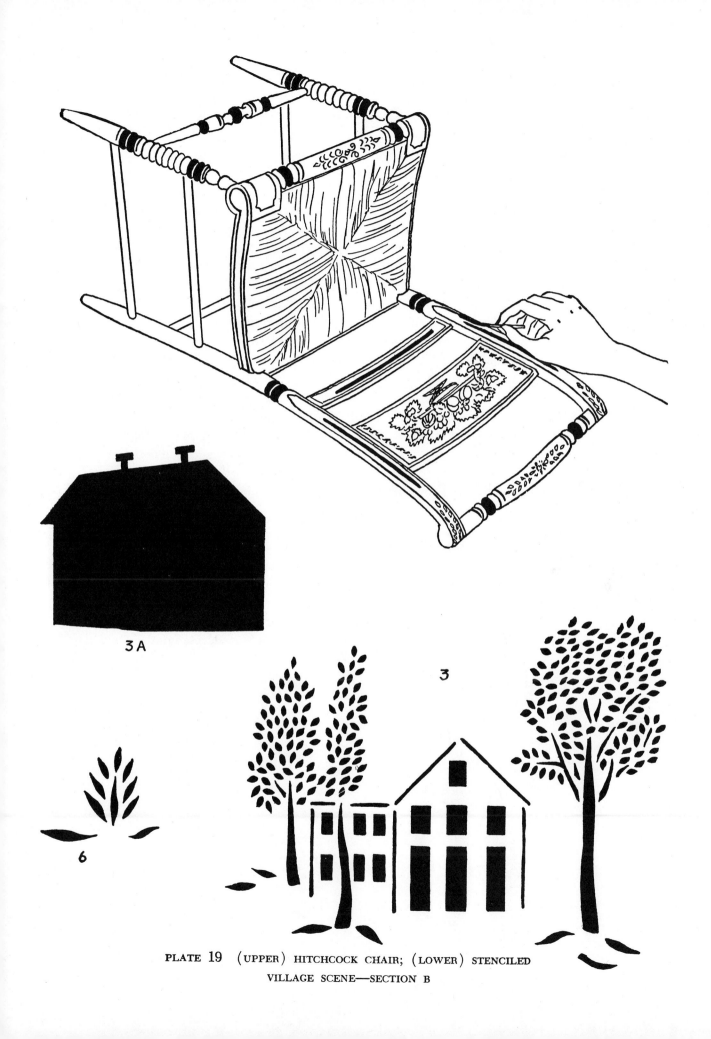

3A

3

6

PLATE 19 (UPPER) HITCHCOCK CHAIR; (LOWER) STENCILED
VILLAGE SCENE—SECTION B

29 Stenciled Village Scene

Stenciled scenes like this one were great favorites in the old days and were used on chairs, trays, boxes, cornices, and other pieces. The original stencils for this scene (preserved in the Metropolitan Museum of Art, New York) are two in number; but it is more helpful in adapting the design to have separate stencils for each feature, as shown in the Plates. To make a copy on black paper, proceed as follows:

1. Trace and cut the stencil units shown in Plates 18 and 19. Unit (1) consists of the courthouse and two trees; (1A), a separate unit, is part of the courthouse, but stenciled separately. (2) and (2A) likewise form a pair, as do (3) and (3A). Number the stencil pieces to correspond with the drawings.

2. Varnish a sheet of black paper, size 15 by 6 inches.

3. When the proper tacky stage is reached, place stencil (1) in position, and stencil it in palegold. Next stencil group (2) in palegold, and then (3), also in palegold. (Note: information being lacking as to the colors of the powders originally used for this pattern, probable and appropriate ones are here supplied.)

Place (1A) in position over the already stenciled courthouse, and apply fire powder to the roof and faintly around the edges of the building so as to give it an air of substance. Do the same with the other buildings.

Stencil (4) in palegold and (4A) in silver. (5) and (6) follow, also in palegold.

Wait another 15 or 20 minutes to allow the surface to become a little drier and then, with very little palegold on the velvet, faintly cloud the ground. Then apply faint touches of silver to the sky.

30 Stenciled Rectangular Tray

The tray here described is 15 by 20 inches in size. It should be painted flat black in the usual way. Then proceed as follows:

1. Cut a sheet of tracing paper the same size as the tray floor, rule a line ⅛ inch from the edge of the paper to indicate the gold band, and transfer the outline of the band to the tray. Study Plate 20 where the band is shown in its relation to the flange line. Paint the band with a mixture of varnish and Japan Vermilion, and, when the surface is tacky, apply palegold powder. Wait 24 hours.

2. Referring to Plate 20, trace the stencil units on linen in the usual way; with the exception of (2), which has the leaf vein extending out at one end of the linen, as illustrated. When this unit is all cut out, the linen may be folded so that the vein will lie in its correct position on the leaf.

3. Cut the stencils, and number the pieces as on Plate 20. (As with other new stenciling projects, a practice copy of the pattern on black paper is advisable before decorating the tray.)

4. Varnish the tray for stenciling. While waiting, study the photograph (Photo. V), and cut a piece of tracing linen, size 5⅝ by 3½ inches, with rounded corners. When the varnished surface is ready for stenciling, lay this linen in the exact center of the tray, checking with a ruler to be sure it is centered. Your floor border will lie between the linen and the gold band.

5. Begin to stencil by placing unit (1) in the exact center of one side, checking with a ruler. Stencil the flower in palegold, very bright around the outside, but shading slightly to darker in the center. There is a flower on each side of the center one, and these are also in palegold at this stage. (Twenty-four hours later, when the stenciling is dry, these two flowers are given an overtone of transparent red.)

Stencil a group of three palegold flowers on each of the other three sides of the tray floor.

6. Place the cut-out leaf (2) in position, and then press down the vein in position on the leaf. Stencil the vein first with a silver-palegold mixture all around the very edge of the vein, stopping before you touch any part of the flowers already done. Mix the powder right on the velvet by

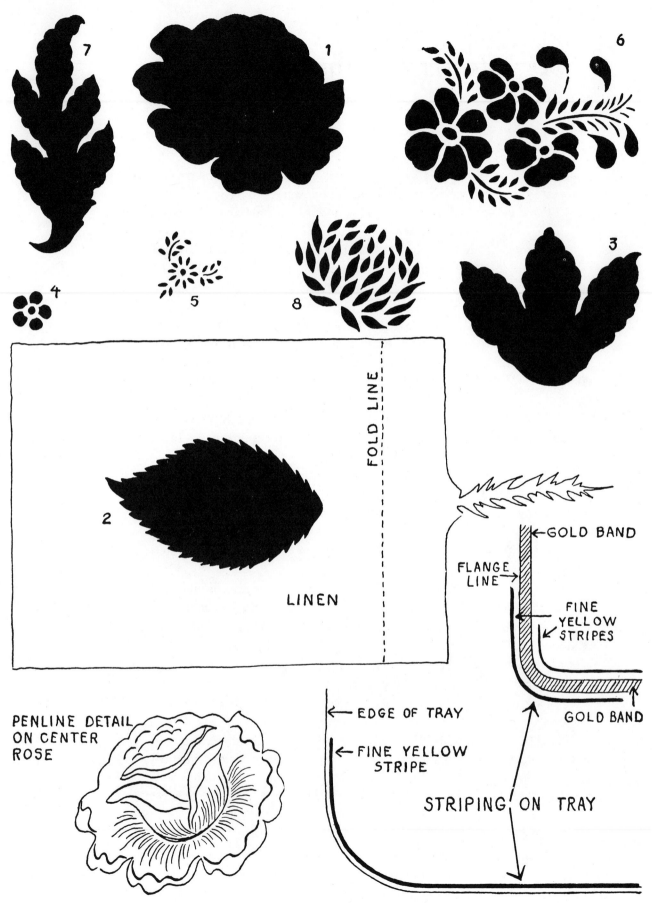

7　　1　　6

4　　5　　8　　3

FOLD LINE

2

LINEN

GOLD BAND

FLANGE
LINE

FINE
YELLOW
STRIPES

EDGE OF TRAY

GOLD BAND

PENLINE DETAIL
ON CENTER
ROSE

FINE YELLOW
STRIPE

STRIPING ON TRAY

PLATE 20 STENCILED RECTANGULAR TRAY

taking up first a little silver and then a little gold. Next, apply the mixed powder around the outer edge of the leaf, leaving a darker area between. Repeat (2) wherever the design calls for it.

7. With the same silver-palegold mixture, stencil (3) always very brightly at the leaf tips, but shading quickly to black before you touch other units of the design.

8. With silver powder, stencil (4) and (5).

9. For the flange border, start with (6) at the handlehole, and alternate with (7) all around the tray, using palegold.

10. The last part of the powder work is to "cloud" *faintly* in silver the outer edges of both the floor and the flange borders. When clouding the floor, use a piece of tracing linen to protect the flange border. When this work is completed, lift the center piece of linen, and let the tray dry for 24 hours.

11. With pen and ink, draw the detail of the *center* flower on each of the four sides of the floor border. See Plate 20 for this detail.

Mix several showcard brushfuls of varnish with a little Alizarin Crimson and a touch of Burnt Umber, and apply the transparent red overtone to all the large flowers other than the four center ones. When this has reached the tacky stage, stencil (8) with palegold powder in the center of each of the eight red flowers. Allow 24 hours for drying.

12. Following the guide in Plate 20, do the hairline striping in mustard yellow.

13. Finish the tray in the usual way.

31 Stenciled Bread Tray

1. Prepare the tray with three or four coats of flat black.

2. Trace the stencil units, depicted in Plate 21, on linen in the usual way. Note that (1) is a silhouette stencil. In this case, after the fruits are cut out, the linen is cut off around the outer edge.

3. Cut the stencils and number them as in the drawing. (This pattern should, of course, be done first on black paper for practice.)

4. Cut out a piece of linen which will exactly cover the floor of the tray, and extend up and cover the parts of the end pieces which are not to be decorated. The outline should first be carefully drawn on tracing paper, and then transferred to the linen. Fold where indicated in the sketch. Now varnish the tray for stenciling. When the varnish is tacky, the prepared piece of linen is laid in position on the tray floor, protecting it and the two curved edge segments at each end.

5. Place the cornucopia (1) in position, and stencil the fruit in silver. Then apply silver all around the edge of the linen to a depth of roughly ¼ to ½ inch. Next, pick up palegold powder, and going over the silver again, work on outward to the edge of the tray, and to the other edges of the area, so that a background of silver and gold is created for the cornucopia. Use a piece of linen to protect each side of the tray in turn from getting powdered. Stencil the other end of the bread tray in the same way.

Stencil (2) in silver in the center of each side. Then add the acorns (3), the leaves (4), and lastly the veins (5), all in silver. With palegold, cloud the ends and the outer edge of the side areas, going right out to the edge of the tray, but leaving some black all around the leaves.

To apply the curved gold lines on the black cornucopia, indicated on Plate 21 by the dotted line areas, use a "spit-brush." Take a small quill brush, wet it with saliva, and pick up loose gold powder the full length of the brush. Apply the powder on the still tacky surface.

Remove the linen from the tray floor. Let the work dry for 24 hours.

6. Give the tray a protective coat of varnish. Allow another 24 hours for drying.

7. Make a tracing of the freehand berries and leaf strokes in the drawing, and transfer them to the tray.

8. Mix Alizarin Crimson and Burnt Umber to make a transparent dark

82

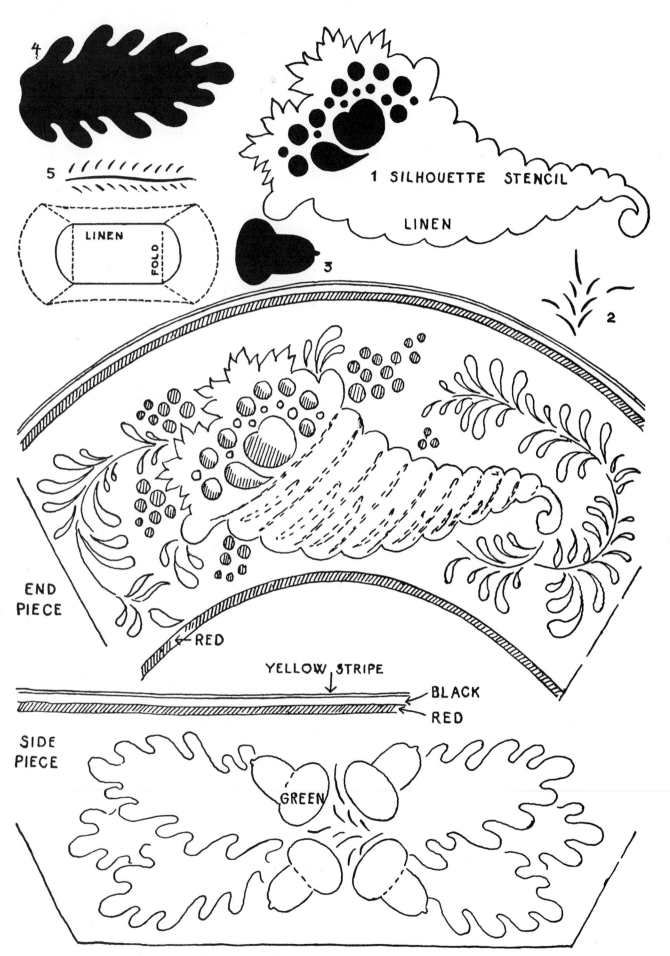

4

5

LINEN

FOLD

1 SILHOUETTE STENCIL

LINEN

3

2

END
PIECE

← RED

YELLOW STRIPE

BLACK

RED

SIDE
PIECE

GREEN

PLATE 21 STENCILED BREAD TRAY

red, and paint the shaded areas of the cornucopia fruit, blending off the edges of the color. Paint the berries outside the cornucopia.

Mix Indian Yellow and Prussian Blue to make a transparent green, and paint the leaves and stems, also the lower part of the acorns. Wait 24 hours.

9. Using transparent dark red, paint a stripe ⅛ inch wide along the lower edge of the end designs. Likewise paint a stripe ⅛ inch wide and ⅛ inch from the edge, all around the top edge of the tray. Allow 24 hours for drying.

10. With Japan Black and varnish, paint out the gold beyond the red stripe, so as to leave a black band ⅛ inch wide all around the edge of the tray. Wait 24 hours.

11. Paint a hairline mustard yellow stripe all around the floor of the tray, and around the top edge of the tray. Wait 24 hours.

12. Finish the tray in the usual way.

32 Stenciled Watering Can

To make a copy of this pattern on black paper, proceed as follows:

1. Trace and cut the stencil units as shown in Plate 22A, making separate stencils for the veins. Number the units as in the illustration, and also mark on each the colored powder to be used with it.

2. Varnish a piece of black paper measuring about 12 by 14 inches, and when this has reached the proper tacky stage proceed to stencil, using the little layout on Plate 22A as a guide.

3. Place unit (1) in position, and stencil in palegold.

Stencil (2) in fire, very bright around the edges of the cut-outs, but leaving the centers black. Stencil (3), also in fire, but stopping short of (2) already stenciled. Do the veins in silver.

The leaves (4) are done in palegold, very bright around the edges, but shading quickly to black. Do not stencil into the flowers, but leave some black all around them. The leaf veins are in silver.

The flower (5) is stenciled in silver, and repeated several times as shown in the layout. Units (6), (7) and (8) are done next in that order, all in palegold.

In decorating a watering can, unit (5) is stenciled at the center of the handle, and the handle unit is added on each side of it.

If you decorate a box with this pattern, the handle unit might be used as a border around the sides of the box. Striping would be in mustard yellow.

85

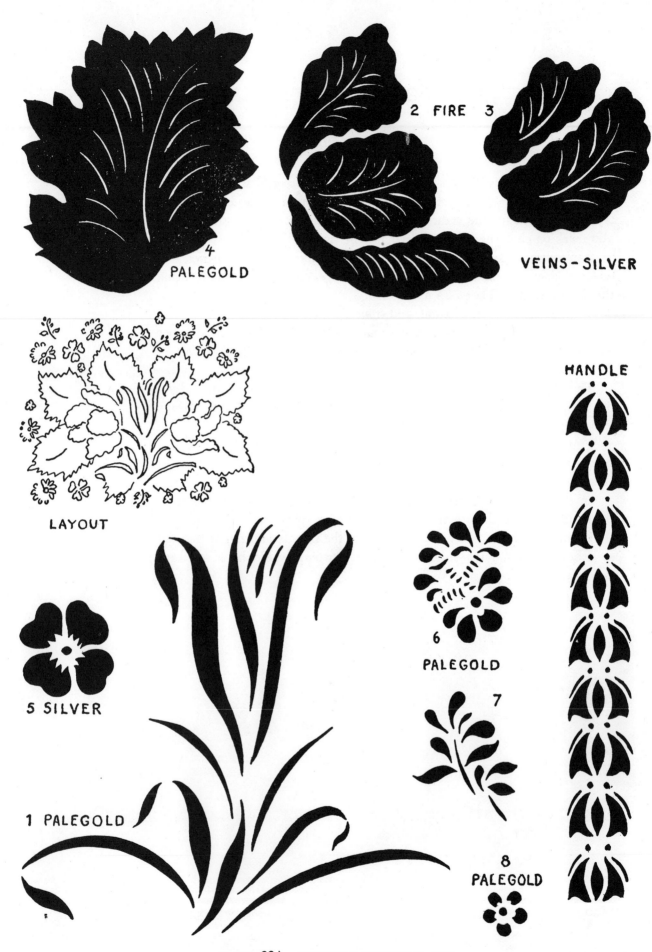

2 FIRE 3

VEINS—SILVER

4
PALEGOLD

LAYOUT

HANDLE

5 SILVER

6
PALEGOLD

7

1 PALEGOLD

8
PALEGOLD

PLATE 22A STENCILED WATERING CAN

33 Stenciled Candle Holder

The flowers of the upper border are done in silver, and the rest in palegold. Apply both colors to each unit of this border before lifting the stencil and moving on to the next unit.

The lower border is in silver with a transparent green (Indian Yellow and Prussian Blue) overtone put on after the silver stenciling is completely dry.

PLATE 22B BORDERS FOR STENCILED CANDLE HOLDER

34 Stenciled Spice Box

The original spice box contained six small canisters, to which access was obtained by means of two sloping lids, one on each side of the handle. Each lid was decorated with the same scene.

1. Prepare the box with three or four coats of flat black.

2. Trace and cut the six stencil units shown in heavy black in Plate 23. Number them to correspond with the numbers in the Plate. (Naturally this pattern should be carried out first on black paper, by way of practice.)

3. Varnish the box for stenciling.

4. When the proper tacky stage has been reached, place unit (1) in position, and stencil in palegold. Next, stencil the little tree once on each side in palegold. Then do the fence behind the tree, also in palegold. The mountain (4) was done in silver, bright where the shading is shown in the upper drawing, but fading off quickly to black. There were faint touches of silver clouding in the sky, and of gold clouding on the ground.

The two long sides of the box were decorated with border stencil (5) in palegold.

On the ends, the group of figures (6) were done in palegold.

5. Fine striping was done in mustard yellow around each of the four sides.

PLATE 23 STENCILED SPICE BOX

35 Stenciled Chair Patterns

PATTERN A

To make a copy of this pattern on black paper, proceed as follows:

1. Trace and cut the stencil units shown in Plate 24. Mark each unit with its number and the name of the colored powder to be used for it.

2. Varnish two sheets of black paper, one 13 by 3 inches, and the other 10 by 2½ inches.

3. When the varnished surface has reached the proper tacky stage, place stencil unit (1) in position. Stencil it in palegold, very bright on the upper half and around the lower edge. Lift stencil, and picking up a speck of fire powder on a clean part of the velvet, barely touch the center of the flower with a faint "cloud" of fire.

Stencil (2) and (3) in deepgold. Numbers (4) and (5) are in palegold with their centers faintly "clouded" with fire. Continue with the other units in numerical order.

For the smaller slat, start with (17) in palegold, then faintly cloud the center with fire; (18) is also in palegold, but fades off to black where it goes behind (17). Continue with (19) and (20). The leaf (6) is placed at each end, and the finishing touches are given by the tiny leaves (15) and (16).

1 PALEGOLD

2 DEEPGOLD

11

10 FIRE

3 DEEPGOLD

12

4 PALEGOLD

5

18 PALEGOLD

20 FIRE

8 DEEP GOLD

9 DEEP GOLD

6 DEEPGOLD

14

7 DEEPGOLD

13

15 DEEPGOLD

16

17 PALEGOLD

19 DEEPGOLD

SIDE POST

PLATE 24 STENCILED CHAIR

PATTERN B

To make a copy of this pattern on black paper, proceed as follows:

1. Trace and cut the stencil units as shown in Plate 25. Then number the units as in the illustration, and mark them with the names of the colored powder or powders to be used for each.

2. Varnish two pieces of black paper, one 12½ by 4¼ inches, and the other 11 by 3 inches.

3. When the paper has reached the proper tacky stage, place stencil unit (1) in position. Stencil it in palegold, very bright on the upper half and around the lower edge. Lift stencil, pick up a speck of fire powder on a clean part of the velvet, and barely touch the center of the flower with a faint "cloud" of fire.

Stencil (2) in palegold, one on each side, and then faintly "cloud" the centers with fire. Stencil the melon (4) at the top center next, making it very bright palegold at the top, shading quickly to fire, and then to black behind the flower (1) already stenciled.

Then stencil the spray (3) in deep gold, once on each side. Next the melon (4) is repeated once on each side in palegold and fire. Continue with (5), (6), and (7), all in deepgold.

For the smaller slat, start with the border (8), doing it on each end in deepgold. Then place (9) in position at the center, stenciling it in palegold. Continue with the spray (10), placing it on each side. Next stencil the melon (11) on each side in bright palegold at the tips, shading quickly to fire, and thence to black. Last of all, add the leaf (12) on each side in deepgold.

OTHER BORDER PATTERNS

Additional patterns for furniture and tray borders are shown in Plates 26 and 27.

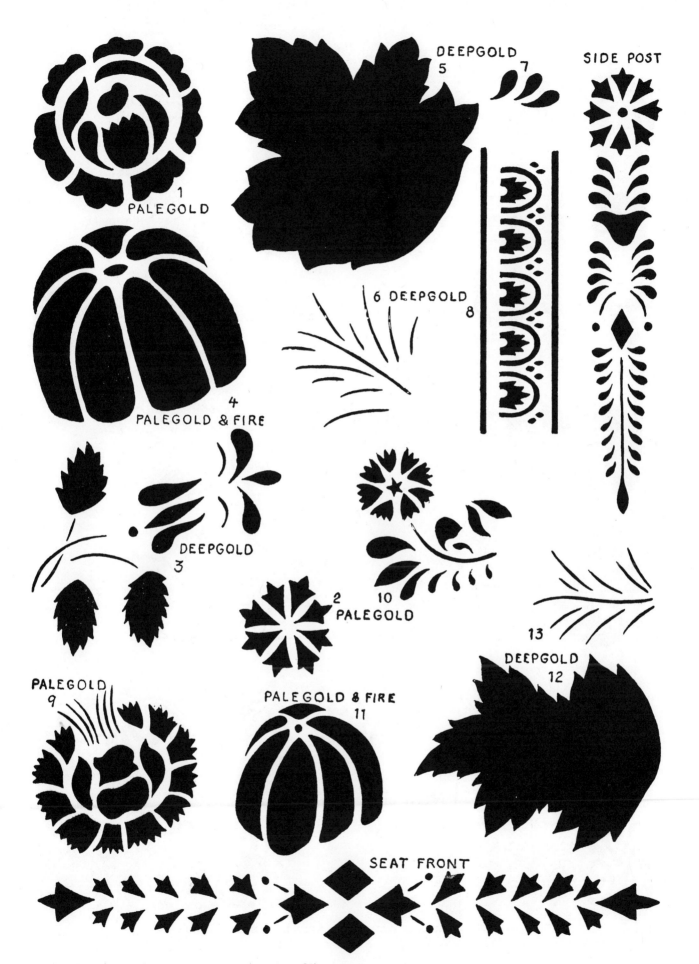

DEEPGOLD 5 7 SIDE POST

1
PALEGOLD

4
PALEGOLD & FIRE

6 DEEPGOLD
8

DEEPGOLD
3

2 10 PALEGOLD

13
DEEPGOLD
12

PALEGOLD
9

PALEGOLD & FIRE
11

SEAT FRONT

PLATE 25 STENCILED CHAIR

CUT ONE
UNIT AND
REPEAT

CUT SEPARATE STENCIL FOR VEIN

STENCILED TRAY BORDERS

PLATE 26 STENCILED FURNITURE AND (LOWER) TRAY BORDERS

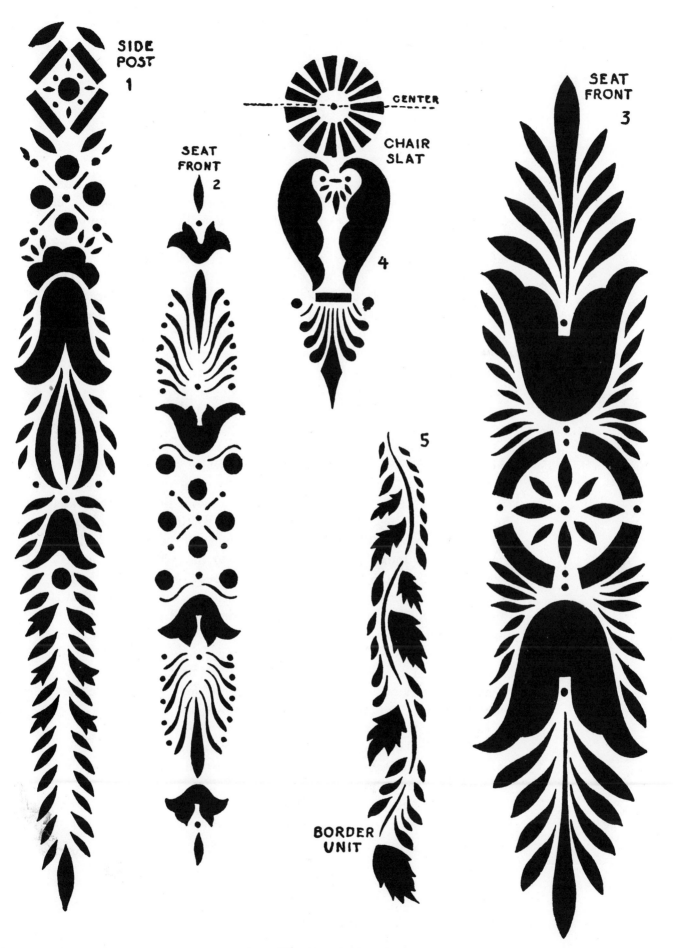

SIDE POST
1

SEAT FRONT
2

CENTER

CHAIR SLAT

4

SEAT FRONT
3

5

BORDER UNIT

PLATE 27 FURNITURE STENCILS

36 Lace-Edge Tray

Lace-edge trays, round, oval, and rectangular in shape, date from about 1770. They were of English manufacture and were popular in America until well into the first half of the nineteenth century. Fruits and flowers were favorite subjects for decorating these trays, and great use was made of transparent tones of colors to give rich effects. The trays usually have a delicate gold leaf border around the edge of the floor. The more elaborate ones often had "tortoise shell" backgrounds and scattered clusters of small blue and white flowers, some of them almost disappearing into the background. The pattern given here is a more simple one, but nevertheless one of my own favorites.

To copy the center pattern, put a piece of frosted acetate over Plate 28, and proceed as follows:

1. With a mixture of off-white, paint the overall areas of the peach and strawberry, covering all detail and shading.

With a bluish country green (Japan Green, Prussian Blue, Raw Umber, and a touch of White), paint all the leaves which are shown in black. Wait 24 hours.

2. Squeeze out Indian Yellow, Alizarin Crimson, Burnt Umber, and Prussian Blue on a newspaper palette for use in floating color. Apply slow varnish to the peach with a showcard brush, wipe off the brush, and then, after picking up some dry yellow, brush it over the center of the peach, covering about two-thirds of the fruit. Add a speck of blue to the yellow to make a pale green and brush over the dotted section. Brush Alizarin Crimson with a touch of Burnt Umber over the shaded section, making it a deep red, which should be darker and browner where the cross-hatching is. The color thus blends from yellow to orange, to red, to deep reddish brown, and then to red again on the left-hand side of the peach.

Apply slow varnish to the strawberry. Brush yellow over the center, adding Alizarin Crimson and Burnt Umber over the shaded areas. Let the work dry for at least a week.

3. With off-white, paint all the leaves and stems and tiny brush strokes which are white in Plate 28. Add blue to the mixture to make a pale blue, and paint the shaded brush strokes.

With a thin mixture of off-white, paint the highlights on the green leaves. Wiping the brush back and forth on the newspaper until it is

96

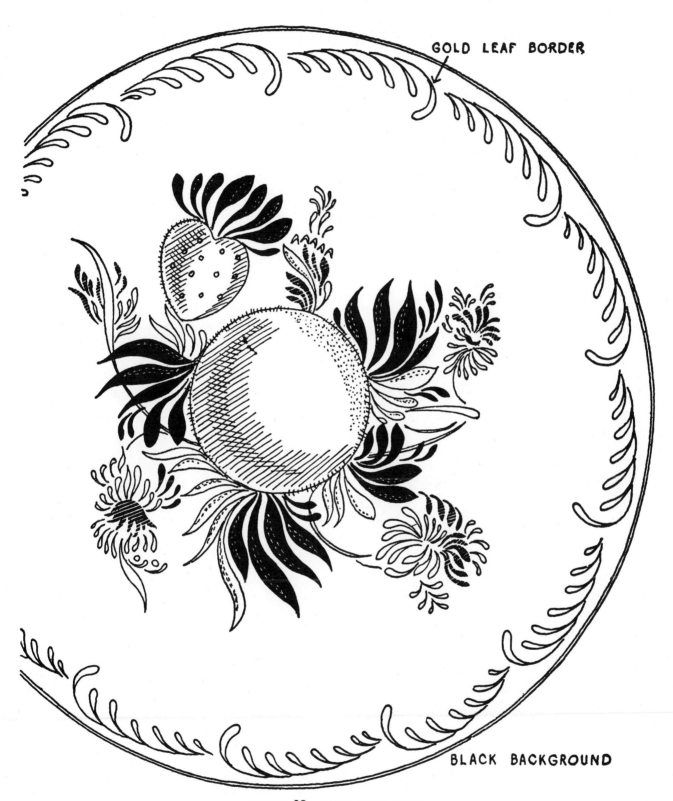

GOLD LEAF BORDER

BLACK BACKGROUND

PLATE 28 LACE EDGE TRAY

rather "dry," go lightly over the face of the peach to give it a slightly downy look. Using a somewhat thicker mixture of off-white, but still keeping the brush "dry," go lightly around the edge of the peach, as shown by the whisker-like lines in the drawing, so as to soften the edge. Use a darker off-white on the shadow side. Do the same with the left edge of the berry. Paint the strawberry dots in off-white.

With a thin mixture of Burnt Umber, paint a stroke on the dark side of each large green and white leaf.

37 Chippendale Tray

Chippendale trays, also known as Gothic trays and Pie Crust trays, originated about 1760, during the Chippendale furniture period. They continued to be manufactured for more than a century and were immensely popular during the Victorian era, when there was a Chippendale revival.

These trays were never stenciled. Some of the earlier ones were decorated with elaborate gold borders, while the center was left blank. Trays of the later period, however, were quite showy, and much use was made of brilliant transparent overtones of rich color in the painting of flowers and of gorgeous birds.

Make a practice copy of the floor design (Plate 29), using palegold powder for this purpose instead of gold leaf.

1. With Japan Vermilion, paint the birds and the basin, disregarding all details. When tacky, apply the gold powder. Dry 24 hours.

2. Mix some Japan Vermilion, Burnt Umber, and White to make a medium deep pink, and with this mixture, paint the large rose A, disregarding all detail. Wipe off the brush and apply a little extra Burnt Umber to darken the areas indicated by broken lines in the illustration. Using the same deep pink, paint the smaller flowers marked B.

Paint the large flower C in Japan Vermilion, blending in a little dry Burnt Umber to darken the center.

With a mixture of Country Green, paint all the leaves, stems, and brush strokes representing small leaves. Wait 24 hours.

3. Mix Prussian Blue and Raw Umber to make a transparent blue, and paint the wings on the bird D; also the head and breast, blending off the lower edge of the blue with a clear varnish brush.

Mix some Alizarin Crimson and Burnt Umber to make a rich transparent red, and paint the wings of the bird E, blending off the color. Mix a little Prussian Blue and Indian Yellow to make light green, and apply this to the back of the bird, blending off the color towards the tail.

Apply slow varnish to the rose A. Wipe off the brush, and then lightly brush some dry Alizarin Crimson and Burnt Umber into the flower to

99

PLATE 29 CHIPPENDALE TRAY—A

produce a deeper pink, darkening the shaded areas with a still darker pink, almost brown.

Apply slow varnish to the red flower C, and immediately brush in a little Alizarin Crimson and Burnt Umber over the entire flower, adding a bit more pigment in the center and around the upper edge to darken those parts. This completes the floating color in this pattern.

Mix a little Alizarin Crimson and Burnt Umber to make a deep pink, and apply this to all the smaller flowers B. Allow the work to dry. The slow varnish takes at least a week to dry, but after 48 hours it is dry enough for you to continue on other parts of the pattern.

4. Add enough varnish to off-white to make a transparent white, and apply this to the tail of the bird D. Wipe the brush, and then picking up some fairly dry White, paint several long, thin strokes on the wet surface to suggest tail feathers. Do the same on the other bird.

Using the same thin off-white, paint the water in the fountain, adding some dry White here and there to accent it.

Apply a transparent overtone of Burnt Umber to one side of each leaf, blending off the inner edge. With a semi-transparent mustard yellow, paint the highlights on the leaves and the brush-strokes in the crest of bird D. Wait 24 hours.

5. Paint the veins of the leaves with Japan Black.

6. When the two large flowers are completely dry, mix a thick off-white to accent the edges of the rose petals. Paint one petal at a time, immediately using a second brush with a little varnish on it to blend and soften the inner edge of the white. Do the same with the smaller flowers and buds.

With a somewhat thinner mixture of off-white, paint the white curved lines on the bird D, the eyes of both birds, and the petal lines on the flower C. Let dry 24 hours.

To decorate a tray:

1. Paint the tray flat black in the usual way.

2. Apply a thin film of whiting in preparation for gold leaf.

3. Make a tracing of the pattern from Plates 29 and 30, and transfer the gold sections to the tray.

4. With the Yellow Ochre and varnish, paint the gold sections of the floor design, the scroll border, and the stripe around the edge. When tacky, lay the gold leaf. Wait one week.

5. Apply a protective coat of varnish. Wait 24 hours.

6. Transfer the rest of the pattern to the tray, following the directions given above for the practice copy.

7. Finish the tray in the usual way.

PLATE 30 CHIPPENDALE TRAY—B

38　Large Oval Tray

Oval trays were first made in England during the Victorian period. This one had a scroll border done in palegold bronze powder, with touches of dark blue. The flowers are mostly in floating color. Good practice may be obtained by first making a copy of the pattern on frosted acetate.

1. On tracing paper, make a complete tracing of the pattern from Plates 31, 32, and 33. Mount this on white cardboard, so that the lines can be seen easily, and put a sheet of frosted acetate over it.

2. Mix White, Raw Umber, and Yellow Ochre to make a pale beige, and paint the overall area of the rose A, disregarding all detail. In the same way, do the small rose G, and the bud F.

Adding more Yellow Ochre to the mixture to make a deep cream, paint the rose B.

With a mixture of off-white, paint the morning-glory C, its buds D, and the blossoms and buds E, H, and K.

With Vermilion, paint the flowers M and N. Wait 24 hours.

3. With a dark bluish country green (Japan Green, Prussian Blue, and Raw Umber), paint all the black areas in the illustrations, disregarding details.

With a yellowish country green (Japan Green, Japan Yellow, and Burnt Umber), paint all the other leaves, buds, and stems. Wait 24 hours.

4. On a newspaper palette, squeeze out Alizarin Crimson, Burnt Umber, Indian Yellow, Prussian Blue, and Raw Umber in preparation for floating color. This procedure involves the application of slow varnish to a flower with a showcard brush. (Refer to Chapter 9 for full general directions on floating color.) Wiping off the brush with a cloth, pick up a tiny speck of the requisite undiluted color, and lightly brush it on the flower, as follows:

Rose A. Brush in Indian Yellow over the middle and lower parts. Then brush Alizarin Crimson and Burnt Umber over those parts that are shaded in the illustration to make them a rose color, using more pigment to darken the part under the "cup" of the rose, and in the "heart" of the rose. Do the same with G and F.

Rose B. Brush in the yellow all over the flower. Then add a touch of

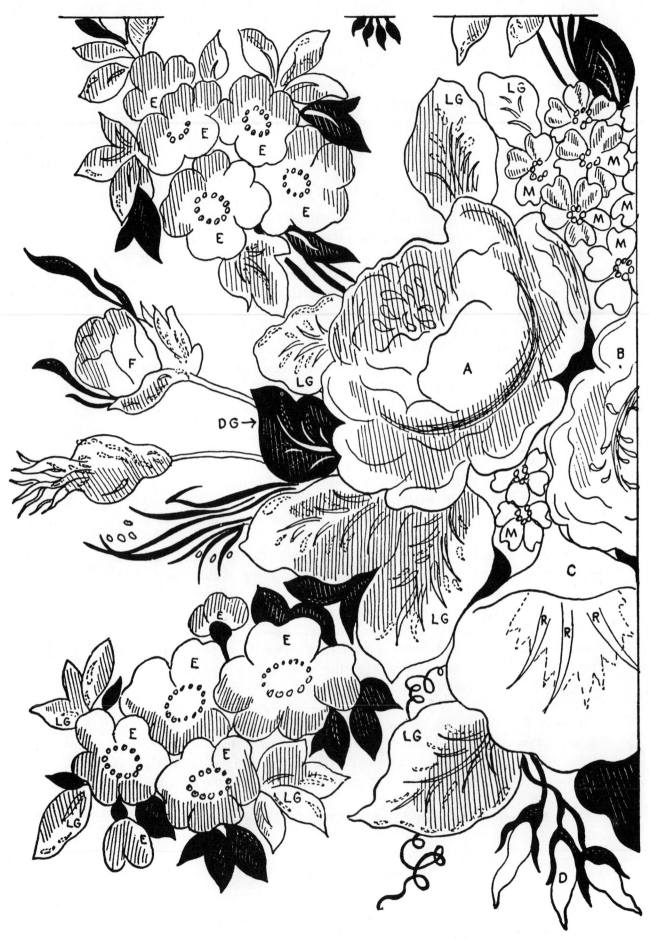

PLATE 31 LARGE OVAL TRAY—A

the blue in the shaded parts to make a pale green, adding a little Burnt Umber for the darker parts of the rose.

Blossoms E. Brush green (Indian Yellow and Prussian Blue) in the centers. Add rose color over the shaded areas, accenting the petals with Burnt Umber.

Morning-glory C. Brush the yellow in the center, adding a hint of green here and there, but keeping it all very light. Then brush blue (Prussian Blue and Raw Umber) over the rest of the flower, applying the brush strokes from the center out to the edges, and making the color a bit darker here and there.

Buds D. Brush blue over the tips, and Raw Umber at the upper ends, applying little and lightly for pale effects in both cases.

Flower H. Brush blue over the shaded areas for a medium blue effect, adding a darker touch to the center.

Flowers K. Brush blue lightly for a pale effect over the shaded areas, adding a little Raw Umber on one side of each flower.

Wait at least a week for the floating color to dry properly.

5. Give the shaded areas on all the leaves, the green rosebud, and the calyx on F, an overtone of Burnt Sienna, blending off the edges with varnish.

Give the shaded areas on the flowers M and N an overtone of transparent dark red (Alizarin Crimson and Burnt Umber), blending the edges here and there. Allow 24 hours to dry.

6. When the slow-varnish parts are completely dry, apply the off-white veiling on the roses A, B, F, and G (see p. 34). White veiling should also be used to highlight some of the petals on the blossoms E.

Mix Japan Yellow and White for a pale yellow, and paint the dots on the flowers E, H, and M, and the little drops on the flowers K; also the dots under the green rosebud and the tear drops on the extreme right.

With Burnt Umber, paint the veins in the leaves as shown in the drawings (not the dotted line veins). Wait 24 hours.

7. With dark red (Alizarin Crimson and Burnt Umber), paint the brush strokes in the heart of the rose A and those on the rose B; also the strokes marked R on the morning-glory. Paint touches of dark red on some of the yellow dots in the flowers E and K.

Mix a thin Yellow Ochre with White, and paint the dotted line strokes on the leaves and green buds, and also those on the flowers N.

To decorate a tray with this pattern:

1. Paint the tray flat black in the usual way.

2. Turn the tray upside down on a large sheet of tracing paper, and trace a line around the edge to get the oval shape. Mark the centers of top and bottom, and of both ends, and trace there the center border motif X, shown in Plate 34. Likewise mark the centers of the four quarters,

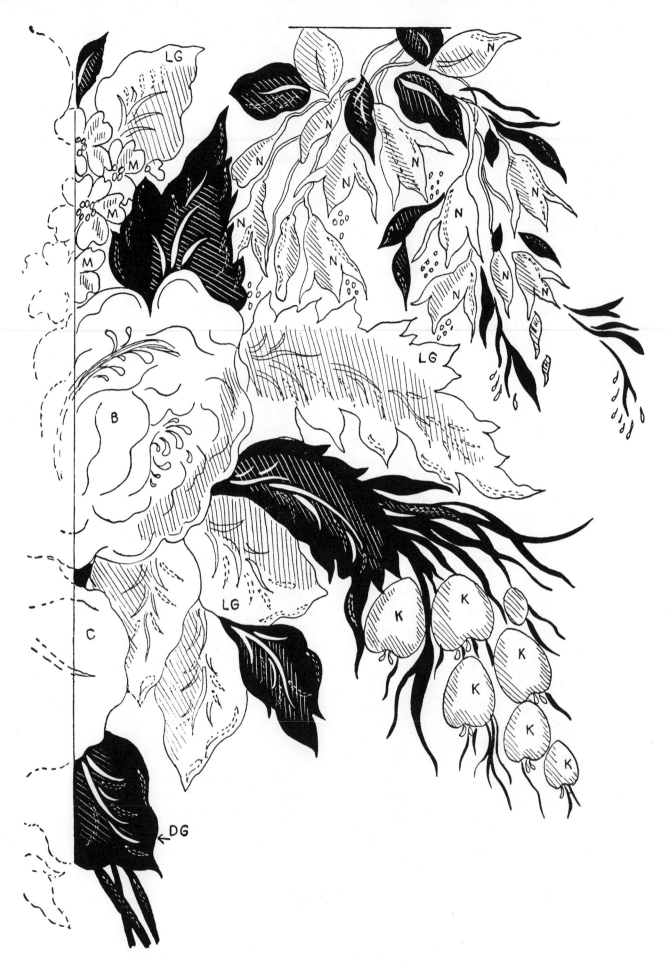

PLATE 32 LARGE OVAL TRAY—B

and trace there the motif Y. Fill in the scroll sections along the edge, making any needed adjustments, and tracing on the wrong side of the paper when required.

3. Transfer the border to the tray (see Chapter 11).

4. With Japan Vermilion paint the scrolls, all of which are white on Plate 34. As you paint along, stop from time to time to apply palegold powder to those parts which have become tacky. Allow 24 hours to dry. The original tray had no gold stripe around the edge.

5. Mix Prussian Blue, Raw Umber, and White to get a deep blue and paint the areas shown in black on Plate 34. Apply touches of transparent Burnt Sienna here and there on the scrolls. Leave to dry for 24 hours.

6. Give the tray a coat of varnish to protect the border.

7. Transfer the center design to the tray, and paint it as described above for the acetate copy.

8. Finish the tray in the usual way.

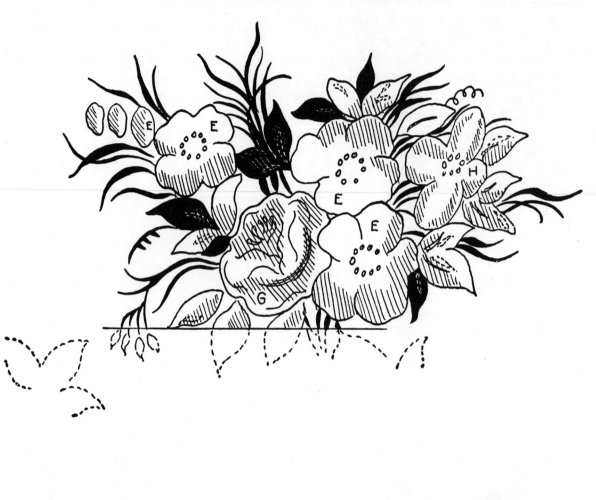

PLATE 33 LARGE OVAL TRAY—C

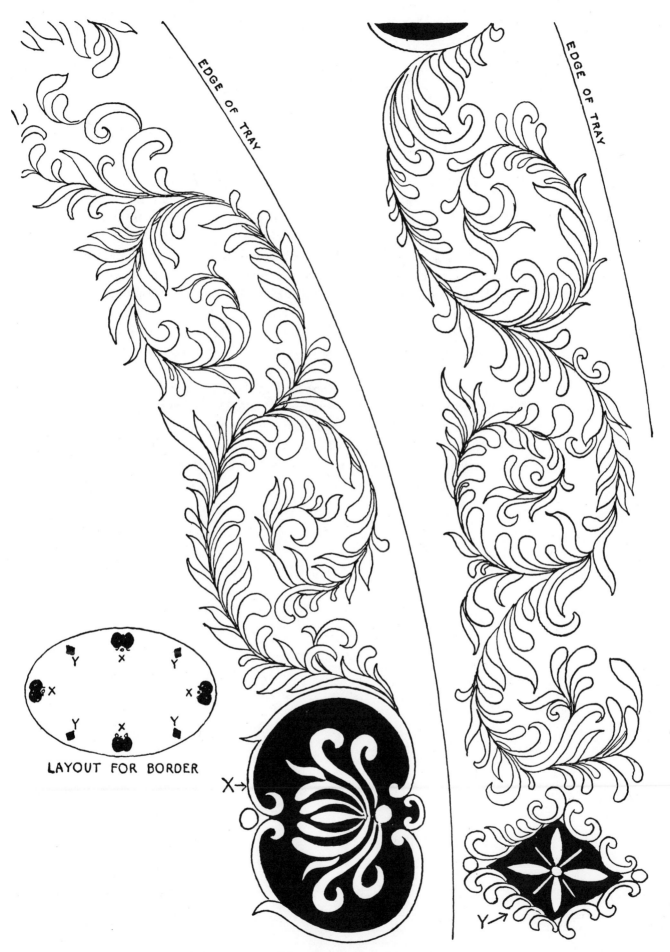

LAYOUT FOR BORDER

X→

Y→

PLATE 34 LARGE OVAL TRAY—D

39 "Queen Anne" Tray

1. Paint the tray flat black in the usual way.

2. Apply a thin film of whiting in preparation for gold leaf.

3. From Plates 6 and 35, trace the pattern, and transfer to the tray the sections which are to be done in gold leaf.

4. With a mixture of Yellow Ochre and varnish, paint those sections which are to be gold, doing first the center part, and then the border, omitting the dots which are *black* in Plate 35. Paint the stripe around the edge. When all this is tacky, lay the gold leaf. Wait one week.

5. Apply a coat of varnish to protect the gold leaf. Wait 24 hours.

6. Go over the surface lightly with steel wool to remove the gloss. Transfer the rest of the design to the tray.

7. Proceed to paint the flowers as described in pages 32-34.

8. The shaded areas of the border (Plate 35) are in transparent Burnt Umber, which should be applied with one brush stroke each time, and then blended off on one side with a clear varnish brush. The dots which are shown in black should be painted in off-white. Wait 24 hours.

9. Finish the tray in the usual way.

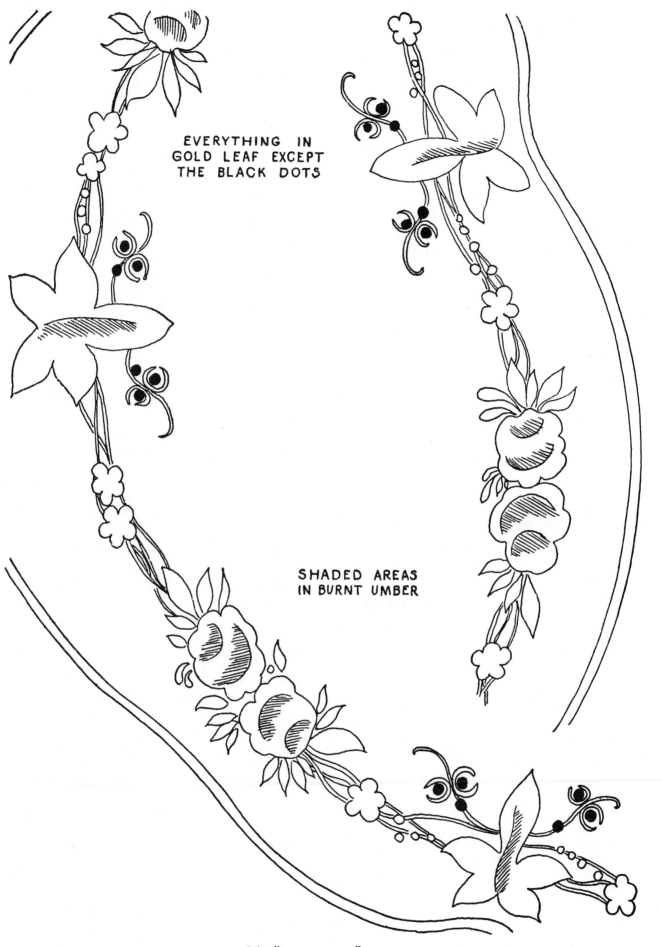

EVERYTHING IN
GOLD LEAF EXCEPT
THE BLACK DOTS

SHADED AREAS
IN BURNT UMBER

PLATE 35 "QUEEN ANNE" TRAY BORDER

40 Rectangular Gold Leaf Tray

Rectangular trays date from about 1760 and were made in all sizes. They were popular for at least a century, and all styles of decoration were used on them.

1. Paint the tray flat black in the usual way.

2. Apply a thin film of whiting in preparation for gold leaf.

3. Trace the flower sprays on Plate 36, using separate pieces of tracing paper for each to facilitate handling. Transfer the tracings to the tray. Next, make a tracing of the section of borders in the upper part of Plate 37, and transfer that also to the tray, repeating until the border is completely around the tray.

4. With a mixture of Yellow Ochre and varnish, paint all the design which is to be gold, doing one section at a time. Everything is gold except the flower centers and the inner parts of their petals. Disregard all the black brush-strokes and leaf veins shown in the drawings.

If the entire tray is too much to do at one time, leave some parts for another day. The fine gold line work on the flange is quite easily done with a striping quill. Note there is no gold stripe to be painted around the edge of the tray.

5. When the proper tacky stage has been reached, lay the gold leaf. Wait one week.

6. Apply a coat of varnish to the tray to protect the gold. Wait 24 hours.

7. Rub gently with steel wool to remove the gloss. With a mixture of off-white, paint the flower centers and the insides of the flower petals. With Japan Black, paint the black brush strokes over the gold along the inner edge of the border. Also paint the leaf veins and shadings, which are shown in black in Plate 36. Wait 24 hours.

8. With a mixture of varnish, Alizarin Crimson, and a touch of Burnt Umber, paint the transparent red overtones on the off-white petals and flower centers where indicated by the broken lines in the same Plate.

9. Add a mustard yellow stripe around the edge of the tray, and finish in the usual way.

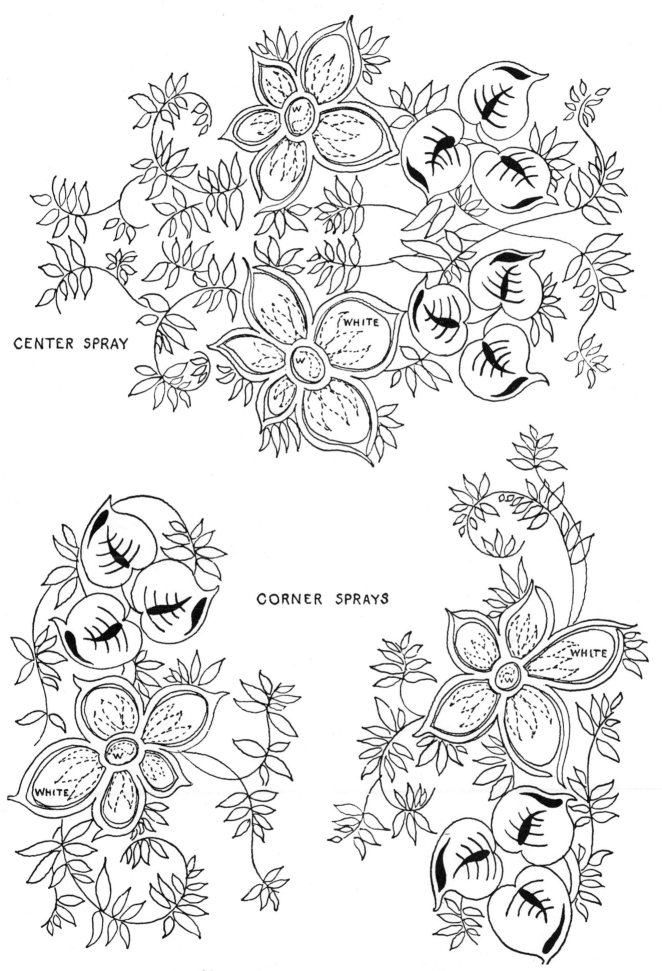

CENTER SPRAY

WHITE

W

CORNER SPRAYS

WHITE

W

WHITE

W

PLATE 36 RECTANGULAR GOLD LEAF TRAY—15″ × 20″

41 Large Oval Gold Leaf Tray

The original of this tray was very large and had a rolled edge. It was painted black, and the border design was done in gold leaf. In the drawing the gold parts are shown in black. The edging was painted over the gold in a creamy white.

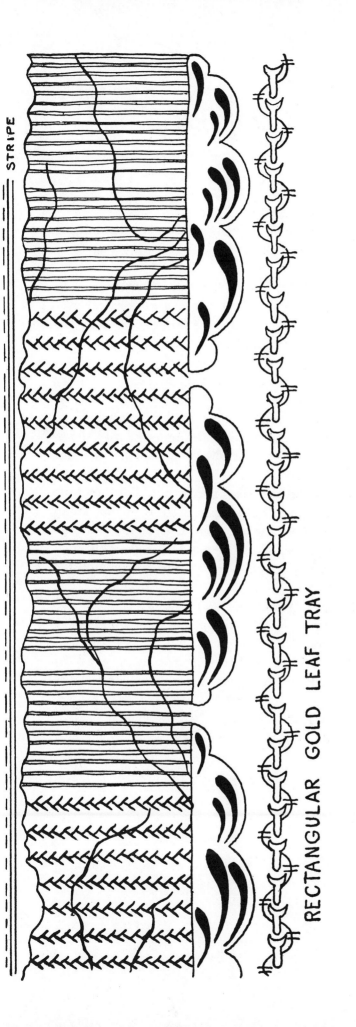

STRIPE

RECTANGULAR GOLD LEAF TRAY

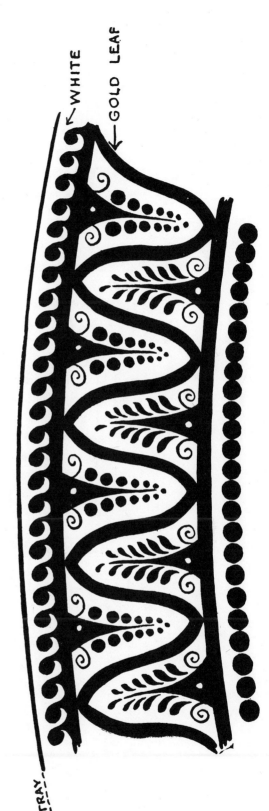

WHITE

GOLD LEAF

EDGE OF TRAY

PLATE 37 GOLD LEAF TRAYS—(UPPER) RECTANGULAR; (LOWER) LARGE OVAL

42 Gold Leaf Box

1. Paint the box flat black in the usual way.

2. Trace the design from Plate 38, making any adjustments that may be necessary to suit the size and shape of the box. Transfer the tracing to the box.

3. With a mixture of Yellow Ochre and varnish, paint the design, with the exception of the small round berries shown black in the drawing. Cover all the details and the shaded areas. Paint also the border stripes on the top and sides of the box. When the proper tacky stage has been reached, lay the gold leaf. Wait one week.

4. Apply a coat of varnish to the box to protect the gold leaf. Let it dry 24 hours.

5. Rub lightly with steel wool to remove gloss. With a crow-quill pen and black ink, draw the leaf veins, the shading on the leaves and stems, and the cross-hatching and detail on the acorns. Wait half an hour for the ink to harden.

6. Mix some varnish with a little Indian Yellow and Prussian Blue to make a transparent green. Taking the parts marked G on the group of leaves at the top of the pattern as a guide, paint a green area on each leaf there and elsewhere. Apply the green with one or two strokes, blending off the edges. Also apply a touch of green over the cross-hatching on the acorns.

Paint the small round berries in Vermilion. Wait 24 hours.

7. Mix Burnt Umber and varnish to get a transparent brown, and taking the parts marked U on the group of leaves at the top of the pattern as the example, paint similar patches here and there at discretion on all the other leaves. On some leaves add brown to the center vein. There is also a touch of brown along one side of each acorn.

8. Finish the box in the usual way.

116

G — TRANSPARENT GREEN
U — " BURNT UMBER

PLATE 38 GOLD LEAF BOX

43 Small Oval Gold Leaf Tray

1. Paint the tray flat black in the usual way.

2. Turn the tray face down on tracing paper, and draw a line around the edge of the tray to get its shape. Put this tracing over the sprays on Plate 39 to see whether they fit your oval. Trace the sprays around the edge of the oval, making any necessary adjustments.

3. With a mixture of Yellow Ochre and varnish, paint the design, including the stripe. When the work is tacky, lay the gold leaf. Wait one week.

4. Apply a coat of varnish to protect the gold leaf. Allow 24 hours for drying.

5. Rub gently with steel wool to remove the gloss. Paint the dots and veins in black. Wait 24 hours.

6. With a transparent brown, made of Burnt Umber and varnish, paint the shaded areas. Wait 24 hours.

7. Finish the tray in the usual way.

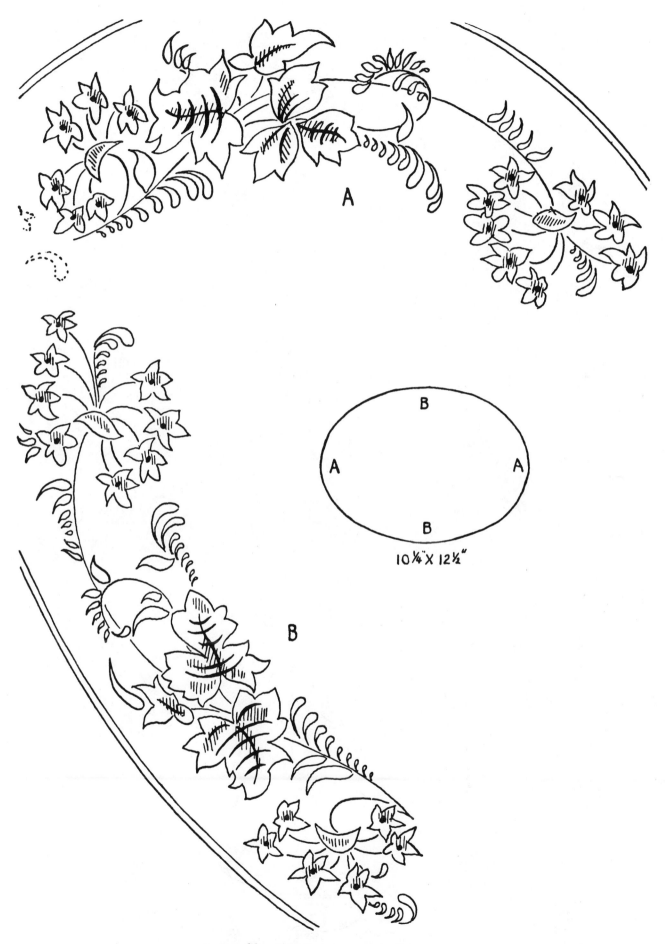

A

B

B

A A

B

10¼"X 12½"

PLATE 39 SMALL OVAL GOLD LEAF TRAY

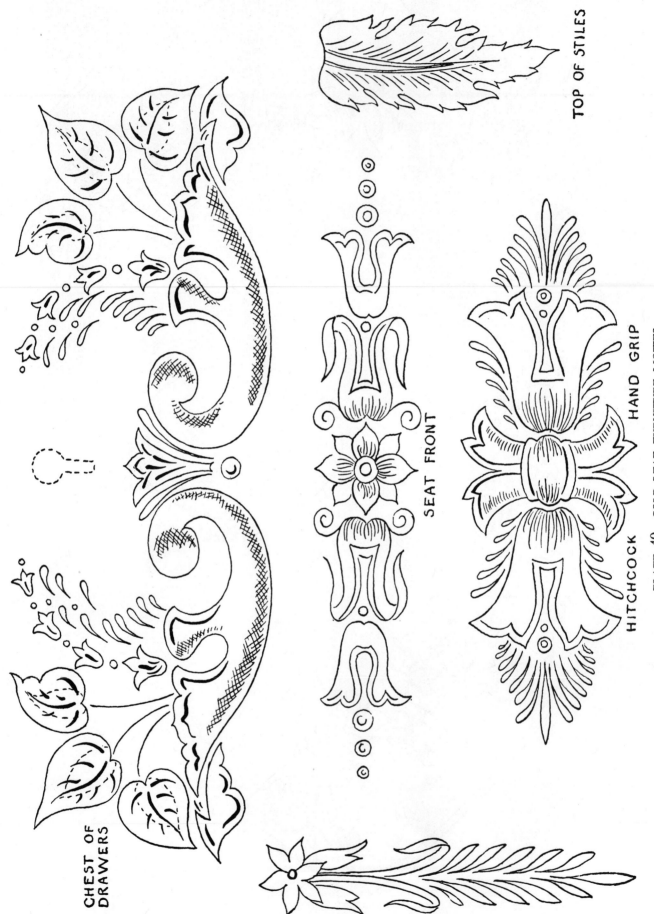

TOP OF STILES

SEAT FRONT

HAND GRIP

HITCHCOCK

CHEST OF
DRAWERS

PLATE 40 GOLD LEAF FURNITURE MOTIFS

American Folk Art

ELLEN S. SABINE

DRAWINGS BY THE AUTHOR

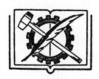

VNR VAN NOSTRAND REINHOLD COMPANY
NEW YORK CINCINNATI TORONTO LONDON MELBORNE

Combined edition first published in 1982
Copyright © 1956 by Van Nostrand Reinhold Company Inc.
Library of Congress Catalog Card Number 81-51277
ISBN 0-442-28423-2

Printed in the United States of America

Van Nostrand Reinhold Company Inc.
135 West 50th Street, New York, NY 10020

Fleet Publishers
1410 Birchmount Road, Scarborough, Ontario M1P 2E7

Van Nostrand Reinhold Australia Pty. Ltd.
480 Latrobe Street, Melbourne, Victoria 3000

Van Nostrand Reinhold Company Ltd.
Molly Millars Lane, Wokingham, Berkshire, England
RG11 2PY

Cloth edition published 1958 by D. Van Nostrand
Company
Second cloth impression 1967
Bonanza cloth reprint edition published 1971 by Crown
Publishers

16 15 14 13 12 11 10 9 8 7 6 5 4 3 2

Preface

The old decorative patterns used by American craftsmen, in the days when life was simpler and less mechanized, have not lost their beauty with the passing of time. This heritage has a timeless appeal, and today more and more people are finding relaxation and joy in adorning their homes with these fascinating designs, created anew by their own hands.

Folk art is a hobby that can be enjoyed both by the young and old; indeed, parents and children can work together on folk art projects with the happiest and most satisfying results. No elaborate art training is needed. The folk artist begins to produce acceptable work almost from the start, and progress is encouraged all the time by real achievement. At the same time, a naturally creative artist, one whose main expression might be in another field of art, learns valuable lessons from folk art techniques, with a resulting enrichment of his natural gifts. The young and growing mind inevitably acquires by the practice of folk art an appreciation of honest form and of the beauty of color; and it would not be out of place if some instruction in our historic American Folk Art formed part of the curriculum of every public school. The desire for the beautiful, inborn in every child, would be enhanced in a wholesome and constructive way.

Folk art, then, is not the exclusive preserve of highly trained professional artists, aiming to meet the tastes of connoisseurs and wealthy buyers. It could not be defined better than in these words, borrowed from William Morris, English poet and decorator of the last century: "Art made by the people and for the people as a joy to the maker and the user."

ACKNOWLEDGMENTS

For permission to use designs, for aid in gathering material, or for other assistance in preparing this book, I gratefully thank Mrs. Hedy Backlin, Mr. James Biddle, Mrs. Julia Borcherding, Miss Hilda M. Borcherding, Brooklyn Museum (Brooklyn, N.Y.), Mr. and Mrs. Vernon H. Brown, Mr. Arthur B. Carlson, Cooper Union Museum (New York), Miss Mary Aileen Dunne, Mr. Joseph Farrell, Free Library of Philadelphia, Index of American Design (National Gallery of Art, Washington, D.C.), Irene L. Lovett Antiques (New York), Mr. Abe E. Kessler, Mrs. Huldah Cail Lorimer, Mrs. John G. McTernan, Metropolitan Museum of Art (New York), New-York Historical Society, New York Public Library, Pennsylvania German Society (publishers of the late Dr. Henry S. Bornemann's classic *Pennsylvania German Illuminated Manuscripts*), Professor Harry W. Pfund, Queens Borough Public Library (Jamaica, N.Y.), Mr. Edward W. Schlechter, Mr. Marvin Schwartz, Miss Carolyn Scoon, Mrs. Jessie Van Doren, Mrs. Marion Wood, and my husband.

Contents

1

A Glance at the Past

American folk art, like so many of our institutions, had its roots in Europe. Craftsmen among the settlers introduced the techniques and cultural motifs of their old homelands to the new country, and from the earliest colonial times articles made and decorated in Europe were imported by colonial merchants and sold to the people. Thus the training of our native-born craftsmen was naturally and inevitably based on the art of England, France, and Germany, and the countries to which those three in turn owed so much.

Many kinds of art expression are embraced by the general term of "folk art," such as weaving, embroidery, pottery making, woodcarving, ornamental ironwork, painting, etc. Here we are concerned with decorative painting on furniture and smaller articles for household use, and also with the Fraktur painting which is such an outstanding part of American folk art.

Contrary to what many people suppose, the homes of an earlier period of our history were characterized by a liberal use of bright colors and cheerful designs. Floors were painted and decorated; walls were often tinted or stenciled, or were decorated with landscape paintings. There were stenciled and embroidered bedspreads, bright woven fabrics, decorated clocks and mirrors, painted furniture, boxes, trays, and other useful items. All these things gave an air of brightness and individuality to homes.

The flourishing period of American folk art was from about the middle of the 18th century to the time of the Civil War. It was then practiced consistently and on a considerable scale in the older parts of the country, notably in the rural communities of New England and Pennsylvania. The folk craftsmen favored traditional motifs, introducing modifications as the need arose or as fancy suggested. And that, let us note, is just what we today find ourselves doing as we follow in their footsteps. We respect tradition, but we are not its prisoners.

1

Connecticut craftsmen probably produced the earliest pieces of decorated furniture, such as chests, highboys, chairs, and boxes. At first, the carpenter or joiner who made the furniture also painted the decoration; later on, coach and sign painters found it profitable to turn their hands to decorating household furniture, the demand for which was continually increasing.

Utensils of tinware decorated with folk art motifs were very popular. Sheets of tinplate (iron that was coated with tin) began to be imported from England in the mid 18th century, and American tinsmiths made it into coffee pots, tea pots, tea caddies, trays, canisters, candle holders, sconces, and many kinds of boxes, such as those for documents, trinkets, and candles. Such articles were also imported ready made. In meeting the demand for decorated ware, the tinsmith either employed an artist or turned that part of the work over to the artistically inclined members of his own family.

The finished pieces of tinware were mostly retailed by peddlers who traveled up and down the land, selling from door to door. Hence it is difficult to be sure just where the articles originated; but it is generally believed that most of them were made in Pennsylvania, Connecticut, and Maine. At first the tin peddler carried his wares on his back. Later he traveled on horseback and, with improving roads, was able to use a cart. In colonial times cash was not plentiful, paper money was disliked, and so the peddler was often glad to take farm produce in exchange for his tinware. His arrival at a farm or hamlet was quite a notable occasion, for besides the brightly decorated wares he brought news and gossip from distant places.

A highly distinctive contribution made to American folk art was that of the Pennsylvania Germans. Refugees from religious and political troubles in their homeland, they settled in southeastern Pennsylvania, bringing with them the rich heritage of their native folk art. Dower chests, cupboards, dressers, benches, boxes of all kinds, and numerous other useful household objects were decorated in bright, gay colors with the designs characteristic of the Pennsylvania "Dutch," who, of course, were not Dutch at all, but German (or *Deutsch* in their own language). Since almost every Pennsylvania German maiden of marriageable age received a dower chest, whose painted decoration usually included her name and a date, it is not surprising that many of those beautiful chests have been carefully preserved by their descendants. Likewise, many bride boxes have come down to us, the bride box being

2

the customary gift of a groom to his bride. It was used to hold the smaller items of her trousseau.

Besides these decorative arts, which were like those of other American communities, the Pennsylvania Germans brought here the unique art of *Fraktur-Schriften,* or the making of illuminated manuscripts. *Fraktur* is a German word meaning a certain design of 15th century Gothic letter, while *schriften* means "writing." The application of Fraktur was gradually expanded in common usage to cover both the design of the lettering and the colored embellishment of it. Eventually the term came to be applied not only to all manuscripts of the type, but also to the style of decoration even when it was unaccompanied by any writing.

Historically, Fraktur painting is a survival from the middle ages, when manuscript records and literary works were accompanied by more or less elaborate drawings or paintings in gold and color. The advent of printing with movable type in the 15th century gradually brought the making of manuscript books to an end, but in some places, and for limited purposes, the art of embellishing manuscripts was continued. In Germany the continued use of the Gothic black-letter for printing, as formerly for writing, encouraged the survival of the art. When the Germans arrived in Pennsylvania they brought the art with them, and it not merely survived there, but in the course of time developed into a form peculiar to the Pennsylvania "Dutch." It came to be an essential part of their cultural life, reaching the peak period of its cultivation between 1800 and 1840. It was used primarily for important documents like certificates of birth, baptism, and marriage; and also for bookplates, for pious inscriptions to hang on the wall as "house blessings," for valentines, and for decorations in song books.

It is significant that Fraktur painting was taught in the schools of the Pennsylvania Germans. A great variety of Fraktur designs were used as specimens to be copied in conjunction with the learning of penmanship; some were awarded to children as prizes; some were made just to display the skill of the schoolmaster himself. The teaching of Fraktur painting continued until the 1850's, when the English school system was established. It is not difficult to see the great influence of the formal teaching of Fraktur. It added to the skill of workers in various practical arts, such as pottery, ironware, joinery, embroidery, box painting, etc., and at the same time it put at their disposal a whole repertoire of art motifs. In all such crafts, Fraktur designs were used again and again.

3

After the Civil War the increasing standardization of life, including the employment of methods of mass production, put an end to the continuity of most folk art in American life. But the old craftsmen had scarcely passed from the scene before some of their descendants began to regret the loss of the knowledge and skill of which the treasured evidences still adorned their homes, alongside the products of the modern age. Gone were most of the old hardships and inconveniences, and a good thing too; but was it inevitable, people began to ask, to abandon arts which satisfy the inner need to create things of beauty with one's own hands? Some of them answered the query by setting to work reverently and painstakingly to revive the practice of the arts of their forefathers.

And so, after this brief glance at the past, we will turn to the means by which we too may recapture and enjoy the forms of American folk art with which this book deals.

2

Materials and How to Care for Them

To begin with, we must have a list of those things which will be necessary in our work. Here is the list, together with instructions for the care of the materials, and (at the end of the chapter) the names of some recommended suppliers:

Tube Colors. (a) Japan Colors in tubes of Vermilion (light), Chrome Green (light), Chrome Yellow (medium), and Lamp Black.

(b) Artists' Oil Colors in small tubes of Alizarin Crimson, Prussian Blue, Burnt Sienna, Burnt Umber, Raw Umber, Yellow Ochre, and Indian Yellow or Yellow Lake; also a medium-sized tube of Titanium White or Superba White. Note that the Alizarin Crimson, Prussian Blue, Indian Yellow, and Yellow Lake differ from the others because they are transparent colors.

The Japan colors were originally ground in Japan and were used in the Western world by the old-time coach painters. They are opaque and, when dry, give a flat, smooth surface. The tubes in which the paint comes should be handled carefully, since they crack easily. When that happens the paint soon dries and is useless. When not in use the tubes should be left standing upside down, that is, with the cap at the bottom. Because the paint oil will rise in the tube, this position tends to keep the oil mixed with the pigment, and avoids oil running out when you squeeze the tube for use. A tin can makes a good tube holder. See Plate 1.

Keep the caps screwed on all tubes when they are not in actual use. If a cap sticks, don't try to unscrew it by using force which would twist the tube. Instead, hold the cap, for a few seconds only, in the flame of a match. The warmth will cause the cap to expand, and using a cloth to protect your fingers, you can then unscrew it.

5

If paint does not emerge from the opening of tube when you try to squeeze some out, do not apply so much pressure that the tube itself splits. Probably some dried paint is clogging the opening, and this can be lifted out with a narrow knife blade.

Varnish. Varnish is used as a medium for mixing tube colors in the painting of designs, and for the finishing coats on a decorated piece.

Varnish should never be stirred. The half pint size is handiest. So long as the can has not been opened, the contents will keep in a perfect state. On contact with the air, the spirits begin to evaporate, and once the varnish shows signs of definite thickening, it should not be used. Since varnish cannot be salvaged, proper care should be taken from the first to ensure that no needless waste occurs. It is obvious that the cover should be kept on the can when the varnish is not in use. Be sure, however, that the cover is on *tightly*—step on it to make quite sure. When about one-third of the varnish has been used, it is a good plan to pour the remainder into small bottles which can be filled to the top and covered with good screw caps. The idea is to expose the varnish to as little air as possible. Even though it is tightly covered, the air, even in a one-third empty can, will thicken the varnish.

Primer. A high-grade metal primer paint which dries smooth and thus requires very little sandpapering should be used. It should be stirred thoroughly before use.

When you have finished using the paint, wipe off any excess paint in the rim of the can with a cloth. Then pour a little turpentine on top of the paint in the can, just enough to cover the surface, letting it float there. The turpentine will prevent a skin forming on the surface of the paint. Then replace the can lid and press it down tightly. The next time you open the can, simply mix the turpentine in with the paint, and it will probably thin it just enough for use.

Background Paints. For flat black background painting, I have for some years used Sapolin. Other high-quality flat black paints which are well spoken of include those of Sherwin Williams.

For flat background colors, see Chapter 6 (How to Mix Background Colors).

Black Drawing Ink.
Crow-quill Pen. A fine-pointed pen.
Drawing Pencils. H, 2H, and 4H.
Decorator's Masking Tape. One roll.

6

Frosted Acetate. One roll, medium weight. This is a transparent plastic sheet, one side of which is slightly frosted so that it will take paint. Its transparency enables one directly to copy a pattern placed under the acetate sheet, without having first to trace an outline.

Tracing Paper. One roll 21 inches wide, thin and very transparent.

Brushes. (a) For applying coats of varnish and background paints, ordinary one-inch flat bristle brushes as sold for a small price in paint stores can be used. Some decorators, however, prefer to use better-quality brushes for this work, and find them worth the extra cost. In any event, it is of the first importance to keep the brush in perfect condition.

To clean a flat bristle brush, first wipe it off thoroughly on newspaper. Then douse it up and down in turpentine, and let it stand for 15 minutes in enough of the fluid to cover the hairs. (This turpentine can be kept in a screw-top jar and used several times over.) Then wash the brush thoroughly in warm (not hot) water, and rinse well. Shake out surplus water, and shape the brush carefully. Stand it up on the handle in a jar where it can dry undisturbed.

If you intend to use a *paint* brush again the next day, it need not be cleaned, but may be left standing overnight in turpentine or in plain water, provided there is enough liquid in the jar to cover the hairs and provided the brush is suspended so that it does not rest on the hairs. A *varnish* brush, however, must be cleaned each time it is used.

(b) For painting designs we require these more specialized types of brushes: (1) *Square-tipped ox-hair rigger or showcard brushes #5 or 6* in certain makes (but not in all, so consult the actual-size drawings of this and the following brush given in Plate 1). The hairs should be $5/8$ to $3/4$ inch long. Buy two for convenience. (2) *Square-tipped camel's hair quill brushes, #0 and #1* in some makes. Hairs should be $3/4$ inch long. (3) *Striper.* This is a square-tipped quill brush with hairs about $1\frac{1}{2}$ inches long, and about the thickness of a #1 quill. It is used without a handle.

To clean these smaller brushes, wipe them gently with a cloth, and then douse them up and down in Carbona Cleaning Fluid or carbon tetrachloride. Let them stand in the fluid about 15 minutes, so that any paint that has worked up into the ferrule is dissolved. Then wash thoroughly in soap and water, and rinse. Shake out surplus water, shape the brush carefully, and stand the brushes on their handles in a jar undisturbed until they are dry.

7

It is only at the end of a painting session that you wash the brush in soap and water as described above, since you cannot paint properly with a brush that is still wet from water. Therefore, when you have finished painting in one color, and want to go on at once and paint in the next color, clean the brush thoroughly and promptly in Carbona only.

Cotton Rags. For wiping up paint or wiping brushes, cotton is best.

Plastic Wood.

Paint and Varnish Remover.

Shellac. This, like the two previous items, is obtainable in the paint stores. Always use fresh shellac. Shellac left over from previous jobs or shellac left standing in half-empty jars for a while should not be used. The shellac will probably not dry properly, but remain sticky, and then your only recourse is to remove it with the paint and varnish remover— a disagreeable and time-wasting job.

Turpentine. One quart. Give can a shake or two before using.

Steel Wool. #000. Buy it in a paint store.

Sandpaper. #000 or very fine.

Crude Oil. Pint bottle can be bought from paint store.

Trichloroethylene is a dry-cleaning fluid that may be used for making erasures either when painting patterns on frosted acetate or when decorating objects. One small can or bottle is enough, as a little on a cloth will do the job. But be sure to read the warning on the label. It seems to be the dry cleaning fluid least harmful to health, but even so use it only in a well-ventilated room, and very sparingly. Don't inhale the fumes and don't use it to remove spots of paint, etc., from your skin. For that use a little, very little, turpentine, or better, soap and water.

Powdered Pumice. 2-oz. size. Can be bought at a drug store or hardware store.

Magnesium Carbonate. 1-oz. cake, usually available at the larger drug stores.

Rusticide, or *Deoxidine.* For removing rust. Rusticide is sometimes procurable in hardware or paint stores.

Bottle Caps. Start saving bottle caps about one inch in diameter and ½ inch high—for example, those that come on catsup bottles. Bottle caps make convenient-sized receptacles for varnish used in painting designs.

Empty Jars and Bottles. Collect some small jars or bottles, about 2 or 3 inches deep, with good, airtight screw tops. These will be needed for holding varnish and dry-cleaning fluid. Cold-cream jars and others of similar type are useful for holding the mixed background colors.

Newspapers. Always have plenty of newspapers on hand. You will need them to spread over your work tables, to wipe brushes, and to use as "palettes" in painting designs.

LIST OF SUPPLIERS

For a list of suppliers see *American Antique Decoration*, p. 7.

3

How to Use the Brush
in Painting Designs

What is the first thing you do in learning the art of decorating objects? Do you take a piece of furniture or tinware and go right to work on it? No! Experience has shown again and again that before you do that you must practice the brush strokes, and you must practice painting patterns. The former is done on paper, and the latter on sheets of frosted acetate (see p. 13). When you have learned in those ways how to handle the brushes, and how to apply color in the painting of designs, you will be better able to start on an actual object. You won't spoil the object, and you will be much happier about the result of your first piece of work than if you went at it without the previous practice.

Before starting the brush stroke practice, the necessary items must be assembled. The work must be done on a table which is not too high for you. A card table has a good height for most people. Protect the top with several sheets of newspaper. This table will be used for all our painting practice.

Take a double sheet of newspaper, and fold it into eighths so as to make a handy "palette." Newspaper is used because it has the advantage of absorbing superfluous oil in the paint. The other things you will need are these:

A small bottle-cap filled with varnish.

A tube of Japan Vermilion.

A square-tipped showcard brush for mixing.

A square-tipped camel's-hair quill brush for painting.

Some tracing paper.

A small jar half full of Carbona Cleaning Fluid for cleaning the brushes.

Some paint rags (cotton).

Brush Strokes in Plate 1

With the items just listed now available, you are ready to begin practicing the brush strokes. Place a piece of tracing paper over Plate 1. Squeeze out a little color on the newspaper palette, and dip out some varnish onto it with the showcard brush. With the showcard brush, mix the varnish with the color. The mixture should contain enough varnish to make it easily manageable, and yet it must not be so thin that it spreads once it has been painted. It should be thoroughly mixed, so that no lumps of paint remain.

Dip the quill brush into this mixture, and then work the brush back and forth once or twice on the palette to work the paint into the hairs. The object is to load the brush to its full length, and not just the tip of it. Avoid overloading—the brush should not be dripping or bulging with paint.

Now hold the brush as illustrated in Plate 1, that is, almost vertically, but with a very slight inclination towards you. The wrist should be off the surface, with the hand resting lightly on the tip of the little finger. Rest the forearm on the edge of the table.

Paint the broad stripe at the top of the Plate, as seen through the tracing paper. Observe how the brush flattens out to a knife-edge once it is lowered. Next, slowly raising the brush, pull it off and down to one side, using the knife-edge to end the stroke on a hairline.

Proceed to paint the rows of brush strokes in the illustration, starting at the broad end of each stroke, and gradually raising the brush to end on a hairline. Paint each stroke slowly and deliberately. If your stroke finishes too thick, either you had too much paint mixture on the brush or you did not raise the brush enough. Too much paint on the brush may also cause the strokes to spread a few minutes after you have painted them.

Except for very small strokes, reload the brush for each stroke, always reloading to the full length of the hairs. With practice you will learn to load the brush instinctively with just the right amount of paint for the size of stroke you desire. If the brush becomes so flattened that you get a stroke like the one marked X, turn the brush slightly, so that, as you put it down on the pattern, the hairs round themselves for the start of the stroke.

For a stroke that starts on a point and ends on a point, flatten the brush on the newspaper palette, and then, holding the brush high, begin the stroke; lower the brush to do the broad part of the stroke,

11

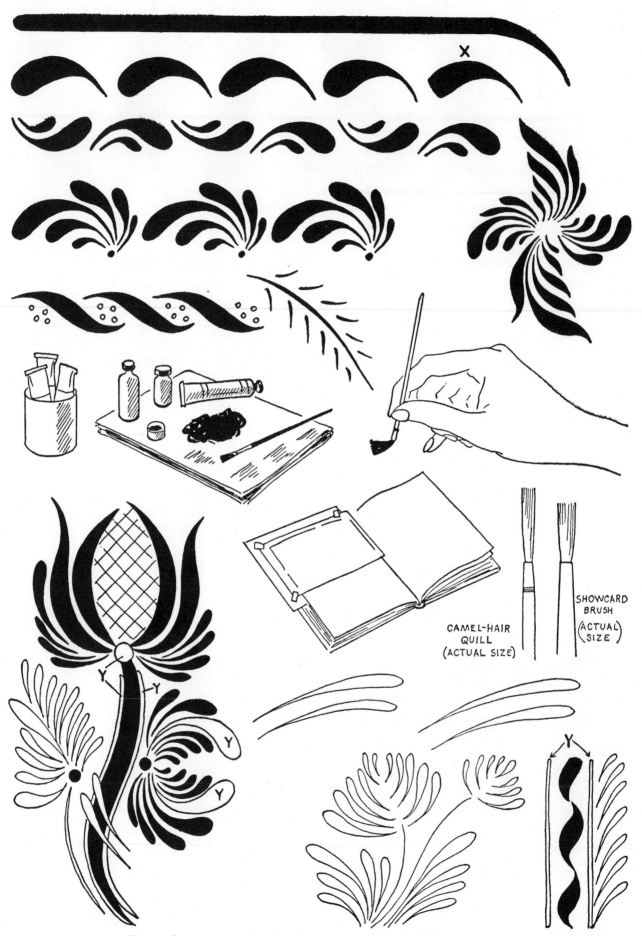

PLATE 1 BRUSH STROKE PRACTICE AND CEDAR WOOD BOX PATTERN

and finally lift it to complete the stroke. For a thin line or vein, flatten the brush on the newspaper and then paint with the knife-like edge. For a dot, round the brush on the newspaper, and then holding the brush high, paint the dot with the end of the brush.

Whenever the paint begins to thicken, clean the brush in Carbona Cleaning Fluid. Squeeze out a little fresh paint, and mix with varnish on another part of the newspaper.

Don't hesitate to turn your work round to any convenient angle that suits the particular stroke you are doing; rotate the work completely around if necessary. It is a good plan to use your left hand to shift the pattern about all the time, so as to suit the work to every new stroke you make; thus you will always be at a comfortable angle for each stroke. Patience and practice will do the rest. By practicing half an hour every day for a week or two, you should acquire a fair command of the brush.

Tea Caddy Pattern on Plate 2

To make a duplicate of the tea caddy pattern on Plate 2, cut a piece of frosted acetate large enough for the design, and attach it by three of its corners to a piece of thin cardboard. Use small pieces of decorator's tape to fasten the corners. Slip this contrivance into the book in the manner shown in the drawing on Plate 1. In this way, you will have brought the tea caddy pattern under the acetate. By painting the pattern directly on the acetate, you will get not merely a color record of it, but also valuable practice at the same time. The step-by-step procedure for painting the tea caddy pattern follows.

1. On a newspaper palette squeeze out a little Japan Vermilion. Using the showcard brush, dip several brushfuls of varnish out of the bottle-cap, and mix them with a small quantity of the color. Paint the large flower and the buds marked V, disregarding the overtone strokes. The paint should be opaque, but yet contain sufficient varnish for it to dry smooth and flat. Clean the brush by wiping off the excess paint on a rag, and then dipping it in Carbona.

2. Squeeze out a little Japan Green and a tiny bit of Burnt Umber. With the showcard brush, mix some Green, adding a speck of Burnt Umber to tone down the Green a little. With this "country green" mixture, paint those "leaves" which are shown black in the illustration, using your quill brush for this purpose.

13

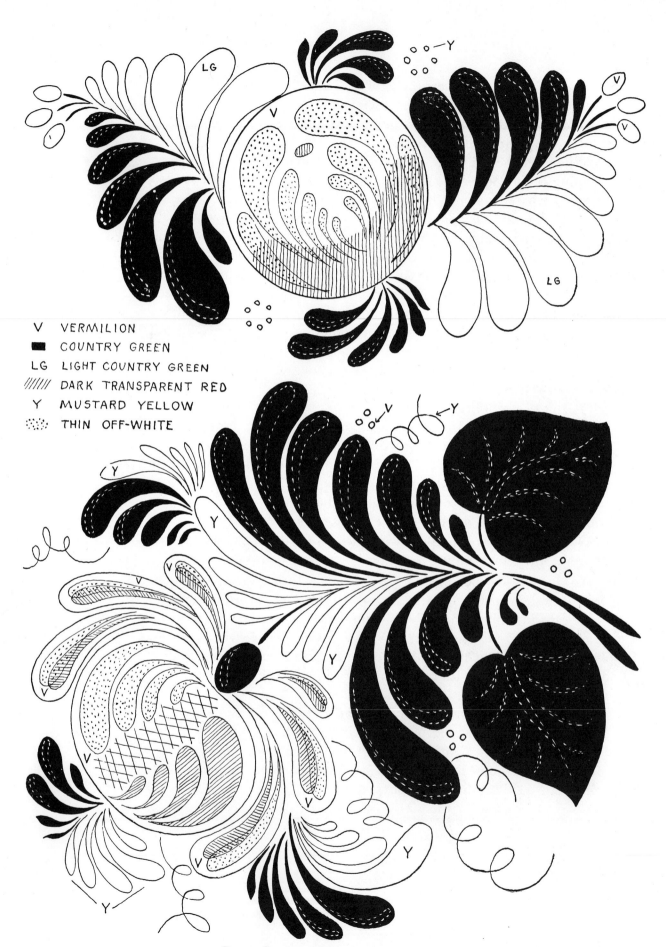

V VERMILION
■ COUNTRY GREEN
LG LIGHT COUNTRY GREEN
///// DARK TRANSPARENT RED
Y MUSTARD YELLOW
⋯⋯ THIN OFF-WHITE

PLATE 2 TEA CADDY AND COFFEE POT

3. Squeeze out a little Japan Yellow and add a touch of it to the green mixture, making a much lighter and yellower green. With this mixture, paint the leaves, which are shown white in the illustration. Remove the cardboard and acetate from the book, and set it aside to dry for 24 hours.

4. To paint the shaded and dotted overtones on the vermilion flower, do not put the acetate back over the illustration. These are done by eye, using the illustration as a guide. On a clean palette mix several brushfuls of varnish with a little Alizarin Crimson and a touch of Burnt Umber, making a rich, dark, semi-transparent red. With this mixture, and using the showcard brush, paint in the line-shaded area on the flower. Only one or two broad strokes should be used. Don't fuss over it. Do it once and leave it.

Immediately that this is done, take a camel's-hair quill brush, dip it in the varnish, and wipe off some of the varnish on the newspaper palette, at the same time flattening the brush. Now, with one stroke, draw the flattened brush along the inner edge of the dark overtone, with the brush partly on the red and partly off. This will blend and soften the edge of the dark red, giving the flower a softly shaded look. If you don't get it just right the first time, you may *immediately* wipe it off with a clean cotton cloth; possibly a little clean Carbona on the cloth may be necessary. But the wiping must be done at once, before the color sets.

If you use too much varnish on the blending brush, it will spread and disturb the smooth appearance of the dark red. Practice tells you just how much to use each time. While you are using the dark red color, do not overlook the large oval dot.

Proceed to mix some Japan Yellow with a little Burnt Umber, making a rich mustard yellow, and with this paint the dots arranged in rings. Add more varnish to the mustard, to make it semi-transparent, and paint the strokes on the green leaves indicated by the dotted white lines. Wait 24 hours.

5. For the dotted overtone strokes, mix some varnish with a little White, and add a touch of Raw Umber to make a semi-transparent off-white overtone. Where this is painted on the vermilion flower, it will take on a fairly pinkish tone. Set aside to dry for 24 hours.

The background color on the original tea caddy was a dark brown asphaltum. But black makes just as suitable a background, and is much easier to do. The use of asphaltum backgrounds need not occupy us at this point (being described later at p. 26).

15

Coffee Pot Pattern on Plate 2

This pattern is very like the one described above, but the leaf strokes shown white in the drawing are to be painted in mustard yellow. The crosshatching and the curlicues also are to be done in mustard yellow. To do the crosshatching, pick up very little paint on the quill brush, flatten the brush on the newspaper, and paint the lines with the knife-like edge thus obtained. Curlicues are best done with a smaller quill brush (#0), using very little paint on the brush, and holding the brush high to paint with just the tip of the hairs. It takes a fair amount of practice to do these well. The dots are in vermilion. The original background was asphaltum.

Important Note

Before proceeding to describe the painting of the next pattern it may be well to repeat the important rule which applies to all our painting work: Let one color dry thoroughly before painting another color over it. The minimum drying time is always 24 hours.

Cedar Wood Box on Plate 1

1. Squeeze out a little Prussian Blue, some Raw Umber, and some White. Mix these together to get a rather dark blue, bearing in mind that Prussian Blue is a powerful color, and that a little of it goes a long way. Also be careful not to add too much Umber, since that would make the color muddy-looking, instead of the rich, soft blue we are seeking. With this blue, paint all those parts of the design which are black in the illustration. Wait 24 hours.

2. Squeeze out a little Japan Yellow, a little Raw Umber, and a touch of White. Mix these to form a pale mustard yellow. Paint those parts of the design marked Y. Wait 24 hours.

3. Mix White with a touch of Raw Umber to get off-white, and paint the remaining parts of the design.

This design was taken from a natural color cedarwood Trinket Box. At a later stage in the work, if you should wish to decorate a box with this design, you may reproduce the color of the original background by mixing White, Burnt Umber, and a touch of Yellow Ochre.

16

Additional Practice

At this point, you will probably have begun to realize how valuable and enjoyable your practice in painting designs can be. So for more practice, turn to one or more of these Plates: 7, 8, 13, 23, 27, 28, 29, 31. Any or all of these may be copied at this stage with the assurance that you are making yourself more skillful with the brush all the time.

Preserving Patterns

When a pattern is completed and thoroughly dry, mount it on a piece of thin cardboard or heavy paper, if possible of the same color as the background of the original. The mounting is done by attaching the pattern at the corners with bits of cellophane tape, and the face of the pattern is protected by a wax-paper flap. Keep the patterns in a folder for future reference.

Color Key for Painted Patterns

Throughout this book we shall be dealing with colors and how to obtain them. Here then is a convenient key to the colors we shall be using. They are more or less standard colors in American antique designs and are arranged in groups for easier reference—the reds, the greens, the blues, the browns, yellow, and off-white. Rarely do we use bright color fresh from the tube. Indeed, with the exception of Vermilion, all the bright colors must be toned down by the addition of Yellow Ochre or one of the browns in order to obtain those beautiful, soft, antique shades that are so admired. Opposite each color in the list below are the tube colors by which it is obtained. Mix the colors with the showcard brush, using varnish as the medium. Of course, the colors must be mixed completely, so that no lumps of pigment remain.

Prefixed to each color is the letter or combination of letters by which it is indicated in the black-and-white drawings.

V	bright red	Japan Vermilion.
S	salmon pink	Japan Vermilion, Yellow Ochre, and a touch of White.
P	pale pink	As for salmon pink, but with more White added.
A	dark red overtone	Alizarin Crimson, with a touch of Burnt Umber and enough varnish to make a semi-transparent rich dark red.

17

G	country green	Japan Green, with a touch of Burnt Umber.
LG	light green	Japan Green with a little Japan Yellow, and a touch of Burnt Umber.
DG	dark country green	Japan Green, a touch of Raw Umber and Prussian Blue.
OG	olive green	Japan Green with a little Burnt Sienna.
YG	yellow green	Japan Yellow, a little Japan Green, and a touch of Raw Umber.
B	medium blue	Prussian Blue, with a little Raw Umber and White.
LB	light blue	White with a little Prussian Blue and Raw Umber.
DB	dark blue	Prussian Blue, with Raw Umber and a touch of White.
RU	dark brown	Raw Umber.
BU	medium brown	Burnt Umber.
BS	reddish brown	Burnt Sienna.
Y	mustard yellow	Japan Yellow, with Burnt Umber added a little at a time until you get the color you want. For a greenish mustard, use Raw Umber. For an orange mustard, use Burnt Sienna.
W	off-white	White with a touch of Raw Umber. For white overtones, use enough varnish to make the mixture semi-transparent.

Transparent Color Mixtures

From time to time, transparent and semi-transparent colors, or "overtones," are mentioned in the pages which follow. These are simply colors sufficiently thinned with varnish for a hint of the color underneath to show through. The degree of transparency will naturally vary according to the quantity of varnish. It is usually best to start with several brushfuls of varnish, adding a very little pigment at a time until you reach the proper consistency.

4

How to Prepare Wood for Decoration

It is wise to begin the work of decorating actual objects by choosing an article made of wood. Few jobs undertaken by the amateur crafts-man give more delight and pride than converting a discarded, perhaps unattractive, piece of furniture into a thing of beauty by using one of our folk art patterns. An old chair, a coffee table, a chest of drawers, a wooden floor lamp, a tray, a box—these are some of the many articles which the folk artist transforms in ways that add new charm and individuality to the home.

Old Wood

To prepare old wood for decoration, proceed as follows:

1. Remove all old paint and varnish with any good brand of paint and varnish remover. Make a thorough job of it, because the prep-aration of a painting surface is as important as the decoration itself. Follow the directions on the can, and have plenty of old rags and news-papers at hand. Work with the windows open to prevent harmful inhalation of the fumes.

2. Fill in all holes and cracks with plastic wood. Let it dry.

3. Smooth the surface by sandpapering the flat parts and rubbing the rounded parts with steel wool.

4. You are now ready for the first background coat of paint. Spread out plenty of newspapers on your worktable.

Flat Background Painting

A properly painted background, whether black or any color, should be a completely flat or dull surface, feeling smooth and free from ridges when the hand is run over it. If you can feel any ridges, your paint was

19

not sufficiently thinned with turpentine. To smooth the surface by sandpapering may take a great deal of time and hard work; therefore, if you apply the paint correctly in the first place, you will save yourself much trouble. With this preliminary word of caution in mind, the following directions should be studied and carefully followed.

The paint should be thinned with enough turpentine to make a very watery mixture. Usually there is not enough room in a fresh can of paint for the necessary amount of turpentine to thin the paint properly. Procure a small empty jar, and pour into it about a quarter of an inch of turpentine. After stirring the black paint in the can until it is thoroughly mixed, dip out one or two brushfuls, and add them to the turpentine in the jar. Mix with the brush. The resulting mixture should be quite thin and watery. Important: give the turpentine can a shake or two before using.

Before applying the paint, examine the object to be painted and decide which part you will paint first, which next, and so on. Also, find out how you will hold the object during the painting. Be sure to leave one part unpainted on which the object can rest while drying, and prepare the place beforehand on which you will set the object to dry. Think all this out *before* you apply the paint.

After dusting off the surface, apply the paint in long even strokes. Don't flood the paint on. Use just enough to cover the surface. Because of the thinner in the paint, the first coat will not cover the surface completely; but don't go back and retouch any part of it. Paint it and leave it. Check around the edges for any dripping. Allow 24 hours for drying.

When applying the second coat, paint any large areas in the opposite direction to the first coat, that is, apply the second coat crosswise. This method achieves an even result. The object should have at least three coats, preferably four. Never apply a second or later coat until the preceding one has dried for at least 24 hours and until it feels thoroughly dry.

Allow the final coat of paint to harden at least a week before doing a design on it. (A longer period of waiting, such as a month, is recommended, especially for the light or colored backgrounds you will do later on. It will be safer to make corrections with cleaning fluid on a completely hardened background). The waiting period can be usefully occupied by further practice with the brush, in painting patterns, or by preparing other pieces of furniture or household articles for decoration.

20

If you did a proper job of sandpapering and preparing the wood in the first place, and you have applied the paint as directed, you should now have a smooth, dull surface which needs no sanding.

If it is necessary, however, sandpaper the last coat *very lightly* with a square inch or so of fine sandpaper. A small piece can be controlled better than a large one. Avoid sandpapering edges and other "vulnerable" parts, by which is meant parts where the sandpaper would take the paint off altogether.

New Wood

In the case of new wood, the process of preparation is as follows:

1. Sandpaper well, first using fairly coarse paper, and then the finer kind. Use steel wool on the turned parts and on carving.

2. Fill in crevices with plastic wood. When it is dry, sandpaper again.

3. Apply a coat of shellac to seal the wood. Let it dry for 24 hours.

4. Sandpaper again.

5. Apply three or four coats of thin background paint in the way already described.

Mass Production

Fortunately, mass production in the usual sense of the term is not applicable to American folk art decoration! But I use the expression to convey an idea of the value of the economical use of time and effort. Practically never do I paint only one object at a time. By a little planning ahead you can generally arrange to carry several articles through the preparatory stages up to background painting. Then you can please yourself as to when you want to decorate them. Similarly, when the time comes to apply the finishing coats of varnish, it is very economical to wait until you have several pieces to do.

5

How to Prepare Tin
for Decoration

Removing Old Paint or Varnish

The first step in preparing a surface for decoration is to remove all old paint or varnish, for which purpose any good brand of paint and varnish remover will do. To reduce the chance of inhaling the fumes, work with the windows open. Read and follow the directions on the can, and have plenty of rags and old newspapers close at hand.

Removing Rust

All tinware should be treated for rust whether the latter is visible or not; for in its initial stage rust is invisible. For this purpose we may use Rusticide. Clean the surface first, removing any dirt and grease. Apply Rusticide with a one-inch bristle paint brush. Wait five minutes, and then go over the surface with steel wool. If the metal is badly rusted, use a second application and leave it on a little longer, making sure that sufficient Rusticide is on the surface to keep the rust wet and thus ensure penetration. Heavy accumulations of rust may require several applications and scrubbings with steel wool to remove the dissolved rust. Wipe off with a clean cloth. The metal should then be perfectly clean and sealed against fresh oxidation, thus providing an excellent base for the primer paint. Allow to dry overnight, and begin painting the next day. If it is necessary to paint immediately, wipe off the surface with alcohol. Although the surface will not immediately re-rust, it is advisable to apply paint with as little delay as possible.

22

Primer Painting

A tin surface must always be given one or two coats of primer paint (see Chapter 2) before the background color is applied, or the latter will not adhere properly. Spread plenty of newspapers on the table or other working surface, and be sure the primer paint has been thoroughly mixed.

The first coat of primer paint is usually not thinned, although it may be thinned a little if it seems too thick. Apply it as you would a background coat of paint. The second coat of primer may be thinned a little with turpentine. On large flat surfaces it should be applied in a crosswise direction to the first coat. When completely dry, go over the surface with sandpaper to remove any tiny "pinheads", and dust thoroughly.

The surface is now ready for the background coat of paint, which is applied in the way which has been described for wood surfaces in Chapter 4.

Note on Painting Trays

If you are painting a tray, rest it upside down on the palm of your left hand, and apply paint to the underside of the flange. Do *not* paint the bottom, since that is left unpainted to provide a resting place while the tray is drying. Next, turn the tray over, so as to rest the unpainted bottom on your left palm, and continue the painting in this order: first the outer edge of the tray, then the top of the flange, and finally the floor of the tray. Use long strokes, the full length of the tray's floor.

Only when all the other work on the tray has been completed, including the finishing coats of varnish, and the last rubbing down, is the bottom of the tray given one or two coats of black paint, nothing more. Occasionally, collectors and dealers in antiques do not want the bottom of a tray touched by paint because many of them can judge age and condition by careful examination of the unpainted bottoms of trays.

23

6

How to Mix
Background Colors

How to apply a flat background paint to a surface has already been described (Chapter 4), and here we shall deal with the mixing of colors for that purpose.

Before making use of any of the colored backgrounds, however, the beginner is advised to work for some time on a black background only. Corrections are not so noticeable on black, and black was often used by the old craftsmen.

Paints to Use

For background colors we generally use good-quality, flat indoor paints. Never use glossy enamels. Sapolin's Dull Black Enamel (see p. 6), among others, gives an excellent dull black surface when it is sufficiently thinned with turpentine. Always remember to mix paint thoroughly before using.

Most of our other background colors have to be obtained by mixing, and for this work we can use small screw-top jars, such as cold-cream jars. It is important when mixing a color to be sure there will be enough left over for touching up after the decoration has been completed. The closed jars serve to keep the colors fresh.

In mixing for a background color, mix the pigments first, and then add the turpentine to get the proper watery consistency. For this reason, mix a relatively small quantity of the pigment color, allowing for the fact that you will have a much larger quantity after the turpentine has been added.

Japan colors mixed with our artist's oil colors can be used for background colors. But for large areas this is expensive, and so we generally start with a can of flat paint nearest to the color we want,

adding tube colors to get the exact shade. Economy is also served by using for this purpose the less expensive tube oil colors, which can be procured in some of the larger paint stores.

Antique Black

To obtain antique black, put a little flat black in a clean jar, adding to it some Raw Umber and White. The best way to go about this is to squeeze a little of the two last-named pigments on to an old saucer, and to dissolve them by mixing in some of the black with a showcard brush or a palette knife. When no lumps remain, add the mixture to the jar of flat black, and stir well with a small stick. Test the color on a piece of paper, using the showcard brush. Keep mixing and adding until the proper shade has been reached. Antique black is really off-black, that is, a very dark, soft, charcoal color. It is very effective as a background for country patterns.

Brown

If the brown you buy needs to be modified it may be done by adding—

White to make it lighter,

Yellow to make it lighter and warmer,

A little Vermilion to make it lighter and still warmer,

Blue to make it darker and colder.

Light Colors

Use flat white paint as a base for all light colors, adding Japan or oil colors to get the desired color. Always allow for the darkening effect of the finishing coats of varnish and, of course, for any antiquing you may intend to do. Among the most used light background colors are these:

Off-White: White with a little Raw Umber added.

Cream: White with a little Yellow Ochre added.

Gray: White with a little Raw Umber added.

Tan: White with a little Burnt Umber added.

Medium Colors

Use the nearest available color in flat paint, and add the necessary tube colors as indicated below.

Antique Red: To get a lovely soft red, such as the background color

25

on the Foot Bath pattern in Color Plate IX, mix a flat red paint with Raw Umber, Chrome Yellow, and a little White. Avoid using Vermilion as it never mixes thoroughly with other pigments, making it almost impossible to get an even background color. Start with ordinary red, indoor, flat paint to reach the color you want.

Mustard Yellows: These are a group of beautiful colors, almost endless in their variations. The result depends on the kind of brown you add to yellow, whether it be Raw Umber, Burnt Umber, or Burnt Sienna, and also on the quantity of White you add, if any. The addition of Raw Umber to Chrome Yellow gives a greenish mustard color, varying with the amount added. Burnt Umber gives a warmer mustard, and Burnt Sienna a rich golden-orange mustard yellow.

Antique Blue: Blue was not used so much as the other colors in the old days, because blue was made from indigo which had be imported. A good antique blue can be made by mixing White and Raw Umber together, and then adding Prussian Blue. The latter is a powerful color, and a little of it goes a long way.

Asphaltum

A background which differs from the colors proper is "asphaltum," a mixture of asphaltum (or asphalt) and varnish. It is a semi-transparent background which was often used over bright tin, but it is difficult to apply satisfactorily. Old examples invariably show more or less streakiness, and therefore beginners need not be unduly discouraged by the results of their first attempts.

If the tin has darkened with age or use, no longer presenting a uniformly bright surface, apply a coat of clear varnish. When this is tacky, that is, not quite dry, apply aluminum or chrome powder with a piece of velvet, and then burnish it with the velvet. This will give a simulated shiny tin surface. After a wait of 24 hours, wash off all loose powder under running cold water, pat the surface thoroughly dry with a lintless cloth, and apply a coat of varnish to protect the surface. Let it dry for another 24 hours.

Asphaltum can be bought in a tube. It should be mixed in a saucer with varnish, to which is added a little each of Alizarin Crimson and of Burnt Umber. The quantity used of these oil colors determines the color of the asphaltum, and the quantity of varnish determines its transparency.

Apply the mixture with a varnish brush, working quickly. Do not

26

go back and retouch any part of it. If you have enough of the mixture on your brush as you apply it, the streakiness may disappear when the asphaltum settles. Use discarded tin cans to experiment with in applying the mixture, and find out what shade of background you like best. Asphaltum must be allowed to dry for at least a week.

7

How to Transfer a Design

When a freehand design is to be painted on a tray, chair, or other object, the design must be transferred to the painted surface of the object. To do this, a careful tracing of the design is made on tracing paper, including everything except the superimposed details, which can be added later by comparison with the original design. Use a well-sharpened H or 2H pencil to make the tracing.

In order to transfer the traced design to the object's surface, a form of carbon paper is necessary. Commercial carbon papers, being greasy, are quite unsuitable for this work. Consequently we make our own kinds of "carbon" papers, as described below, and keep them in hand for future use.

Homemade "Carbons"

A white "carbon" is required to transfer to dark backgrounds. Take a sheet of tracing paper, size about 6″ × 12″. Rub a cake of magnesium carbonate (see Chapter 2) over the surface; then rub the deposited powder well into the paper with your fingertips. Blow off the excess powder on the tracing paper. Fold the paper in half with the white powder on the inside of the fold. Put the folded paper under a book, or in a portfolio, so that some pressure is on it. Leave it there for a week, during which time the white powder will work into the surface of the tracing paper. A smaller white carbon, about 4″ × 8″, is desirable for smaller jobs.

A dark "carbon" for transfers to light or medium backgrounds is made by penciling a sheet of tracing paper with the flat side of the point of an H or 2H pencil. Do *not* use a soft smudgy pencil. This time there is no need to use the fingers, and the carbon paper thus made can be used immediately without any waiting period.

28

Transferring to a Dark Background

Place your pencil tracing of the design in position on the surface to be decorated, making sure the design is *exactly* where you want it to be. (Consider this point very carefully, not only looking at the tracing, but consulting also your finished copy of the pattern on frosted acetate. Once the design has been painted, if a careless placing shows up, it is often impossible to correct it without doing all the work over again).

Secure the tracing to the surface with 2 or 3 tiny pieces of masking tape, so placed that you can slide your white carbon paper, white side down, underneath the tracing without disturbing the tape.

Then proceed to retrace the design with a well-sharpened 3H pencil. Move the carbon along when and if necessary to keep it under the pencil point. When you have finished retracing, and have removed the tracing paper and carbon, you will find a white outline of the pattern left on the object. Then you proceed to paint the pattern as you did on your acetate copy.

Transferring to a Light Background

Proceed as for a dark background, using your pencil "carbon" paper instead of the white one.

8

How to Stripe

There are some old decorated pieces which have no stripes, but it is correct to say that most of them do include some striping. Nothing will help to give a "professional" touch to your work more than a well-executed bit of striping. It is most desirable, therefore, that you should learn how to paint a stripe.

At first, this may seem difficult, but the fact is that striping is easily learned, given a certain amount of practice. Practice steadies the hand, and you soon gain facility in the use of the brush.

The proper brush for striping is a square-tipped, camel's-hair, or badger hair, quill brush, with hairs about 1½ inches long, and about #1 in thickness. The brush is used without a handle, and in the act of striping, the brush is always pulled towards you. (See Plate 6).

Begin by half filling a bottle cap with varnish. Using a showcard brush, mix in with the varnish a little Japan Yellow and a touch of Burnt Umber, until the color is a fairly deep mustard yellow. With the brush, lift out some of the mixture on the newspaper palette. Dip the striper into the mixture on the palette, moderately loading it the full length of the hairs. Pull it back and forth on the newspaper to get the feel of the brush.

Practice striping first on a piece of paper, always pulling the striper towards you. The stripe should be about ⅛ inch wide. To get a narrower stripe, flatten the brush on the newspaper palette by pulling it back and forth a few times, and then stripe with the thin edge of the brush.

Some of the old chairs, trays, etc., have opaque stripes, while others have stripes which are semi-transparent. In the former instance, less varnish is used in the mixture in proportion to the paint; in the latter, more varnish.

30

The student may find it helpful to practice striping on a raw tray, and thus get the feel of working on an object. The paint can easily be cleaned off with turpentine. With a striper adequately loaded with paint, you should be able to stripe one side of a tray without replenishing the brush.

In striping a rectangular shape, such as a chair slat, do not try to make two stripes meet in a perfect angle. Instead, carry the stripes across one another and on to the ends of the area. This done, *immediately* clean off the bits of striping outside the intersection by wiping with a clean cloth. Or touch up with background paint when dry.

Striping is best done on a glossy or varnished surface that is thoroughly dry. As will be described in the next chapter, after a decoration is completed, the object is given several finishing coats of varnish. Where there is striping, however, one such coat should be put on before the striping is done, and should be allowed to dry for 24 hours. After the striping, the finishing coats of varnish are applied. The glossy surface keeps the stripe from "fuzzing" at the edges, and also facilitates corrections. These adjustments must be done at once, if you use either a clean cloth or a cloth and a little turpentine to wipe away surplus. Another, and often easier, way to make corrections is to wait until the stripe is thoroughly dry, and then to touch it up with the background paint. This, of course, means waiting until the next day.

For a very broad band or stripe, outline the stripe, and then fill it in.

In all striping work we must keep in mind that while its function is to enhance the appearance of the decoration as a whole, it should never be so prominent as to distract the eye away from the main decoration. So keep the stripes from getting too wide. Usually they should not exceed one-eighth of an inch in width on the largest objects. You will notice, however, that the old decorators did sometimes make effective use of broad striping. Our striping in red, green, blue, or yellow may be subdued by adding one of the browns (oil colors); quite a lot being added in the case of yellow.

9

The Final Stages

Varnishing

To protect a decorated object from wear and tear, and also to give it the satin smooth finish characteristic of an old piece, we apply at least six coats of varnish after the decoration has been completed. On trays and table tops (for which a heatproof and alcohol-resistant surface is always desirable) the last two coats should be of Super Valspar varnish, procurable in most paint stores.

Antiquing

Some of the coats of varnish may be toned with oil pigments to give an antique color, and this process we call antiquing. The varnish so tinted must remain completely transparent, and therefore only a very little color should be used. Otherwise unsightly streaks will appear on the decorated surface. For most purposes we use Burnt Umber or Raw Umber, but Indian Yellow, Black, or Prussian Blue are occasionally used. Antiquing is generally done with the first coat, or the first two or three coats, depending·on the depth of color you want. Since most beginners tend to over-antique, it is a good thing to act on the principle that a little antiquing goes a long way.

Conditions Necessary for Varnishing

It is important to do all varnishing in an atmosphere free from dust. Clean the room first, and allow the dust to settle. Close the windows, and while the varnish is drying keep traffic away from the room for the first three or four hours.

Varnish should be applied in a warm room, one in which the temperature is 70 degrees or more. The varnish itself should be at least that warm, and so should the object to be varnished. To achieve this, let them both stand in the room for some time before the varnishing is

32

begun. They may be placed near a radiator to raise their temperature a little. Varnish applied to a cold surface or in a cold room will "crawl" —that is, will tend to separate, leaving bare places—and "ridge."

How to Proceed—First Day

Taking a tin tray as our example, we will now go step by step through the procedure of varnishing, antiquing, and the other processes of finishing.

Before you open the can of varnish, assemble the necessary equipment, which consists of plenty of newspapers, the varnish brush, paint rags, and the "brush bath," a jar half full of turpentine for cleaning the brush. Flick the dry brush to get rid of any lose hairs or dust particles.

Dust the tray carefully, and place it on clean newspapers. Decide where to put the tray to dry after it has been varnished, and spread newspapers there. Place a can or other firmly set stand on which the wet tray may finally be rested approximately in the center of the spread newspapers. Just before beginning to varnish, wipe the tray again, this time with the palm of your hand, so as to remove any remaining lint or dust particles, especially from the corners. Now you are ready.

On a clean newspaper palette squeeze out a little Burnt Umber. (We are assuming that antiquing is desired—if it is not, of course, you omit the Burnt Umber.) Using your one-inch varnish brush, dip out four or five brushfuls of varnish, and mix with them on the palette a touch of Burnt Umber. Try it out on a clean piece of paper to test the color, which should not be much darker than the clear varnish itself. Work quickly because varnish thickens on contact with the air.

If it is the right color—that is, a very pale brown—start to varnish the tray at once. Support the tray on the palm of your left hand. First do the underside of the flange, then the edge, then the top side of the flange, and finally the floor. (Refer back to the last paragraph of Chapter 5, where the method of holding a tray while painting it is described.) Don't flood the varnish on, as that will only cause the excess to run down and settle in the corners, where it cannot dry properly. Spread the varnish out, and work with the light falling across your work, so as to enable you to see that every bit of surface is being covered. Work quickly and surely, taking more varnish only as you need it, but never flooding the surface. Then, without taking any more varnish unless it is absolutely necessary, use the brush in a crosswise direction to ensure an even distribution. If it becomes necessary to mix more

varnish and Burnt Umber as you work, do it as rapidly as possible, but keep a sharp watch lest any brown streaks appear; that would mean that you have added too much color to the varnish.

When everything is covered, examine the work, and with a very light touch, using only the tip of the brush, pick up any tiny bubbles or any brush hairs which may be on the surface. Last of all, hold the tray high, and pick up with the brush any varnish drippings from the underside. Set the tray down on the prepared stand, and leave it to dry for 24 hours.

Second Day

Dust off the tray, and apply the second coat of varnish, adding a touch of Burnt Umber if you want a darker color. Dry for 24 hours.

Third Day

Dust off, and apply the third coat of varnish. Dry for 24 hours.

Fourth Day

Cut some *very fine* sandpaper into 1½ by 3½ inch pieces, and fold them in half, with the sand outside. Sandpaper the surface with these small pieces. Starting on the floor of the tray, sandpaper diagonally, first from upper left to lower right, and next from upper right to lower left. Work on small sections in turn. When one hand is tired, use the other, and by thus changing back and forth you will save time and not become fatigued.

Although sandpapering has to be thorough, you must be careful not to do it too long or to press too hard, or you might go right through the coats of varnish. Once the floor of the tray has been sanded, do the flanges, keeping away from the edges, where the sandpaper can very easily take off both varnish and paint. Naturally, this caution must be observed in dealing with any kind of object, large or small.

After the sanding is completed, dust off the tray. If any sand particles are stuck in the corners, it shows you used too much varnish previously, with the result that it could not dry properly. In this event, you will have to wait another 24 hours for the varnish to dry, after which the corners may be sanded out.

Apply the fourth coat of varnish, and allow it to dry for 24 hours.

34

Fifth Day

Sandpaper the surface as described above. Dust off thoroughly. Apply a coat of Super Valspar varnish (in the case of trays and table tops, otherwise ordinary varnish again). This is a heavier varnish than the previous coats, so that you must work quickly and vigorously to brush it all over the surface before it starts to set. Let it dry for 24 hours.

Sixth Day

Instead of sandpaper, use steel wool #000, rubbing on the diagonal again. In dusting off, be sure to get all the remnants of steel wool out of the corners. Apply another coat of Super Valspar (or ordinary varnish where appropriate), and let it dry for 48 hours.

Final Rubbing

In an old saucer, place about a teaspoonful of powdered pumice. Take a soft cotton flannel cloth, and put a little crude oil on it. Dip the oiled cloth into the pumice, and begin to rub a small section of the tray, a few square inches at a time. There is no need to rub long, for the high gloss of the varnish comes off immediately. If you rub too much, you will give the tray a dull, lifeless finish, whereas the proper effect is that of a satiny gleam. This is achieved very quickly, and without strenuous effort. Use enough crude oil to keep the rubbing moist.

When you have gone over the whole tray, rub off the remains of the oil and pumice with a clean flannelette cloth, and let the surface dry. In about fifteen minutes inspect the surface, and if any bright glossy spots are visible, give them a rubbing as before. Wipe off again with a clean cloth. This satiny finish needs no furniture polish to preserve it. All it needs is the application now and then of a damp cloth.

10

How to Make Designs Larger or Smaller

Enlarging or reducing a design is a simple, almost mechanical process, the successive steps of which are given below. We may conveniently take the small flower in Plate 3 to illustrate enlarging.

To Enlarge a Design

1. Trace the flower (or whatever else you may choose to enlarge) on the upper left-hand corner of a piece of tracing paper large enough to contain also the enlarged size you want.

2. Draw a rectangle around the flower which will just box it in and touch it on all four sides. Use a small right-angle triangle or a postcard to get right angles at all the corners. Draw with a well-sharpened 2H pencil.

3. Extend the right-hand side of the rectangle downwards several inches, and extend the bottom line several inches out to the right.

4. Using a ruler, draw a line diagonally from the upper left-hand corner to the lower right one and beyond, as in the illustration.

5. Measure either the width or the height of the larger size that you want, and complete the larger rectangle. Use the triangle or the postcard to get right angles at the corners, and be sure the diagonal already drawn passes through the lower right-hand corner. This ensures that the enlarged size will be in the same proportion as the original.

6. With the ruler, divide the sides of the smaller rectangle in half, then in quarters, and then in eighths. Do the same with the larger rectangle. If the design is more complicated than our present example, divide the sides into sixteenths or even thirty-seconds.

7. Rule in the lines and number them as shown in the illustration.

36

8. You will observe that the outline of the smaller flower is crossed by the dividing lines at certain points in the little square. Where these points occur, place a dot in the corresponding place in the larger square. Watch the numbers to be sure you are in the corresponding square each time. When all the dots are in, join them up with lines of the same character as those in the original.

9. If the finished flower looks a little stiff, put a fresh piece of tracing paper over it, and retrace it. While doing this you have an opportunity to improve the drawing.

To Reduce a Design

Proceed in the same way as for enlarging, but this time when extending the bottom and right-hand sides of the rectangle you will, of course, make a *smaller* rectangle, corresponding to the size of the reduction you need. (By turning Plate 3 upside down you can see how the two rectangles should look for reducing purposes.)

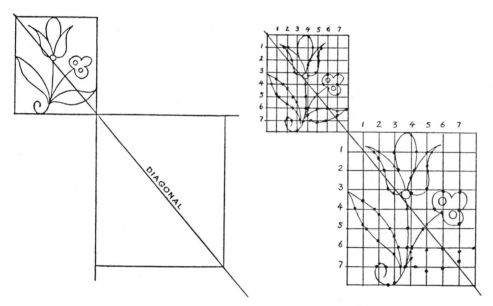

PLATE 3 ENLARGING AND REDUCING A DESIGN

11

How to Use and
Adapt Designs

If you are decorating objects which are reproductions of old pieces, it is particularly important to use appropriate designs. For example, use a wooden box design on a wooden box, and a country tin design on a piece of tinware. Make a habit of studying old pieces so that you will know what is appropriate.

If you are decorating modern pieces with these old folk patterns, I can think of no sound objection to allowing oneself a somewhat greater freedom in the choice of a design to be used. Good taste, however, must be our guiding principle.

You may be a trained artist and have thus taken some pains to cultivate good taste, but unless you are, it would be unsafe to assume that you were born with it ready-made. Few people are, but fortunately most people can develop it. So let us all be a little humble in this matter, and take every opportunity to improve our appreciation of decorative art. Visit museums to study the old pieces, noting how they were decorated, how much space was left around the designs, how the colors were combined, and so on. Take notes, and make little rough sketches as the professionals do. If no museums are handy, study old pieces in houses where you may visit, or in the windows of antique shops. In the latter case you may find it more discreet to make only mental notes on the spot.

In this book nothing has been said in the way of instruction in the restoring of painted decorations on old pieces, because this is a book chiefly for those who are starting to learn to decorate. At this stage no one should attempt restorations, but should wait until a good deal of experience has been acquired. Old pieces, of whatever nature, are valuable from more than one point of view, and we should not risk

38

ruining them. If, however, you are an experienced decorator and want information on the restoration of old pieces, you may find it helpful to refer to the chapter on "Restoring Decorated Articles" in my earlier book, *American Antique Decoration*.

Naturally, there are times when we have to enlarge or reduce designs to fit the available space. But do not carry this to great extremes. Thus if you need a large design, do not enlarge a very small one, but choose one nearer in size to what you want.

If the proportions of a design need to be adapted, if for instance you want a design to be a little longer but not at the same time any wider, proceed as follows: First mark out on a sheet of tracing paper the area you want to fill. Put this tracing over the original pattern, and proceed to make a revised drawing of the pattern according to your needs. You move the tracing paper so that the different parts of the design will appear where you want them. When you are working in a larger area, you may find it desirable to enlarge or multiply some parts. For example, a central flower or fruit may be expanded in size, or two small leaves may be increased to three. Similarly for smaller areas, parts may be reduced or omitted altogether. Such changes are made by the eye, and judgment is used to preserve balance and good proportion in the whole design. Generally speaking, adaptations should aim at keeping an original design as little changed as possible.

In our resolution to exercise good taste, we include two "don'ts" which it should not be difficult to follow. One is, don't *over*-decorate by crowding in every possible thing. And the other is, of course, don't go to the opposite extreme and put some mousy little design on a huge piece of furniture!

12

Reverse Painting on Glass

Paintings on glass were used to adorn many of the old mirrors and clocks. These decorative paintings were done on the back of the glass panel in *reverse,* so that the correct picture or design was seen through the glass from the front. The detail was therefore painted first, and the sky or background last. Various subjects were used, including landscapes, buildings, seascapes, ships, fruits, flowers, figures, portraits, and formal designs; in fact, reverse paintings were made of almost any subject that might appeal to the craftsman's or his customer's fancy. Some of the paintings were crudely done; others reflect the skill of an experienced artist.

The glass pattern shown in line in Plate 4 was taken from an old mirror. Old glass paintings were done on very thin glass, so when you come to do one, use a piece of thin glass. But before that you should do a practice copy.

How to Copy a Pattern

To copy the pattern in Plate 4 follow the detailed steps given below. Of course, you will use a piece of frosted acetate for this preliminary practice.

1. Make a pencil tracing of the pattern on tracing paper. Put it face down on a white cardboard, and secure it at the corners with masking tape. This gives you the pattern in reverse. Note that the drawing in Plate 4 is given to you just as I traced it from the old mirror, and has *not* been reversed.

2. Place a piece of frosted acetate over your reversed tracing, and with pen and ink put in the black dots which outline the trees, houses, and fence. Paint the horizontal line which runs completely across under the buildings, fence, etc., in Burnt Umber. Also put in the black foreground using Lamp Black thinned well with varnish, so that it is transparent in places. This completes the first stage. Wait 24 hours.

40

3. Certain parts of the picture are done in *transparent* colors, and these are to be painted now. (Refer to p. 18 for the mixing of transparent colors). It is convenient to divide the work into two parts, (a) and (b).

(a) Mix some Prussian Blue and Indian Yellow to make a transparent bluish green, and apply this to all the diagonally shaded parts of the picture. Begin with one of the trees, using two or three strokes of the brush. Immediately take a clear varnish brush and blend the edges. Do the same with the next tree, and so on with the rest. Apply this same color to the windows and doors, but here the edges are not blended off. Some of the windows and doors appear to be done in a different color at this point, but this is only because there are other colors painted behind the dark green in the next stage of the work. Now apply this same green to the lawn, but of course only to the shaded part of it, and blend off the edges here and there. Leave for 24 hours.

(b) For the transparent color touches in the sky, you will need to work with three brushes. With one brush, mix Prussian Blue and a touch of Raw Umber to make a dark transparent blue. With the second brush, mix Burnt Umber and Yellow Ochre to make a transparent yellowish brown. In each case the mixture should consist mostly of varnish with just enough pigment to give the color you want. Try it out on the edge of the newspaper palette.

First, apply this blue to the wavy horizontal areas of the sky. Next, paint the fine dotted area of the sky with the yellowish brown. Immediately use the third brush, with just a little varnish on it, to blend the edges of the colors here and there.

To paint the dark red of the roofs and chimneys, shown crosshatched in the drawing, mix Alizarin Crimson and a little Burnt Umber to make a rich dark transparent red. Leave for 24 hours.

It is possible to do the work described under both (a) and (b) in one operation. However, it is easier to divide the work as suggested above.

4. At this stage, we apply the opaque colors on the buildings, fence, trees, and lawn. For the orange color on the smaller house, mix Japan Yellow, Japan Vermilion, and enough Burnt Umber to obtain a dull orange. Apply this to the side, roof, and chimney, going right over the green windows and the dark red roof and chimney. Pick up one edge of the acetate to see the effect on the "front" side. The same color goes over the other dark red parts.

The mustard yellow on the larger building is a mixture of Japan Yellow, Raw Umber, and a little White, and is applied right over the

41

BLUE

CREAM

DARK BLUE

PALER BLUE

PINK

YELLOWISH BROWN

CREAM

PALER BLUE

PINK

PINK

CREAM

PINK

BROWN LINE

PLATE 4 REVERSE PAINTING ON GLASS

windows and doors. For the white sections, mix White and a little Raw Umber to get an off-white. For the opaque green on the trees and lawn, mix Japan Green with Burnt Umber and a touch of Yellow Ochre. Let dry 24 hours.

5. The next stage is the completion of the sky. Some artists prefer to use regular flat artist's oil brushes (about ¼ inch wide for this work); others like the showcard brushes. The quill-brushes are too soft. Whatever brushes you use, you should have three of them, one each for the blue, the pale pink, and the cream color. Mix all three colors before you start to paint. Work quickly, because varnish thickens on contact with the air.

Mix White, Raw Umber, and a little Prussian Blue to get the blue of the sky. You can easily add a little more White when you paint the paler blue of the distant sky lower down in the picture. For the pale pink, mix White, Raw Umber, and a touch of Alizarin Crimson and of Yellow Ochre. For the cream color, mix White, Yellow Ochre, and a touch of Burnt Umber.

In painting the sky, don't do it by filling in spaces, but paint right across the picture, covering the buildings and trees. Keep watching the other side of the acetate to judge the effect. Some artists use their fingers to blend the edges where two colors meet. Dry the work for 48 hours.

6. Apply a coat of white paint over everything.

To Paint on Glass

To do this pattern on a piece of glass, first of all clean both sides of the glass with a piece of crumpled wet newspaper. Then take another piece of newspaper, dry this time, crumple it, and use it to dry the glass thoroughly. The important thing to remember is that the glass must be thoroughly clean. You may have other methods of cleaning glass which you feel are preferable.

Next, give one side of the glass a coat of varnish, antiqued with a little Raw Umber. Let it dry for 24 hours. See Chapter 9.

Finally, proceed to paint the pattern on the glass as you did previously on the acetate. You work on the varnished surface, which will not only enable you to use the pen and ink without difficulty, but will give an air of antiquity to the whole picture.

Framed Picture

If you wish to paint a glass to be used as a framed picture on the wall, it will save time and bother if you buy a glass to paint which already has a frame.

13

Designs from Old Fraktur Paintings

Fraktur paintings, described and discussed historically in Chapter 1, were usually done on white paper. The design was first outlined in brown* ink with a goose quill, and the colors, generally water-color dyes, were then applied with a brush, which often was a homemade cat's-hair brush.

Many of the motifs found in Fraktur designs are so beautiful that they can stand alone simply as pictures for framing and hanging on the walls. Fraktur can also be used to provide decorative ideas in stenciling and silk screening on fabrics and stationery, in embroidery, in making appliqué quilts and in the decorating of furniture and smaller objects.

Since the originals were most often done on white paper, it would be best to use these motifs on light backgrounds, such as off-white or cream. The designs can first be outlined with a fine pen line in brown waterproof drawing ink, the transparent colors being then applied. If you find it difficult to get a good pen line on a painted surface, give the surface a coat of varnish first. Let it dry 24 hours, and then go over it lightly with steel wool, just sufficiently to take off the high gloss. This makes the surface more receptive to the ink and, moreover, makes it easier to carry out corrections with dry-cleaning fluid.

If you are decorating woodenware or tinware, use artist's oil colors thinned with varnish for your transparent colors. If you prefer to use opaque colors, which are easier to apply, the motifs should *not* be outlined first in ink, but the flat opaque color applied. After that, it is not usually necessary to add an outline.

* The early illuminators had black, green, blue, red, and yellow inks. The black ink turned brown in the course of time, as ancient writing has done in documents everywhere. This is probably the reason why the later Pennsylvania scribes and decorators often used a brown ink which would imitate the effect of antique ink.

44

When doing a picture to be framed, use water-color paper, outline the motif in brown waterproof drawing ink, and then use water colors to fill in the design.

Whatever kinds of paint you use, be sure to add a little brown to all reds, greens, yellows, and blues to achieve soft but still bright antique colors. Guard against adding too much brown, for that will result in dull, sad colors; but garish crude colors are quite out of place in this work.

If you want to paint one of these designs in watercolor on water-color paper, you will naturally do the outlines first with a pen and brown waterproof drawing ink; then paint the black areas in black waterproof ink with a small pointed watercolor brush. Wait several hours to give the black ink time to harden. Then paint the colors, using the watercolor brush.

14

Decorated Barns

Besides their Fraktur paintings, the Pennsylvania Germans have given us another charming form of folk art in the decorated barn. The traveler through parts of Pennsylvania, chiefly Lebanon, Berks, Montgomery, and Lehigh counties, is delighted by the big, vividly colored geometric designs he sees painted on the barns. Some people call them "hex signs," and think they were originally intended to scare away demons and witches, "hex" or "hexe" being an ancient Teutonic name for a witch. One may also surmise that "hex" is an abbreviation of hexagon, or of some kindred word, since six (Greek *hex*) points or angles are frequent in the designs. Similar designs were used on the walls, stained glass windows, and tessellated floors or pavements of churches and other buildings of medieval Europe. Although their religious or mystical significance may have been forgotten, it is not improbable that the farmers here did use them originally as protective devices. In any case, they applied them in a way as unique in this country as it is attractive.

Dark red was commonly used for the background color, and the generally simple structural lines of the barns were often relieved by painting on the surface white columns and arches, in addition to the large circular geometric or "hex" designs. A string and a piece of chalk are the simple means used to draw the giant circles. Backgrounds less frequently seen than dark red are yellow and dark olive-green.

46

15

Hints on Learning and Working

Anyone learning a new skill needs and should receive all the guidance and encouragement which the teacher can give. And this covers not merely the do's and don'ts of the technical instruction, but also whatever help of a more general kind the teacher's experience suggests will lead the student to success. So here are a few hints which have been useful to me and others.

1. You may find it helpful to read directions aloud to yourself a few times. Seeing an idea in print and at the same time hearing it spoken (by yourself in this case) are often more effective than the seeing alone.

2. To succeed in learning any skilled craft, you need practice, of course. But even more important, you must keep in your mind's eye a picture of yourself as doing beautifully whatever you seek to do. Concentrate only on success!

3. Get into the habit of following directions exactly. All directions have been worded so as to make them as plain and easy to follow as possible. If, in trying to carry out an operation new to you, something goes wrong, read every word of the instructions again. You'll probably find you missed some important point.

4. Nothing worth while in this world is accomplished without some thought. So think a process out before you act.

5. Don't try to rush the learning process. An idea new to you must have time to become a part of you. If nature takes many months to produce a flower, why should you expect to produce perfect brush strokes in one week?

6. There is only one way to get a job done—to get busy and do it. If your available time is limited to one hour, then do what you can in that hour.

7. It is important to keep your brushes, paints, varnish, all your equipment, in perfect condition at all times. Also keep your supplies and tools arranged in an orderly and convenient manner, so that you always know where each thing is.

8. Your acetate copies of patterns should each be mounted on cardboard or heavy paper with a wax-paper flap to protect them, and all should be kept together in filing folders or portfolios. They are the fruits of your time and labor, and time and labor are valuable. A portfolio can be made by folding a large sheet of plain or corrugated cardboard in half. Keep the larger patterns by themselves in a portfolio of their size.

9. Just a reminder of the value of acquiring the habit of studying old pieces, as advised in Chapter 11.

MORE PATTERNS

In describing the patterns which follow it won't be necessary to repeat instructions which you can find by referring to the chapters describing the main processes.

It is advisable to copy each pattern first on frosted acetate, so as to get the necessary practice in mixing colors and in painting the various stages. The beginner is also advised to spend five or ten minutes each day in practicing brush strokes, such as those shown in Plate 1, before going on to paint patterns. It saves time in the end because it makes for better work. You shouldn't be too easily satisfied with what you do. Aim at perfect brush strokes. Plate 1 can be a continually useful guide for practice work.

Blue Box

1. You will notice that the three large flowers have dark center areas. In Plate 5 these areas are enclosed by broken lines. Mix some Raw Umber and a little Lamp Black with enough varnish to make a semi-transparent dark gray, and apply this to a flower center, immediately blending off the edges with a clear varnish brush before going on to the next flower.

Mix Japan Green, a little Raw Umber, and a touch of White to make a country green, and paint all the leaves, stems, etc. Let it dry for 24 hours.

2. With a thin, semi-transparent, off-white mixture, paint the center rose and the date at the top.

With Japan Vermilion to which has been added a little Burnt Umber, paint all the solid black parts on Plate 5, disregarding the superimposed details. Wait 24 hours.

3. With a thin, transparent mixture of Japan Vermilion, apply the pale pink on the white rose, as indicated by the shaded parts on Plate 5. Add a bit more Vermilion to the mixture, and paint the darker accents on the lower petals. Add the red touches on the date.

With a thin, transparent mixture of Japan Black, add the dark over-tones on the green leaves and stems, and on the red bow-knot, as shown by the crosshatched areas on Plate 5. Here and there, blend off *some* of the edges, to soften the general effect a bit. Wait 24 hours.

4. With a thin, semi-transparent off-white, add the center dots and white accents to the three small flowers; also the white highlights on the leaves and stems, and on the red bow-knot, where it is indicated by dotted areas (white dots being used on the black). Add a little Japan Yellow and Raw Umber to the brush, and apply the thin yellow touch on the lower part of the stem. Allow 24 hours for drying.

The blue background color for this pattern is made by mixing Prussian Blue, Raw Umber, a little White, and a touch of Alizarin Crimson.

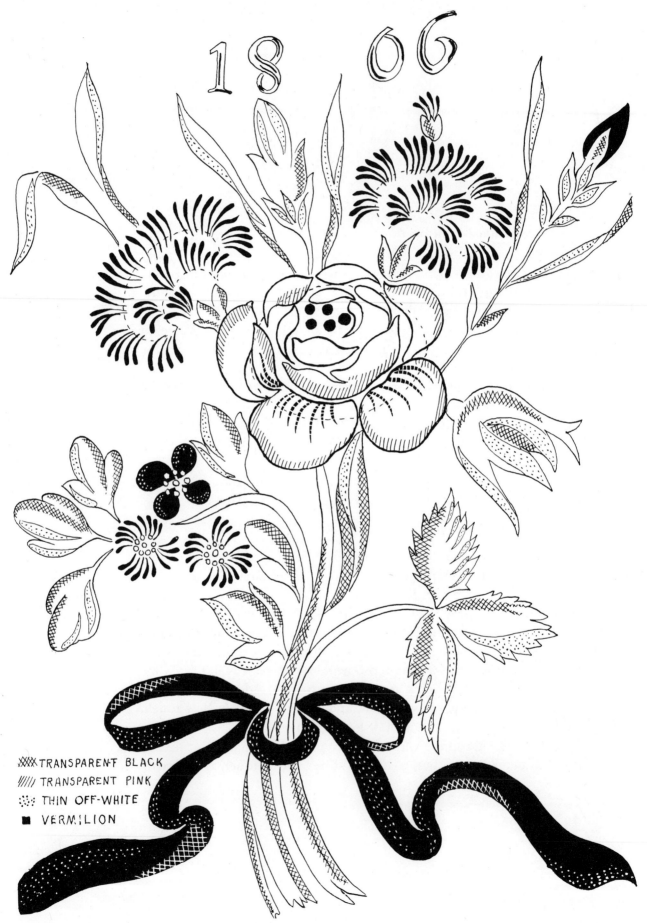

1806

XXX TRANSPARENT BLACK
//// TRANSPARENT PINK
∴ THIN OFF-WHITE
■ VERMILION

PLATE 5 BLUE BOX

Coffin Tray

Small octagonal tin trays were made in considerable quantities during the 19th century by the local tinsmiths and received their quaint name because they were fashioned in a shape something like the old-style coffins. They were usually painted in black or asphaltum, but the brightly colored design was often painted on an off-white border. The pattern illustrated is a typical one. To decorate a tray with it, proceed as follows:

1. Paint your tray flat black in the usual way.

2. The off-white border on the floor of the tray starts right at the point where the floor or flat part of the tray meets the sloping flange. On a piece of tracing paper, trace the floor area of your tray, and then draw a second line 1⁵⁄₁₆ inches inward from that, thus creating the border area. Carefully measure with a ruler on each side to be sure the width of the border is the same all round. Transfer this second line to the tray, and paint in the off-white border, using a thin paint mixture to insure a smooth surface. Let it dry thoroughly.

3. Put your tracing back on to Plate 6, and trace the border motifs, disregarding all details which can be painted in later by eye. If your tray is a different size or shape, you may have to alter the size and positions of some of the motifs to suit it; but keep the red tomatoes in the middle of the long sides, and also keep the large leaves on either side of the tomatoes. Make any necessary changes at the corners and ends. Transfer the outlines of the design to the white border on the tray.

4. With Japan Vermilion paint all the areas marked V in Plate 6, disregarding all the superimposed details. Paint all the leaves marked with crosshatching in country green. With a rather thin mixture of Burnt Sienna and Burnt Umber, paint the large leaves and the smaller areas marked BS. Let the work dry for 24 hours.

5. Mix Japan Yellow and a little Raw Umber to make a mustard yellow, and paint the areas marked Y; also the dots which are represented by tiny *open* circles on the red grapes at the corners. Apply this

51

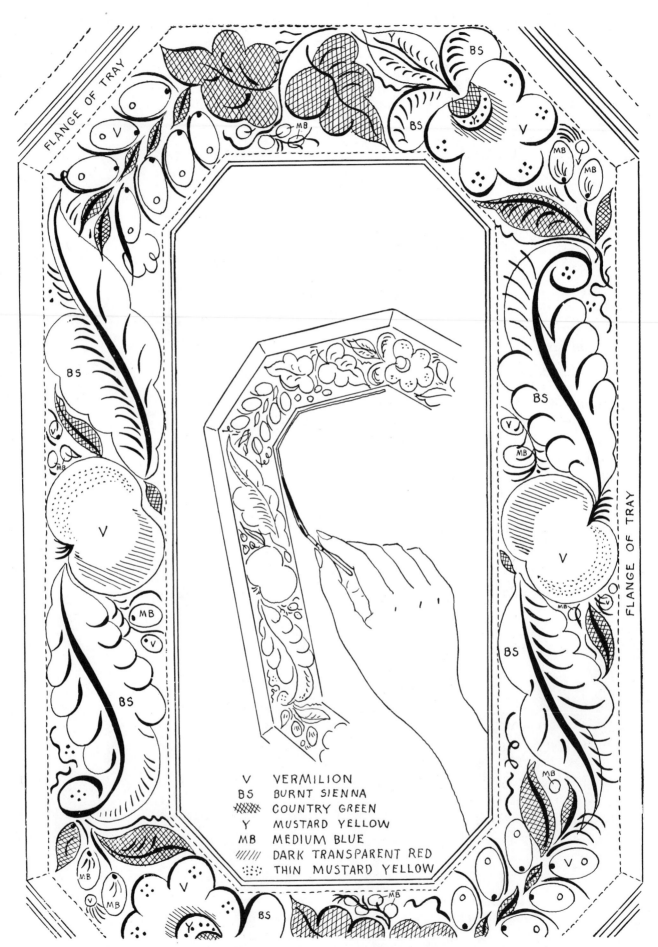

V VERMILION
BS BURNT SIENNA
▨ COUNTRY GREEN
Y MUSTARD YELLOW
MB MEDIUM BLUE
▧ DARK TRANSPARENT RED
▨ THIN MUSTARD YELLOW

PLATE 6 COFFIN TRAY AND STRIPING

yellow to the dotted area on the tomatoes, immediately using a clear varnish brush to blend off the inner edge in each case.

With a medium blue, paint the parts marked MB.

With semi-transparent dark red, paint the shaded areas on the tomatoes and large flowers, immediately blending off the edges with a clear varnish brush as you paint each unit. Dry for 24 hours.

6. With Lamp Black, paint all the black accents, veins, stems, "whiskers," curlicues, dots, etc., shown in Plate 6.

7. Striping is in mustard yellow.

8. Finish the tray in the usual way.

New York Tin Box

Black is the background color of this old box, now in the Cooper Union Museum, New York. To copy the patterns (note that the end of the box is in Plate 8), proceed thus:

1. Paint the flowers and buds in salmon pink.

With a mixture of country green paint all the black areas. Let the work dry for 24 hours.

2. Paint the shaded strokes on the flowers and buds in semi-transparent dark red. Wait 24 hours.

3. With a semi-transparent off-white, paint the dotted strokes on the flowers and buds, and the large center vein on the leaves.

Mix some Japan Yellow and Raw Umber to make a mustard yellow; with this, paint all the remaining leaf strokes, stems, etc. Add more varnish to the mustard yellow to get a semi-transparent mixture, and paint the smaller side veins on the large leaves as shown by the white dotted lines. Wait 24 hours.

The brush strokes on the box top, the borders, and the striping are in mustard yellow. Also in mustard yellow is the crosshatching of the end design.

4. Finish the box in the usual way.

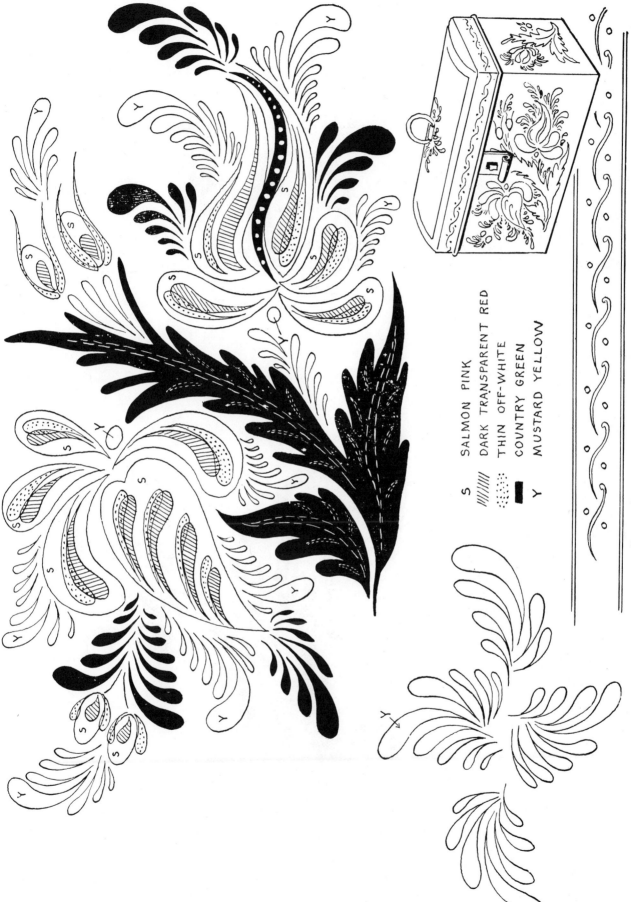

S SALMON PINK
////// DARK TRANSPARENT RED
:::::: THIN OFF-WHITE
█ COUNTRY GREEN
Y MUSTARD YELLOW

PLATE 7 NEW YORK TIN BOX

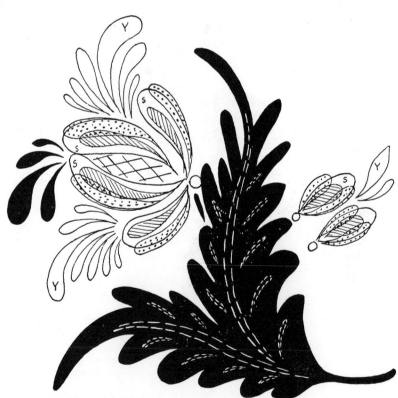

S SALMON PINK
/////// DARK TRANSPARENT RED
::::: THIN OFF-WHITE
■ COUNTRY GREEN
Y MUSTARD YELLOW

PLATE 8 PENNSYLVANIA BARN AND END OF NEW YORK TIN BOX

Connecticut Chest

This pattern is from a blanket chest, which probably originated in Guildford, Connecticut, and is now in the Metropolitan Museum in New York. Made of oak and pine, it opens from the top and has one drawer at the bottom. It is dated 1705. This fine design is now much worn, but it is easy to see that when the chest was new it was a very attractive item indeed. The background color is dark oak.

On a sheet of tracing paper, make a complete tracing of the outlines of the thistle pattern, which is shown divided in Plates 9 and 12. Ignore the superimposed details. Mount the tracing on white cardboard, which will make the lines more easily seen, and fix a sheet of frosted acetate over it. Similarly make a tracing of the pattern in Plate 10, and its separated piece in Plate 12. Finally, make a tracing of the drawer pattern, the two parts of which are in Plates 11 and 12.

1. To paint the thistle motif in Plate 9, proceed as follows:

(a) The areas shown in white are all painted in a deep cream color, made by mixing White, Yellow Ochre, and a little Raw Umber. Paint the over-all area of the thistle, disregarding the heavy black crosshatching, the shaded dots, and the fine and heavy lines; similarly paint the over-all areas of the large leaves, the stems, small white leaves, and the base; also the over-all areas of the medium-sized and small flowers. Let the work dry for 24 hours.

(b) With Japan Black paint all the parts shown in heavy black, including the *heavier* black lines in the upper part of the thistle (not the thin ones). Mix Japan Green with a little Raw Umber to make a country green, and paint the small shaded leaves and the widely spaced "tartan" crosshatching on the two middle flowers. Let dry for 24 hours.

(c) With Japan Vermilion paint the large shaded dots on the lower part of the thistle, and on the small flowers; also the thin pen lines shown on the upper part of the thistle, on the large leaves, and on the central part of the two middle flowers. Let dry for 24 hours.

57

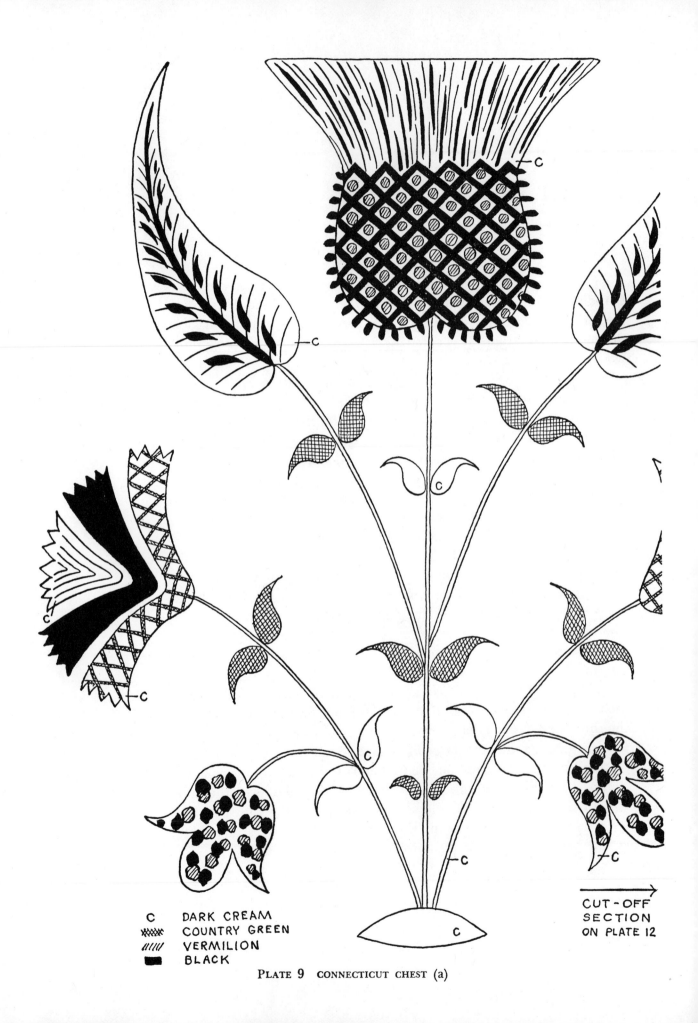

C DARK CREAM
 COUNTRY GREEN
 VERMILION
 BLACK

CUT-OFF
SECTION
ON PLATE 12

PLATE 9 CONNECTICUT CHEST (a)

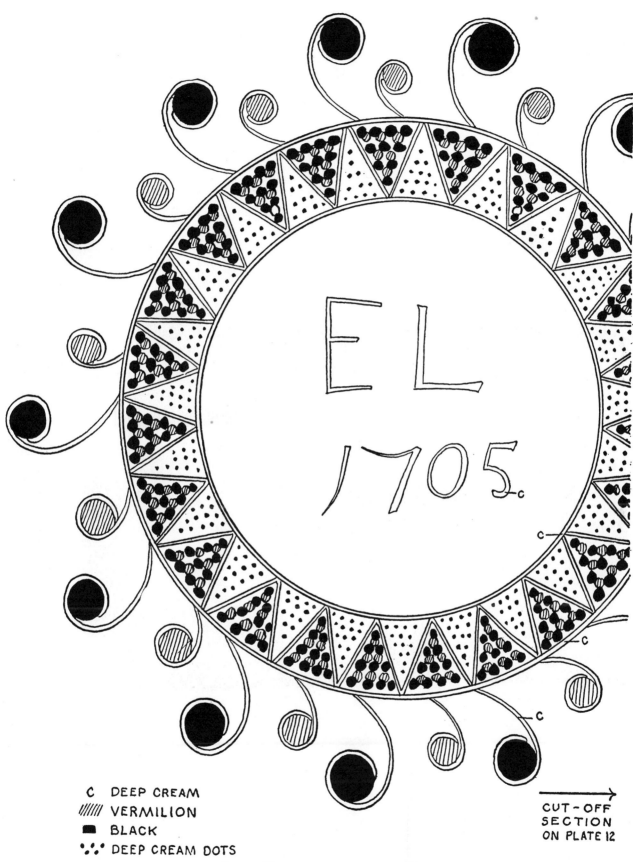

C DEEP CREAM
///// VERMILION
■ BLACK
'.'.' DEEP CREAM DOTS

CUT - OFF
SECTION
ON PLATE 12

PLATE 10 CONNECTICUT CHEST (b)

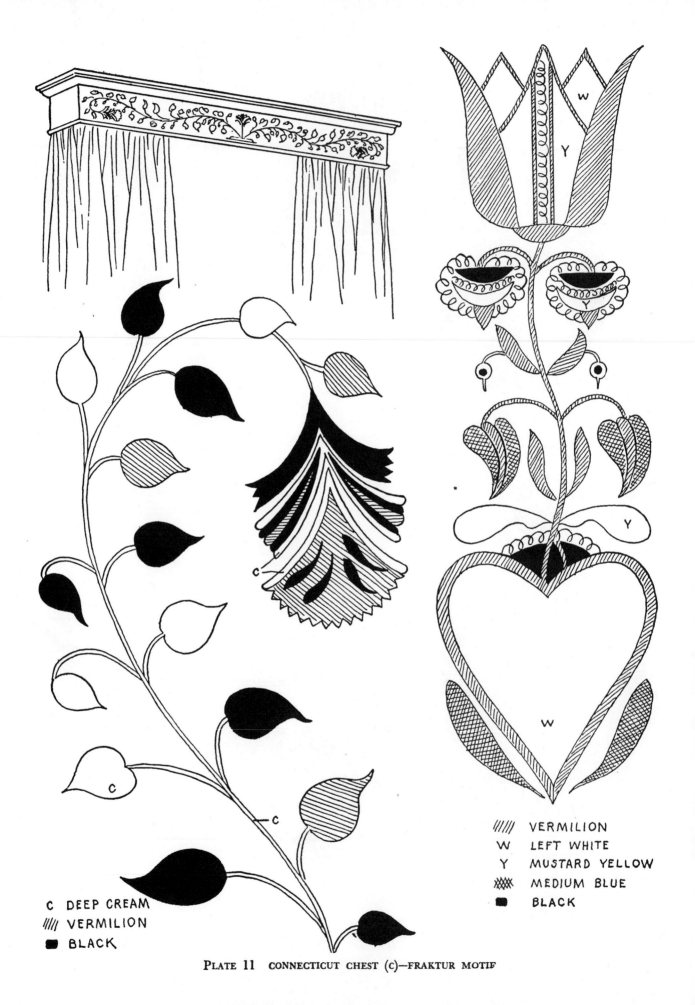

C DEEP CREAM
///// VERMILION
◼ BLACK

///// VERMILION
W LEFT WHITE
Y MUSTARD YELLOW
⚒ MEDIUM BLUE
◼ BLACK

PLATE 11 CONNECTICUT CHEST (C)—FRAKTUR MOTIF

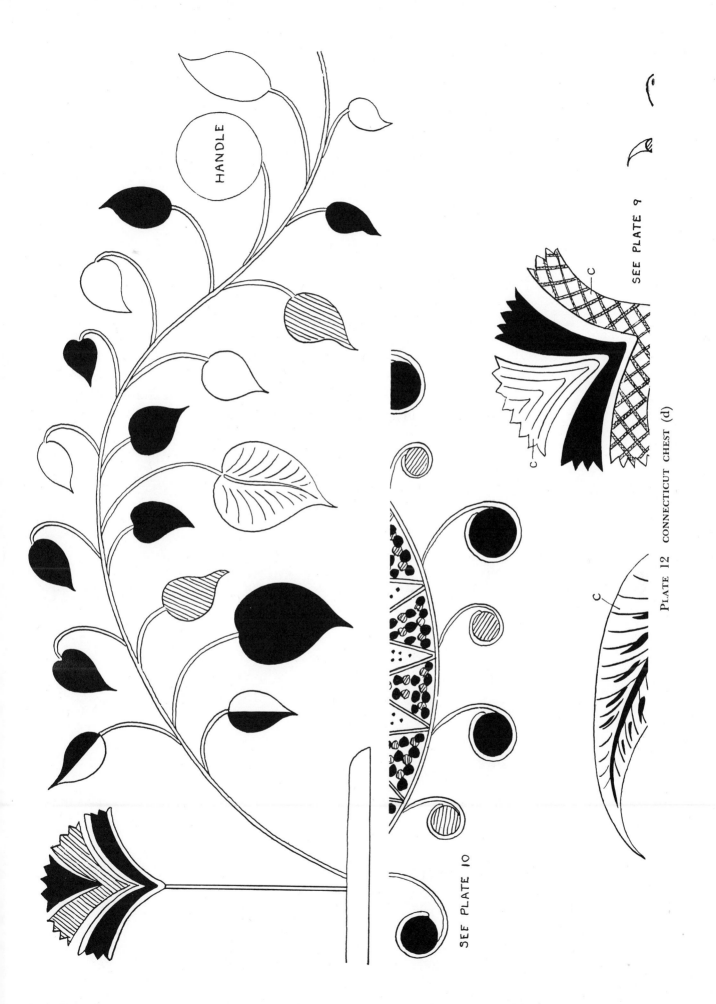

HANDLE

SEE PLATE 10

SEE PLATE 9

C

C

C

PLATE 12 CONNECTICUT CHEST (d)

2. For the pattern in Plate 10 the stages are:

(a) With the cream color used for Plate 9, paint the initials and date; then the two fine-line circles which outline the wide band; then the fine strokes marking off the little triangles inside the band. Use a striping brush for the two circles. Also in cream color are the very small pinpoint dots in the alternate triangles, and the swirling lines outside the band. Allow 24 hours for drying.

(b) Paint the large shaded dots and the shaded balls in Vermilion, and allow to dry for 24 hours.

(c) Paint the large black dots and the black balls in black.

In transferring this pattern to a surface that you want to decorate, there is no need to trace the dots within the wide band. Do these by eye. Be sure not to have an excess of paint on your brush, or the dots will spread after a few minutes and run into each other. The two large circles may be drawn with a compass.

Plates 11 and 12, which give half of the design on the drawer of the chest, are painted in a similar manner to the parts described above. The fine pen line veins on the leaf in Plate 12 are done in Vermilion. This design could be easily adapted for use on a cornice, as suggested by the sketch in Plate 11.

Pennsylvania German Dough Trough

This pattern was taken from a Dauphin County, Pennsylvania dough trough which is preserved in the Metropolitan Museum of Art in New York. The utensil was made of poplar wood about the period 1780 to 1800. The two painted panels have a cream-colored background, while the over-all color of the trough is a deep honey.

1. Paint first the shaded areas in a mustard yellow, made by mixing Japan Yellow with Burnt Sienna. Then do the crosshatched areas in dark country green, made by mixing Japan Green with a little Raw Umber. Wait 24 hours.

2. The dotted areas are done in red, made by mixing Japan Vermilion with Yellow Ochre and a touch of Burnt Umber. The parts left plain white are to be painted in a dark blue. Allow 24 hours for drying.

3. The pot is done in an antique black, and so are the veins on the dark green, and the markings on the dark blue areas. Add more varnish to the antique black to make a semi-transparent black, and paint the markings on the red and yellow parts of the flowers.

For a deep honey color for the rest of the trough (or whatever you decorate), mix Japan Yellow, Burnt Umber, and White.

MUSTARD YELLOW
COUNTRY GREEN
VERMILION
D.B. DARK BLUE
BLACK

D.B.

PLATE 13 PENNSYLVANIA GERMAN DOUGH TROUGH

Tulip Box Pattern

This pattern was taken from a Pennsylvania German wooden box dated 1763. The box was painted a creamy off-white, which is made by mixing White, Raw Umber, and Yellow Ochre. To copy this pattern on frosted acetate, the steps are:

1. On tracing paper make a complete tracing of the pattern shown in Plate 14. Mount this on white cardboard, so that the lines can be seen easily, and put a piece of frosted acetate over it.

2. With Japan Vermilion paint the over-all areas of the large tulip, the medium-sized flower on the left, and the fruit on the right. With a mixture of dark country green, paint all the leaves, stems, etc., as shown by the shaded areas in Plate 14, disregarding all the superimposed black and other details. Let the work dry for 24 hours.

3. With a mixture of mustard yellow, paint the areas marked Y on the large tulip, the center of the medium-sized flower, the single brush stroke on the fruit, and the small bell-like flowers on either side. Allow 24 hours for drying.

4. With Lamp Black, paint all the heavier black accents, brush strokes, and other detail shown in Plate 14. Wait 24 hours.

5. With a semi-transparent off-white, paint all the dotted brush strokes.

Suggested objects to which this pattern might be applied as a decoration include a chair, a window box, a chest of drawers, and a bread box.

V VERMILION
//// DARK COUNTRY GREEN
Y MUSTARD YELLOW
■ BLACK
∷ THIN OFF-WHITE

PLATE 14 TULIP BOX

Pennsylvania German Foot Bath

The background color on the old foot bath was a lovely soft antique red. To mix this color, see Chapter 6. In making a practice copy of the pattern on frosted acetate, your background can be a sheet of red paper, or you may paint a piece of cardboard red for the purpose. Then proceed in this order:

1. On a sheet of tracing paper of adequate size make a complete tracing of the outlines of the pattern from Plates 15, 16, and 17, ignoring all superimposed details. Mount this tracing on white cardboard, which will make the lines more easily seen, and fix a sheet of frosted acetate over it.

2. You will notice that the three large fruits have dark shaded areas (indicated by line shading in Plates 16 and 17). These are actually the red background showing through a very thin mustard yellow. To paint these fruits, work with two brushes. On one brush have an ordinary mixture of mustard yellow, made by mixing Japan Yellow with Raw Umber. On the other brush have an extremely thin mixture that is mostly varnish with just a trace of the mustard yellow in it.

Do one fruit at a time, blending the thinner and heavier yellows where they meet. Work *quickly* to get the blending done before the varnish thickens. From time to time, slip the red paper under your painted fruits to see if you are getting the right effect.

With the heavier mustard yellow mixture, paint the rest of the yellow parts of the pattern, with the exception of the curlicues, which should be left to the very end when everything else on the pattern has been painted. Let dry 24 hours.

3. Mix some Japan Green, Raw Umber, a little Japan Yellow and a little White to get a soft country green, and paint all the green leaves.

Mix some White, Raw Umber, and a little Prussian Blue to get a rather light blue, and paint the light blue, crescent-shaped areas which surround the fruit marked F in the line illustration. The shading will be added later. Also paint all the round and oval grapes except those marked X, which are a light violet. Add a little Alizarin Crimson to your blue mixture to get a light violet, and paint the remaining grapes. In painting the grapes, disregard all the light and dark overtones and the black accents. Wait 24 hours.

4. With a thin mixture of Burnt Umber, apply the transparent brown overtones on the green leaves, as indicated by the shaded areas in the line illustration. Do one leaf at a time, and immediately blend off the inner edge of the brown, using a clear varnish brush.

If the darker parts of the three large fruits are not dark enough, an overtone of brown blended off at the edges will rectify this. Also, add the transparent brown shading on all the grapes, and on the light blue parts surrounding the fruit marked F, as indicated by the line shading in the illustration. Wait 24 hours.

5. With a semi-transparent mixture of off-white, paint the white strokes on the grapes, as indicated by the dotted areas in Plates 15, 16, and 17. Wait 24 hours.

6. With Lamp Black, paint all the black stems, veins, brush strokes, dots, accents, etc. Wait 24 hours.

7. With a mixture of mustard yellow, paint the tendrils or curlicues. Add some more varnish to the yellow to make a semi-transparent mustard yellow, and paint the highlights on the leaves. Add a little Japan Yellow to the mixture to make a brighter yellow, and paint the highlights on some of the yellow brush strokes, as indicated by the dotted outlines in the line illustration. Add the bright yellow dots on the fruit. This completes the pattern.

Striping on the foot bath was in mustard yellow.

PLATE 15 PENNSYLVANIA GERMAN FOOT BATH (a)

PLATE 16 PENNSYLVANIA GERMAN FOOT BATH (b)

PLATE 17 PENNSYLVANIA GERMAN FOOT BATH (C)

Cornucopia Canister

To make a copy of this pattern on frosted acetate, proceed as follows:

1. On tracing paper make a complete tracing of the pattern from the drawing in Plate 18, and its continuation in the upper corner of Plate 19. Mount this on white cardboard, so that the lines can be seen easily, and put a sheet of frosted acetate over it.

2. With Japan Vermilion, paint the two large flowers, the buds, and the stems, *completely disregarding* at this time the black leaves which pass over the stems. Similarly paint the over-all shape of the cornucopia and the small buds around its edge, ignoring all the superimposed detail. Allow 24 hours for drying.

3. Now paint all the solid black parts of the illustration with a country green mixture, so thin that the red stems will just show through it, as well as a hint of the red cornucopia.

Mix some Alizarin Crimson and Burnt Umber to form a transparent dark red, and paint all the shaded brush strokes. Let it dry for 24 hours.

4. With a semi-transparent mixture of off-white, paint the dotted brush strokes.

With a mustard yellow made of Japan Yellow and Raw Umber, paint the lines forming the crosshatching on all the flowers; also the dots and stems on the cornucopia, and the hairline strokes projecting from its edge. With a semi-transparent mixture of the same yellow, paint the veins and highlight strokes which are indicated by broken white lines on the black leaves of the illustration.

Striping and borders are in mustard yellow. The brush stroke unit in the upper right-hand corner of Plate 1 would be appropriate on the cover of the canister. The background color of the canister (owned by Mrs. John G. McTernan, of Brooklyn, N.Y.) was black.

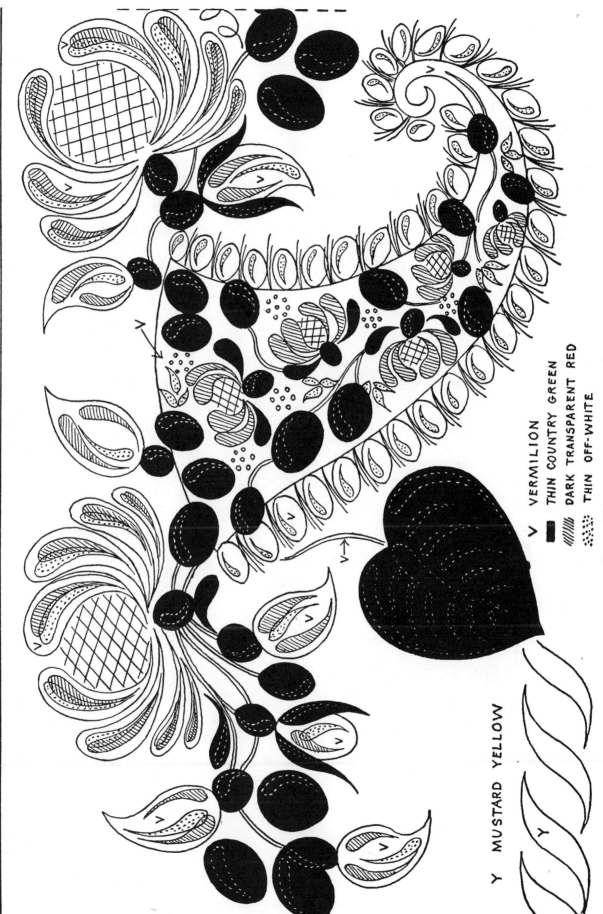

Y MUSTARD YELLOW

> VERMILION

THIN COUNTRY GREEN

▬ DARK TRANSPARENT RED

THIN OFF-WHITE

PLATE 18 CORNUCOPIA CANISTER

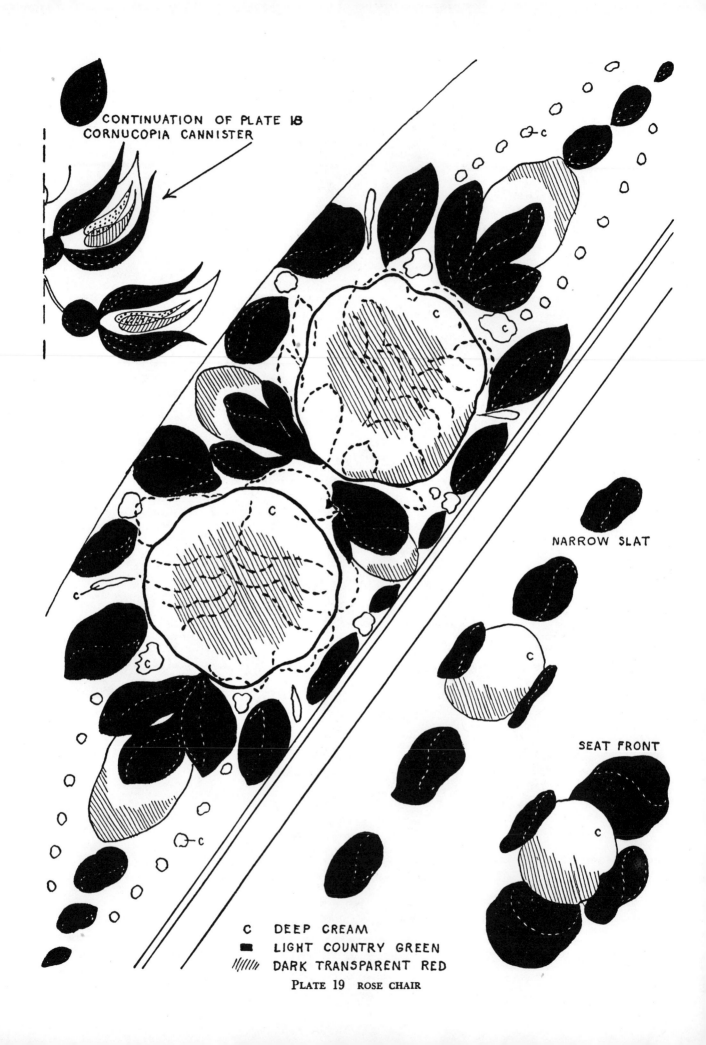

CONTINUATION OF PLATE 18
CORNUCOPIA CANNISTER

NARROW SLAT

SEAT FRONT

C DEEP CREAM
◼ LIGHT COUNTRY GREEN
▨ DARK TRANSPARENT RED

PLATE 19 ROSE CHAIR

Rose Chair

The steps for making a frosted acetate copy of the pattern in Plate 19 will be given first, and then the actual work on a chair will be described. (Disregard the design in the upper left-hand corner of Plate 19, that being a continuation of the previous Plate.)

1. Mix White, Raw Umber, and Yellow Ochre to get a deep cream color, and paint the over-all areas of the two roses, as shown by the heavy outlines. Disregard the shaded areas and the petal indications. Also paint the buds, and the uneven dots and strokes, all shown in white in Plate 19.

With a mixture of light country green, paint all the parts shown in black in the illustration. Wait 24 hours.

2. Mix Alizarin Crimson and Burnt Umber to form a transparent dark red; with this paint the shaded areas on the flowers and buds, one area at a time, and, *immediately* after each area is done, blend off the edges with a clear varnish brush before going on to the next shaded area. Work quickly, using as few strokes as possible, and with enough dark red on your brush for it to settle in a few minutes to form a smooth even color.

Mix some Prussian Blue and Indian Yellow to make a dark transparent green, and apply this to the areas indicated by the dotted white lines. Do one leaf at a time, blending off the inner edge of the dark green with a clear varnish brush before going on to the next leaf. Let the work dry for 24 hours.

3. Now the edges of the petals can be "veiled." Using hardly any varnish at all, mix a little White with a touch of Raw Umber to get a thick off-white with which to indicate the edges of the petals; this is known as "veiling." Paint one petal at a time, immediately taking a second brush with a little varnish on it to blend and soften the inner edge of each white stroke.

To Decorate a Chair

Before proceeding to decorate a chair with this pattern, you should

study the instructions on preparation of wood and on mixing background colors in Chapters 4 and 6. The background color for this chair is a dark reddish brown.

After the last coat of brown has been applied, allow it to harden for at least a week or two. Gold bands have been applied around these parts: the side posts of the back just below the middle slat; the middles of the little spokes in the back; the front legs; and the front rung. These broad gold bands, found on many old chairs, were naturally varied according to the construction of the piece. Generally they adorned the round turnings. If your chair has no turned parts, you may suggest them by putting the gold bands where you think they would look well.

The gold bands are applied before any of the painted decorations. For this work you will need some pale gold bronze lining powder, obtainable from an artist's supply store, and a small piece of satin-backed velvet ribbon, size about 2″ × 3″.

On a newspaper palette, and using a showcard brush, mix some varnish with a little Japan Vermilion to make a thin, semi-transparent red. With a few broad strokes of the brush, apply this mixture to the places chosen for the gold bands. Apply the paint evenly, so that no place is over wet. Do not go back and repaint any part—paint it and leave it. A flat, even surface is your objective. As you advance in the work, keep a watch on the bands already painted, and, as they begin to dry, apply pale gold powder to the tacky surface with the piece of velvet. Apply the powder with a very light touch, using a small circular motion. Continue in this way, painting and applying the powder to the drying bands. This method will give you a bright, shining gold effect.

The secret of success in this work is to apply the powder at just the right stage of dryness. If you do it too soon, the surface of the paint will be roughened, and some of the hairs of the velvet will stick to it. If you wait too long, the surface will be too dry for the powder to stick. The proper time varies from twenty minutes to an hour, according to the amount of varnish in your mixture, and according to the temperature and the moisture in the air. So it would be a good plan to get experience by painting a few patches on a piece of acetate, and experimenting in applying the powder to them before dealing with the chair.

When you have finished applying the last of the gold powder, let the chair dry for 24 hours.

Next day, gently wipe off all excess gold powder with a damp sponge, after which the surface may be dried by patting it with a linen towel. If powder still remains where it is not wanted, it can be painted out with the original background paint.

(As an historical note, the foregoing method of painting the gold bands was not the only one used in the old days, and you may find bands merely painted on a chair with a mixture of gold powder and varnish).

To paint the decoration, lay the chair on its back on your work table, and work upside down. Turn your pattern upside down, too, when you copy from it.

For the striping, decide how best to do it, taking into account the construction of your chair. The broad green stripe goes on first and is a mixture of Japan Green, Raw Umber, and a little White, using enough Raw Umber to get a dull green. The fine yellow stripe is a dull mustard, made by mixing Japan Yellow, Raw Umber, and a touch of White, and is applied when the green stripe is thoroughly dry.

Finish the chair in the usual way (see Chapter 9).

The original chair described in this chapter is owned by Mr. and Mrs. Vernon H. Brown of New York City.

PLATE 20 TRINKET BOX (a)

YELLOW
BLUE GREEN
ORANGE RED

SIDE OF BOX

COUNTRY GREEN

BLACK
VERMILION

MUSTARD YELLOW

PLATE 21 TRINKET BOX (b) AND BARN SIGNS

Trinket Box

This pattern was taken from a Pennsylvania German trinket box, dating from about 1780. It is now in the museum of the New-York Historical Society. Plate 20 shows most of the top, the rest being continued on part of Plate 21, where also one of the sides of the box is shown. The background is an antique black. The colors are all transparent ones, done over an off-white underpainting. Good practice may be obtained by first making a copy of the pattern on frosted acetate.

1. On a sheet of tracing paper, make a complete tracing of the pattern outlines from Plates 20 and 21, disregarding the shaded, crosshatched, and dotted indications of color. Mount this on gray cardboard, so that the lines can be seen easily, and put a sheet of frosted acetate over it.

2. With a mixture of off-white, paint the whole design. Allow 24 hours for drying.

3. With a mixture of transparent yellow (Indian Yellow or Yellow Lake), paint the dotted areas, extending the color right to the top or bottom of the flowers, or both, as the case may be. Some of the red parts will be painted over the transparent yellow. For example, the large red balls along the sides are all painted over the yellow. Wait 24 hours.

4. With a transparent bluish green (Prussian Blue and Indian Yellow), do all the shaded parts. Wait 24 hours.

5. Mix Alizarin Crimson and Indian Yellow with a touch of Burnt Umber, using enough varnish to make a transparent orange red, and go over all the crosshatched parts.

If you should paint this pattern on a box intended as a gift, it would be appropriate to substitute the initials of the recipient.

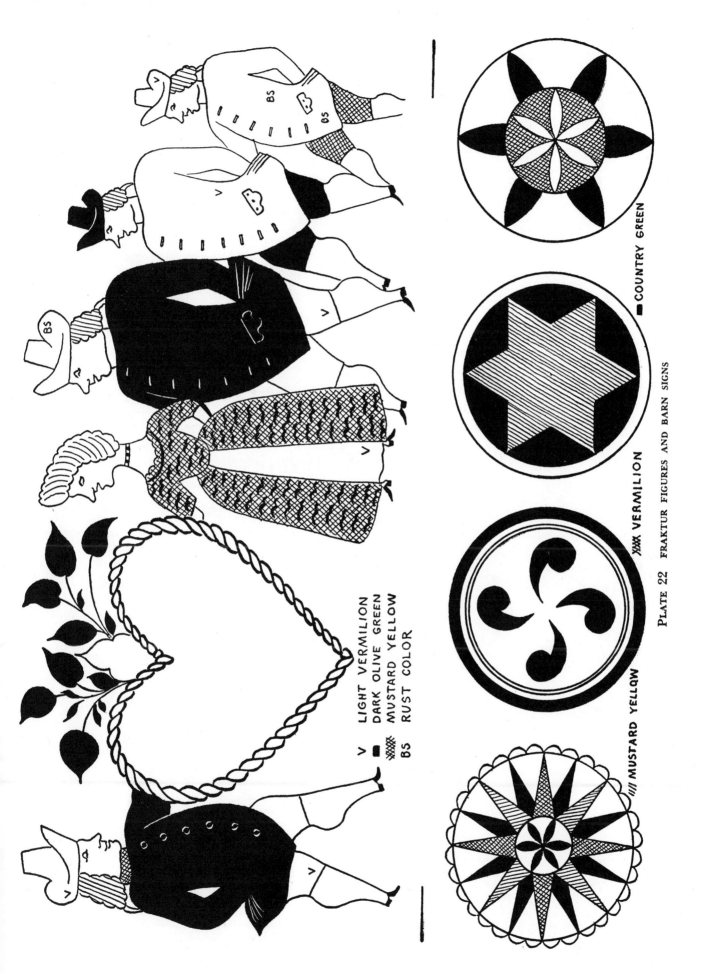

V LIGHT VERMILION
DARK OLIVE GREEN
MUSTARD YELLOW
BS RUST COLOR

/// MUSTARD YELLOW XXX VERMILION

COUNTRY GREEN

PLATE 22 FRAKTUR FIGURES AND BARN SIGNS

Tea Caddy Pattern

Put a sheet of acetate over the pattern. With Japan Vermilion, paint the over-all shapes of the flowers and fruits, disregarding the superimposed details. Wait 24 hours.

With a dark transparent red, made by mixing Alizarin Crimson and a little Burnt Umber, paint the brush strokes shown by line shading in Plate 23, painting on top of the vermilion.

With a mixture of country green, paint all the parts shown in black in Plate 23. Wait 24 hours.

With a thin off-white, paint the brush strokes shown dotted in the illustration.

With a mustard yellow, made by adding Raw Umber to Japan Yellow, paint the small leaves shown white, and also the large dots in groups of four.

Add varnish to the mustard yellow to get a semi-transparent color, and paint the veins on the green leaves.

The original background color was black.

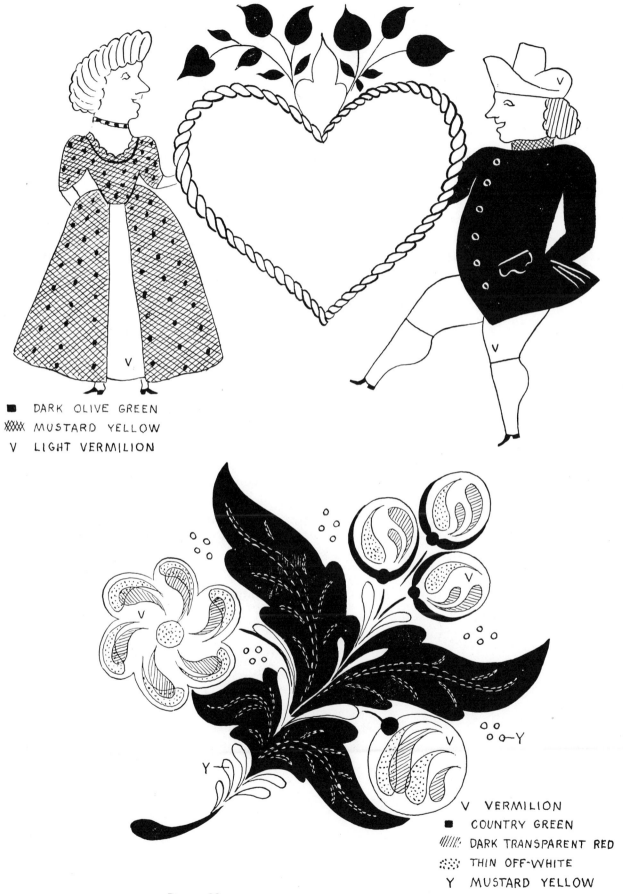

■ DARK OLIVE GREEN
░░ MUSTARD YELLOW
V LIGHT VERMILION

V VERMILION
■ COUNTRY GREEN
░ DARK TRANSPARENT RED
░ THIN OFF-WHITE
Y MUSTARD YELLOW

PLATE 23 TWO FRAKTUR FIGURES AND TEA CADDY

Tower House Pattern

This pattern was taken from the top of an old Pennsylvania German box owned by the New-York Historical Society. It extended right to the edges. The upper section, with the towered building, was repeated on each of the four sides. The background color is the deep off-white that serves for the sky behind the buildings. To copy the pattern, proceed as follows:

1. Mix some Japan Yellow and Raw Umber to make a mustard yellow. Paint the sections of the buildings which are marked Y in Plate 24; and also the foregrounds, which are the broad bands of yellow extending, in both upper and lower sections, from the buildings down to the dark blue. The green and black in the foregrounds will be painted over the yellow when the latter is dry.

Add a touch of Prussian Blue to the mustard yellow to make a light yellow green, and paint the portions of the buildings marked LG.

With Japan Vermilion paint the roofs and flags, disregarding the heavy black accent lines, which will be put on later. Let the work dry for 24 hours.

2. With a mixture of country green, and disregarding the heavy black parts, paint the tree foliage and the green in the foregrounds. In painting the latter, wipe the brush back and forth on newspaper a few times to get a "dry" brush.

Mix some Prussian Blue, Raw Umber, and a touch of White to get dark blue, and paint the blue areas. Again use a "dry" brush to finish off the blue just above the buildings. Wait 24 hours.

3. With transparent Raw Umber, apply the shadows on buildings (shown by the line-shaded areas), doing one at a time, and immediately blending off the left-hand side with a clear varnish brush. Wait 24 hours.

4. With Lamp Black, paint all the heavy black parts.

Mix some Vermilion, Burnt Umber, and White to make a somewhat faded red, and paint the border.

84

PLATE 24 TOWER HOUSE

Flower Motifs from a Corner Cupboard

These motifs come from an old hand-carved and painted corner cupboard that was made in Switzerland. Used in the Pennsylvania German country, it is a type of early imported art work which inevitably influenced American folk decorators. It is now the property of the New-York Historical Society. The background color for the motifs is a creamy off-white, made by mixing White, Raw Umber, and a little Yellow Ochre.

To make a copy of these patterns on frosted acetate, follow these steps.

Motif A

1. With an off-white mixture, paint the over-all area of the petals, marked W, disregarding the little lines on the petals. With a semi-transparent mustard yellow paint the shaded parts of the larger leaves on the left, immediately blending off the edges with a clear varnish brush. With a thicker mixture of mustard yellow, paint the flower center. Add a little Prussian Blue to the mixture to make a yellow green, and paint the small leaves marked YG. Add more blue to make a regular country green, and paint the crosshatched leaves and stem. Allow 24 hours for drying.

2. With Japan Black, paint all the heavy black accents, veins, and dots. The fine little lines on the petals are in country green.

Motif B

1. Paint the over-all area of the flower in off-white, disregarding all details. With country green, do the crosshatched areas and the tiny stems to the little balls outside the flower. Add some Japan Yellow to this green to make a light yellow green, and paint the large leaf on the right. Wait 24 hours.

86

W OFF·WHITE
///// MUSTARD YELLOW
COUNTRY GREEN
YG YELLOW GREEN
P PINK
LIGHT BLUE
MB MEDIUM BLUE
BLACK

PLATE 25 FLOWER MOTIFS FROM OLD CORNER CUPBOARD

2. With a pale pink, paint the outer edge of the large flower and the little white balls. With a mustard yellow, paint the remaining balls and the center of the flower. Wait 24 hours.

3. With Japan Black, paint the leaf veins and the stamen stems or filaments on the flower. The fine lines on the petals are in a mixture of country green.

Motif C

1. With pale blue, paint the dotted areas. With a mixture of mustard yellow, do the six small shaded brush strokes. Add a little Prussian Blue to make a yellow green, and paint the oval top of the large flower. Add still more blue to make a country green, and paint all the crosshatched leaves and stems. Wait 24 hours.

2. With medium dark blue, paint the area marked MB. With a pale pink mixture, paint the over-all areas marked P, doing first the leaf at the top, and then the lower right-hand flower. Add a little Alizarin Crimson to the mixture to make a darker pink, and *at once* brush in the darker parts on the flower, as shown by the shading lines. Do this immediately before the pale pink has had time to set. Wait 24 hours.

3. With Japan Black, add the black accents and veins.

Motif D

1. With off-white, paint the areas marked W. Add a little Alizarin Crimson and a touch of yellow to this mixture, making a pale pink, and paint the parts marked P. With a mixture of medium blue, paint the flower marked MB. Wait 24 hours.

2. With a mustard yellow mixture, paint the shaded area of the large flower. Add a little blue to make a yellow-green, and paint the leaves marked YG. Add still more blue to make country green, and paint the crosshatched parts. Wait 24 hours.

3. Add the black veins, accents, dots, curlicues, etc.

Money Box

The original of this box in the museum of the New-York Historical Society has a slot in its lid. It could have been used for coins. The background color is a dark off-white, which is made by mixing White and Raw Umber. The box has a broad stripe of white around the edges of the top and sides. The steps in copying the pattern are:

1. With a mixture of off-white, paint the over-all areas of the birds, the flowers, and the swags of bunting, disregarding all superimposed black and other detail including the shading on the bunting. With dark country green, paint the leaves and stems which are crosshatched in Plate 26. With a mixture of lighter olive green, paint the small leaf strokes shown by fine dots in Plate 26. Let the work dry for 24 hours.

2. With a bright red but thin mixture of Japan Vermilion, paint all the solid black parts on the birds, flowers, and swags, *with the exception of* those flowers marked B. Wait 24 hours.

3. With a slightly transparent dark blue, made by mixing Prussian Blue and Raw Umber, paint the swirls on the flowers marked B. Add the blue brush strokes on the birds, which strokes are indicated by line shading in Plate 26. Also paint the shaded parts of the swags. Now, having wiped the brush back and forth a few times on a piece of newspaper, so as to get rid of most of the paint on it, pick up the merest speck of blue pigment with the flattened brush, and add a few dark accents on the swags to indicate folds.

The birds' eyes also are done in dark blue.

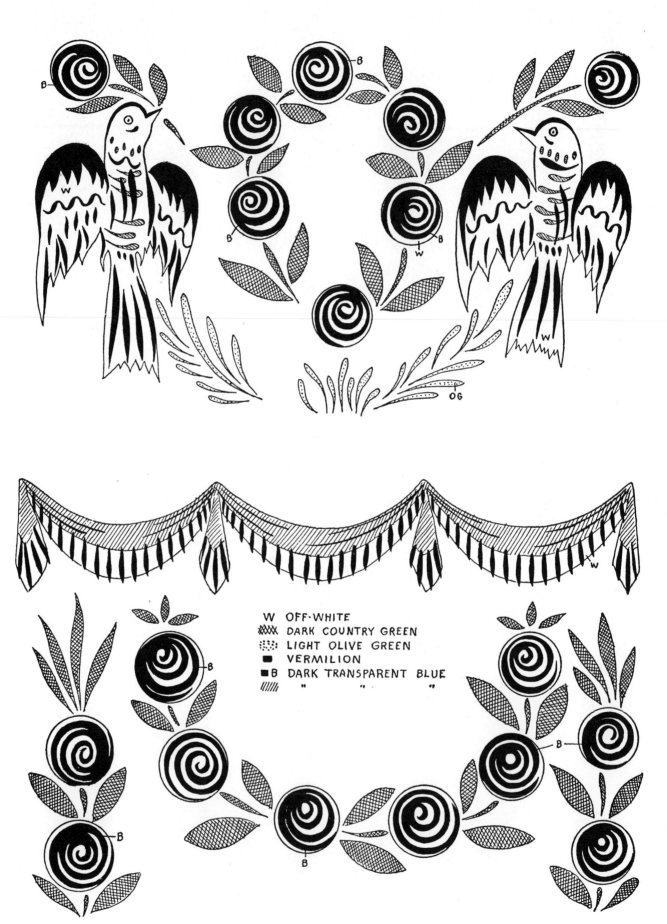

W OFF·WHITE
DARK COUNTRY GREEN
LIGHT OLIVE GREEN
VERMILION
B DARK TRANSPARENT BLUE
" " "

PLATE 26 MONEY BOX

Yellow Candle Box

This candle box, now in the New York Metropolitan Museum of Art, has a yellow background and a different decoration on each of the five surfaces. Plate 27 gives the strawberry design from the cover, and the designs from the ends of the box. Plates 28 and 29 show the two long side decorations.

The background color is a golden mustard yellow, made by mixing Japan Yellow and some Burnt Sienna. There is no striping on this box.

On all three Plates (27, 28, 29), the areas left white are done in Japan Vermilion. Add a little Burnt Umber to the Vermilion to make it slightly darker. For the line shaded areas in Plates 27 and 29, add a little White to Japan Vermilion to get pink.

The parts shown in black are done in a dark country green. The crosshatched areas are in dark blue. For the dotted areas, indicating large round patches over the vermilion, mix Japan Yellow and Raw Umber to get a mustard yellow which is darker than the background color, and also of a greenish cast in contrast to the background yellow.

91

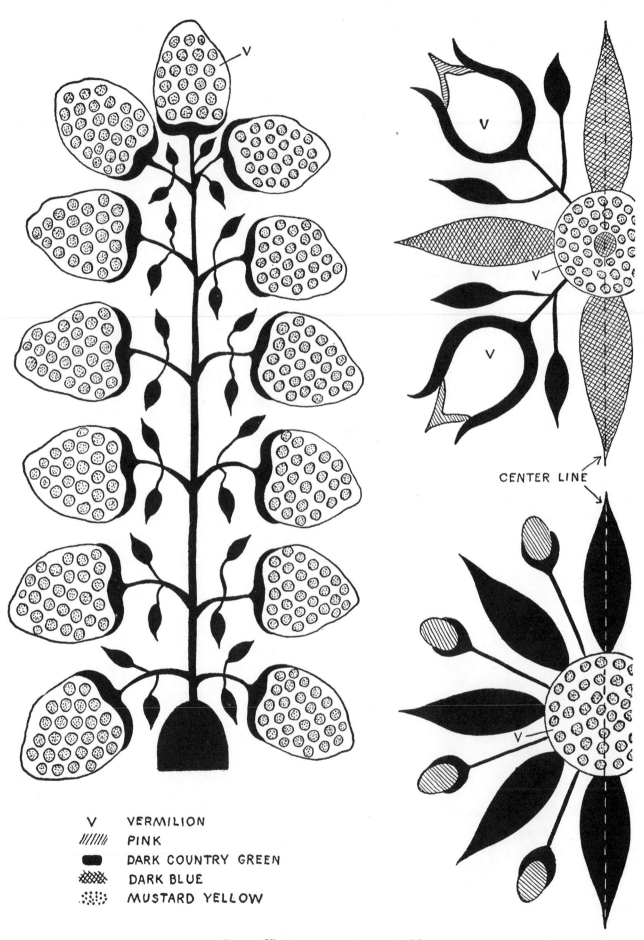

V VERMILION

//////// PINK

▆ DARK COUNTRY GREEN

▨ DARK BLUE

∴∴ MUSTARD YELLOW

CENTER LINE

PLATE 27 YELLOW CANDLE BOX (a)

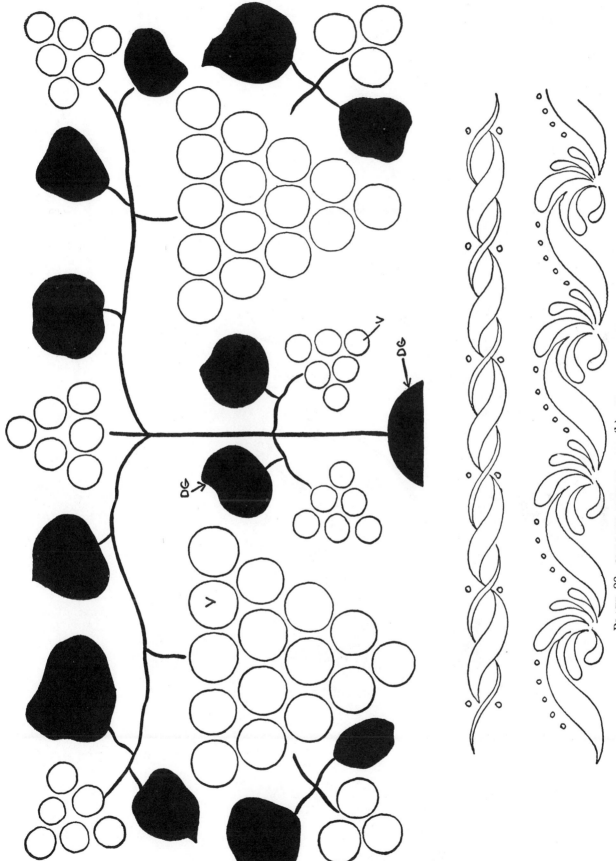

PLATE 28 YELLOW CANDLE BOX (b) AND BRUSH—STROKE BORDERS

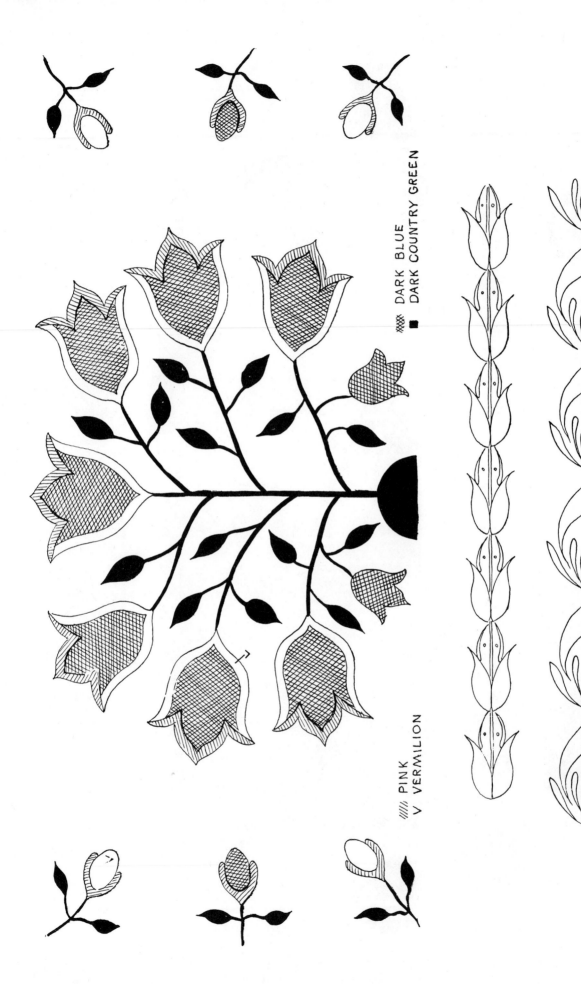

DARK BLUE
DARK COUNTRY GREEN

PINK
VERMILION

PLATE 29 YELLOW CANDLE BOX (c) AND BRUSH-STROKE BORDERS

Decorated Wooden Urn

Line Plate 30 — Color Plate VIII (p. 67)

Although the artist did not sign it, this Pennsylvania German urn, dated 1861, was probably the work of Joseph Lehn, a man who produced many such pieces in the latter half of the 19th century. It is from the collection of Mrs. Huldah Cail Lorimer and is reproduced here by courtesy of the Brooklyn Museum.

Lehn, a retired farmer, began the manufacture and decoration of woodenware as a hobby about 1860. Soon he found that people liked to buy his creations, and for about twenty-five years he turned out many spice chests, egg cups, wooden urns, boxes, tubs, buckets, kegs, and similar things. He is remembered as an outstanding example of the home craftsman and of the folk artist who works in the traditional spirit of his community, producing objects that are both useful and attractive. This champion of folk art against the rising challenge of mass production proved himself a conscientious and capable craftsman. Most of the things he made have withstood the passage of time remarkably well: the colors are still bright, and the finish is more or less intact. Some of Lehn's woodenware, however, was decorated by other artists.

The three motifs lettered A, B, and C in Plate 30 appear in succession around the sides of the urn, and the motif D is one half of the border on the cover. The background color is off-white, now somewhat yellowed with age. To paint the pattern, proceed thus:

1. Mix Japan Vermilion with a little Burnt Umber to make an antique red, and paint the line-shaded areas in motifs B and C. The shading of the strawberries in C is achieved by applying the color to one berry at a time, and then blending off the edge with a varnish brush (see the third paragraph on p. 15), thus leaving a white or unpainted area along one side of each berry, which gives a rounded appearance to the fruit.

With pale pink (obtained by adding White to the above red) paint the narrow band between the edge of the flowers in A and C, and the parallel dotted line. Disregard the dots between these lines.

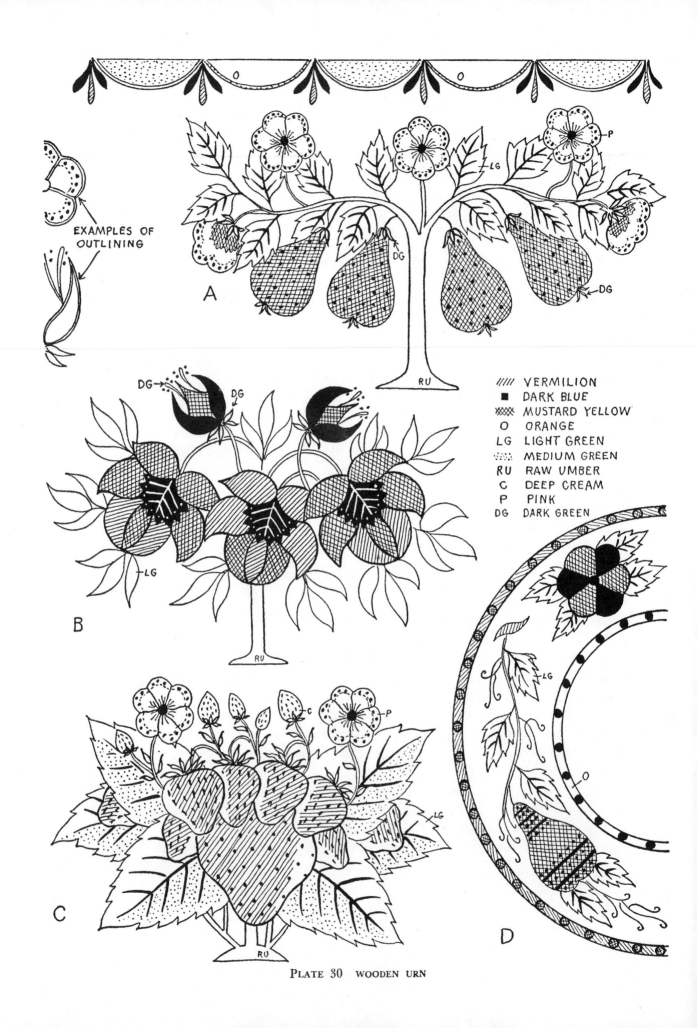

EXAMPLES OF OUTLINING

A

B

C

D

///// VERMILION
■ DARK BLUE
MUSTARD YELLOW
O ORANGE
LG LIGHT GREEN
MEDIUM GREEN
RU RAW UMBER
C DEEP CREAM
P PINK
DG DARK GREEN

PLATE 30 WOODEN URN

Mix Japan Yellow with Burnt Sienna and Burnt Umber to make a golden mustard yellow, and paint all the crosshatched parts in A, B, and D.

Paint the tiny berries in C with a deep cream color. Wait 24 hours.

2. With dark blue, paint the broad areas shown in black, and also the following details: the centers of the flowers in A and C, and their tiny stamens; the dots on the pink bands; the heavy lines on the fruit in D.

With light country green, paint all the large leaves in A, B, and D (for the tiny leaves in these and in C, see paragraph 3 below). The large leaves in C are painted with two brushes, one for light green and one for medium green. Use the light green on the unshaded part of one leaf, and then immediately apply the medium green to the dotted area of it; blend the two areas together a little where they meet. Complete one leaf before going on to the next leaf. Wait 24 hours.

3. With dark green, paint the tiny leaves, and the dots on the yellow strawberries in A; the tiny leaves, the stamens, and the dots on the two upper flowers in B; the tiny leaves in C; and the leaf veins in A, C, and D.

With mustard yellow, paint the veins and dots on the blue flower centers in B. With off-white, paint the seed marks on the red berries in C. Mix Raw Umber and White to make a light brown, and paint the stems and tree trunks in A, B, C, and D. Wait 24 hours.

4. Certain parts of the motifs are outlined in color. To make clear what is here meant by "outlining," halves of two flowers have been sketched on a larger scale to the left of A.

For this work you may find it best to use a small pointed #2 water-color brush. The secret in painting with a pointed brush is quite simple: after picking up the color, twirl the hairs of the brush on the newspaper to shape the hairs and bring them to a fine point. Then apply the color to the pattern.

The following parts are outlined in dark red (Alizarin Crimson and Burnt Umber): the petals of the flowers in A and C; the two upper flowers or half-opened buds in B; the tiny curled tendrils, and the flower petals in D. Also, while you are using the dark red, do the seed marks on the five tiny, cream-colored berries in C.

With dark green, outline the yellow and red parts of the three large flowers in B; and also the five tiny, cream-colored berries in C.

The border at the top of Plate 30 has its colors indicated. For the orange, mix Japan Vermilion, Japan Yellow, and a little Raw Umber

97

to make an antique orange. The orange sections are outlined next day with dark green; and the intervening dark green sections are outlined in mustard yellow.

All the motifs in this Plate may be used individually on small boxes, trays, canisters, etc., as well as in combination on bigger pieces.

Oval Trinket Box

An oval cedarwood box provides this pattern. The steps in copying are:

1. Mix some Prussian Blue, a little Raw Umber, a touch of White, and a touch of Japan Yellow to make a greenish blue with which you paint all the parts shown in black on Plate 31.

Mix some mustard yellow, adding a touch of White to it, and paint all the shaded areas. Wait 24 hours.

2. With a rather thin mixture of off-white, paint all the strokes shown in white on Plate 31.

There was no striping on this box.

///// MUSTARD YELLOW

▪ DARK GREENISH BLUE

'W OFF-WHITE

PLATE 31 OVAL TRINKET BOX

Fraktur Birds and a Medallion

The design on Plate 32 is taken from an old Fraktur painting. It is a useful pattern when a vertical motif is needed and is very effectively and easily used for the decorated side of a bread board. Choose a board of very light-colored wood, and proceed as follows:

1. Sandpaper the board and give it a coat of shellac to seal the wood. Allow 24 hours for drying.

2. Sandpaper the surface. Apply a coat of varnish to the side you select for the decoration. Let it dry for 24 hours. The varnish will enable any corrections to be made with Carbona without staining the wood.

3. When varnish is dry, go over it lightly with steel wool, just enough to take off the high gloss. Transfer the design to the board.

Paint the shaded areas, as shown in Plate 32, with a mustard yellow either light enough or dark enough to show easily against the color of the wood, depending on the particular shade of wood your board is made of. Also paint the veins on the center petal of the flower (not those on the side petals). Allow 24 hours for drying.

4. Add a little Burnt Umber to Japan Vermilion, so as to make it slightly darker, and paint all the dotted areas in Plate 32. Also with this color, paint the veins on the two side petals of the flower.

With a very dark country green, paint the crosshatched areas. Dry 24 hours.

5. Using Japan Black, paint the areas shown in black. The birds' eyes are left unpainted.

6. After the usual drying period, finish the decorated surface with one or two coats of varnish.

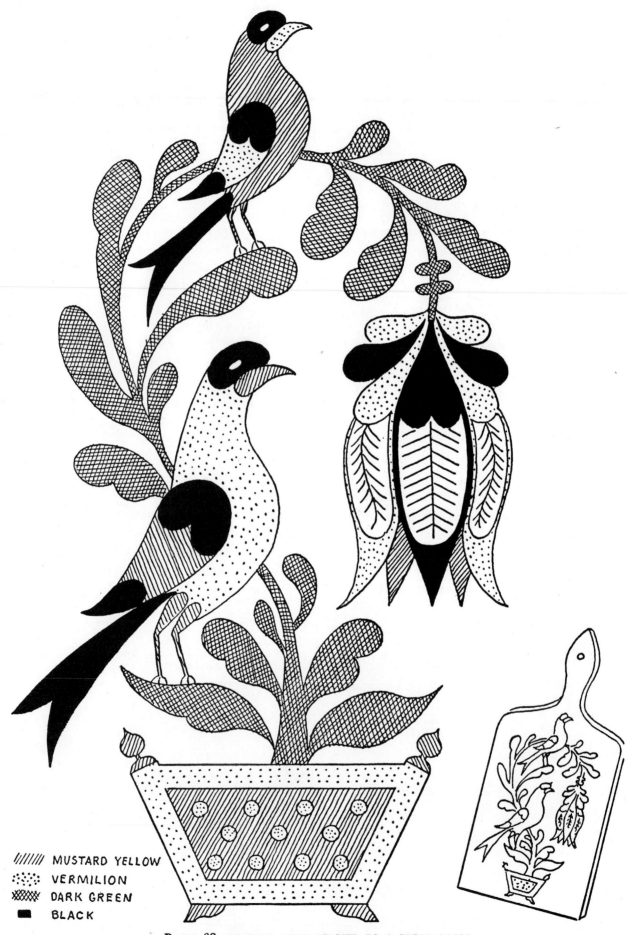

/////// MUSTARD YELLOW

∴∴∴ VERMILION

XXXXX DARK GREEN

■■ BLACK

PLATE 32 FRAKTUR BIRDS APPLIED TO A BREAD BOARD

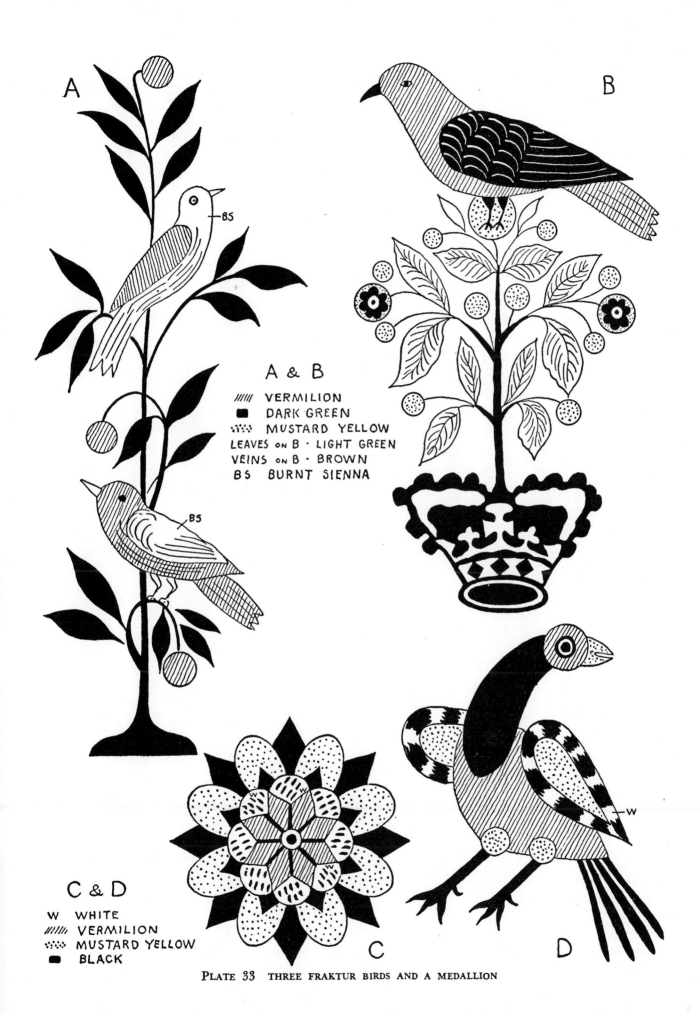

A

B

A & B

///// VERMILION
■ DARK GREEN
⋰⋰⋰ MUSTARD YELLOW
LEAVES on B · LIGHT GREEN
VEINS on B · BROWN
BS BURNT SIENNA

BS

BS

C & D

W WHITE
///// VERMILION
⋰⋰⋰ MUSTARD YELLOW
■ BLACK

C

D

PLATE 33 THREE FRAKTUR BIRDS AND A MEDALLION

Pennsylvania German Plate

The Brooklyn Museum preserves the old plate from which this pattern is taken. The background is a light cream color. The steps in painting the pattern are:

1. Mix a dull olive green, and paint all the crosshatched parts in Plate 34.

Mix some White, Raw Umber, and a little Prussian Blue to make a dull grayish blue, and paint the line shaded areas. Allow 24 hours for drying.

2. Mix some Burnt Sienna with just a touch of White to make it a little more opaque, and paint the parts shown in solid black, the heavy black lines, veins, etc., and also the border. Dry 24 hours.

This pattern is suitable for a round tray or bowl. It should be used only on a light neutral background; for example, on off-white, pale gray, or cream color.

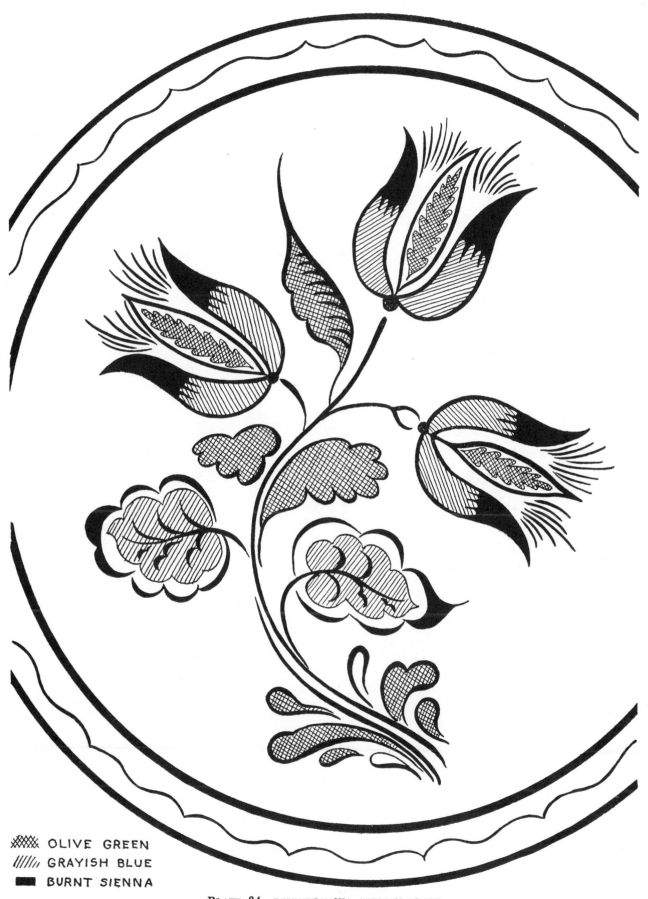

XXXX OLIVE GREEN
///// GRAYISH BLUE
■■■ BURNT SIENNA

PLATE 34 PENNSYLVANIA GERMAN PLATE

Early American
Decorative Patterns
AND HOW TO PAINT THEM

ELLEN S. SABINE

DRAWINGS BY THE AUTHOR

VNR VAN NOSTRAND REINHOLD COMPANY
NEW YORK CINCINNATI TORONTO LONDON MELBORNE

Combined edition first published in 1982
Copyright © 1956 by Van Nostrand Reinhold Company Inc.
Library of Congress Catalog Card Number 81-51277
ISBN 0-442-28423-2

Printed in the United States of America

Van Nostrand Reinhold Company Inc.
135 West 50th Street, New York, NY 10020

Fleet Publishers
1410 Birchmount Road, Scarborough, Ontario M1P 2E7

Van Nostrand Reinhold Australia Pty. Ltd.
480 Latrobe Street, Melbourne, Victoria 3000

Van Nostrand Reinhold Company Ltd.
Molly Millars Lane, Wokingham, Berkshire, England
RG11 2PY

Cloth edition published 1958 by D. Van Nostrand
Company
Second cloth impression 1967
Bonanza cloth reprint edition published 1971 by Crown
Publishers

16 15 14 13 12 11 10 9 8 7 6 5 4 3 2

Foreword

This book is intended to show how, without previous training or special skill, you can introduce into your home painted decoration in the styles which flourished in the Colonial, Federalist, and other pre-Civil War periods of American history. The techniques explained in the book include country painting, stenciling in bronze powder, wall stenciling, freehand bronze, gold leaf decoration, and reverse painting on glass. In addition to the basic instruction in the foregoing decorating techniques, the book contains a large number of patterns for the further development of skill or for the use of those who are already well versed in the techniques.

ACKNOWLEDGMENTS

It is a pleasure to have this opportunity to thank those who have permitted their designs to be copied into this book, and those who have advised or assisted me in its preparation, namely: Mrs. Hedy Backlin, Dr. and Mrs. Roswell P. Barnes, Mr. James Biddle, Mrs. Julia Borcherding, Miss Hilda Borcherding, Mr. and Mrs. Carstairs Bracey, Mr. and Mrs. George E. Brookens, Mr. and Mrs. Vernon H. Brown, Cooper Union Museum for the Arts of Decoration (New York), Mr. Abbott Lowell Cummings, Miss Mary Aileen Dunne, Mr. Robert Hale, Mr. David Johnson, Mr. and Mrs. George E. Jones, Mr. Bertram K. Little, Mrs. Irene L. Lovett, Mr. and Mrs. Roderick D. MacAlpine, Mrs. John G. McTernan, Metropolitan Museum of Art (New York), Mr. Richard J. Metzger, New York Historical Society, New York Public Library, Mrs. J. Woodhull Overton, Queens Borough Public Library (Jamaica, N.Y.), Miss Gertrude E. Robertson, Mr. William H. W. Sabine, Miss Carolyn Scoon, Mrs. Alden Shuman, Mrs. C. Van Dorn Smith, Society for the Preservation of New England Antiquities, Dr. and Mrs. Louis T. Stevenson, Mr. and Mrs. Arthur Tompkins.

E. S. S.

[*iii*]

Contents

PORTFOLIO OF ADDITIONAL PATTERNS

1

Painted Decoration in Early American Homes

Throughout historic time—and indeed during some prehistoric time—men have cultivated arts that transcended the merely useful, and by which they sought to add something to daily life that would render it more interesting and beautiful to contemplate. Painted decoration in the home has been among those arts, and when it is of a kind that conveys to every onlooker a sense of beauty and well-ordered composition, the value of its influence can hardly be overestimated. Its qualities permeate the family, and most importantly and profoundly the children within it. To be surrounded by beautiful things—what better environment could one aim at?

Assuredly, then, we foster a desirable influence when we renew the decorative arts that were practiced by preceding generations. Although not very many examples of painted ornamentation in earlier American homes have survived the passage of time intact, a considerable number of pieces (worn, discolored, thick with grime or with obliterating coats of paint, etc.) have been restored in recent years by the skillful labors of dedicated and enthusiastic researchers. As a result, a large and ever increasing collection of authentic patterns is now available to us as decorative artists in the home.

Earliest Examples

Ornamental painting in America probably started toward the end of the seventeenth century at the mouth of the Connecticut River. The people who originally settled there had been of some substance in England, and with them, or soon after them, came numbers of skilled workmen who met the requirements of their employers not only for

1

fine homes but for well-made and decorated furniture to go into them. Highboys, chests of drawers, small chests, Bible boxes, and numerous other articles for good living were constructed by capable and industrious artisans. From the district around Guilford and Saybrook came beautiful blanket and clothing chests, painted with colorful designs similar to those found in old English crewel embroideries. At a somewhat later period, Berlin became a noted center for the making and decorating of tinware of all sorts, including coffee and tea pots, tea caddies, trays, canisters, sconces, trinket boxes, document boxes, and boxes for many other uses.

Massachusetts lagged far behind at first, chiefly on account of the Puritans' acquired conviction that ornament, being attractive, must be sinful! But time brought its changes, and this colony also began to turn out decorated chests. Though in general these never equaled the products of Connecticut in quantity or in beauty, mention should be made of the fine chests produced about 1725-1745 in the region of Taunton, decorated usually with graceful vines or tree-of-life motifs. Salem too was noted for its fine furniture makers: much of its furniture was painted in light colors, and delightfully decorated with fruits, flowers, vines, and leaves—an unsophisticated style with an attraction all its own.

Japanning

In this study, we are constantly reminded that early American ornamentation had its roots in Europe and beyond. During the seventeenth, eighteenth, and nineteenth centuries a great deal of Oriental lacquered furniture and smaller pieces was brought to Europe, and in course of time this style of decoration came to be widely imitated there. Thus it was that the craftsmen of Europe developed the art which they called "japanning." They succeeded in imitating the Oriental designs comparatively inexpensively by the substitution of coats of varnish for the lengthy hand polishing employed in the original lacquer work.

The fashionable taste for japanned furniture spread in due course to America, and early in the eighteenth century men trained in this craft were attracted to the more flourishing towns and cities such as Boston, Salem, Newport, New York, and Philadelphia. A wide variety of period furniture, including highboys, secretaries, small tables, clock cases, and mirror frames, owed its ornamentation to local craftsmen.

Much of their work was very fine indeed; some of it elaborate to a degree.

Pennsylvania "Dutch"

During the middle and latter part of the same century, the German (or so-called "Dutch") decorators in Pennsylvania were painting those beautiful and colorful dower chests that are so treasured by present-day collectors. Theirs was an extension of a folk art that had its roots in Middle Europe, one whose naive charms contrasted strongly with the sophisticated elegance of the elaborate japanned pieces. The German folk artists also decorated chests of drawers, chairs, and all sorts of smaller pieces for use in the home or for its adornment. The outstanding suggestion of this Pennsylvania German work is that of a people who found sheer joy in painting simple straightforward decorations in gay and beautiful colors.

The Sheraton Period

The Revolutionary War brought a temporary eclipse of the ornamental arts, and it was not until the 1790's, when there was a general upturn in American trade, that such arts again began to flourish. This period is known in the history of furniture as the American Sheraton, its chief inspiration coming from the English cabinetmaker of that name. The period is characterized by many pieces of outstanding taste and beauty of line, such as painted settees, sewing tables, dressing tables, mirrors, chests, commodes, and beds. The much admired background colors in light apple greens, grays, pale yellows, vermilion, coral, and white were then in vogue.

It was during this period that painted ornamentation on chairs became the fashion, and every home that could afford it had one or more of the "fancy chairs." The term was rather loosely used to include almost any chair with a painted decoration, and the vogue lasted into the 1840's. The great majority of the chairs were made of inexpensive woods, since mahogany chairs were too expensive for all but a few. Chair manufacturing flourished greatly, especially in the neighborhood of forests from which the wood could be obtained conveniently and cheaply.

Stenciling

But this period of good taste and fine design in decorated furniture did not last long. The small producers began to feel the effect of competition from large factories which were turning out copies of the same chairs and other pieces in bulk. Trying to meet the consequent price-cutting, the small makers and their decorators were led in one way or another to revise their earlier standards. Stenciling in bronze powders—a speedier method of decoration than the purely freehand techniques—was introduced about 1815. Chief among the manufacturers of stenciled chairs was Lambert Hitchcock of western Connecticut, and examples of his work and that of some other early stencilers show exquisite taste and craftsmanship. But, generally speaking, the individual craftsman was in the long run unable to go on competing with factory production. Decorative standards were lowered, work showed evidences of more and more haste and at last the competition and the public's lack of sufficient artistic discrimination put an end for several decades to the production of the painted ornamental design on furniture which is now again so highly esteemed.

Decorated Walls and Floors

The decoration of furniture and utensils was sometimes supplemented in American homes by the decoration of walls and floors, particularly by means of stencils. In Colonial days, well-to-do people could buy fine imported wallpapers from France, England, and the Orient; while wallpaper produced in the Colonies was also available at less cost. Toward the end of the 18th century there was developed a form of decorating walls by painting them so as to resemble wallpaper. This wall decoration, in which stencils came to be most commonly used, was done by traveling decorators who carried their stencil kits and designs from place to place. In the more inaccessible parts of Maine, New Hampshire, Vermont, Massachusetts, and Connecticut one may, if lucky, still find examples of their work, or more likely some small remains of it. Even so, it is often under many layers of wallpaper applied by succeeding generations. In general, the designs used for walls were bright and gay.

Floors too might be painted or stenciled. The commonest pattern was that of a rug with wide running borders and an overall repeated design. The period of decorated floors ranged from the 1780's until well into the nineteenth century.

4

Beauty in the Home

Even this brief survey may help us to realize how big a part was played by color and design in brightening and enriching the lives of our predecessors in a less mechanized age. They may not have talked or thought much about the reasons for ornamenting their homes in this way, but there is no doubt that they derived great pleasure from these beautiful decorations applied by hand to their home surroundings. Perhaps today we cannot recapture the instinctive folk spirit of those people or the simplicity of much of their life. But even if we must be more conscious and deliberate in our revival of their arts, we still feel the same human needs which they did, and what we create invariably brings us the same satisfying results within and without.

"Decoration" or "Ornamentation"?

The name of the skills we practice is not of great importance to our results; yet in any discussion, written or spoken, terms ought to be the most suitable we can find. It may be noticed that in these pages the words "decoration" and "ornamentation" are used in much the same sense, with a decided preference given to the former. This preference should be explained.

In the early nineteenth century, we find that the term "ornamental artist" was assumed by those rather sophisticated amateurs (that is to say, ladies of leisure) who painted on velvet or glass; modeled in a variety of materials; made artificial fruits and flowers, flower stands, screens, worsted work baskets, and straw baskets; engraved, painted, and beribboned innumerable kinds of boxes from cardboard, glass, and wood; and so on. Thus the word "ornamental" was one of extremely wide scope even with the amateur, while in the professional field it took in inlays of wood, metal, ivory, mother-of-pearl, etc., not to mention the moldings and carvings which characterized the most elaborate productions. In addition, small articles were called "ornamental," not because they were ornamented (sometimes they were plain) but because they themselves were "ornaments," that is, articles added to the more essential furniture with more of an eye to the general effect than to the utility of the additions themselves. In short, the word "ornament" and its derivatives convey at first glance the idea of something raised from the surface, or even of a separate article.

One may conclude, therefore, that in the titling of her monumental

5

book *Early American Decoration* (1940), the late Esther Stevens Brazer made a good choice of the word "decoration," for this word is far less comprehensive than the word "ornamentation," and is most appropriate to the flat, painted, stenciled, and gilded work with which Mrs. Brazer dealt, and with which we are almost exclusively concerned in the present book. At the same time, since the word "ornamentation" does also cover our work, we may vary the language occasionally by using it as a synonym for "decoration."

2

Types of Decoration

The main types of decoration dealt with in this book are freehand bronze, stenciling in bronze powders, gold leaf, country painting, painting on glass, and wall stenciling. With the exception of stenciling, these are all broadly known as freehand methods of decoration. But even in painting "freehand," and when no stencils are used, the designs are first traced on the surface to be decorated; so you have an outline to follow when you begin to paint. Let us see what is involved in each type of decoration.

Freehand Bronze

Freehand bronze is a method of applying metal powders to an underpainting that is partly dry and to which the powder will stick. The technique is centuries old, and in all probability had its origin in the Orient. More than one shade of metal powder was frequently used by the early American decorators, and examples of this are found in conjunction with gold leaf, and sometimes with stenciling. In some cases the painted surface was entirely covered with the metal powder; in others only parts were covered. Delicate shading and beautiful effects can be obtained with bronze powder, and the finished decorations invariably convey an air of elegance.

Stenciling with Bronze Powders

A much quicker method of decoration than freehand bronze employs stencils. The chief period of popularity of stenciling was from about 1820 to 1850, and it was used on chairs, wardrobes, pianos, beds, cornices, chests, and the many small articles used in the home. The early work generally shows the greatest skill and finest detail, being done in pale gold powder, often in conjunction with gold leaf. The cutting of the stencils was admirable, and fruits and leaf veins were

7

delicately shaded. Later, silver was used as well as fire and deeper gold powders. But as time went on, and as competition with factories became keener, stenciling deteriorated, being performed with more haste and less skill. Toward the latter part of the period, many all-in-one stencils were used, and design and execution were equally poor. The chief advantage of stenciling today is that it repeats beautiful decorations for us with a minimum of labor; it does not mean that one must work in a hurry. Besides, stenciling is special fun to do!

Gold Leaf

Gold leaf decoration was used in ancient civilizations and has been adopted and enthusiastically admired wherever it has been introduced. For a combination of magnificence and beauty, nothing can equal it. From the seventeenth century onward, the importation of decorated articles from the Orient spurred first European and then American craftsmen to experiment in copying these superb lacquered wares. Although Western craftsmen seldom equaled the patient Orientals in their extremely fine and detailed work (time was too precious for that), the work they did is justly admired. And if the early high standards declined as time went on, it certainly was no fault of the artists. Once again, the public neglected to give preference to its best artists and craftsmen and began to patronize artistically inferior factory-made products. But no craftsman who once begins work in gold leaf, fails to be fascinated by its enchanting splendor.

Country Painting

This is the name given to that decoration which is specially reminiscent of country folk art: primitive designs, bright colors, and simple forthright arrangements. Subtlety, elegance, and sophistication play no part in this type of decoration. But it is lovely in its kind, at once gay and restful. It is relaxing to do and wonderful to live with; in short, it is a most beneficial antidote to the complexities of our modern mode of living. If in this book only a few country patterns are given, and the emphasis is laid largely on the gold and bronze powder types of decoration, it is not because I love country painting any the less, but simply because my last book, *American Folk Art*, dealt exclusively with that form of decoration, and this time much space must be given to the others.

8

Painting on Glass

Painting on glass, in reverse, was used to decorate many mirrors and clocks in the old days, and despite the fragility of the foundation, many of these paintings have survived. One also finds a certain number of glass paintings which were made simply to hang on the walls as pictures. The painting work was carried out on the back or underside of the piece of glass, and was done, of course, in reverse. This meant that fine details of drawing and highlights had to be painted first, and background or sky last. Many glasses were done in gold leaf only, or in gold leaf and color; others have stenciled borders or details. Subjects might be almost anything, but great favorites were ships, eagles, and landscapes. Glass paintings are exciting to do, and delightful to look at.

Stenciling on Walls

Wall stenciling was originally done to imitate wallpaper. Most stenciled rooms that have survived appear to belong to the first quarter of the nineteenth century. Simple motifs, symmetrical arrangements, absence of shading, and soft clear flat colors, are their chief characteristics. One finds a variety of forms among the patterns: borders of flowering stems, acorns, and conventionalized leaves outlined windows, mantels, and doors; while deep friezes edged the ceilings. Floral sprays, pineapples, hearts, geometrical designs based on the circle, swags, eagles, and flower-filled urns were popular.

3

Materials Required
and Their Care

To do good work in painting and decorating, it is necessary not only to have the proper materials but also to know how to take care of them. The following are the essential required items, with directions for their care.

Paint Brushes. *(a)* For applying background paints and for varnishing, you can use ordinary one-inch wide flat bristle brushes as sold for a small price in paint stores. The half-inch size is also useful for small areas. Some artists prefer better quality brushes, and find them worth the extra cost. In any case, it is of prime importance to keep your brushes in good shape and perfectly clean.

For cleaning brushes, have on hand a screw-top jar of turpentine, or "brush bath"; this can be used several times over. To clean a brush, first wipe it off on newspaper. Then, after dowsing it up and down in the brush bath, let it stand twenty minutes or more in enough of the fluid to cover the hairs. After this, wash out the brush thoroughly in hot water (not boiling or near boiling), using yellow laundry soap. Rinse well with clean hot water, shake out the surplus water, and shape the brush carefully so that all hairs are in alignment. Stand it up on its handle in a jar where it can dry undisturbed.

Varnish brushes must be thoroughly cleaned each time they are used. In the case of *paint* brushes, however, if you intend to use one the next day, it may be left standing overnight in turpentine or in plain water, so long as there is enough liquid to cover the hairs, and provided the brush is suspended so that it does not rest on the hairs.

(b) For painting the designs you will need the following:

1. Square-tipped ox-hair rigger or showcard brushes. As the size numbers used by different makers are not uniform, the actual size of

10

the required brush has been illustrated in Figure 1. Buy two for convenience.

2. Square-tipped camel's hair French quill brushes, #0 and #1, also illustrated in actual size in Figure 1. Buy two #1, and one #0. #2 (not illustrated) is useful for larger strokes.

3. Striping brushes. These square-tipped quill brushes, illustrated in Figure 1, are used without a handle.

4. Red sable scroller—a long-haired pointed brush for painting long fine lines and curlicues.

These brushes are cleaned in the same way as described above for varnish and paint brushes, although it is convenient to have a smaller brush bath jar. It is particularly important in the case of these brushes to let them stand in the turpentine, so that the paint and varnish that has worked up into the ferrule is dissolved.

It is only at the end of a painting session that you wash brushes with soap and water (as described above), since you cannot paint properly with a paint and varnish mixture if your brush is still wet from water. So during the painting session, when you want to go from one color to another, just douse the brush up and down in the turpentine, and then wipe the turpentine off with a soft cotton cloth.

It is possible to clean brushes in a dry cleaning fluid instead of in turpentine, but I cannot advise anyone to do so. On the contrary, information has come to my attention which obliges me to issue the emphatic warning that most cleaning fluids that will dissolve varnish are dangerous to health, especially their fumes. Therefore, repeated use of them should be rigidly avoided.

There are, however, one or two jobs that do necessitate use of a dry cleaning fluid, and these are mentioned in the next paragraph, and in the later paragraph headed "Architect's Tracing Linen." Note the warning in the next paragraph.

Trichloroethylene is a dry-cleaning fluid that may be used for making erasures either when painting patterns on frosted acetate or when decorating objects. One small can or bottle is enough as a little on a cloth will do the job. Be sure to read the warning on the can. This seems to be the dry cleaning fluid least harmful to health, but even so it should be used only in a well-ventilated room. Use it sparingly and do not inhale the direct fumes. Do not use it to remove paint or varnish spots on your

skin. A little, very little, turpentine may be used for that purpose, but soap and water is best for your skin.

Tube Colors. (*a*) Japan Colors in tubes: Light Vermilion, Light Chrome Green, and Medium Chrome Yellow. Also Lamp Black or Ivory Black.

(*b*) Artists' Oil Colors in small tubes: Prussian Blue, Alizarin Crimson, Raw Umber, Burnt Umber, Burnt Sienna, Yellow Ochre, and Yellow Lake (or Indian Yellow). Add a medium-sized tube of Titanium White or Superba White. Note that Prussian Blue, Alizarin Crimson, Yellow Lake, and Indian Yellow differ from the others in that they are transparent colors.

As the name suggests, the Japan colors were originally made in that country, and came to be included in the decorative equipment of, amongst others, our old-time coach painters. Japan colors are opaque, and give a flat, smooth surface. The tubes containing them should be handled carefully because they crack easily, and when this happens the paint soon dries out and is useless. When they are not in use, stand the tubes upside down, with the cap at the bottom. This will cause the oil to rise in the tube and remain mixed with the pigment. A tin can makes quite a good tube holder (see Figure 1).

Keep the caps screwed on all tubes when not in actual use. If a cap sticks, don't try to unscrew it by force and so twist the tube. Just hold the cap for a second or two in the flame of a match, which will cause the metal to expand. Using a cloth to protect your fingers, you can then unscrew it.

If the paint remains inside when you try to squeeze some out, avoid using force, which will split the tube. Probably some dried paint is clogging the opening, and this can be removed with a narrow knife-blade.

Varnish. Buy quality varnish in the half-pint size. I use it as a medium for mixing tube colors in the painting of designs, for stenciling, and also for the finishing coats on a decorated piece. When buying a varnish, remember that very heavy varnishes are not good for our work.

Never stir varnish. So long as the can has not been opened, the contents will keep perfectly. However, once varnish comes in contact with air, the spirits begin to evaporate; and varnish that shows signs of a definite thickening should not be used. Since there is no way to

12

salvage varnish, proper care should be taken to avoid needless waste. Keep the cover on the can when the varnish is not in use. Be sure the cover is on *tightly*—step on it to make quite sure.

When about one-fourth of the varnish has been used, pour the remainder into small bottles with good screw caps. Fill them to the top. The idea is to expose varnish to as little air as possible. Even when tightly covered, the air inside a partly empty can will thicken the varnish.

Bronze Powders. Pale gold lining, deep gold, aluminum (for silver color) and fire. These powders should be put in small bottles for convenience in handling.

Some of the bronze powders are finer than others, and these are generally called the "lining" powders. The difference is not important at the start of this work, with the exception that the finer or lining powders should always be used in pale gold and in aluminum.

Gold Leaf. One book of mounted pale gold.

Tracing Paper. One roll, thin and very transparent, twenty-one inches wide.

Frosted Acetate. One roll, medium weight. This is a semi-transparent plastic sheet, one side of which is frosted so that it will take paint. Its transparency enables one directly to copy a pattern placed under the acetate sheet, without having first to trace an outline on tracing paper.

Black Drawing Ink.

Crow-quill Pen. A fine-pointed pen.

Drawing Pencils. H, 2H, and 4H.

Decorator's Masking Tape. One roll.

Architect's Tracing Linen. One yard. We make our stencils out of architect's tracing linen, the kind that has a shiny undersurface. This strong fabric will last almost indefinitely if it is properly cared for. It should be kept away from all forms of moisture. Cut stencils should be kept in wax paper envelopes, which can be made from kitchen waxed paper secured with scotch tape. Stencils should be kept lying flat and, immediately after being used, should be cleaned on both sides with dry-cleaning fluid and a soft cloth. They dry in a few minutes. In connection with the use of dry-cleaning fluid, see the caution above (p. 11).

Stencil Scissors. These are cuticle scissors but with *straight* blades. Don't try to cut stencils with an inadequately sharpened pair of scissors. The tiny points must be extremely pointed and perfectly aligned.

Mohair. A piece, about 9 by 12 inches, of this high-piled upholstery fabric, to be used as a "palette" for holding the bronze powders when you stencil or do any freehand bronze shading. Blanket-stitch or overcast the edges of the mohair to prevent fraying. The powders are placed along the lengthwise center fold, as shown in Figure 4. When not in use, the mohair should be folded in half lengthwise, rolled up tightly crosswise and secured with an elastic band. The high pile and the tight rolling keep the powders from mixing.

Velvet. Three-inch wide, silk-backed black velvet ribbon of the best quality (tightest weave) you can get. This is used to apply the bronze powders. Prepare three or four pieces, each four inches long, by sewing the two rough edges together to form a cylinder, leaving both selvage ends open. These are called "velvet fingers." Keep one for freehand bronze, one for gold stenciling, and one for aluminum powder.

Black Paper. For copying stencil patterns, and for practice in stenciling. This may be prepared by painting convenient lengths of ordinary shelf paper with two thin coats of flat black. For directions on thinning black paint, see Chapter 13.

Primer Paint. Used on all tinware as an undercoat before the background color is applied. A high-grade metal primer paint should be used, one which dries quite smooth and so requires very little sandpapering. It should be stirred thoroughly before use, and may be thinned with turpentine. Ordinary red lead is not good enough for our purposes.

Once you have finished using the paint, wipe off any excess paint lying in the rim of the can with a cloth. Then pour a little turpentine on top of the paint in the can, just enough to cover the surface, letting it float there. The turpentine will prevent a skin forming on the surface of the paint. Then replace the can lid and press it down tightly. The next time you open the can, simply mix the turpentine in with the paint, which will probably thin it just enough for use.

Flat Black Paint.

Paint and Varnish Remover.

Plastic Wood.

Turpentine. One quart. Give the can a shake or two before using.

Steel Wool. #000, or #0000.

Sandpaper. #000 or very fine.

Kitchen Aluminum Foil. One roll. For use in making a "tinsel" picture; and as a palette for mixing colors for wall stenciling.

Crude Oil. Small bottle.

Shellac. This, like the six previous items, is obtainable in the paint stores. Always use fresh shellac. Shellac left over from previous jobs or shellac left standing in half-empty jars for a while should not be used, as it will probably not dry properly, but remain sticky; then your only recourse is to remove it with the paint and varnish remover—a tedious job.

Rusticide. For removing rust. Rusticide is sometimes obtainable from local hardware or paint stores.

Kneaded Erasers. Two or three small ones for use in freehand bronze work. Store in a screw-top jar to keep them from drying out.

Asphaltum.

Magnesium Carbonate. 1 oz. cake, usually available at the larger drug stores.

Powdered Pumice. 2 oz. size. Should be bought in a drug store in order to obtain a finer quality than in a hardware store.

Cotton Rags. For wiping up paint or wiping brushes.

Bottle Caps. At every opportunity save bottle caps about one inch in diameter and one-half inch deep—for example, those that come on catsup bottles. Such bottle caps make conveniently-sized receptacles for varnish used in painting designs.

Empty Jars and Bottles. Collect some small jars or bottles, about 2 or 3 inches deep, having good airtight screw tops. These will be needed for holding varnish, turpentine, and cleaning fluid. Bronze powders, which come in packets, are handled more conveniently if they are transferred to small bottles or jars. Cold-cream jars and others of similar types are useful for holding the mixed background colors.

Newspapers. Always have plenty of newspapers on hand. You will need them to spread over your work tables, to wipe brushes, and to use as "palettes" in painting designs.

List of Suppliers

For a list of suppliers see *American Antique Decoration,* p. 8.

4

The Painting of Patterns

An important part of your training is the painting of patterns on frosted acetate. Not only does this give you color records of the patterns, but it is a means of getting much valuable practice. There is another important advantage in this saving of your time and energy. Mistakes made in work on frosted acetate can simply be discarded. But a mistake made on furniture means a lot of hard work in cleaning off the surface and repainting the background color—not to mention that inevitable feeling of defeat, irritation, and depression! Nobody wants to waste time or to do unnecessary work.

To paint a pattern, cut a piece of frosted acetate large enough to cover the design you want to do, and attach it to a piece of thin cardboard by three of its corners. Let the frosted side be uppermost, and use small pieces of decorator's tape to fasten the corners. Slip this device into the book so that the acetate will be directly over the design to be painted, and the cardboard under it (see Figure 1). Proceed to paint directly on the acetate, according to the directions which will be given in the succeeding chapters.

Sometimes this method may not be convenient, or even practical, as, for example, where a pattern extends over to another page as in Figures 25, 26. Then it is necessary to make a careful tracing of the complete pattern on tracing paper, using a well-sharpened H or 2H pencil. Mount the complete tracing on a white cardboard by means of small pieces of decorator's tape at the corners. Place the frosted acetate over this. Never anchor your work down to the table surface.

When the pattern has been painted, keep the tracing carefully preserved in your filing folders, as these tracings are necessary when decorating (see Chapter 15, Transferring the Design), and can be used any number of times.

All patterns are painted in stages, and each stage must be allowed to

17

dry thoroughly, at least for twenty-four hours, before the painting of the next stage. If you paint on something not thoroughly dry, what is underneath will never fully dry out, and will subsequently cause a cracking off of the paint or varnish covering it.

When painting with French Quill brushes it is important to have pieces of tracing paper on hand, in order to try out brush strokes now and then, and so make sure the brush remains flexible and its hairs in alignment.

It should be borne in mind when painting patterns that all colors are mixed with varnish. We never use turpentine as a medium in painting designs, although we do use it for our background coats of paint. The varnish should be in good condition: don't paint with varnish that has begun to thicken. In mixing color with varnish, be sure it is thoroughly mixed, with no lumps remaining. To "thin" a color in this connection means to add more varnish to the mixture.

Incidentally, the tiny hairlines in Figure 2, Border 1, and the stems in Border 8 are shown as fine pen lines. When painted they will, of course, be slightly thicker, but I have shown them as fine pen lines because the natural tendency is to paint slightly heavier. If I drew a double line to show thickness, you would probably paint the stems still thicker, and so lose the delicacy of the design. This explanation applies to all patterns throughout the book.

Stencil patterns should also be copied for practice, but these are not done usually on frosted acetate, but rather on black paper as described in Chapter 7.

When completed and thoroughly dry, all patterns should be mounted on thin cardboard or heavy mounting paper, and the mount should be, if possible, of the same color as the original piece from which the patterns were taken. The mounting is done by means of small pieces of transparent Scotch tape at the corners. Last of all, the pattern should be given a protective waxed paper flap, folded over at the top and secured by Scotch tape on the back of the mount. Keep patterns standing upright in folders or portfolios, for future reference.

Your first patterns may not be done well enough to satisfy you, but do not throw them away. It is a valuable part of your training and of the development of your critical faculties to look back from time to time at your earlier efforts. And it can be very encouraging too!

18

5

The Basic Brush Strokes

The foundation of all our decorative painting is the free-hand brush strokes which are shown in Figure 1. These strokes are made with a square-tipped camel's hair French-quill brush. A certain degree of skill in handling this brush and in painting these strokes is needed before you can go on to successfully decorating furniture, etc. To gain this skill one should practice the basic strokes on sheets of tracing paper.

The best kind of table to work at is a rather low one, such as a card table. Cover the top with several layers of newspaper as a protection. Then take a double sheet of newspaper and fold it in eighths for a "palette." We use newspaper for a palette chiefly because it is a kind of paper which readily absorbs superfluous oil in the paint.

Now set out the following necessary items on the table or close at hand:

A tube of Japan Vermilion.

Square-tipped showcard brush for mixing.

Square-tipped camel's hair #1 quill brush for painting.

Tracing paper.

Small jar of turpentine for cleaning brushes.

Cotton paint rags.

Small bottle cap filled with varnish and placed on the palette.

A weight to anchor the palette (a full varnish can will do).

Brush rest—to keep the handles clean (notches cut in a cardboard box cover do well).

Brush Stroke Practice

Place a piece of tracing paper over Figure 1. Squeeze out about an inch of Japan Vermilion on to the newspaper palette. (Squeeze out more as you need it).

Using the showcard brush, dip out several brushfuls of varnish on

19

to the Vermilion and mix together thoroughly, so that no lumps remain. The mixture should contain enough varnish to be easily manageable yet not so much that it becomes thin and watery and spreads as soon as it has been painted. Lay down the mixing brush on the brush rest.

Take the quill brush and dip it in the red mixture. Draw the brush back and forth a few times on the palette so that the paint works into the full length of the hairs. The brush should be loaded to its full length, not just the tip of it; and each time you go back for more of the mixture in the process of painting, be sure again to load the brush to its full length. However, avoid overloading it: the brush should not be dripping and bulging with paint.

Now hold the brush as shown in the illustration, that is, almost vertically, but slightly inclined toward the hand holding it; the wrist off the ground; and the hand resting lightly on the tip of the little finger. The forearm can rest on the edge of the table. The thumb and forefinger are used to raise or lower the brush as needed—lowering it for a broad stroke, raising it for the narrower parts of the stroke or to finish the stroke.

Paint the broad stripe A in Figure 1, as seen through the tracing paper. Notice how the brush flattens out to a knife-edge when it is lowered to paint the stripe. Now, slowly raising the brush, pull it off to one side, using the knife-edge to end the stroke on a hairline.

Now paint the row of brush strokes B. Begin at the broad end of the stroke by lowering the brush and then gradually raising it to end on a hairline. Hold the brush steady with the thumb and forefinger, without twirling it. The direction and movement of the whole hand and arm are used to arch the stroke. The fingers are used only to raise and lower the brush as needed. Paint each stroke slowly and deliberately. Do several lines of the strokes. Of course, each stroke should be done with one application of the brush—no going back to touch up.

If your strokes end up too thick, you have too much paint mixture on the brush, or you failed to raise the brush enough at the end. Too much paint may also cause the stroke to spread out or "run" after a few minutes. Reload and re-shape the brush for each stroke. With practice, you will learn instinctively to load the brush with the right amount of paint for the size of stroke you want to make. If the brush becomes so flattened that you find yourself painting strokes like the one marked C, turn the brush a little, so that as you lower it, the hairs round themselves for the start of the stroke.

20

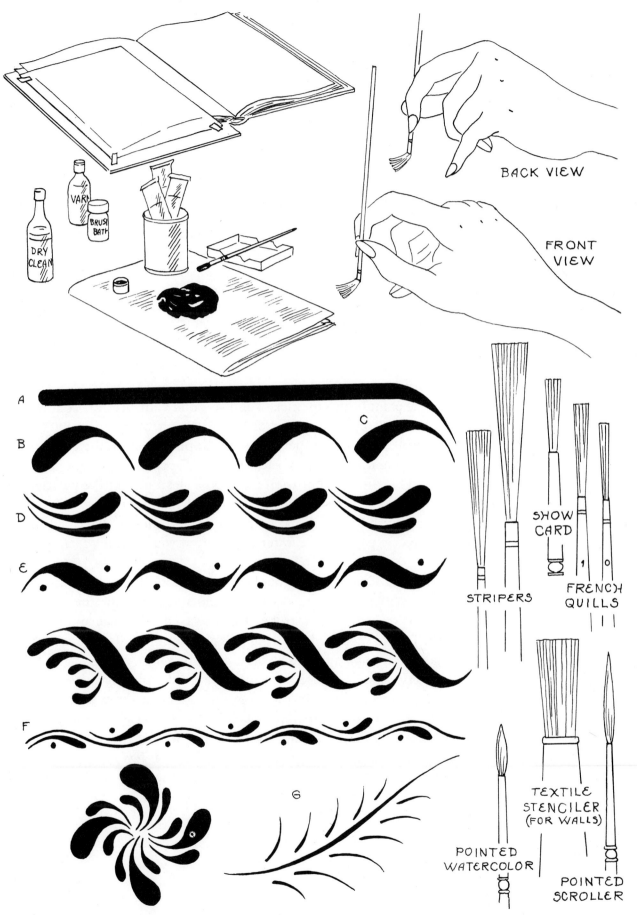

BACK VIEW

FRONT VIEW

DRY CLEAN

VARN

BRUSH BATH

A

B

C

D

E

F

G

STRIPERS

SHOW CARD

FRENCH QUILLS

TEXTILE STENCILER (FOR WALLS)

POINTED WATERCOLOR

POINTED SCROLLER

FIGURE 1 BASIC BRUSH STROKES

To paint the line marked D, turn the book almost completely around, so that you can paint toward you, which is the proper method for this kind of work. In painting a cluster of strokes, start with the largest one each time.

For strokes that begin with a point and end with a point, as in line E, flatten the brush on the palette as you load it. Then, holding the brush high, with the flattened edge pointing in the direction the stroke is to take, begin to paint, gradually lowering the brush to do the broad part, and then gradually raising it again to finish. Go back to the palette again after each stroke to re-load and flatten the brush. Paint all the broad strokes in E first, then the dots.

To paint a dot, round the brush on the palette, and then, holding the brush upright, paint with the end of the hairs. If your brush resists being rounded, paint the dot with one end of the flattened edge.

To paint the thin running line F, flatten the brush on the palette, and paint with the knife-edge. For a vein, as in G, do the same, but lower the brush slightly for the broader parts.

When the paint begins to thicken and you find your brush becoming less flexible, clean both quill and showcard brush by first wiping off excess paint on clean newspaper and then dipping them in the turpentine. Douse them up and down a few times. Wipe off turpentine with a clean rag. Then squeeze out fresh paint on a clean part of the palette, and mix with fresh varnish. Proceed with your painting. It is only at the end of a painting session that you wash the brushes, as described in Chapter 3. Never paint with a water-wet brush if you are using a varnish mixture.

As you paint, keep turning your work around so that it is always at the most convenient angle, one which permits you to draw the brush toward you as you paint each stroke. Keep relaxed. Patience and practice are the keys to success. Practicing half an hour every day for a week or two should give you a fair command of the brush.

For practice you may use Figure 2 as a guide, placing a piece of tracing paper over it. In painting large units, such as those in the top border, we use the same principle of brush stroke, that is, lowering the brush to cover a wider area, and raising it for the narrower parts or to finish off on a point such as the tip of a leaf. We use as few strokes as possible, and we paint deliberately, but at the same time as quickly as possible, so that the finished surface will be smooth and flat. Going over

22

an area repeatedly with numerous little dabbing brush strokes, will only produce a rumpled, messy, and amateurish surface.

In the top border, Leaf A has been marked off into four areas, each one representing a brush stroke. Paint the strokes in their numerical order, each stroke slightly overlapping the previous one, so that you leave no spaces unpainted to which you have to go back for touching up. Never paint such a unit by outlining it first with the paint brush and then filling in; this type of work will inevitably show up on the finished surface and proclaim your lack of mastery. Flower B is similarly marked off in areas, and should be painted in four strokes, as numbered.

For the time being, disregard all superimposed details in Borders 1, 5, and 8, which are explained in the chapter on Freehand Bronze. In Border 2, paint the running line first, as a guide line, then the brush strokes, and lastly the dots. All the borders are freehand bronze or gold leaf borders, techniques which are described in subsequent chapters.

6

Freehand Bronze

Freehand bronze painting is the description given to a method of applying bronze powders to a painted surface that is still only partly dry. The word "bronze" in this connection means all the metal powders which give the effect not only of bronze but of silver, gold, copper, and brass in a great variety of shades. Note that we do *not* paint with a liquid metal paint: we use these metal powders dry.

In order that the loose powder may not stick where it is not wanted, we must start with an absolutely dry background of flat or dull paint. The pattern is then painted on the background with a mixture of Japan paint and varnish. The result is allowed to dry to a certain tacky stage, whereupon the metal powders are applied with a piece of velvet, either completely covering the tacky surfare, as shown in Illustration 7, or partially covering it in a shaded manner. Black penline or painted details are added at a later stage.

To Copy a Border Pattern

1. Turn to the gold leaf patterns in Figure 2. These will serve excellently for our first freehand bronze practice. Cut a piece of frosted acetate large enough to cover the upper half of the page, and attach it, frosted side up, by three of its corners to a thin cardboard. Use small bits of masking tape. Slip this over the page and into the book as shown in Figure 1, so that the acetate is just over the upper half of Figure 2. Using the illustrations under the acetate as a guide, you will paint directly on the acetate. Review the chapter on Basic Brush Strokes.

2. In one corner of your newspaper palette place a small mound of pale gold lining powder. Set out a "velvet finger." Now, on the palette mix some Japan Vermilion and varnish together as described in Chapter 5, but this time using enough varnish to make the mixture rather thin—

24

A B 1. ICE BUCKET

2 SMALL BOX

3 CHEST OF DRAWERS

4 BOX

5 BELLOWS

6 LACE EDGE TRAY

7 HIGHBOY

8 TRAY

FIGURE 2 GOLD LEAF BORDERS

so thin that when painted on the acetate it will be a slightly transparent light red.

Using a #1 quill brush, and disregarding all superimposed details, start with Border 1 by painting first the larger leaves and flowers, then the smaller leaves, and last of all the tiny hairlines. Be sure not to over-load the brush. Apply the mixture evenly, without leaving any overly wet places. Paint carefully, so that you do not have to go back to touch up any places. Paint it and leave it. Your work should have a smooth glossy surface.

In working along, keep watch on the parts already painted, and as they begin to dry, but before they are actually dry, apply the pale gold powder with a "velvet finger." (Figure 4 shows you how to wrap the velvet tightly around your forefinger). Pick up a good supply of gold powder on the fingertip, and use a small circular motion and a very light touch to apply it. Do not dab it on. Just skim the surface lightly with the small circular motion. Continue painting and applying the powder to the drying areas.

The trick is to apply the powder at just the right stage of tackiness. If you do it too soon, or use the velvet with too much pressure, some of the hairs of the velvet may stick to the surface, or the surface may be roughened. If you wait too long, the surface will be too dry for the powder to stick. Practice will give you the proper timing. Remember that on a dry day the surface will dry more quickly than on a wet day.

In painting a pattern, or a particular section of a pattern, we usually paint the larger parts first, then the medium-sized ones, and so on down to the smallest. This is done because the larger areas take longer to dry, whereas the tiny hairlines dry almost at once.

When you have finished applying the last of the gold powder, lay the pattern aside to dry for twenty-four hours.

3. Wipe off the excess loose gold powder with a soft cloth. If the powder sticks to the acetate, use a damp sponge, patting the surface dry with a clean linen towel. Be sure to remove every bit of loose powder on the pattern and on the acetate.

A "kneaded rubber" eraser is sometimes useful at this stage in re-moving excess powder from the acetate. Cut a fresh eraser in half; take the half you intend to use and pull it apart into small pieces; then knead the pieces back together again, using the fingers of one hand to knead the material in the palm of the other. The warmth of the hands will help, and you will find that you can form the eraser into any desired

26

shape, pulling it out to a point if you like. With this eraser, go over the acetate, and it will pick up the excess powder. Be careful not to touch the painted design. From time to time, re-knead the rubber to get a clean surface on it.

With a crow quill pen and black drawing ink, draw in the details of veins, stamens, etc., shown in white on Figure 2. Allow an hour for the ink to harden.

For practice do the rest of the borders in Figure 2, and the patterns in Figures 21-23, 25-27, and 29.

Excess Bronze Powder

In decorating a painted object, it is sometimes difficult to wipe off the excess loose powder after the twenty-four-hour drying period. A metal object may be held under running cold water. For a wooden object, use a damp sponge, patting the surface dry afterwards. If powder still sticks, use the kneaded eraser, as described above. There are, however, two things you can do before the decoration is applied to diminish this hazard: (a) Wait one month after the last coat of background paint has been applied, to allow the paint to harden. A longer wait is still better. (b) Just before you transfer the pattern outlines (see Chapter 15), take a *pinch* of whiting powder, and, with your finger tips, rub it lightly over the painted surface. Blow off all excess powder.

The fine bronze lining powders tend to stick where they are not wanted, but as they give a more beautiful surface than the coarser powders, it is worth while to learn how to use them. A little patience and practice will get results.

The Protective Coat of Varnish

Understandably enough, beginners are often a bit shaky when they first come to draw the pen and ink lines and details on the gold surface. They may make mistakes which they find difficult to rectify.

One way to cope with this problem is to give the gold surface a coat of varnish (see p. 34). Wait twenty-four hours, and then go over the varnish lightly with #000 steel wool, applying just enough pressure to take off the gloss, which disappears almost at once. Dust off the surface and then transfer (see p. 80) a few of the main lines of the pen and ink detail, to act as a broad guide. But leave most of the detail to be done by eye, thus preserving that freedom and spontaneity which is the charm of patterns of this type.

27

Warning

There is a warning, however, which must be heeded whenever you use a protective coat of varnish over bronze powders during the decoration of a piece of furniture or any other object. The decoration must be completed as soon as possible and the finishing coats of varnish applied without delay; otherwise the metal powder will probably tarnish. I have seen gold powder that has had one or two coats of varnish become tarnished within six weeks. Why this should happen I don't know. But if the six or more finishing coats of varnish are applied without any lapse of time, the beautiful gold powder surface is perfectly safe.

Shaded Freehand Bronze

Instead of the entire painted surface being covered with bronze powder, here the powder is applied with shaded effects, and a good deal of the underpainting (black and green in this case) is left exposed to form part of the decoration.

This kind of decoration is somewhat more advanced, and so the patterns for it are given later in the book (Figures 56 and 57). The beginner will use them after some more practice in painting.

7

Stenciling in Bronze Powders

Stenciling is a technique which many amateurs tend to regard disdainfully, as a form of decoration not worthy of their serious study. They may have at some time come upon crude manifestations of the art, and consequently adopted a sweeping attitude towards the entire technique. But professional artists know—or at least are open to the opinion —that stenciling, like any other technique, is to be judged by its finest examples. And as we look back in the historical field we find countless specimens of stenciling that were obviously done by the best artists and craftsmen of their day. Indeed, first-rate artists have never hesitated to use stencils to achieve the exquisite and beautiful effects which they know that only stencils can give.

For our present purpose, stenciling means the application of bronze powders through a stencil made of architect's tracing linen, on to a varnished surface that is partly dry. Black is usually the background color, since this provides the beautiful deep shadows that give depth and roundness to the shaded fruits, flowers, leaves, etc.

A chair belonging to Mr. and Mrs. George E. Jones of East Hartland, Connecticut will serve excellently for the demonstration which follows.

To Trace Stencils for the Jones Chair Pattern

Architect's tracing linen, which we use for our stencils, is semi-transparent, thus enabling us to trace a design directly on it. The tracing is done on the dull side of the linen with a crow-quill pen and black drawing ink. Turning to Figure 3, we find the units for the chair pattern. The black areas are the parts to be cut out.

When tracing, allow at least *one inch* margin of linen around each unit. Small units may be traced two on a piece of linen, but be sure to allow an inch of linen between them. For convenience, trace the two

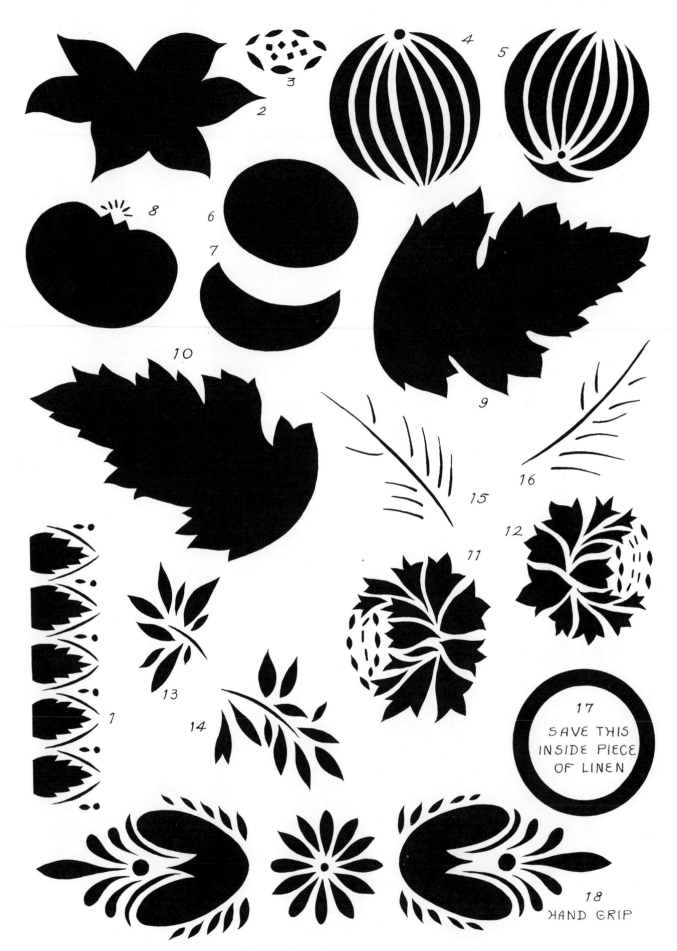

FIGURE 3 STENCILS FOR THE JONES CHAIR

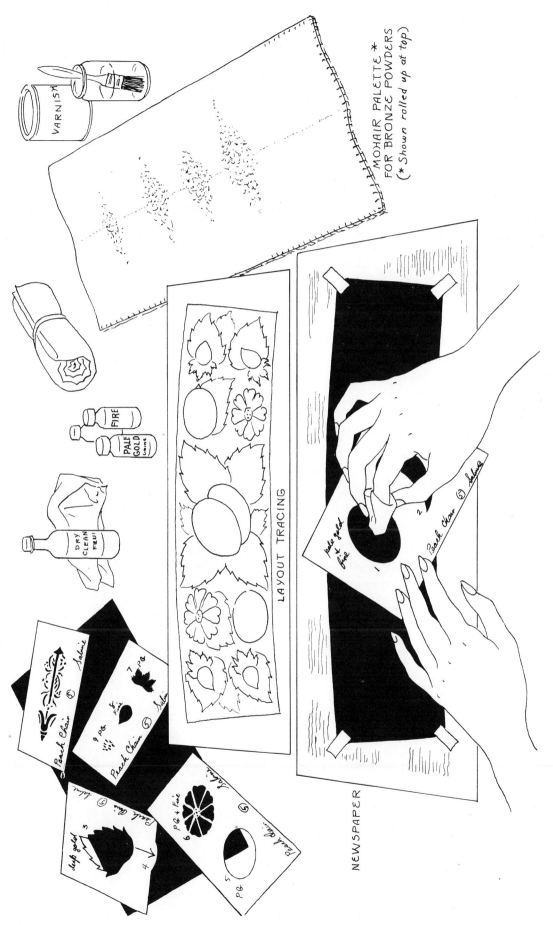

FIGURE 4 STENCILING A CHAIR PATTERN

parts of the peach on one piece of linen. Do not bear down too heavily on the pen, or you will get a thick line. The units for the stile, seat front, and narrow slat, are on Figure 37. Above all, trace carefully and accurately.

Number the stencil units in ink to correspond with the numbers in Figure 3. Refer to p. 13 for the proper care of stencils. For your own convenience, count the total number of linen pieces when you have finished tracing, and write that figure on each piece, together with the pattern's name (make up a name if you like). Also, sign your own name on each piece. See the illustration of stencils given in Figure 4. Illustration 1 shows the finished pattern and the relative positions of the units on a chair.

To Cut Stencils

Careful, accurate cutting is essential for a fine stencil job. Take the time, and exercise the patience to do it well. Provide yourself with a comfortable chair, a good light right over your shoulder, and the proper scissors (see p. 14). Be comfortable and relaxed. A black cloth on your lap will make it easier to see what you are doing, and at the same time catch the bits that fall.

In cutting, be careful not to stretch the edges of the linen cutouts. Do not pierce the cloth on the traced line, but rather inside of it. Take small snips as you go along, leaving no jagged edges. For a leaf vein, pierce the cloth in the middle, then cut towards the pointed ends. For a tiny dot, pierce the cloth with just the point of the scissors, then take five or six tiny cuts around. In a unit made up of many pieces, such as the one numbered 12, cut the smallest bit first, gradually working up in order of size to the largest one.

Making a Layout Tracing

Cut a piece of tracing paper to $13\frac{1}{2}$ by $3\frac{5}{8}$ inches for the main slat. Fold it in half to get the vertical center line, and keep it folded. Turn to Illustration 1, and with a pencil draw roughly the shape of one half of the main slat on the folded tracing paper. Slope the top line down to the side, and slant the side line in a bit. The slope of the bottom line, as can be seen in the photograph, is somewhat less than that of the top line. Still without unfolding the tracing, cut along your pencil lines. Unfolded, the tracing paper should be roughly the shape of the chair slat.

32

Now assemble your cut stencils on a dark surface (dark table top or black paper), and roughly trace in position the various pieces. Put the tracing paper on *top* of your cut stencils in order to trace. The middle flower is slightly to the left of center.

This is your layout tracing.

Black Paper

Just as it is important to do a painted pattern on frosted acetate before applying it as a decoration to an object, so it is important to do a stenciled pattern on black paper before putting it on a chair. This is particularly important for the beginner, who should be prepared to practice the pattern not only once but several times if necessary to get a perfect result.

Cut a piece of black stenciling paper (see p. 14) to the size and shape of your layout tracing. Tack this to a half page of a newspaper, using small bits of masking tape at the corners.

Varnishing

Spread out plenty of newspapers on your work table. Set out the varnish brush, a paint rag, the brush bath (a jar half full of turpentine), and the can of varnish, which should be opened only after everything is ready. Do not shake or stir the varnish.

After carefully dusting off the black paper, and flicking the brush to get rid of any loose hairs or dust, open the can of varnish. Dip the hairs about half their length into the varnish, and, holding down one end of the black paper with the other hand, apply the varnish. Use long sweeping strokes the full length of the paper, pressing the brush down all the way.

Work so that the light falls across the paper and you can see that every bit of surface gets covered. Work quickly, taking more varnish only as you need it, but never flooding the surface. Then, without taking more varnish, go over the surface in the crosswise direction, thus making sure that there is not too much varnish in some places, and too little in others, but instead an even distribution. Last of all, with a very light touch and using only the tips of the hairs, pick up any tiny bubbles on the surface. (If there are so many tiny bubbles that you can't possibly pick them all up, it means that you have used too much varnish. Start again on a fresh piece of paper.)

Set the varnished paper aside to dry in a dust-free place until it

33

reaches the proper tacky stage. When you come eventually to varnish a chair or other object, you proceed in the same way as for varnishing the black paper.

The Tacky Surface

How long it will take for the varnished surface to reach the proper tacky stage for stenciling will depend on the amount of varnish used, and the amount of moisture in the air. Usually it takes between forty-five minutes and one hour, but on a wet day it would take longer. Do not put the varnished surface to dry by an open window, nor over a hot radiator, nor in the sunlight, as all these, in one way or another, can spoil the surface. When the surface is dry enough to feel sticky to the touch but yet the fingertip leaves no mark on the surface, it is ready for stenciling.

Stenciling

1. Open your mohair palette and put a little mound of gold powder somewhere on the lengthwise center fold.

2. Check your cut stencils to be sure they are all at hand.

3. Wrap the velvet "finger" (see Figure 4) around your forefinger, drawing the folds tightly to the back, and holding them in place with the second finger. The tiny working surface of the velvet at the fingertip should be quite smooth and about one quarter of an inch in diameter. If the size of your finger makes a larger surface than that, stencil with the side of the fingertip. (Incidentally, you should keep two or three velvet fingers exclusively for stenciling, not using them for free-hand bronze work, as this latter so saturates the velvet with bronze powder as to make it of little use for stenciling.)

4. To begin stenciling, place stencil 1 (Figure 3) in position at the left-hand side, with the shiny side of the linen downward, of course. Use Illustration 1 as your guide. Press down lightly over the cut edges, to make them stick. With the velvet finger, pick up a speck of gold powder from the outer edge of the mound—so little that it is barely visible on the fingertip—and tap it once on a clean part of the mohair. Then, with a light circular (tiny circles) motion apply the powder along the inner or pointed edge of the cut stencil. Take up more powder as you need it, a speck at a time, and generally shade off to black at the outer edge. To give the gold an added luster, go back again over the brighter parts with the velvet, and apply a little more pressure so as to burnish them.

34

Naturally, this pressure must not be so great as to rub off the gold or scuff the surface; and it should not be applied at all to the shaded parts. Next, lift the stencil and, having placed it in position at the right-hand side, apply the powder in the same way as before.

It is important to stencil with very little gold powder at a time, because if you use too much there is no way of picking it up again from the sticky surface. Work cautiously. If you pick up too much powder on the velvet, just tap it on a clean part of the mohair palette.

Now place stencil 2 in position slightly to the left of center. Check its position by holding the layout tracing just over it without actually laying it down (but if the tracing does happen to touch the black paper, it should not stick if you have waited for the proper degree of dryness.) Put the tracing aside, and apply the powder very brightly around the edges of the stencil, gradually shading off toward the center, but leaving the center quite black. Lift stencil 2, put stencil 3 in place and apply the powder.

Next, stencil the melon (4) very bright at the top, gradually fading off to deep black *before* you reach the center flower already stenciled. It is the swift transition from very bright gold to deep black that gives depth to the pattern, roundness to the fruit, and brilliance to the finished decoration.

Continue stenciling the pieces in their numerical order, and referring to the photograph for the shading. Always stencil the brightest part first each time, then fade off to black. Always apply the gold powder with a circular motion (tiny circles) and very lightly. Do not dab it on. Above all, remember to leave some black each time, so that a unit will look as if it is partly behind the one in front.

When the stenciling is done, immediately clean both sides of the stencils with dry cleaning fluid and a soft cotton cloth, working on newspaper. They dry in a few minutes. Let the stenciled pattern dry twenty-four hours.

Pattern for the Stenciled Fruit Rocker

Figure 5 gives the stencils. This pattern is first stenciled in pale gold. Color is added at a later stage, and consists of transparent overlays of color made by mixing varnish and artist's oil colors. The order of proceeding is as follows:

1. Trace the black units on linen, disregarding all the dotted lines, both black and white. Drawings 5 and 5A together form one single

35

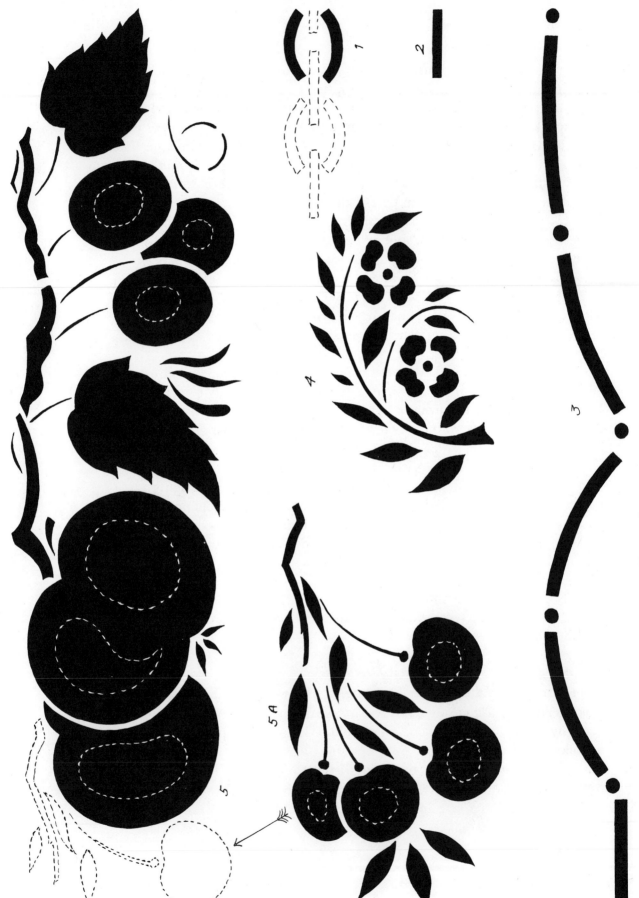

FIGURE 5 STENCILED FRUIT ROCKER

unit, as can be seen in the photograph, and should be traced as such on one piece of linen. Don't forget the one-inch margin of linen all around. Trace drawings 1 and 2 on one piece of linen, just as they are in position in Figure 5. If you are doing this pattern for a particular chair, alter 3 if so required to fit the lower edge of your slat, first drawing it on tracing paper.

2. There will be no need to make a layout tracing for this pattern, as the arrangement is a simple one, but a tracing of the overall area of the slat would be useful in cutting your black paper. Cut a piece of black paper 20⅜ by 4⅝ inches. Round off the ends, but leave the lower edge straight.

3. Varnish the black paper, and when it is tacky, stencil the entire pattern in pale gold. Stencil the chain border first by repeating drawing 1 from one side, along the top, to the other side, keeping it always the same distance from the edge and with equal spaces between. Then add 2 in the spaces between. Next, stencil 3 along the bottom, doing first one half; after cleaning stencil on both sides with cleaning fluid, reverse it to do the other half. Unit 4 is done next, first on the left side, and is made a bright gold where the flowers are, and not quite so bright on the outer side of the stem. Reverse the stencil and do the other side.

Now place the main fruit spray in position, centering it carefully by eye. First stencil the very bright highlights on the fruits, which are indicated by the dotted white line on Figure 5, then shading off to the darker parts. Add an extra touch of gold around the outer edges to give a reflected light. Keep looking at the color plate for the shading. The two larger leaves are very bright around the edges, darker toward the center. In this spray we do not leave any parts completely black, as there will be plenty of black spaces between the fruits and leaves when we lift the stencil. However, be sure to keep the center division in the main peach fairly dark, and to retain dark shadows around the lower and outer edges of all the fruits. Note that the main stem should be brighter in some parts, darker in others. (Note in general that all shading must be done at this stage, as the transparent colors to be added later are even washes of color and will add nothing to the brightness or darkness of the pattern.) Lift the stencil.

Set pattern aside to dry for at least twenty-four hours.

4. *The transparent color overlays* are applied next. With a damp sponge, gently go over the dry pattern to wipe off all the loose gold

powder. Remove every speck of it. Then pat it dry with a clean, lint-less towel.

Set out your Yellow Lake or Indian Yellow, and Prussian Blue artist's oil colors, a newspaper palette, paint rag, turpentine brush bath, a bottle cap of varnish, a showcard brush, and a quill brush. Squeeze out about $\frac{1}{4}$ inch of yellow and about $\frac{1}{8}$ inch of blue.

With the No. 1 quill brush, dip out three or four brushfuls of varnish, and pull in just enough yellow to make a deep, strong, but transparent yellow. Apply this to the three yellow plums, two or three strokes to each plum, using just enough of the yellow to cover the area comfortably but not flooding it. Don't putter and dabble over this operation. Do it quickly and then leave it. Also, apply the yellow to the left side of the center peach, *immediately* blending off the inner edge of the yellow with another quill brush dipped in clear varnish. To do this, first dip the brush in varnish, and then wipe it back and forth on the newspaper to remove excess varnish, flattening the brush at the same time. With the flattened edge, go along the inner edge of the yellow, thus fading off the color, with one stroke of the brush. Do the same with the second peach. Work quickly.

Now, using the yellow quill brush, mix a transparent green by adding a little blue to the yellow. Referring to the color plate, apply this green to the leaves, each time blending off the inner edge of the color.

Set aside to dry at least twenty-four hours.

5. To apply the transparent red, use Alizarin Crimson and add a touch of Burnt Umber. Apply this to the cherries and the small flowers at the ends. Turn the whole pattern upside down and apply red to the large center peach as shown in the color plate, blending off the inner edge where it meets the yellow with a varnish brush. Do the same to the remaining peach. Set the work aside to dry for twenty-four hours.

Stenciling on Stained and Varnished Furniture

It is possible to stencil on dark furniture without first painting the background in the way described in Chapter 13. But only furniture of very dark woods should be chosen for this purpose, such as the darker forms of mahogany, walnut, oak, etc. A dark background

38

is necessary to give the effect of the deep shadows which are a distinctive part of this type of ornamentation.

The first step is to wash the surface thoroughly with warm water and a mild soap or detergent, so as to remove every vestige of grease, wax, or furniture oil that may have been used in the past. Let the surface dry out thoroughly for a day. Then apply a coat of varnish, and when it is tacky, stencil the decoration.

To Stencil a Chair

After the chair has been painted with the background color (see Chapter 13), and before any stenciling is done, the broad gold bands should be applied. The turnings on the stiles (the posts on either side of the chair back) are done in gold, also some of the turnings on the legs, on the front rung, and on the hand grip. The finer stripes, not as bright as the gold, are painted mustard yellow.

The gold bands should be painted on the flat background paint with a showcard brush and a mixture of Japan Vermilion and varnish. When the surface is tacky, gold powder is applied in the usual way. After the work is thoroughly dry, remove all loose gold powder, and then proceed with the stenciling, but varnish only those parts which are to be stenciled that day. When all the stenciling has been completed, the chair is given a coat of varnish, on which, when dry, the fine mustard yellow stripes are painted with a striping brush (see Chapter 16).

The placing of the gold bands and the yellow striping depends more or less on the construction of the chair, and should be done so as to enhance the rest of the ornamentation and the general appearance of the chair.

When stenciling the main design on a chair, lay the chair on its back on your work table. Work upside down, placing the pattern you are copying upside down also.

8

Country Painting

The basic brush strokes for Country Painting are the same as for Freehand Bronze, and are described in Chapter 5. The student should review that chapter and practice the brush strokes on tracing paper before going on to the patterns described below. Chapter 4 ("The Painting of Patterns") should also be read over again.

Tin Box Pattern (Figure 6)

This pattern was taken from a small black tin document box belonging to Mrs. John G. McTernan. The sketch shows how the various parts of the box were decorated. Proceed to paint as follows:

1. With a mixture of Japan Vermilion and varnish, paint the two large flowers and the eighteen buds, marked V, disregarding the overtone strokes shown as dotted and line-shaded areas. The mixture should contain enough varnish for it to dry smooth and flat, and at the same time give a bright opaque vermilion color. Clean the mixing brush and the quill brush by wiping them first on newspaper to remove most of the paint, and then dousing them up and down a few times in the brush bath. Afterwards wipe them dry with a cotton cloth.

2. Squeeze out some Japan Green and a tiny bit of Raw Umber. With the showcard brush, mix some Green with a little varnish, and pull in a speck of Raw Umber to tone down the Green a bit. With this "country green" mixture, and using a quill brush, paint the large and small leaves, the stems, and the calyxes on the two large flowers, all of which are shown black in the illustration. But do not paint the curlicues. This completes the present stage. Set your work aside to dry for at least twenty-four hours.

3. To paint the shaded and dotted overtones on the flowers and

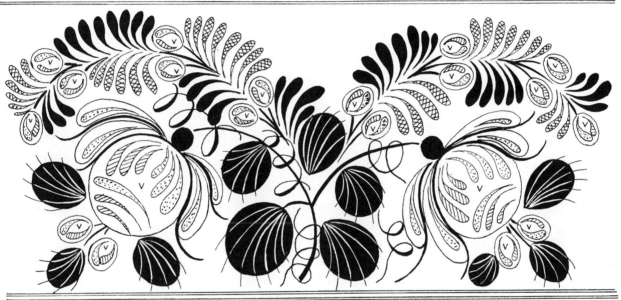

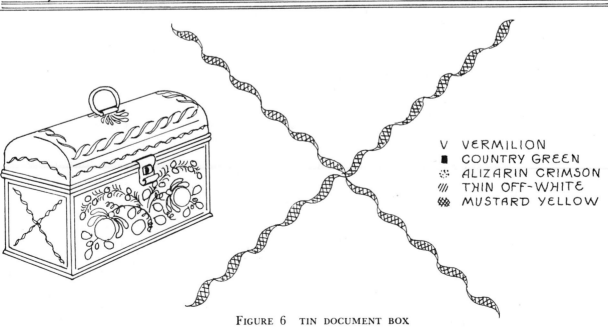

V VERMILION
■ COUNTRY GREEN
⁂ ALIZARIN CRIMSON
/// THIN OFF-WHITE
✸ MUSTARD YELLOW

FIGURE 6 TIN DOCUMENT BOX

buds, do not put the frosted acetate over the tracing, but keep it separate. These overtone strokes are done by eye, using the illustration as a guide. On a clean newspaper palette, mix several brushfuls of varnish with a little Alizarin Crimson and just a touch of Burnt Umber, to make a rich, dark, but semi-transparent red. With this mixture, paint the dotted strokes, using your quill brush. Be sure not to overload your brush.

4. Mix some Japan Yellow with a little Burnt Umber to make a rich mustard yellow, and enough varnish to give it just a hint of semi-transparency when it is painted. With this mixture, paint the cross-hatched small leaves. Using a small quill, paint the curlicues. This will require a certain amount of practice to do correctly. Hold the brush upright, and be careful not to overload it with the paint mixture.

Add a bit more varnish to the mustard to make it semi-transparent, and paint the fine vein-like strokes on the larger green leaves, also the borders and the brush strokes that comprise the decorations on the top and sides of the box. Wait at least twenty-four hours for this to dry.

5. For the semi-transparent off-white overtones, squeeze out some Titan White and a little Raw Umber on a clean newspaper palette. Dip out several showcard brushfuls of varnish and pull in a little of the White, and a tiny bit of Raw Umber to make a semi-transparent off-white. With this mixture, and using your quill brush, paint the line-shaded strokes on the flowers and buds. The mixture should be so thin that the off-white looks slightly pinkish after it is painted on the vermilion. Be sure not to overload your brush. This completes the pattern, which should now be allowed to dry for at least twenty-four hours.

Small Chest Pattern (Figure 7)

This pattern comes from a small Connecticut Chest which is owned by Mrs. J. Woodhull Overton, and which is exhibited in the Metropolitan Museum of Art, New York.

The chest is in dark oak, which may be represented by using brown paint, and the design is done in off-white, red, and black. It has been necessary to give the pattern in a reduced size on Figure 7, but as the design is a very simple one, it can be easily enlarged, as described in Chapter 18. In enlarging a pattern, enlarge only the main lines and shapes, disregarding small details such as those on the

42

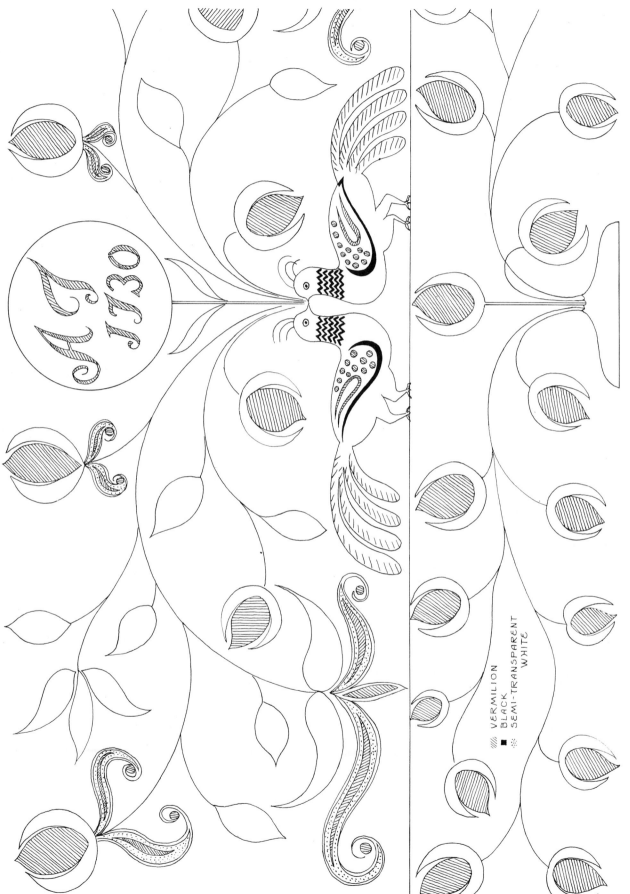

VERMILION
BLACK
SEMI-TRANSPARENT
WHITE

AM
1730

FIGURE 7 SMALL CONNECTICUT CHEST PATTERN

birds. Such details can be drawn in later by eye. The original design is not exactly the same on both sides of the center line, but the differences are trifling. Therefore, you need enlarge only half the design. Thus, if you make a tracing of the left half, you have only to turn this over and you have the right half also. Join this to the left, and the whole design is before you. Measurements of the design on the front of the chest are $25\frac{1}{2}$ by $13\frac{1}{4}$ inches.

For practice, it would be well to paint the enlarged pattern on a piece of frosted acetate. After you make your enlarged tracing, place it on a white cardboard so that you can see the design clearly, and then place the frosted acetate over that. Proceed to paint as follows:

1. With a mixture of Titan White, a little Raw Umber, and a little varnish, paint all the off-white parts of the design, with the exception of the stems, which are best left for another day. Disregard the monogram, the date, and the details on the birds, but paint the fine lines springing from the heads of the birds. Wait twenty-four hours.

2. Make a tracing of the outlines of the birds, and then draw in the details freehand, using Figure 7 as a guide. Be sure you get a nice swing to the wings. Then transfer these details to the pattern

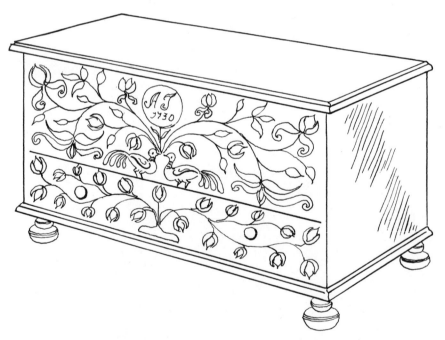

FIGURE 8 SMALL CONNECTICUT CHEST

44

(see Chapter 15). Do the same for the monogram and date, whether they are the originals or others which you may prefer to substitute. Then, using Japan Black, paint in the black details: these are the throat bands, the wing outlines, and the eyes. If you find it easier, do the eyes in pen and ink.

3. The dotted areas in Figure 7 are an almost-transparent off-white, and should be painted with one or two quick strokes of the brush. Don't fuss over this—do it and leave it. The almost transparent off-white is mixed by starting with several brushfuls of varnish, and then pulling in a little White and a speck of Raw Umber. Wait twenty-four hours.

4. Mix some Japan Vermilion with a little Burnt Umber, just enough to tone down the red slightly, and paint all the line-shaded areas in the pattern on Figure 7. For the red details on the birds' bodies, the tail marks, and the monogram and date, thin the Vermilion just a bit by adding a little more varnish to the mixture. Wait twenty-four hours.

5. Mix some off-white as near to the shade you used in stage 1 as possible, but with a bit more varnish in it to make the mixture a little thinner, and paint the stems. Use a small striping brush for this purpose, and practice a few times on tracing paper placed over the pattern. This completes the pattern.

Final Notes

When the pattern is being painted on a chest, I suggest giving the whole design a coat of varnish before painting the stems; then, if you don't get a stem just right the first time, you can rub it off for a second attempt, without disturbing the brown background color. Striping for the chest might be done in Vermilion.

9

Gold Leaf

The most essential requirement for laying gold leaf is to have such complete control of your quill brush that you are able to paint a pattern with perfect brush strokes: there should be no overly wet places, no lumpy surfaces, no touched up spots, no spreading of the color mixture after the design has been painted; but the surface should dry perfectly smooth. To acquire this proficiency, you should first copy all the gold patterns in the book on to frosted acetate, using pale gold powder. When you can do those patterns to perfection, only then are you ready for gold leaf.

Gold Leaf Booklets

Gold leaf is made up for sale in two kinds of small booklets. In one, the leaf is mounted on tissue paper; in the other, it comes unmounted. When learning to lay gold leaf without the personal guidance of a teacher, one should start with the mounted kind.

Cut a piece of cardboard the size of the booklet, and lay the booklet on it. This not only keeps the leaves flat but makes the booklet easier to handle. When not in use, keep book and cardboard in a small envelope.

Flat Background

Like freehand bronze, gold leaf decoration requires an absolutely dry background of flat or dull paint, and preferably one that has hardened for at least two months.

To Prevent Sticking

Gold leaf has a decided tendency to stick where it is not wanted, and it is for this reason that I advise two months, or even longer, for the background paint to harden.

46

An added measure of precaution, and a very important one, is to take a *pinch* of whiting powder and rub it lightly with the fingertips over the painted surface just *before* you transfer the pattern outlines. Blow off *all* excess powder.

Underpainting for Bread Tray Pattern

To practice laying gold leaf, put a piece of frosted acetate over sections D and E of the Bread Tray pattern in Figure 22.

With a semi-transparent mixture of varnish and Yellow Ochre oil color, paint the two units, ignoring the pen-line details and the heavy black accents which indicate the Burnt Umber which later on will be applied over the gold. We use oil color because the linseed oil in it will slow up the drying process and will therefore allow more time at the tacky stage. Use just enough Yellow Ochre to give the varnish a definite color, but not so much as to make a lumpy surface.

In each unit, paint first the larger parts, then the next size, and so on down to the fine stems and tiny strokes which come last. Try to work so that the whole unit will reach the tacky stage at the same time. Set the pattern aside to dry, but keep watching it, and when the proper tacky stage has been reached, that is, when it feels sticky to the touch but you leave no fingerprint, lay the gold leaf.

Laying Gold Leaf

Pick up a mounted piece of gold leaf, holding it by the tissue paper with both hands, and with the gold side down. Hold it just above the painted design until you know exactly where you want it. Then lay it down on the tacky surface, and with your fingertips, or a clean piece of velvet, press it down, but very gently. Then lift up the tissue and, with the gold remaining on it, proceed to the next section of the pattern, slightly overlapping the leaf as you apply it, and continue in this way. With the bits that may still remain on the tissue, go back to touch up any places that may not have been covered.

Wait three or four hours, and then gently remove the loose gold with a clean piece of velvet. Let the whole thing dry for forty-eight hours. Then complete the pattern as described below.

47

Touching Up

When decorating a tray or any other object, you will find that after the gold leaf has been laid and allowed to dry thoroughly for forty-eight hours, there are places still without gold on them. These must be touched up. Take a quill brush, dip it in varnish, and then work it back and forth once or twice on the newspaper palette so that only a little varnish remains on the brush. With this go over the bare spots. When the spots are tacky, which in the case of very tiny spots may take only a few minutes, lay the gold leaf. The whole job should then dry for a week.

Protective Coat of Varnish

Before completing the pattern on a tray or other item, it is useful to apply a protective coat of varnish over the gold leaf. Dust off the surface, taking care to remove any remaining loose bits of gold leaf. Apply a coat of varnish in the usual way (see p. 33). Let it dry twenty-four hours, and then go over it lightly with #000 steel wool, applying just enough pressure to take off the high gloss. This will provide a good surface for pen lines and any further painting.

To Complete the Bread Tray Pattern

With a somewhat dark mixture of Burnt Umber and varnish, paint the details indicated in Figure 22 by the fine pen lines and the heavy black accents.

10

Gesso and Gold Leaf

Gesso for Raised Effects

On many of the old pieces that were decorated with gold leaf use was made of gesso to obtain raised effects. In the seventeenth century gesso was largely used for the raised decorations on the familiar gilt furniture of that period, which decorations took the forms of elaborate scrolls, birds, flowers, shells, cupids, and suchlike emblems. Pieces of the kind are often mistakenly spoken of nowadays as carved furniture, but the fact is that the raised effects were more often achieved by the use of gesso than by the carving of wood.

During the eighteenth and nineteenth centuries, gesso was widely used in the elaborately modeled ornamentation of ceilings, walls, gilded mirror and picture frames, as well as on furniture, caskets, boxes, screens, sconces, etc.

Origin of Gesso

In ancient times it was realized that to enhance the beauty of gilding on carved wood, it was necessary first to prepare a perfectly smooth surface, and it was discovered that the best way to achieve this was by the application of half-a-dozen or more coats of parchment size mixed with whiting. From this method of surface priming the use of raised gesso in ornamentation was evolved.

Composition of Gesso

As a rule, gesso is composed of three ingredients—whiting, plaster of Paris, and glue; but variations are sometimes made to produce a gesso suitable for special purposes. As a matter of interest, gelatine, boiled linseed oil, resin, marble dust, sugar, wax, starch, pipeclay, and

49

powdered pumice have all at one time or another been used. But none of these directly concern our present purposes.

The basic method of making gesso has changed little in the course of centuries, for it would be hard to improve on the original method, and indeed some has lasted for centuries when properly made. Its earliest known use is said to have been for the priming of the wood and canvas panels used by the early painters in oils and tempera. An artist's training then included learning to make gesso. Today's artists, however, do not make their own gesso. It can be bought ready mixed in a jar.

Japanned Highboy

Though there are several ways of using gesso for decoration, we shall now discuss only the kind of decoration in which gesso is found used to form a low relief. In this type of decoration, the pattern is traced or sketched on the painted surface, and gesso is applied with a paint brush.

Consistency

Gesso should be the consistency of very thick cream, flowing only slightly from the brush and thick enough to keep whatever shape is given to it by the brush strokes. If it shows a tendency to sink or flatten out after it is applied, the mixture is too thin. In that case, leave the gesso jar standing uncovered for a time, or add to the mixture some dry finely powdered whiting. Experiment first on odd pieces of wood or cardboard.

Brushes

The brush to use for the smaller areas is a fine scroller, which is a pointed brush with hairs about one inch long. For large areas a small-size flat oil brush is good. Very fine details like hairline strokes cannot well be painted in gesso, as the successive coats tend to broaden the fine lines.

The Relief Effect

Since the aim is to get a relief effect, don't be timid. Gesso invariably flattens as it dries, so there is little risk of overdoing the surface modeling. Several coats are usually necessary, and each coat must be thoroughly dry (several hours wait) before the next is applied.

50

Surface modeling should be ignored until several coats have been applied. Then a small sharp penknife, or a linoleum block cutter, or some other small blade to the use of which your hand is accustomed, may be used to scrape out here and there to add emphasis to the wing of a bird, the pack on the camel's back, the sleeve with hand resting on a table, etc. Tiny pieces of sandpaper may be used to smooth out the parts that need it. Obviously, experimental practice on scrap wood or cardboard is called for.

When the gesso work is completed and thoroughly dry, gold leaf is applied, as described in Chapter 9.

11

Stenciling on Walls

The Josiah Sage House

There can be no better introduction to stenciling on walls than to visit one of the best surviving examples of this old art. Let me describe my visit to the Josiah Sage House, which you may find it possible to visit some time in person.

One summer day I took the train from Grand Central Station, New York, to Great Barrington, Massachusetts. From there a car took me to Dodd Road in the township of Sandisfield, finally depositing me at the quiet hillside in the Berkshires on which stands the house I had come to see. The white house, with its reeded door moldings, and its semi-elliptical windows under the gable eaves is charmingly reminiscent of days gone by. A chimney stone bears the date 1803, but this is not the oldest part of the house, which belongs to the later decades of the eighteenth century. Its present appreciative owners, Mr. and Mrs. George E. Brookens, showed me every hospitality, and saw that I did not miss anything of interest.

That same afternoon the friendly co-operation of the family enabled me to set to work tracing on frosted acetate the beautiful old designs on the walls. A step ladder helped me to reach the frieze close to the ceiling; I got down on hands and knees to trace the border along the baseboard, where the more than friendly attentions of the two dogs and one cat added variations to the task. Very appropriately, I slept that night in the lovely old stenciled bedroom. Next morning I traced more units from a wall in the attic, where in 1815 the original craftsman had tried out some of the designs to show the effect to his employers. This man was an itinerant decorator whose name has been lost, but who had a fine sense of design, cut beautiful stencils, and knew how to use them to advantage.

52

Old Stenciling

Examples of old wall stenciling can be found chiefly in rural parts of Maine, New Hampshire, Vermont, Massachusetts, Rhode Island, Connecticut, New York, and Ohio. Most of these date from the first quarter of the nineteenth century when wall stenciling was chiefly in favor. The repainting and the papering of walls have in the course of time hidden or destroyed most original stencil work. Restoration, when possible, is always difficult. Today, however, great interest is being taken in preserving the interesting and beautiful remains of this once flourishing American craft.

Inspired by Wallpapers

The high cost of the French and English wallpapers imported during the eighteenth century, led to domestic production of wallpapers, but even these were so expensive that very few were able or willing to pay the price. It was in these circumstances that the idea of stenciling on walls arose, and it is not surprising to note that the influence of wallpaper is clearly discernible in the old stencil patterns. But since stenciled walls could imitate wallpaper only to a limited degree, they developed a style of their own, the chief characteristics of which are a certain bold conception of design, and the use of clear flat colors without shading.

The Journeyman Artist

The work was usually done by journeymen artists, working singly or in pairs, who traveled from place to place in search of patronage. One can easily imagine the importance of the occasion to a household when the artist arrived, unpacked his kit of dry colors, brushes, measuring tools, chalk, and above all his supply of stencils cut from thick paper. We can picture the eager audience standing around, watching him mix colors, helping him to choose designs and to decide the arrangements, and perhaps even giving him a hand in the actual stenciling.

Design Forms

The designs stenciled on walls by the old artists were quite varied in form, including flowers, leaves, running vines, acorns, pineapples, hearts, weeping willow trees, American eagles, urns filled with flowers, swags with bells and heavy tassels, sunbursts, diamonds, and class-

53

ical motifs. Borders usually framed windows, doors, and cupboards. Wall spaces sometimes carried just a delicate border design around the edges. Broad wall spaces were often divided into panels, or given an all-over design treatment. The overmantel, being a focal point in a room, generally received some special treatment in design arrangement.

Colorings

Most of the colors used in the old stenciling have faded considerably, but the indications are that strong rich colors, such as bright reds, dark greens, deep yellow, rose, olive green, black, and occasionally dark blue were preferred. Background wall colors were usually light, and included white, grays, yellow ochre, pink, and pale blue.

For those of us who stencil walls today, it is usually advisable to avoid stenciling designs in the darker colors, and to use instead paler ones, so that there is not so much contrast in value between the stenciled motifs and the background. This color scheme would be more in tune with modern decorating trends, and it meets our need for restful surroundings in an age when mechanism and speed have made life more complex and exacting than it was in the days of the original stencilers. Some suggested color schemes are as follows:

Green and salmon pinks on white, gray, or buff walls.
Olive green and light red on pink walls.
Delicate charcoal gray borders on blue walls.
Apple green and rose on white or pale yellow walls.
Dark gray and salmon pink on pale blue walls.
Dark green and light green on pink walls.
Dark blue and medium blue on pale yellow ochre walls.

Add a little brown to all colors to "antique" them, and add white to make them paler.

To Stencil a Room of Your Own—
Preparation of Wall Surface

Go over the plaster walls, filling in any cracks or holes with patching plaster. When dry, sandpaper the surface. Then apply two coats of good quality flat paint to the walls, allowing at least twenty-four hours for each coat to dry. Save some paint for touching up later on. Also, and this is important, paint some sheets of shelf paper or pieces of masonite, on which to try out colors and to practice stenciling.

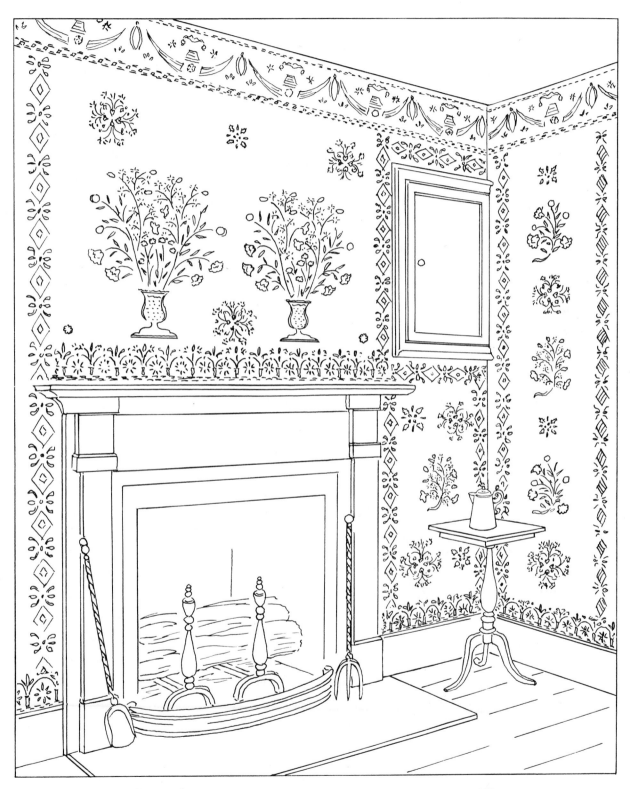

FIGURE 9 STENCILED SITTING ROOM OF THE JOSIAH SAGE HOUSE

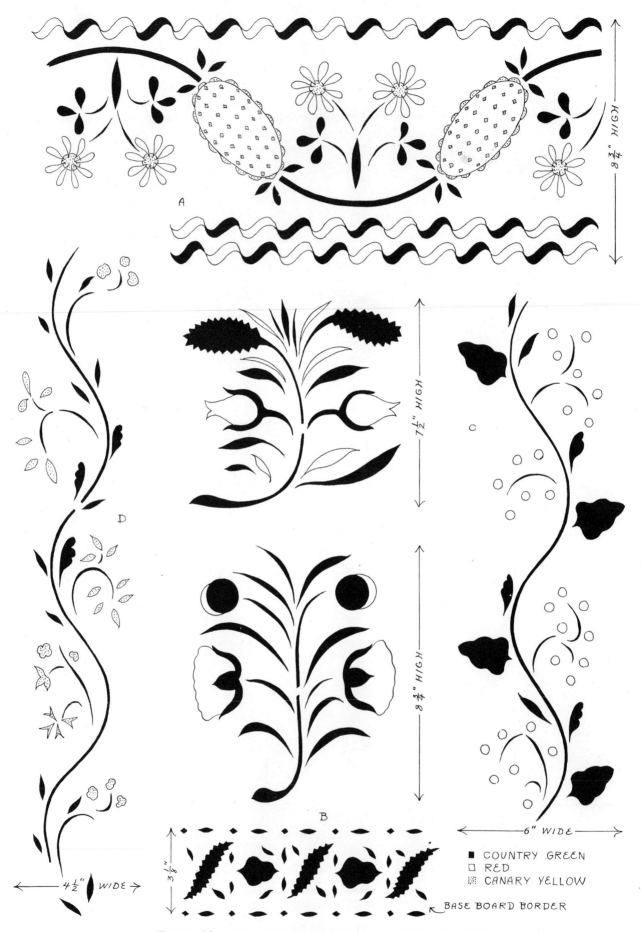

8¾" HIGH

A

7½" HIGH

8¾" HIGH

C

D

6" WIDE

4½" WIDE

3⅛"

B

■ COUNTRY GREEN
□ RED
▒ CANARY YELLOW

BASE BOARD BORDER

FIGURE 10 WALL STENCILS FROM THE JOSIAH SAGE HOUSE

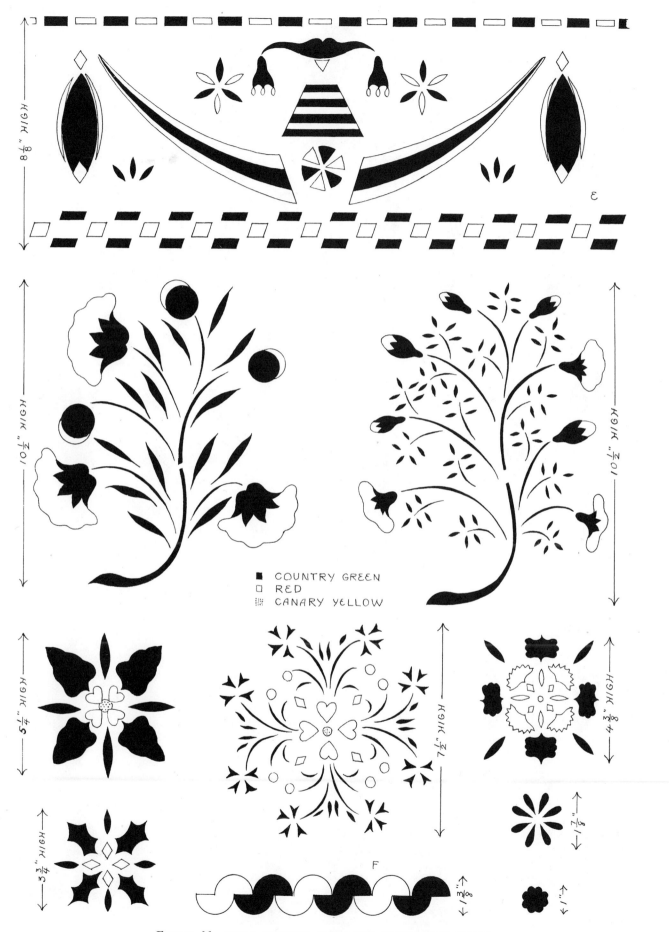

8¼" HIGH

10½" HIGH

10½" HIGH

COUNTRY GREEN
RED
CANARY YELLOW

5¼" HIGH

7½" HIGH

4⅜" HIGH

3¾" HIGH

1⅞"

⅜"

1"

FIGURE 11 WALL STENCILS FROM THE JOSIAH SAGE HOUSE

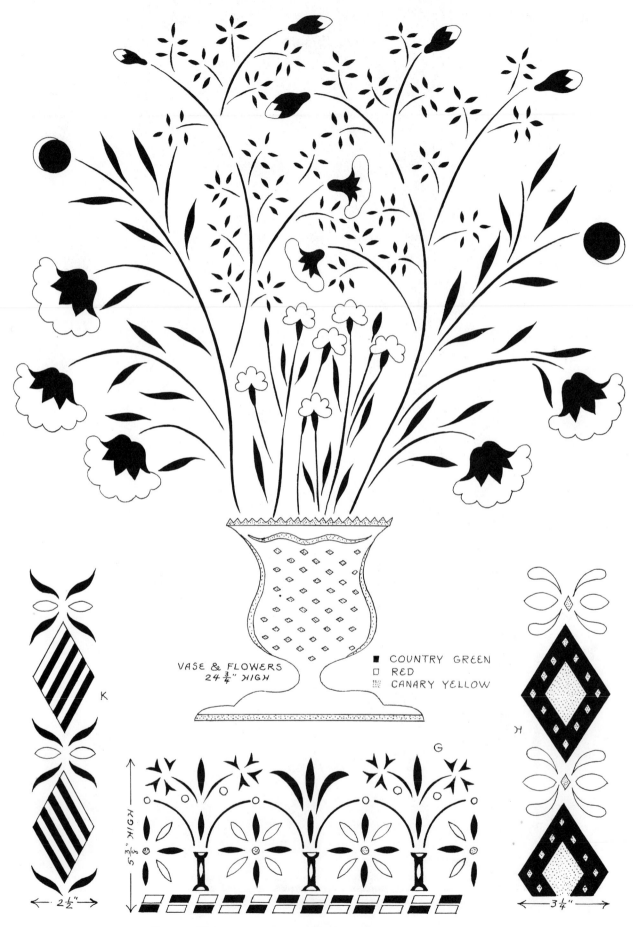

VASE & FLOWERS
24 ¾" HIGH

■ COUNTRY GREEN
□ RED
▦ CANARY YELLOW

5 ⅜" HIGH

← 2 ½" →

K

G

H

← 3 ¼" →

FIGURE 12 WALL STENCILS FROM THE JOSIAH SAGE HOUSE

Planning the Decoration

Figures 10, 11, and 12 give the stencil units traced from the sitting room and bedroom of the Josiah Sage House. Figure 9 shows them in position on the walls of the house.

In the bedroom, the running borders (Figure 10) were stenciled first: the pineapple frieze A around the ceiling, the acorn border B around the baseboard, and the red berry border C around the windows and doors as far as possible, and also at the corners of the room. The two little odd panels which are shown in the photograph with the chest of drawers below them, were given special consideration, border D running around the upper panel, C around the lower one. The single design units were then stenciled in the spaces between. The running vine C was further used to divide the larger wall spaces into panels about twelve to fifteen inches wide.

In the sitting room, a similar procedure was followed. The frieze of bells, swags, and tassels E (Figure 11) was used around the ceiling; the flower border G (Figure 12) around the baseboard and at the top of the fireplace; borders H and K around the doors and windows, and to divide the larger wall spaces into panels; border F (Figure 11) was used around two small panels similar to those in the bedroom. The single units were then stenciled in the panels, their choice as to size and position depending on the size and shape of the panels. Note the arrangements of units in the panels over the fireplace and to the right of it, and the panel at the extreme right in Figure 9.

Keep to the same general procedure in planning your own room. Choose the units you wish to use, and take plenty of time to decide where you will place them. For other examples of old wall treatments, refer to Janet Waring's *Early American Wall Stencils*, a book now out of print, but which may be found in most large public libraries. You may decide to stencil only one or two walls of your room, leaving the other walls plain, a course which would be in keeping with modern wall treatment.

Enlarging the Designs

The wall units are of necessity reproduced here in a reduced size. A glance at their original height or length, given in inches alongside each unit, will make plain the impracticability of reproducing such large designs in full size in a book. It is, however, an easy matter to enlarge the reductions (see Chapter 18), especially as the designs are

simple straightforward ones, and have all been reduced here in the same proportion. One and one-half inches here was four inches in the original. You can enlarge as much or as little as you like. My advice would be to enlarge the units to their original sizes, large as that may seem at first glance. Have plenty of tracing paper on hand for the job. The enlarged tracing of a unit in a running border should be repeated several times on another piece of tracing paper, so as to make a strip about twenty inches long, which is a convenient size to handle in stenciling.

Next, lay out the enlarged tracings on a flat surface, and decide how much linen you will need, bearing in mind that for each unit there must be a separate stencil for each color used. Also allow for a two-inch margin of linen around each unit. It is advisable to make at least *two sets* of stencils, so that one can be cleaned while you are using the other. A stencil that must be repeatedly used tends to wear out (but keep the worn stencils as they can sometimes be used in places hard to get at, such as where there is a projection, and a piece of the stencil must be cut off).

Tracing on Linen

Tracing should be done in pen and ink on a heavy quality tracing cloth (see note on "Materials" at the end of this chapter). Pencil guide lines, made with a ruler or triangle, may be drawn on the linen to aid in keeping running borders straight.

Suppose you want to make stencils for the large vase of flowers in Figure 12. You will need three separate pieces of linen, one for each color. Place a piece of linen over your tracing of the enlarged design, and see that it is large enough to cover the whole unit and extend two inches all around. Trace the over-all shape of the vase, and all the white areas of the flowers and buds, referring to Figure 12. This linen will be for the red. Next, place another piece of linen over your tracing paper, large enough to cover the solid black parts shown in Figure 12, plus the two-inch margins, and trace all the black parts. This will be for the green. Take a third piece of linen, large enough to cover the dotted areas of the vase, and trace these. This will be for the yellow.

Follow this same procedure for the rest of the designs, with this exception. When a running border is to be stenciled close to the ceiling or along a door or window frame, allow only a one-half inch mar-

60

gin of linen on one side. This will make it possible to do the border close to the edge of the wall space.

Cutting Stencils

Stencils may be cut with the small stencil scissors. Take care not to stretch the linen when cutting. Good stencil cutting, with no jagged edges, is essential to a professional-looking job. The cut-out edges should be smooth; curved lines should be graceful and even; and points (as at the tips of leaves) should be sharp and neat.

Mixing Paints

Japan Colors mixed with a little turpentine are best for stenciling on walls, as they will dry with a flat effect. To get the proper mixed colors, artist's oil colors can be added. Using a palette knife or mixing brush, mix the colors in a thick creamy form on a piece of kitchen tinfoil, and, when they are thoroughly mixed, put each color in a small screw-top jar together with a few drops of turpentine on the surface to prevent a skin from forming. About four ounces of thick paint in each of the two chief colors will be needed for a medium-sized room.

Applying the Paint

For applying the paint through the stencil on to the wall, I use a good quality textile stencil brush as illustrated in Figure 1. The hairs should be an inch long. Get two or three brushes. The brush should be held at right angles to the wall, and used with a very light circular motion.

With a palette knife, remove a small amount of mixed color from the jar to a piece of tinfoil, adding a small amount of turpentine (use a medicine dropper) if needed. Pick up a little of the thick paint from the tinfoil with just the tip of the brush, then tap it on newspaper to get rid of excess color, and apply the color to the wall with a "dry" brush. Work with a light circular motion, moving the brush all the time from the outside edge of the cut-out toward the center, so that paint will not get under the stencil edge. If the mixture has been too much thinned with turpentine, or if too much paint is on the brush, or if the brush is used with too much pressure, color will seep under the linen. If this should happen, try to wipe it off with a touch of dry-cleaning fluid, or wait until it is thoroughly dry and touch it up with the background paint.

61

When the brush gets too stiff with dried out paint, dip it in turpentine, but be sure to wipe it dry again with a rag before going on.

Some decorators prefer a piece of velvet to a stencil brush. The velvet is wrapped around the forefinger, and the procedure is then the same as described above. A rubber finger-stall may be used to protect the forefinger from the paint.

Stenciling Procedure

Start with the stencils for the main color (which was generally green on old walls). When the first color has dried for twenty-four hours, apply the second.

When placing a stencil in position, use small bits of masking tape to hold it in place, leaving your left hand free to hold the cut-out part close to the wall while you apply the paint. Have plenty of clean rags at hand. When centering the single units within a panel, have a yardstick handy to make sure they are correctly placed.

If possible, have someone to help you. Each time a stencil is used, it must be cleaned on both sides with dry-cleaning fluid, and an assistant is particularly helpful here. An assistant can hold a plumb line (a string with a weight at the bottom) close to the ceiling while you chalk the upright lines to indicate where the borders are to go which will mark off the panels, thus making sure that they will be really straight. And, of course, in handing you things you need, an assistant can save you much climbing up and down the ladder.

Materials

A heavier linen is used for wall stenciling than for ordinary stenciling. It can be ordered in sheets of any size, or in twenty-yard rolls, thirty and thirty-six inches wide, suitable for teachers or groups.

The type of brush best fitted to this work has been described earlier in this chapter under "Applying the Paint."

Additional Designs

Since designs *in situ* are rare, and access to private homes cannot always be obtained, it may be useful to note here that the Museum of the Society for the Preservation of New England Antiquities, 141 Cambridge Street, Boston, Mass., contains the Janet Waring collection of wall stencils, and also preserves some original specimens of stenciling

62

removed from walls and floors in old houses. Visitors may trace the photostats of the stencils, provided they bring the necessary materials with them, including frosted acetate to trace on; also, they may order prints from the negative photostats in the files.

12

Tinsel Pictures

Paintings on Glass

One of the most curious of the old folk art media is that of painting on glass. Pictures were painted in reverse on the back of the glass, so that the correct picture would be seen through the glass from the front. The details, therefore, were painted first, and the background last. The art flourished in this country between 1815 and 1835, the panes of glass being used chiefly to decorate shelf clocks and small or half-length mirrors. An example was taken from a wall mirror to illustrate the chapter on "Glass Painting" in my *American Folk Art* (1958). In the present book, however, a speciment is used which belongs to a slightly later period when interest had waned in the above described use of painting on glass, and had been transferred to a novel variation of the art.

Crystal or Oriental Painting

In the 1850's "Crystal" or "Oriental" painting became popular. The second name was due to the fact that the method produced effects reminiscent of the glowing colors of oriental painted flowers and birds. Flower studies were painted on glass in transparent or semi-transparent oil colors, and with opaque backgrounds. Loosely crushed tinfoil was then placed behind the painting, so that it glittered or glimmered through the glowing colors. No style of painting has ever been devised which shows off these colors to such advantage, and "tinsel pictures," as we call them today, never fail to attract admiring attention.

Pennsylvania Tinsel Picture

The original glass, which measures 15½ by 19½ inches, is owned by Miss Gertrude E. Robertson. The pattern given in Figures 13 and 14 is reduced in size, and would be suitable for a glass 13¾ by 10¾ inches.

There is not enough space on the figures to show all the background that appears in the color plate, but this can be added without difficulty.

To Prepare a Tinsel Glass

Procure a pane of glass as near the size of the pattern as possible. It is easier to get a framed glass to begin with, than to have a frame made to fit a piece of glass after it has been painted. Cut a piece of cardboard the same size as the glass. Take a sheet of kitchen tinfoil about two or three inches larger than the glass all around. Crush it loosely bit by bit until it is the same size as the glass. Mount it to the cardboard with bits of Scotch tape at the edges. Then cut strips of slim cardboard one-eighth of an inch wide or even less (use a ruler and a razor blade) to fit all four edges of the cardboard backing. Fasten the strips or slivers to top of the tinfoil, along the edges, by means of Scotch tape. Now place the glass on top of this (but do not fasten it), and you have a surface with glittering crushed tinfoil below on which to work. The strips of cardboard at the edges hold the glass away from the foil, and prevent the foil from being flattened out. See the inset sketch in the corner of Figure 14.

To Make a Tracing

Cut a piece of tracing paper 10¾ by 13¾ inches, and fold in half to make two halves 6⅞ by 10¾ inches. Place center fold line along the right hand edge of Figure 13, and let the top and bottom edges of the tracing paper each extend about five-eighths of an inch beyond the top and bottom of Figure 13. Make a complete pencil outline tracing of the birds and flowers, using Figures 13 and 14, but omitting the swirling background represented by dotted lines. Call this "Tracing A."

Cut another piece of tracing paper the same size, center it in the same way, and make a tracing of the background (the dotted lines) in ordinary pencil outline. Continue the background to the edge of the tracing paper. Call this "Tracing B."

To Make a Pattern on Frosted Acetate

1. Put Tracing A face down on a white cardboard. This gives you the pattern in reverse. The drawings in Figures 13 and 14 are given as they appeared from the front of the old glass picture, and have *not* been reversed. Place frosted acetate over your reversed tracing, securing it only at the top, leaving the other three sides free so that you can, in the

65

process of painting, place the acetate directly over the tinfoil glass to make sure your painting is transparent enough for the sparkle of the tinsel to show through.

2. The line-shaded parts of Figures 13 and 14 indicate vermilion. The vermilion is semi-transparent in some places, opaque in others. This is achieved by working with three brushes, one with a thin semi-transparent mixture of Japan Vermilion and varnish, one with almost pure thick pigment on it, and one with clear varnish on it for blending edges. Paint a given area first with the thin mixture but don't flood it on; then *at once* dab in a few touches here and there with the thick pigment. Don't fuss over it. Do it *quickly* and then leave it. Paint one bird at a time, blending off the free edges (not the outlined ones) of the vermilion here and there with the clear varnish brush in order to soften them.

The two large flowers numbered 2 are done in the same way. (The large "mouths" of these flowers are left clear glass, as may be seen in the color plate, as are also the spaces behind the large heavy dots or pellets in all the flowers.) Continue by doing the rest of the line-shaded flowers and buds with the exception of 6. Add the opaque vermilion outline on flower 5 and on the wings, crests, and eyes of the birds; also add the large heavy dots or pellets in flowers 4, 5, 7, and in the birds' wings and tails, all of which pellets are shown in white in Figures 13 and 14.

Mix some salmon pink and paint the heavy outlines and "dabs" in each 6, and the broad band in 5; also the outline on the wings alongside the already painted vermilion one. Wait twenty-four hours for drying.

3. The semi-transparent light violet-blue areas are all outlined in a transparent dark violet-blue, made by mixing Prussian Blue with a little Alizarin Crimson and varnish. So paint the *outlines* of the flower 4 and also the six "dabs"; the outline on both sides of the pink band in 5; the outlines of the birds' necks, also around the vermilion eyes; the outlines of the four flowers numbered 9; the touches in the two small four-petaled flowers which are also numbered 9; and the outlines on the birds' wings. All the foregoing are shown as dotted areas in the drawing. The same transparent violet-blue is used for the large heavy dots or pellets in the vermilion flowers.

66

FIGURE 13 "TINSEL" PAINTING ON GLASS

GLASS

TIN FOIL →

CARD-
BOARD
STRIP

CARDBOARD BACKING

FIGURE 14 "TINSEL" PAINTING ON GLASS

With Japan Black, add the black touches (shown in black in Figures 13 and 14) in the four flowers numbered 2 and 3, blending off the edges here and there in each 2.

With transparent green (Prussian Blue and Yellow Lake), paint the dark shadows on the leaves and on the birds' perches (shown in dotted white in Figures 13 and 14), blending off with a clear varnish brush here and there. These shadows are only small touches; leave most of the leaves, etc., unpainted at this stage. The downward-pointing strokes in the "mouth" of each 2 are also transparent green. Let the work dry twenty-four hours.

4. Mix Japan Green with a little Burnt Sienna to make an opaque country green, and paint all the leaves, stems, and other remaining parts shown in black in Figures 13 and 14, painting right over the transparent green already painted. This is the only color outside of the off-white in the background that has no hint of transparency. Wait twenty-four hours.

5. Mix Prussian Blue, White, and a touch of Alizarin Crimson, to make a semi-transparent violet-blue, and paint all the light violet-blue parts numbered 9 and the flower 4, leaving bits of clear acetate here and there for the tinsel to shine through. The center of 4 behind the large heavy dots or pellets is left clear acetate.

The brown "tortoise-shell" of the birds' wings, legs, and tails is done with a transparent brown (Burnt Sienna) with darker dabs of Raw Umber here and there. The flowers 3 and 8 are done in the same way. There are also touches of "tortoise shell" in the flowers 2 and on the larger buds. The eyes on the birds are brown. Dry for twenty-four hours.

6. Remove acetate from Tracing A. Place Tracing B face down on the cardboard. Place the acetate pattern over this. Mix some White with a little Raw Umber to make an off-white, and paint the swirling lines shown by the dotted parts of Figures 13 and 14. As you can see, I have not filled in all the dots, but the fully dotted part in the lower corner of Figure 13 is enough to show you the parts to be painted off-white. What is not off-white, is left clear acetate (or glass), so that there will be plenty of tinsel highlights showing through. Use a quill-brush, held more or less vertically, and with the wrist off the ground, paint the broad lines with one stroke, raising or lowering the brush as needed. Paint also the dotted circles between the swirling lines, and the pattern is complete.

Preparing the Glass

First clean both sides of the glass with a piece of crumpled wet newspaper. Then dry them thoroughly with crumpled dry newspaper. The glass must be absolutely clean, and free from lint. Then proceed to paint the pattern on the glass according to the instruction given above for painting on the frosted acetate.

13

Preparing the Surface for Decoration

Old Pieces of Wood or Tin

There are many pieces of old furniture and other household articles which may be nondescript, worn, and more or less treated as ready for the trash heap, but which cry aloud to the decorator for transformation. Old chests of drawers, chairs, tables of all sorts, chests, and boxes may be turned into possessions of beauty and lasting interest. And there are few jobs that give more pleasure and lasting satisfaction to the decorating artist, who knows that many people will in the course of time both use and admire what has been rescued and re-created. Now the preparation of the surface for decoration is as important as the decoration itself. So to do a good job, take time and thought. You will be glad you did.

Remove Old Paint and Varnish

Any good paint and varnish remover may be used. Read and follow the directions on the label carefully. Work with the windows open to avoid inhaling the fumes, and have plenty of old rags and newspaper at hand.

Old Wood

1. Fill in any holes or cracks with plastic wood. Let it dry thoroughly.

2. Sandpaper the flat surfaces, and rub the rounded parts with steel wool to obtain a smooth surface.

3. Apply three or four coats of flat background paint (see final section of this chapter).

New Wood

1. Sandpaper the surface, using first fairly coarse paper if the surface is very rough, then the finer paper. Use steel wool on the rounded parts and on carving.

2. Fill in crevices or holes with plastic wood. When dry, sand again.

3. Apply a coat of fresh shellac to seal the new wood. Let it dry twenty-four hours.

4. Sandpaper again with very fine sandpaper.

5. Apply three or four coats of flat background paint (see final section of this chapter).

Removing Rust on Tinware

All tinware should be treated for rust whether the latter is visible or not; for in its initial stage rust is invisible. For this purpose we may use Rusticide. Clean the surface first, removing any dirt and grease. Apply Rusticide with a one-inch bristle paint brush. Wait five minutes, and then go over the surface with steel wool. If the metal is badly rusted, use a second application and leave it on a little longer, making sure that sufficient Rusticide is on the surface to keep the rust wet and thus ensure penetration. Heavy accumulations of rust may require several applications and scrubbings with steel wool to remove the dissolved rust. Wipe off with a clean cloth. The metal should then be perfectly clean and sealed against fresh oxidation, thus providing an excellent base for the primer paint. Allow to dry overnight, and begin painting the next day. If it is necessary to paint immediately, wipe off the surface with alcohol. Although the surface will not immediately re-rust, it is advisable to apply paint with as little delay as possible.

Primer Painting on Tinware

Never paint a piece of tinware without giving it one or two coats of a good primer paint (see Chapter 3), or the paint will not stick properly. Be sure the primer paint has been thoroughly mixed. The first coat of primer paint may be used straight from the can if it is fairly thin, but if it seems overly thick, thin it a little with turpentine. Apply it as you would a background coat of paint (see below). The second coat may be thinned a bit more. On large flat surfaces it should be applied in a crosswise direction to the first coat. When the primer coats are completely dry, sandpaper the surface until it is perfectly smooth to the

72

touch. Dust thoroughly. Now you are ready for the background coats of paint.

Flat Background Painting

The mark of a professional job of background painting, whether in black or any other color, is that the surface be flat or dull to the eye, and perfectly smooth to the touch. If you feel any ridges, your paint was not sufficiently thinned with turpentine to make it a very thin and watery mixture. To sandpaper it smooth takes time and labor, and may take off too much paint in spots. Besides, it is unprofessional—that is, below the high standard we aim at. Apply the paint properly in the first place. Study the directions given below very carefully, and follow them exactly.

Before applying any paint at all, examine the object to be painted and decide how you will hold it during the process, which part you will paint first, which second, and so on. Make sure you leave one part unpainted on which to rest the object while drying. Have a place prepared on which to set the object for drying. You can see how necessary it is to attend to these matters before you apply the paint. Also, the object should be dusted off carefully before painting begins.

Open the can of black paint and stir it thoroughly with a small stick until it is completely mixed. There is usually not enough room in a fresh can of paint to add sufficient turpentine for thinning. So take a small jar, and pour into it about an eighth of an inch of turpentine, or more if you are doing a big job (be sure to give the can of turpentine a shake or two before using it, to mix it up). With your one-inch bristle brush, dip out several brushfuls of paint, adding them to the turpentine in the jar. Mix with the brush. The mixture should be quite thin and watery.

Begin to apply the paint in long even strokes, all in the same direction. Don't flood it on—use just enough to cover. Because of the thinness of the paint, the first coat will not entirely cover the surface, but don't go back to retouch any part of it. Paint it and leave it, and work quickly. Last of all, check around the edges for any dripping. Let the work dry for twenty-four hours.

In applying the second coat, paint the large areas in the opposite direction to the first coat; that is, apply the second coat crosswise to the first one, thus achieving an even result. Never apply a succeeding coat until the preceding one has dried at least twenty-four hours, and feels

73

completely dry. Every object should have at least three coats and preferably four.

Now if you have done a proper job of sanding and preparing the wood in the beginning, and have applied the paint correctly, you should have a smooth, dull surface that needs no sanding. If it is necessary, however, sandpaper the last coat very lightly, when it is thoroughly dry, with a square inch or so of very fine sandpaper. A tiny piece can be controlled better than a large one. Avoid sanding the edges or other "vulnerable" parts, that is, parts where the sandpaper might take off the paint altogether.

Allow the final coat of paint to harden a month or longer before applying a decoration, although a shorter time is all right if you intend to do a stenciled decoration. The longer waiting period is necessary for light or colored backgrounds, or when gold leaf or bronze powders are to be used. The waiting period can be employed in brush-stroke practice, painting patterns, or in preparing other objects for decoration.

14

Background Colors

Black backgrounds are the easiest to work on, since corrections are least noticeable on black. For this reason, beginners are strongly advised to work for some time only on black, and to go on to the colored grounds later.

The paints we use for background coats are good quality flat indoor paints. By flat, I mean paints that give a dull surface. Never use glossy enamels. How to apply a coat of flat background paint has already been described in Chapter 13.

Testing a Paint

The paint manufacturers' chemists have been making changes in the composition of many paints of late, and this makes it difficult to advise which brands of paint are reliable for our purposes. A flat black that I formerly recommended to my students and readers has been changed so completely within the last few years as to become useless to us. Recommendations of brands in this book should be understood, therefore, to be only currently valid.

It is a good idea to paint a piece of cardboard with two or three coats of a paint (if you are in doubt about it), and make a brush stroke test with the same mixtures you intend to use in painting the decoration. Also cover a section of the background paint with clear varnish. If the colors and the clear varnish sink right into the background paint so that they dry in a spotty fashion, you had better change your brand. The brush strokes should look and behave the same on the paint as they do on the frosted acetate.

Buying Paint

Another difficulty which confronts us today is in getting colors like dark brown, dark green, and red in flat paints that can be thinned with

75

turpentine. Manufacturers are tending to stylize their colors according to the prevailing popular taste, which at present is supposed to be for pastel colors. Do not use paints that can be thinned with water. We use the kind that can be thinned with turpentine.

When you buy paint, you must know just what you want, and you must check (by reading the labels) to be sure you get what you ask for.

Mixing

Since many of our background colors have to be obtained by mixing, it is useful to save small screw-top jars for the purpose. Mix sufficient color to ensure that you will still have some left over in the jar which can be used for touching up after the decoration is on. Mix the pigments first, then add the turpentine to get the proper watery consistency (see p. 73). Mix relatively small quantities of the thick color, because the addition of the turpentine will greatly increase the quantity. Always remember when mixing colors to allow for the darkening and yellowing effect of the finishing coats of varnish.

Antique Black

This is characteristic of many old pieces, and might be described as an off-black or charcoal color. It is very effective in giving a job the antique look.

To mix antique black, put some Flat Black in a clean jar and add some Raw Umber and White in the following manner: squeeze a little of the Raw Umber and White on to an old saucer; dissolve them by mixing in some of the black with a showcard brush or palette knife; when no lumps remain, add the mixture to the jar of flat black and stir thoroughly with a small stick. Test the color on a piece of paper, using the showcard brush.

Brown

Any brown can be modified by adding:
 Yellow to make it lighter and warmer;
 Vermilion or red to make it still warmer;
 Prussian Blue to make it darker and colder;
 White to make it lighter.

76

Medium Colors

Use the nearest available color in flat paint, and add the necessary tube colors as indicated below:

1. *Antique Red.* To flat spectrum red paint (if you can get it) add Raw Umber, Japan Yellow, and a little White. Avoid using Vermilion because, in large quantities, it does not mix well with other pigments, thus making it almost impossible to get an even background color.

E. P. Lynch, Inc. have an excellent antique red already mixed, called Harreth Red.

2. *Antique Blue.* A sample of a good antique blue can be prepared on your newspaper palette by mixing White and Raw Umber together, and then adding Prussian Blue. Paint one or more samples of antique blue on a card, and take it to your paint store as a sample of what you want.

3. *Olive Green.* Olive green is made by starting with Japan Green and adding Burnt Umber and Yellow Ochre. Another olive green can be had by adding Burnt Sienna to the Japan Green.

Light Colors

Use flat white paint as a base for all light colors, adding Japan or oil colors to get the color you want.

1. *Off-White.* White with a little Raw Umber added.

2. *Gray.* White with more Raw Umber added until you get the color you want.

3. *Cream.* White with a little Yellow Ochre added.

4. *Pale Antique Yellow.* White, Japan Yellow, and Raw Umber.

5. *Pale Apple Green.* White, Japan Yellow, Raw Umber, and a touch of Prussian Blue.

Japan Colors

Japan colors can be used for background paints where small quantities are called for. Mix them with turpentine, adding other tube colors when necessary to get the colors you want.

Grained Backgrounds

Painted furniture was sometimes given a grained background in order to imitate expensive woods. Occasionally, graining was used on

77

boxes. The graining was generally done in black over a dull red painted background (to imitate rosewood), or over a walnut stained background.

For "rosewood" graining, first apply two or three thin coats of dull red in the usual way. The red is a Venetian red or brownish red, made by adding a little Vermilion to flat brown paint. When the color is dry, apply a coat of rather thin flat black, and *immediately* grain lengthwise along the wood by pulling a crumpled piece of stiff muslin across the wet surface. Experiment on painted cardboard first.

Graining can also be done by using a crumpled piece of soft plastic film, or of newspaper; crushed cellophane; a piece of cardboard, or thin wood with the edge cut in irregular notches; or anything else you may have at hand that will produce the desired effect. The graining should be subdued in character or it will distract attention from the decoration.

On large pieces of furniture, apply the black in sections in order that the graining can be done comfortably before the black sets or begins to dry. On a stenciled chair, the main slat is not grained, but is painted black.

Asphaltum

A background that is often found on old tinware is asphaltum, a mixture of asphalt and varnish. It is a somewhat transparent background painted directly over the bright tin, in shades ranging from black through dark brown, and its special charm is in the hint of bright tin showing through the color. But asphaltum is difficult to apply, for it tends to show streakiness, and thus it is advisable to begin with plenty of practice on bright tin cans.

Asphaltum comes in cans, and if applied straight from the can without thinning it is completely black. So for our purposes it needs thinning, but thin it only with *varnish*. When varnish is added, the color becomes a lovely lustrous brown, darker or lighter depending on the amount of varnish added. Some decorators like to add a little Alizarin Crimson to get a reddish brown. Mix the amount you require in a separate jar.

Apply the mixture with a varnish brush (some decorators prefer a flat camel's hair brush), working quickly, and flowing it on, rather than painting it on. Use as few strokes as possible, and don't go back to retouch. If you have enough of the mixture on your brush as you apply it, the streakiness may disapper when the asphaltum settles. If mistakes

78

are made in applying it, the surface can be cleaned off immediately with turpentine, and another attempt made.

Asphaltum should dry for one week, after which time it can be given a protective coat of varnish, but this coat of varnish must also be flowed on, with as few strokes as possible, or you may disturb the surface.

If your tinware is no longer bright, you can simulate a bright shiny surface by applying a coat of varnish. When this is tacky, that is, not quite dry, apply aluminum or chrome powder with a piece of velvet, and then burnish the surface with a little extra pressure on the velvet. Wait twenty-four hours, wash off all the loose powder under running cold water, and pat the surface dry with a lintless towel. Then apply a coat of varnish to protect the surface. Let this dry twenty-four hours. Finally, apply the asphaltum mixture.

15

Transferring the Design

After the surface of an object has been prepared for a freehand painted decoration, there is one more step to be taken before the design is actually painted. An outline of the pattern has to be transferred to the surface as a guide. Commercial carbon papers, being greasy, are unsuited to our purpose, and so we must make our own type of "carbon" paper, as described below. Once made, these carbons can be used again and again. Preserve them for future use in a folder.

White "Carbons"

A white "carbon" is needed to transfer a pattern to a dark ground. Rub a cake of magnesium carbonate (see p. 16) over the surface of one side of a piece of tracing paper, 6 by 12 inches. Then rub the deposited powder well into the paper with the fingertips. Blow off the excess powder. Fold the tracing paper in half, with the powdered surface inside, and put this in a book, so that there is some pressure on it. Leave it there for a week, during which time the powder will work into the paper. A second white carbon, about 4 by 8 inches, is useful for the smaller jobs.

Dark "Carbons"

For transferring a design to light backgrounds you will need a dark "carbon," which can be made by penciling all over one side of tracing paper with the flat side of the lead of an H or 2H pencil. Do not use a soft, smudgy pencil. There is no need to rub the penciling in, and the carbon can be used immediately without any waiting period.

Trace the Design

Make a careful tracing on tracing paper of the design you intend to use. Include everything but the superimposed details which can be added later by eye. Use a well-sharpened H or 2H pencil.

80

Transferring to a Dark Background

Place your pencil tracing of the design in position on the surface to be decorated. Make sure the design is exactly where you want it to be, for carelessness at this stage will spoil the whole job. Stand up to place the design, so that you can see everything to better advantage. Don't rely on measuring with a ruler, for most patterns are not exactly alike on both sides. Consider not only the tracing, but also your finished copy on frosted acetate, so that you can judge the "weighting" of the pattern. Be sure the tracing is not tipped to one side or the other.

When it is just right, secure the tracing to the surface with two or three tiny pieces of masking tape, placed so that you can slide the carbon, white side down, underneath the tracing without distrubing the tape.

Now retrace the design over the carbon with a well-sharpened 3H pencil, exerting some pressure in the process. Pick up one corner of the carbon from time to time to make sure you are getting a white outline on the painted surface. Move the carbon along, when and if necessary, to keep it under the pencil point. When the transfer is completed, you are ready to paint the pattern just as you did in your frosted acetate copy.

Transferring to a Light Background

Proceed as for a dark background, using your pencil carbon instead of the white one.

Stencil Patterns

The above instructions are all for free-hand painted designs, or parts of designs. The carbons are of no use in stenciling a design. See Chapter 7, "Stenciling."

16

Striping

Striping is not the difficult thing it appears to be at first glance. A little practice and determination are all that are required, and they will be amply rewarded. Nothing gives such a professional finish to your work as a nice bit of striping.

Although not every old piece was striped, the majority of them were. For this reason, and because of the added embellishment, it is recommended that you stripe everything you decorate.

Function

The function of striping is further to enhance the appearance of the decoration, and to put a finishing touch to the whole piece. Although striping is always in a contrasting color to the background, it should never be so prominent that it distracts the eye away from the main decoration, or from the piece as a whole. In a word, striping should not be conspicuous.

With this in mind, we keep the gold or bronze powder stripes from getting too wide. Usually they should not be more than one-eighth to three-sixteenths of an inch wide on the very largest objects that you decorate. For very fine or hairline stripes, which should not be wider than one-sixteenth of an inch at the most, we generally use a Japan color. And in the case of red, green, or yellow, we add one of the browns (oil colors) to subdue the color, adding quite a lot of brown in the case of yellow.

Striping Colors

1. *On Black Backgrounds.* When the background is black, and the main decoration is in a gold technique, the striping is usually in gold too. These gold stripes are usually accompanied by a fine mustard yellow stripe made on the inner side. A gold stripe is made by striping first

82

in Yellow Ochre (for gold leaf) or Japan Vermilion (for gold powder), and when the tacky stage has been reached, applying the gold.

For black grounds that have a country-painting style of decoration, striping should be in a vermilion, a mustard yellow, or a dull off-white.

2. *Off-White or Gray Backgrounds.* We seldom use a stark white background but rather add a little Raw Umber to soften the white. If you keep adding Raw Umber you will get a whole series of beautiful pale grays.

Striping should be in vermilion, dark country green, black, or brown (Raw Umber or Burnt Umber), depending on the colors in the decoration.

3. *Brown Backgrounds.* These usually have a pattern in the country style of painting, and striping should be in off-white, vermilion, or mustard yellow.

4. *Pale Yellow Backgrounds.* Striping should be in black, brown, country green, or vermilion.

5. *Red Backgrounds.* With gold decorations, the striping should in gold. With country style decorations, striping should be in black, or mustard yellow, or off white.

6. *General.* Striping colors generally reflect the prevailing color in the decoration. On some of the old chairs and trays, we find opaque stripes, while on others they are semi-transparent. In the former case, less varnish is used in the striping mixture; in the latter, more varnish.

Surfaces for Striping

Gold or other bronze powder striping should be done on the flat or dull background paint. In the case of a stenciled decoration, the gold striping should be done before the surface is varnished in preparation for the stenciling.

Colored striping, generally done with Japan color, or in Japan colors mixed with oil colors, is best laid on a dry varnished or glossy surface which will keep the stripe from feathering, and also facilitate erasures. Corrections must be made at once, with a little turpentine or dry-cleaning fluid on a rag.

Brushes

A minimum of two brushes is necessary, one for very fine striping, and one for the wider striping (see Figure 2). Stripers are square-tipped

83

quill brushes, with hairs one and one-half to two inches long, and are used without a handle.

Making the Stripe

In the act of striping, the brush is always pulled toward you (see Figure 15). To mix some mustard yellow for striping practice, fill a bottle cap one-third full of varnish. Using a showcard brush, add a little Japan Yellow and a little Raw Umber to the varnish until the color is a rather dark mustard yellow, and the mixture somewhat thin. Lift out a few brushfuls of the mixture on the newspaper palette. Dip the striping brush into it, moderately loading it to the full length of the hairs, and pulling it back and forth on the newspaper to get the feel of the brush.

Practice striping on a piece of the black glazed stenciling paper. The stripe should be about one eighth of an inch wide, and you should be able to stripe about a foot or two before you need to replenish the brush. To get a narrower stripe, flatten the brush on the newspaper palette, and then stripe with the thin edge of the brush.

It is also helpful to practice striping on a raw tray to get the feel of working on a hard object. The paint can easily be cleaned off with turpentine.

When striping a rectangular shape, such as the top of a box, or a chair slat, do not try to make two stripes meet in a perfect angle at the corner. Instead, carry the stripes across one another and on to the ends of the area. This done, immediately clean off the bit of unwanted striping at the intersection by wiping with a clean cloth. Or wait twenty-four hours for the striping to dry, and cover up the unwanted part with the background paint.

Furniture, or anything else you décorate, is generally striped according to the construction of the piece.

17

The Finishing Coats
of Varnish

Once the decoration has been completed, including the striping, you are ready to apply the finishing coats of varnish. But first carefully inspect your work, and if any touching up is necessary—and some usually is—this is the time to do it.

Touching Up

For this purpose use the extra background paint that you saved specially. Don't stir the paint, but with a palette knife or small stick, lift out some of the thick paint at the bottom of the can and place it on the newspaper palette. If you need to thin it as you work, use the "juice" from the top of the can. Use a small quill brush or a pointed water color brush, and touch up wherever there are obvious faults which can be corrected in this way: perhaps smudges of gold powder on the background, or pointed leaves that aren't as pointed as they should be, or a stripe that needs a little straightening out. Don't do so much touching up that it becomes noticeable. Don't bother to touch up little faults that no one is likely to observe. You must use your judgment. Stand away from your work now and then to get the general effect. When touching up is finished, let the work dry for twenty-four hours.

Varnishing

To simulate the satin smooth finish found on most old pieces, we apply at least six coats of the regular high gloss varnish. On table tops or trays for which a heat or alcohol resistant surface is needed, an extra two coats is advisable. Warning: If your decoration includes the use of any bronze powders, the successive coats of varnish must be applied

85

as soon as possible once the first coat is on, otherwise the powders will probably tarnish (see p. 28).

Antiquing

To simulate the antique coloring found on many old surfaces, we may tone one or two coats of the varnish with oil pigments. But the varnish must remain completely transparent, and so only the barest touch of color should be used; otherwise you will get ugly streaks across the surface. Oil pigments generally used for this purpose are Raw Umber or Burnt Umber, but occasionally, to get special effects, Yellow Lake, Black, or Prussian Blue are necessary. Antiquing is generally done on the first coat, or the first two coats, depending on the effect you want. Be careful not to "over-antique," as a little of this varnish goes a long way. Besides, the clear varnish naturally turns darker in a few years at most, and this is all the more reason to be very cautious indeed if you antique.

Getting Ready to Varnish

Since one great enemy of a good varnish job is dust, clean the room first, and allow the dust to settle. Close all windows and doors, and keep all traffic away for the first three or four hours after varnish is applied.

The room should be 70 degrees or warmer, and the can of varnish and the object to be varnished should have been standing in that temperature for some time. Varnish applied to a cold surface in a cold room will "crawl," that is, tend to separate or "ridge." A freshly varnished surface should be kept away from hot radiators, cold places, drafts, open windows, and direct rays of the sun.

Applying the Coats

Taking a tray as an example, proceed as follows:

First Day. Spread out plenty of clean newspapers to work on. Decide where the tray will rest in order to dry, and place newspapers there, with a tin can or other suitable object on which to set the tray. Dust off the tray, and just before varnishing wipe off with your hand, to remove any remaining dust or lint, especially in the corners.

Assuming that you want to "antique," squeeze out a little Raw Umber alongside the opened varnish can (which you ought to have standing on the clean newspaper palette). With your one-inch varnish brush, dip

86

out several brushfuls of varnish, and pulling in a speck of Raw Umber mix a puddle of "antique" varnish. Try it out on a clean piece of paper to see the color, which should be very little darker than the clear varnish itself. Work very quickly as the varnish thickens on contact with air.

Then apply the "antique" varnish to the tray in this order: first do the underside of the flange; then turn the tray over and do the edge and the top side of the flange; and finally do the floor. Work with the light falling across your work; in this way you can see that every bit of surface is covered. Don't flood the varnish on, as it will only run down and settle in the corners where it can't dry properly. Spread the varnish out with the brush, using long strokes the full length of the floor. Then, without taking any more varnish unless absolutely necessary, use the brush in the crosswise direction to ensure an even distribution. Work quickly, mixing more varnish and Raw Umber if you need to.

When you have finished, inspect the work carefully, and with a very light touch, and using only the tip of the brush, pick up any tiny bubbles and/or brush hairs which may appear on the surface. Last of all, check the underside of the tray for any varnish drippings. Let the work dry for twenty-four hours.

Second Day. After dusting off the surface, apply the second coat of varnish, adding a touch of Raw Umber only if you want a darker color. Dry for twenty-four hours.

Third Day. Dust off the surface and apply the third coat of varnish. Dry for twenty-four hours.

Fourth Day. Although sandpapering must be thorough, be careful not to do too much of it, or to apply too much pressure, as otherwise you might go right through the coats of varnish. Sand first the floor of the tray, then the flange, but keep away from the edges where you might very easily take off both varnish and paint. This caution should be observed, of course, with any kind or size of object.

Take some very fine sandpaper, and cut it into pieces about 1½ by 3½ inches, fold them in half with the sand outside, and begin to sand the floor of the tray. Sandpaper diagonally, first from upper left to lower right, then from upper right to lower left, taking only small sections at a time. When one hand is tired, use the other, thus saving time and avoiding fatigue.

When the sanding is finished, dust off the tray.

If any sand particles remain stuck in the corners, it means you used

87

too much varnish previously, with the result that it did not dry properly. If this happens, wait another 24 hours for the corners to dry out; then sand again.

Apply the fourth coat of varnish. Let it dry twenty-four hours.

Fifth Day. Sandpaper the surface as described above with still finer sandpaper or with #000 steel wool. Dust off. Apply the fifth coat of varnish.

Sixth Day. Sandpaper the surface again. Dust off. Apply the sixth coat.

Extra Coats

Six coats of varnish are the minimum. For a really beautiful and extra smooth, satiny finish more coats are necessary. Eight or ten coats give a superb finish, although it must be remembered that extra coats tend to darken and yellow the decoration. For this reason, when extra coats are to be applied, I would not use any Raw Umber in the initial coats, or I would use a less amount than usual.

The Final Rubbing

This calls for powdered pumice, crude oil, and a cotton flannel cloth. Put about a teaspoon of the powder in a saucer. Take a small flannel cloth, put some crude oil on it, and then dip it into the pumice. Begin to rub small sections of the tray floor, a few square inches at a time, using a small circular motion. There is no need to rub long, for the high gloss of the varnish comes off immediately, and that is all you want. If you rub too long, the surface will be dull and lifeless, whereas the proper result is a satiny gleam. Use enough crude oil to keep the rubbing moist.

When you have gone over the whole surface, rub off the remains of the oil and pumice with a clean flannel cloth, and let the surface dry. If any bright glossy spots show up, give them a rubbing as before. This satin finish needs no furniture polish to preserve it, but only a damp cloth now and then. (We do not use a satin-finish varnish).

18

Enlarging and Reducing Patterns

Enlarging

Take Border 5 in Figure 2 for an example, and proceed to enlarge it as follows:

1. Trace one or two units of the border on the upper left-hand corner of a piece of tracing paper. Refer to the drawings in Figure 16.

2. Using a small right-angle triangle, or a postcard, draw a rectangle around the units which will box them in and touch them on all four sides. Use the triangle to get right-angles at all four corners, and draw the lines with a well-sharpened 2H pencil.

3. Continue the right-hand side of the rectangle downwards a few inches, and extend the bottom line out to the right several inches.

4. With a ruler or triangle, draw a diagonal line from the upper left-hand corner to the lower right one, and continue it out beyond the box, as in the illustration.

5. Measure either the width or the height of the larger size that you want (in this case it would be the height of the border), and complete the larger of the two rectangles joined by their corners as in the illustration. Use the triangle to get right-angles, and be sure that the diagonal line mentioned in the preceding paragraph passes through the lower right-hand corner. This ensures that the enlargement will be in the same proportion as the original.

6. Divide the long sides of the first rectangle in half, then in quarters, and finally in eighths. Divide the short sides into quarters. Do the same with the larger rectangle. In the case of larger and more complicated patterns, the sides could be divided into sixteenths, thirty-seconds, and so on.

89

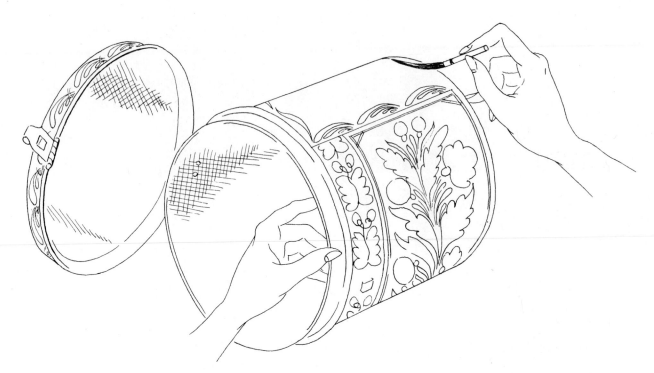

FIGURE 15 STRIPING THE CANISTER

FIGURE 16 TO ENLARGE A DESIGN

DIAGONAL

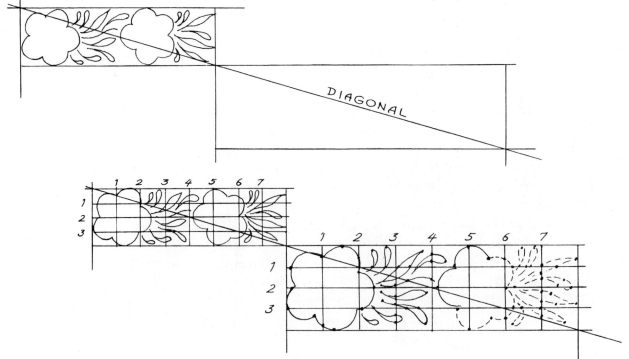

7. Rule and number the lines, as shown in the lower drawing in Figure 16.

8. The outlines of the pattern in the smaller rectangle are crossed by the ruled lines. Note where each point of intersection occurs, and put a dot at the corresponding place in the larger rectangle. When the dots are all in place, join them up with lines of the same character as those in the original.

9. If the finished drawing seems a bit stiff, place a fresh piece of tracing paper over it, and retrace it, improving the drawing as you go along.

Reducing

The general procedure is the same, but when extending the right-hand side and the bottom of the first triangle, you will, of course, make a *smaller* rectangle, corresponding to the size of the reduction you seek. By turning Figure 16 upside down, you can see how the two rectangles should look for reducing purposes.

19

How to Use the Patterns

"Good Taste"

Everyone will agree that good taste should be a guiding principle in work of this kind, and even those who are naturally gifted in this direction can cultivate their gift to a higher degree. A few ways to acquire or develop good taste in our field of decoration are:

1. Visit museums to study old pieces of ornamented furniture and smaller objects of all kinds. When you plan a vacation, try to include visits to museums at a distance from home. Your public library has reference books which indicate what museums are in particular localities, and what kind of exhibits they contain. Write to local chambers of commerce for further information. With a little preparation, vacations can be made educational as well as recreational, and if you can interest your family and friends in your plans, so much the better. Similarly, one may study old pieces in the windows of antique shops, or in private homes.

2. In studying old pieces, note the kind of ornamentation that was used, how much blank space was left around the designs, and how the designs reflect the general lines and shape of the whole piece; for example, a light, delicate, graceful design on a light, gracefully shaped chair, or a heavy, strong, bold design on a bulky chest of drawers. Note what colors were used, and how they combined to give a pleasing effect.

Have a small notebook and make entries in it. Include rough sketches. Buy photographs of the objects when these are available. All this will help you to remember what you have seen, and will form source material of special value to you.

3. Most libraries have books on antique decoration, design, and decorative arts of all kinds. Some may be taken home for perusal, others must be read in the reference rooms of the libraries. Making yourself familiar with such books will help enormously in cultivating a sense of

what looks well and what doesn't. If your budget allows you to buy some art books, that is all to the good, for books which are at your elbow and you consult constantly become, in a sense, part of you.

4. If you are decorating objects which are reproductions of old pieces, or old pieces whose decorations have worn off, it is particularly important to use appropriate designs. A tin box should have a tin box design, a chair a chair design, and a tray a tray design. Size and type of design will be carefully considered in relation to the size and type of article. In ornamenting modern pieces with the old patterns, greater freedom may be used in the choice and placing of designs, but of course good taste remains an indispensable ingredient of the work.

To Enlarge or Reduce a Design

Naturally, there are times when a design must be enlarged or reduced to fit a certain space. Here the required caution is to avoid extremes. Choose a design as near as possible to the size you need. For the method of enlarging and reducing see Chapter 18.

To Adapt a Design

If you need to adapt a design for use on an area the size and shape of which are somewhat different from that of the original, proceed as follows:

Mark off on a sheet of tracing paper the area you want to decorate. Put this tracing over the original pattern, and proceed to make a revised drawing of the pattern according to your needs, moving the tracing paper about so that different parts will appear where you want them. Draw in the larger or more important parts first, then the secondary parts, and finally the least important parts or the "fill-ins." As you work, add to or leave out parts of the design as needed. These changes should be made by eye, care being taken to preserve balance and good proportion in the whole design. As a general rule, however, change the original design as little as possible.

20

The Happy Artist

When our efforts in any direction are crowned with success, we are able to look back upon the whole process with a feeling of happiness. But since success in any field depends on following the proper "recipe," on knowing the "tricks," or the "secrets of success," I set down below a few hints and suggestions that my pupils and I have found helpful. Some of these will seem prosaic, not to say commonplace. But these commonplace principles, when applied faithfully, are the key to that sustained endeavor which leads us to successful results.

1. Learn to criticize your own work by looking back on what you did the day before, and picking out the flaws, the downright mistakes, all the things that might have been better. Praise from those around you is very sweet, but don't let it keep you from sternly criticizing your own work.

2. Strive for ultimate perfection in everything you do. Endeavor to trace an outline exactly. Try to paint a pattern exactly as it should be done. Follow instructions precisely.

3. At the same time, deliberately cultivate a mental attitude of patience. The learning process takes a certain amount of time. Be willing to do a thing as many times as it may be necessary in order to get it right. And just as deliberately maintain a happy frame of mind while learning and doing.

4. Practice is essential in learning a new skill. But just as important is your mental attitude while you practice. Always picture yourself as doing beautifully whatever you seek to do.

5. While you work, concentrate in a constructive way on what you are doing. If you are painting a tree, think "tree"—think of the sturdy trunk rooted in the ground, drawing nourishment from the soil; think of the leaves that murmur in the breeze, that lift their faces to the sun, that glisten in the rain, that provide shade for the traveler. In a light-

94

hearted way be a bit poetical about it all, and you'll paint a better tree.

6. Keep your artist's materials in perfect condition and in order: your brushes clean and soft, your pencils well sharpened, varnish in perfect condition, tracing paper, linen, and frosted acetate smooth and free from wrinkles. Arrange things in an orderly manner, so that they are readily available for use.

7. Provide proper lighting when you work. A north window is best for daytime work. In the evening, you should have a lamp close by, directed right on your work.

8. Work in a clean room, and always dust the material or the article which you are ornamenting.

9. If a written instruction seems difficult to understand at first, read it aloud. Seeing an idea in print, and at the same time hearing it spoken (by yourself in this case) is often more effective than just seeing it alone.

21

Restoration of Old Decorated Pieces

Restoration requires a great deal of skill and experience, and therefore it should be undertaken only by one who has studied original pieces over a long period of time, and who has become an expert in the decorating techniques concerned.

Moreover, it must never be forgotten that most old pieces will be more highly esteemed when they have *not* been restored. Restoration, if not done by experts, can all too easily lessen the market value of an old piece. So the first rule in all cases must be to think carefully about the whole problem, and to act with the utmost restraint.

Other points to be considered are whether the decoration is genuinely old, and whether it has sufficient merit to justify restoration. Genuine worth-while decorations are recognized by their expert brushwork, their evidence of finely cut stencils, and their well-balanced, artistically conceived designs. As a rule, only the highly skilled decorator with many years of experience will be qualified to judge these points.

Although the following paragraphs give an outline of the procedures, each case must be studied to decide how much or how little work is required. Generally speaking, it is far better to do too little in the way of restoration rather than too much.

Cleaning
Remove surface dirt with the gentle and judicious application of a damp cloth and a little mild soap. Rinse with another damp cloth, and dry.

White Film
To remove any white stains or film caused by old shellac, use dena-

96

tured alcohol on a cloth, but only a little at a time. Proceed cautiously, doing only a small section at a time, and if any color comes off, stop at once. A hint of white film may remain, but this will disappear when varnish is applied.

Removing Paint

If an old coat of paint covers an original decoration, the paint must be removed slowly and carefully to preserve the decoration. The repeated application of soap on a damp cloth is sometimes all that is needed. In some cases, rubbing small sections at a time with denatured alcohol will take off the paint. Or chipping off the paint bit by bit with a small knife may be best. In all cases, judgment and discretion must be exercised if the decoration is to be saved.

Note. Do not use the regular paint and varnish remover on an old piece. When dealing with an old piece that has been painted over, always proceed on the assumption that there is a decoration under the paint.

Removing Rust

In the case of tin objects, all rust must be removed. This may be done with Rusticide. Although this preparation will not harm paint, it should be applied just on the rust spots. A small paint brush is a convenient applicator. In rubbing with steel wool you should try to avoid as much as possible rubbing the paint and decoration surrounding the rusted area. Use steel wool twisted around a pointed stick. Rinse and dry.

Touching Up

Whenever it is at all possible, keep the original decoration, merely touching up background and decoration where parts are missing. Match colors as closely as possible. Bronze powders may be mixed with varnish on the newspaper palette, and applied with a small brush; if necessary, add touches of oil paint to get the color you want. After drying for twenty-four hours, the touched-up parts may be "antiqued," if need be, by using transparent overtones to match the original.

Complete Restoration

If too much of a decoration has disappeared to make touching-up feasible, make a careful copy of it on frosted acetate. The first step to-

97

ward this is to apply a coat of varnish and let it dry. The glossy surface will bring out more clearly all traces of the pattern. Make a careful tracing on the frosted acetate of everything that is even faintly visible. Sometimes all that remains of gold scrolls are faint impressions which may be seen when the painted surface is held at certain angles. Then put a fresh piece of frosted acetate over the tracing, and make a complete painted copy, supplying any missing sections from research or imagination. After this, you can proceed to remove the old finish entirely from the article, and start the job of restoration on the raw metal or bare wood.

Pitted Surface

After rust has been removed, or paint has been chipped off, the floor of an old tray may be badly pitted. In this case, take some thick sediment from the bottom of a can of flat black that has been standing awhile, and mix it with powdered pumice to make a heavy paste. Add a few drops of varnish, and use this compound as a filler, smoothing it on with a palette knife or your finger. Let this dry for several days, and then sandpaper it. For a colored background, use the appropriate color instead of flat black.

Gold Leaf Restoration

It is very difficult to match old gold leaf, but in cases where rust has set in, restoration is better than neglect. Make a tracing of the original pattern, and supply the missing parts. Transpose the outlines to the prepared surface. Then apply the gold leaf in the usual way over a mixture of Yellow Ochre and varnish. Let it dry for a week, and then apply a protective coat of varnish. When this is dry, use transparent colored overtones over the newly laid gold leaf to match as closely as possible the color of the old metal.

Restoring Old Painted Chests and Boxes

These pieces were usually painted and decorated with colors containing turpentine and linseed oil, and so require an oiling once a year to keep them in good condition. First, clean the surface by washing it carefully and gently. Wait twenty-four hours. Then treat the surface with a colorless or neutral lotion cream (such as is sold for fine leather shoes, handbags, etc.), applying it with a soft cloth.

If parts of the decoration need restoring, this should be done with

Japan and oil colors, mixed with turpentine, linseed oil, and a few drops of Japan Dryer to hasten the drying. Colors containing linseed oil require at least a week to dry thoroughly. This should be remembered when painting one color over another.

Avoid the use of Vermilion in matching mixed background colors. It never mixes properly with certain colors, separating after the mixed color has been applied and so changing that color.

Restoring a Stenciled Decoration

1. Trace the design on frosted acetate, accurately and precisely. Supply any missing parts.

2. Place architect's tracing linen over the acetate, and trace the missing parts. Cut the stencils.

3. Buy several shades of bronze powders corresponding as closely as possible to the colors in the original decoration.

4. Varnish the surface, and when it is tacky, stencil the missing parts. Let the work dry twenty-four hours.

5. "Antique" the newly stenciled parts, by mixing varnish with a touch of oil color, and applying a transparent overtone to match the original parts as closely as possible. Use as little varnish as you can, so that it will not form a ridge around the edges when it settles. When desirable, flatten or smooth out the edges of the varnish patch with the finger tip.

Another procedure is to give the area a coat of varnish; then, immediately wiping the brush almost dry, pick up minute bits of dry color on the brush, and go lightly over the newer parts until you get the color you want. If necessary, use a smaller brush to apply the color. This process requires great speed and considerable skill to get the color just where you want it and to avoid streakiness.

Portfolio of Additional Patterns

The patterns in the following pages are accompanied by brief directions for painting: the more detailed instructions can easily be found in the chapters on the various techniques. Students are advised to review those chapters, and to keep on practicing the brush strokes at every opportunity. Before each painting session, five or ten minutes of brush stroke practice is of inestimable value in improving your work and in saving time. Make perfect brush strokes your aim.

It is strongly recommended that you paint each of the patterns at least once on frosted acetate. This will give you practice in painting the various stages, in mixing colors, and generally in wielding the brush with facility. Many of my students take great pride in their painted patterns, which they mount carefully and keep in portfolios. This provides a convenient reference and a means of displaying the patterns to their friends.

Blue Dower Chest

The Frontispiece shows the general appearance of this splendid nineteenth century Pennsylvania painted dower chest which is preserved in the Metropolitan Museum of Art, New York. With its sunken arched panels and lovely tulip motifs the chest is of a type associated with Lancaster County. It measures 52 inches long, 26 inches deep, and 29 inches high.

In view of these dimensions, the line drawings in Figures 17-20 have naturally had to be reduced; but the outlines are simple, and enlargement to any other size you may require is not difficult (see Chapter 18). The original sizes of the parts are as follows: Figures 17 and 18—13½ inches high; Figure 19—13 inches high; Figure 20—15⅝ inches wide at the center line. The designs are painted on cream panels.

To make patterns on frosted acetate, first do any desired enlargement of the patterns in Figures 17-20. Make corrected tracings of the enlargements (see Chapter 18). Place frosted acetate over the tracings, and proceed in each case as follows.

Figure 17

1. In the three flowers marked V you see dotted areas on the petals: these indicate the Raw Umber that is to be worked into the wet color as you paint each petal. Work with two brushes: one, a showcard brush, with a dry mixture of Raw Umber; the other, a quill brush, with a mixture of salmon pink, made by mixing Vermilion, a little White, and a touch of Raw Umber. Using the quill brush, paint the petals one at a time with the pink, immediately working in a touch of the Raw Umber and blending it with the pink. Disregard all the superimposed details, and leave the large centers (in *all* the flowers) unpainted at this stage. With the same salmon pink, paint the petals of the flowers VM.

Mix Prussian Blue, a little White, Raw Umber, and a touch of Ja-

FIGURE 17 BLUE DOWER CHEST: CENTER FRONT PANEL

pan Vermilion, to make a dark medium blue, and paint the petals of the flowers B.

Mix some Yellow Ochre with a little Japan Yellow to make a golden mustard yellow, and paint all the flower centers. As you paint each center, work in on the wet surface the few strokes of dry Burnt Sienna which can be seen in the drawing. Allow twenty-four hours for drying.

2. Mix some Japan Green, a little Raw Umber, and a touch of Prussian Blue, to make a country green, and paint all the line-shaded parts as shown in Figure 17, disregarding the black strokes.

Mix some Yellow Ochre and Raw Umber to make a thin, somewhat transparent mixture of dark mustard yellow, and paint the flowers VM, going right over the salmon pink underpainting, but leaving hints of the salmon pink at the tips and here and there. Let dry twenty-four hours.

3. Mix Raw Umber and Prussian Blue to make a very dark blue, and paint the accent strokes shown as solid black in Figure 17. Then wipe the brush back and forth on the newspaper to flatten it and at the same time to get rid of most of the paint on it. With this, add the small, fine dry-brush sort of strokes on the petals of each flower.

Figure 18

This is painted in the same way as Figure 17, except that Figure 18 has no flower B.

The berries are in salmon pink.

Figure 19

The flowers marked V are in salmon pink. For the flowers O, mix some Japan Vermilion, a little Japan Yellow, and a little Raw Umber to make a dull orange. The oval and the heavy accents are painted in the same blue black color that has been used for the accenting strokes in the previous figures. The oval is best done with a striping brush. The line-shaded parts are painted as before (Figure 17).

Figure 20

This shows one half of the large oval which is centered on the lid of the chest. The centers of all the flowers are a purplish red, made by mixing Alizarin Crimson, Burnt Sienna, and a touch of Prussian Blue, and they are painted rather sloppily, with the mixture thicker and thin-

FIGURE 18 BLUE DOWER CHEST: FRONT PANEL

FIGURE 19 BLUE DOWER CHEST: SIDE PANEL

CENTER LINE

FIGURE 20 BLUE DOWER CHEST: TOP PANEL

ner here and there. The petals of the flowers B are in the same blue as was used previously. The flowers VM are painted in two colors: first the dotted line parts are done in the salmon pink, and when this is dry (after twenty-four hours), the dull mustard yellow over-strokes are painted, each stroke partly obscuring the pink strokes.

There is no occasion to copy the old name on the lid, or to insert any name. But if you do happen to want to put a name on, do it in some old style of lettering.

To Decorate a Chest

1. Prepare the surface for paint (see Chapter 13).
2. Apply the blue background color.
3. Paint the recessed panels and the oval panels on top and sides of the chest with a cream color flat paint.
4. Apply the salmon pink trim.
5. Paint the decorations.

The Finish

Old ornamented chests were not originally painted with varnish in the colors, nor were the chests given finishing coats of varnish. If an old chest is to be restored, and needs just a little touching up here and there, mix your colors with turpentine and a little linseed oil, as the old decorators did. But to keep paint of that kind in good condition, it is necessary to rub it over once a year with neutral leather cream.

If, however, you are starting from the beginning on a chest, you will probably prefer to use varnish in mixing the colors, and to finish up with the six coats of varnish generally recommended. This finish wears better, and requires little or no attention.

Watering Can

This pattern is done in freehand gold, with touches of light vermilion. To make a copy on frosted acetate, proceed as follows:

1. Cut a piece of tracing paper, 9 by 10 inches. Lay it over Figure 21, and make a complete tracing of the pattern, joining the two separate sections, (A) and (B), to the main pattern. Lay a piece of frosted acetate over your finished tracing.

2. With a thin mixture of Japan Vermilion and varnish, paint all those parts of the pattern shown in black in Figure 21, including the fine stems and grasses, but disregarding the white lines. When tacky, apply pale gold powder. Let dry twenty-four hours.

3. Remove all loose powder. Mix Japan Vermilion, Yellow Ochre, and a speck of White, to make a light vermilion, and paint the line-shaded areas in Figure 21. Let dry twenty-four hours.

4. With a quill brush and Japan Black, paint the black lines which in Figure 21 are shown in white.

The background color of the original watering can is black, and the striping is in gold.

108

■ PALE GOLD
///// VERMILION

FIGURE 21 WATERING CAN

Seamed Coffin Tray

From 1720 to 1830 British tinplate was imported for manufacture by our tinsmiths into household articles. As it came only in sheets 8 by 14 inches, many articles requiring larger sheets had to be pieced together. This tray, shown in Illustration 6, is an example. Such trays were usually decorated with a country pattern, and I rather think this one was re-decorated in the late nineteenth century with this gold pattern which has a distinctly Victorian air about it.

To make a copy on frosted acetate of this example of freehand bronze, proceed as follows:

1. Make a complete tracing of the pattern (section A, B, and C in Figure 22) on tracing paper, omitting the superimposed details on the leaves and flowers, which can be added later by eye. Place a piece of frosted acetate over your tracing.

2. With a thin mixture of Japan Vermilion and varnish, paint the whole pattern. When the work is tacky, apply the pale gold powder. Let dry twenty-four hours.

3. Remove all loose gold powder. With pen and ink, draw in the fine leaf veins and the details on the flowers, disregarding the dotted and line-shaded areas shown in section A of Figure 22. Wait half an hour for the ink to harden.

Mix a little Alizarin Crimson with a speck of Burnt Umber and enough varnish to make a light transparent red when applied to the gold, and paint the line-shaded areas in section A, immediately blending off the edges here and there with a clear varnish brush.

With a transparent Burnt Sienna, paint the dotted areas, blending off the edges here and there.

:::: BURNT SIENNA
///// ALIZARIN CRIMSON

Figure 22 coffin tray and bread tray

FLOOR BORDER

Red Foot Bath

To make a copy of this freehand bronze pattern on frosted acetate, proceed as follows:

1. Lay a piece of frosted acetate over Figure 23.

2. With a thin mixture of Japan Vermilion, paint the entire area of the building, trees, and foreground, disregarding all line details. Paint the area in sections. By this I mean that when you stop at any point in the process, you should stop along a line in the design—the line of the fence, or of the roof, or of the side of the building. Thus, when you resume painting there will be no unsightly hump made in a conspicuous place on the surface. When it is tacky, apply pale gold powder over the entire surface. The brush stroke borders around the top and bottom of the foot bath are also in gold. Let the work dry twenty-four hours.

3. Remove all loose powder. With pen and ink, add the line detail and shading.

The background color is an antique vermilion. The striping at top and bottom is in gold.

This pattern comes to us by courtesy of Mrs. Irene Lovett.

FIGURE 23 RED FOOT BATH

New York Table

This pattern comes from a round table which was made about 1820, and is now owned by the Cooper Union Museum for the Arts of Decoration in New York City. It is made of "mahogany, stained to simulate rosewood," and the elegantly beautiful decorations are in gold leaf. The table, which is 30½ inches high and 35½ inches in diameter, is illustrated in Figure 24.

For practice purposes, make a pattern on frosted acetate, using pale gold powder instead of gold leaf. Proceed as follows:

1. Cut a piece of tracing paper 14 inches square. Fold it lengthwise and crosswise, open it up again and rule a line in pencil along each fold. This gives you the center of the paper, and this center you place on the center of the design in Figure 25. See that the ruled lines are over the lengthwise and crosswise center axes of the pattern. Holding the paper firmly in position, making a tracing of the main lines of the pattern, but omitting all small superimposed details that can be added later by eye. Shift the tracing in order to join the separate sections A and B to their proper places in the design. Then turn to Figure 26, and place the tracing over the C section given there, thus completing the whole design.

Similarly, make a tracing of the side design in Figure 26, connecting the separate sections to the main unit. Also, make tracings of sections F, G, and H in Figure 27.

2. Place frosted acetate over each of the tracings and proceed to paint the patterns in a thin mixture of Japan Vermilion, disregarding all pen line detail and shading. The star (H) is an outlined star, the center not being painted. As you paint, keep watching the parts already painted and apply the pale gold powder as they become tacky. Set the pattern aside to dry for twenty-four hours.

3. Remove all loose gold powder. With pen and ink, add the line detail and shading. The pen line work on the two center medalions of the two large designs is difficult to do by eye. So make a tracing of the

114

main lines. Then put your gold pattern over a blotter or something equally soft, place the tracing on top of the pattern, and, with a sharp pencil, retrace the lines, making an indentation in the gold which can be followed with the pen. (Note that when doing a pattern on acetate it is not necessary to apply the protective coat of varnish preparatory to transferring the main pen lines). Complete the rest of the pen lines and the pen line shading. Allow the work to dry and harden for half an hour. This time is sufficient for a pattern—when decorating a table allow several hours for the pen lines to dry.

The transparent Burnt Umber shading (see pen line shading) is applied with a quill brush. Immediately after each stroke is made, the inner edges of the brown are blended off with a clear varnish brush. Sections F and G in Figure 27 are similarly shaded with transparent brown.

FIGURE 24 NEW YORK TABLE

115

FIGURE 25 NEW YORK TABLE: TOP

FIGURE 26 NEW YORK TABLE: TOP AND SIDES

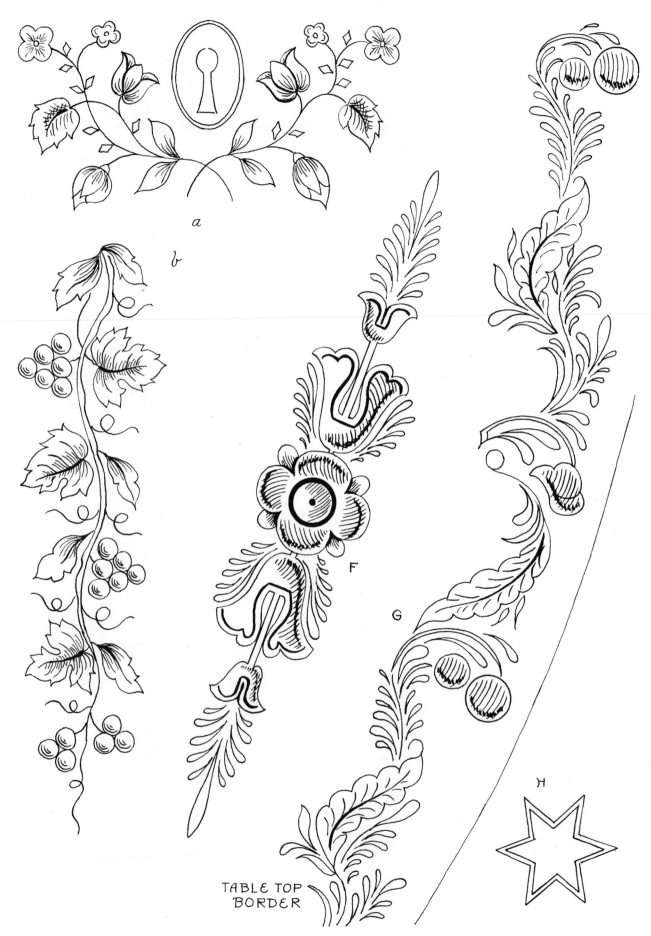

a

b

F

G

H

TABLE TOP
BORDER

FIGURE 27 DRESSING TABLE AND NEW YORK TABLE

Dressing Table

This pattern comes from an old dressing table which is illustrated in Figure 28. When I first saw this table in an antique shop, it was of a dark-colored wood and the design was done in what appeared to be

FIGURE 28 DRESSING TABLE

119

a gold leaf which had a particularly luminous quality. Closer inspection still left me wondering just what the "gold leaf" was. Some weeks later, on going back to the shop, I was dismayed to see that the many coats of varnish which had apparently covered the table had been removed, right down to the bare light-colored wood, at the same time revealing that the once gold-looking decoration was an inlay of thick white shell with finely etched detail. It was not nearly as attractive and impressive then as it had been before "restoration." But I feel justified in including this beautiful pattern here, and offer it as the gold leaf pattern it once seemed to be! It is adaptable to many purposes.

To make a practice copy of the pattern on frosted acetate in freehand bronze, using pale gold powder, turn to Figure 29 and proceed as follows:

1. Make a complete tracing on tracing paper of the center spray, and of the corner spray, adding the separate part A to the corner spray at the place indicated. Disregard all penline superimposed details, which can be added later by eye. Place frosted acetate over your tracing.

2. With a thin mixture of Japan Vermilion, paint the pattern. Be sure to keep it all light and delicate, especially the fine stems. When it is tacky, apply palegold powder. Let the work dry twenty-four hours.

3. Remove all loose powder. With pen and ink, add the fine line details. Heavier black details can be painted in with a quill brush and Japan Black. Allow twenty-four hours for drying.

4. It greatly enhances the pattern to add touches of pale transparent Burnt Sienna shading, similar to those in the top spray in Figure 22. But in the present case I would confine the shading to just one color, the Burnt Sienna.

The keyhole spray, and the small vertical grape spray in Figure 27 are also part of this dressing table pattern, which is used here by the courtesy of Mrs. Irene Lovett.

120

Two Chair Patterns from Granville, Massachusetts:

Fancy chairs with stenciled decorations were being turned out in great quantities by 1820. Though made of common woods, many were painted and grained to resemble such more expensive woods as rosewood and walnut; others were painted a solid color, generally black. Lambert Hitchcock was the early chairmaker and stenciler whose name is best known to us to-day, and his factory was at what is now called Riverton, Conn. Another early chairmaker in Riverton was William Moore, Jr., who signed the chair from which the pattern in Figure 30 is taken. This chair is one of a set in the Granville, Massachusetts house of Dr. and Mrs. Louis Stevenson. The pattern which follows (Figure 31) is also from that Granville house, and although in this instance the chair is not signed, the testimony handed down in the family is that both sets of chairs were from the same craftsman.

When Moore worked alone he signed his chairs. Later, not growing too prosperous, he joined with Hitchcock, and they seem to have pooled their stencils, since chairs attributed to one of them display in many cases the same stencils as chairs attributed to the other. Moore was buried in Riverton, but his grave is unmarked. (The story goes that the gravestone was sold to pay for the mending of a crack in the church bell!)

First Granville Pattern

To make a copy of this pattern on black paper, proceed as follows:

1. Trace and cut the numbered stencil units shown in Figure 30, disregarding for the present the lettered units, these being a separate pattern. Notice that the leaf 3 has an arrow pointing to a curved line which represents the edge of the linen. This curved edge will be used as a guide in placing the veins in position on the leaf, as will be ex-

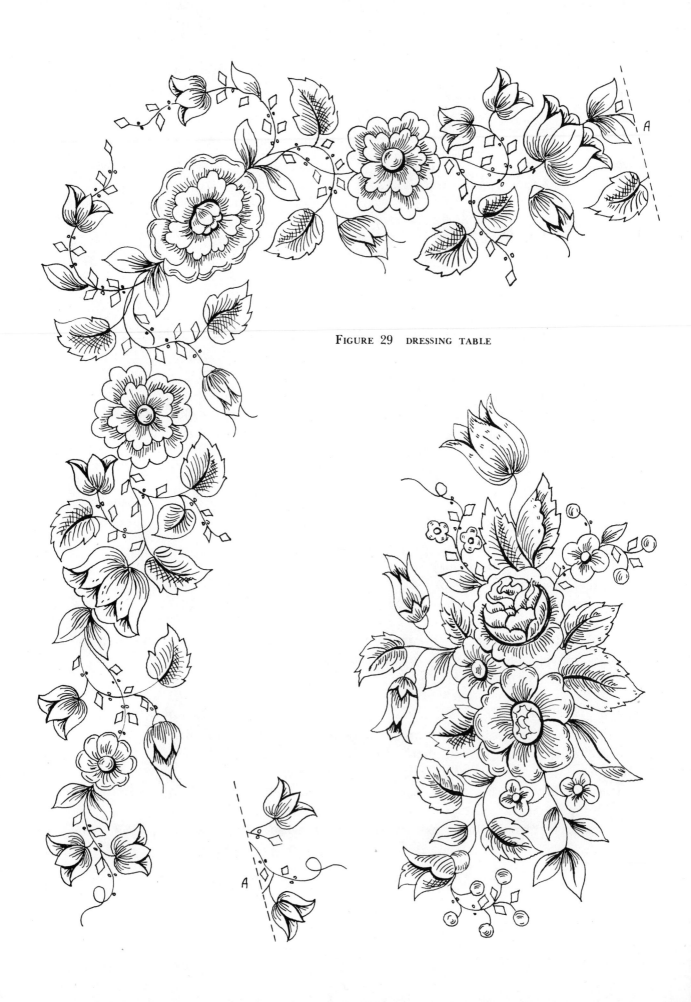

FIGURE 29 DRESSING TABLE

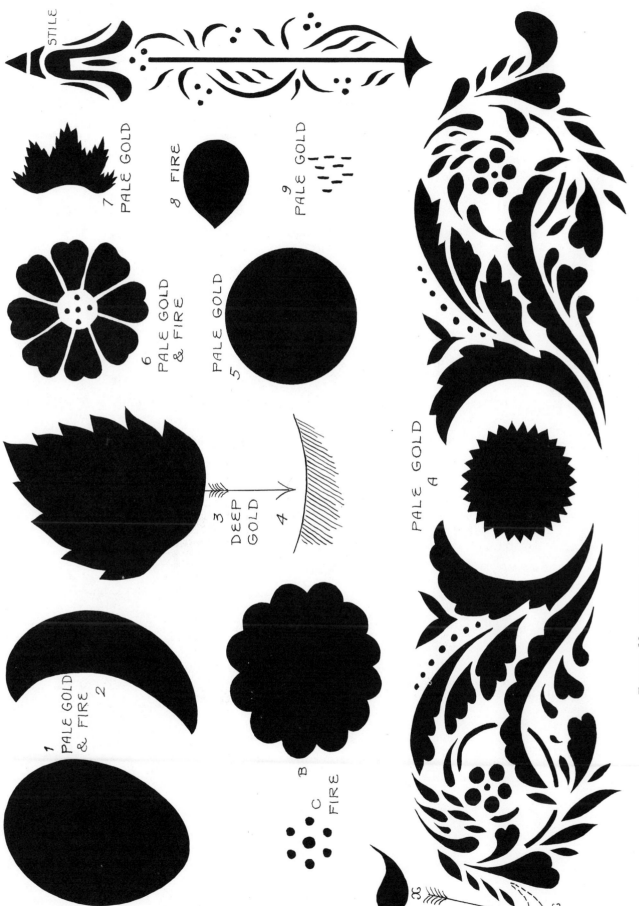

STILE

7 PALE GOLD

8 FIRE

9 PALE GOLD

6 PALE GOLD & FIRE

5 PALE GOLD

3 DEEP GOLD

4

PALE GOLD A

1 PALE GOLD & FIRE 2

B

C FIRE

x

x

FIGURE 30 STENCILS FOR FIRST GRANVILLE CHAIR, AND SEPARATE CHAIR SLAT

plained in a moment. Incidentally, all the stencils of this pattern were used as a general illustration in Figure 4.

Number the units in ink to correspond with the numbers in Figure 30 and also write on each the bronze powders to be used. As is the case with all stencil patterns, you should practice the stenciling of this pattern on black paper until you can do it beautifully. Only then should any attempt be made to decorate an actual chair.

2. Cut a piece of tracing paper $12\frac{3}{4}$ by $4\frac{1}{2}$ inches, and make a layout tracing (see p. 38). Then cut a piece of black stenciling paper to the same size and shape as the layout tracing.

3. Varnish the black paper, and when this is tacky, proceed to stencil. Place stencil 1 in position, checking the correctness of the position by holding your layout tracing just over it. Start by applying a little bright gold to the center highlight, then shading it off a bit with a little fire powder, letting it go quickly to black. Then add a little gold around the outer edge. Lift stencil 1, and place 2 in position, applying palegold to the brightest part, and shading off with fire to black. Add the barest hint of fire around the outer edge. Place 3 in position, stencil just around the edges with deep gold, shading off quickly to black. Stencil the leaf in its four positions around the peach. Then do the veins by placing the edge (4) of the linen in position and applying just a touch of powder for a vein. Move the linen along for each vein in turn: there are about seven veins in one leaf.

Next, put 5 in place, and stencil the two bright highlights first, fading off quickly to black, and then giving a suggestion of gold about the edges. The flower (6) is very bright palegold at the center, shading to fire, to black; then add a touch of gold around the outer edge of the flower. Next stencil 7 in palegold, followed by 8 in fire, leaving about half the berry black, on which you can add 9 in gold. Last of all, take 3 again and add it behind the strawberries, behind one of the fruits (5), and behind one of the flowers.

When all is complete, half close your eyes, and compare your pattern with the photograph for overall values. If your pattern is very much brighter, you will know you have used too much gold; and if your pattern is much darker, it will be obvious you have not used enough. Learn to evaluate your own work, and don't be too easily satisfied. Probably you will have to do the pattern two, three, or more times before you get just the right effect.

124

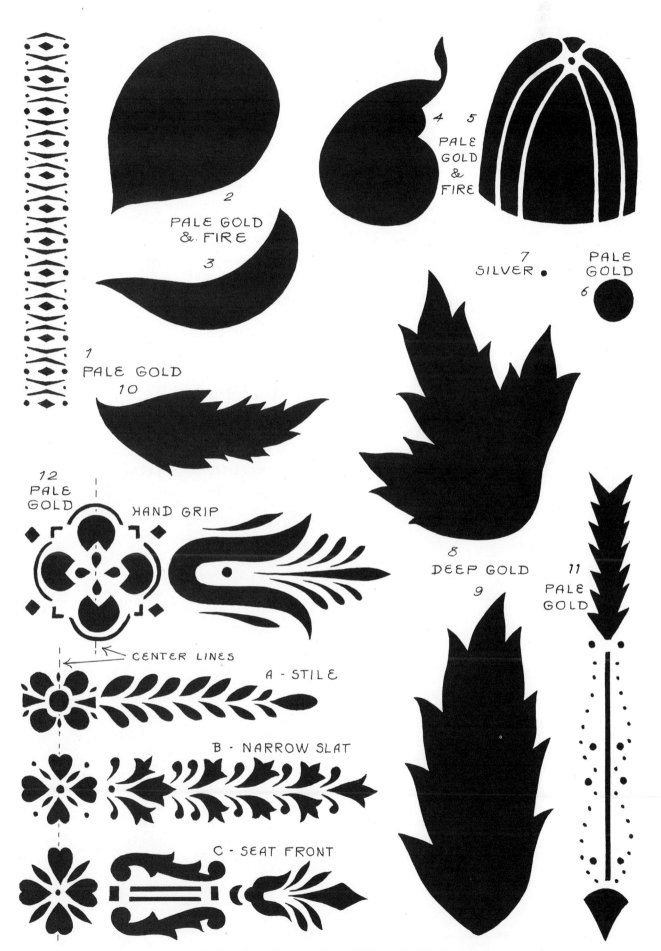

2
PALE GOLD
& FIRE

3

4 5
PALE
GOLD
&
FIRE

7
SILVER •

PALE
GOLD
6

1 PALE GOLD

10

12
PALE
GOLD

HAND GRIP

8
DEEP GOLD

9

11
PALE
GOLD

CENTER LINES

A - STILE

B - NARROW SLAT

C - SEAT FRONT

FIGURE 31 STENCILS FOR SECOND GRANVILLE CHAIR

Second Granville Pattern (Figure 31—Illustration 9)

To make a pattern on black paper, proceed as follows:

1. Trace and cut the numbered stencil units in Figure 31, disregarding the lettered units (which are quite separate pieces not connected with the numbered ones). In tracing unit 12, note the center guide line, with one complete half of the unit on the right of it. Trace this half, and then turn the linen around and trace the other half.

Number the pieces in ink to correspond with the numbers in Figure 31, and also write on each the bronze powder which applies to it.

2. Cut a piece of tracing paper 12½ by 4 inches, and make a layout tracing. Then cut a piece of black paper in the same size and shape as the layout tracing.

3. Varnish the black paper, and when it is tacky, proceed to stencil. Stencil the pieces in their numerical order. Always shade pale gold off to fire, and then to dark or black.

In stenciling the grapes (6), always stencil first the grape that is most to the front in the group of three, then add those behind. Always leave a large portion of each grape black, so as to give the impression of roundness. When all the grapes are stenciled, the silver highlight (7) is added. Place it in each case in the dark part of the grape.

Units 10 and 11 were taken from the stiles of this chair.

Hitchcock-Type
Chair Pattern

To make a pattern on black paper, the proceeding is:

1. Trace and cut the stencils, noting that the linen of unit 2 has a curved edge numbered 3 which will be used as a guide in the placing of the leaf veins, as described on p. 121.

Number the units in ink to correspond with the numbers in Figure 32, and write on each the bronze powder to be used with it.

2. Cut a piece of tracing paper 13⅜ by 5¼ inches, and make the layout tracing (see p. 32). Then cut a piece of black stenciling paper in the same size and shape as the layout tracing.

3. Varnish the black paper, and when this is tacky, proceed to stencil.

4. Begin with the border stencil (1), stenciling first on one side, then on the other. Then stencil the large leaf (2), followed by the veins (3). Next come the two melons (4), which are bright palegold at the top, shading into fire, and thence to black. Continue stenciling the units in the order of their numbers, completing the pattern for the slat with 14. Unit 15 is the top of the stile, and the other part of the stile is given in Figure 37.

This pattern comes from a chair owned by Mrs. C. Van Dorn Smith of Port Washington, Long Island.

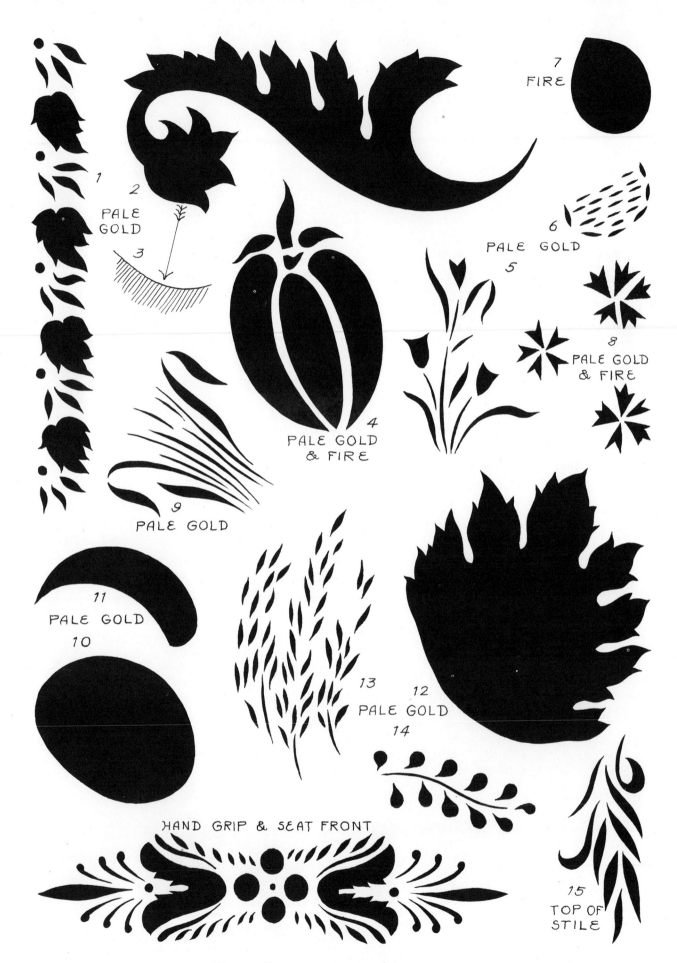

FIGURE 32 HITCHCOCK- TYPE CHAIR STENCILS

Stenciled Turtle-Back Chair

Proceed as follows in making a copy on black paper of this pattern, which comes from a chair in the Cooper Union Museum, New York:

1. Trace and cut the stencil units in Figure 33. Make separate stencils for the veins of the leaves, to be applied as shown on leaf 12. Number the units in ink to correspond with the numbers in Figure 33.

2. Cut a piece of tracing paper 13 by 5½ inches, and make a layout tracing. Then cut a piece of black stenciling paper to the same size and shape as the layout tracing.

3. Varnish the black paper, and when it is tacky, proceed to stencil. Stencil the units in their numerical order. When you stencil the bowl (3) face off the upper right-hand corner to black, so that when you put leaf 4 in position, there will be black between it and the bowl; thus giving the leaf the appearance of overhanging the bowl.

In stenciling the fruit alongside the leaf, lay unit 5 in position, but before applying any gold powder, lay unit 6 right over it. In this position, stencil 6. Then lift 6 and stencil 5. In stenciling the grapes, stencil first those on the right side of the bowl; then clean the stencil on both sides with cleaning fluid, pat it dry, and, having turned it over, stencil the grapes on the other side of the bowl. The faint "clouding" on the bowl which can be seen in the photograph, is done last of all, that is, after all the units have been stenciled. Without using a stencil at all, and after waiting until the surface is almost completely dry, lightly add the gold "cloud," using *very* little powder on your velvet.

129

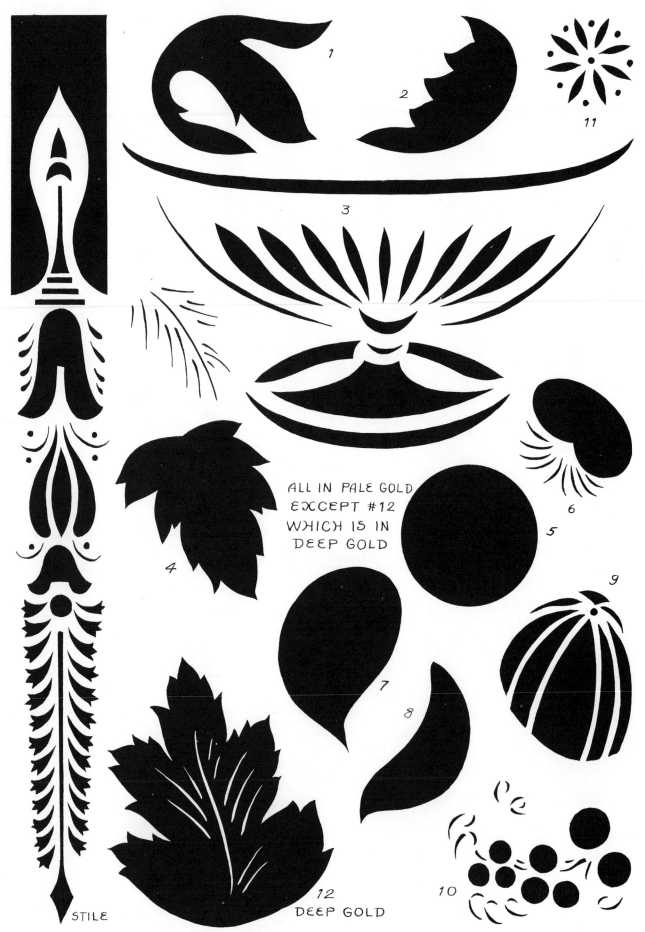

1

2

11

3

ALL IN PALE GOLD
EXCEPT #12
WHICH IS IN
DEEP GOLD

4

5

6

9

7

8

10

12
DEEP GOLD

STILE

FIGURE 33 TURTLE-BACK CHAIR STENCILS

Stenciled Fruit Basket Chair

To make a copy of this pattern on black paper, these are the steps.

1. Trace and cut the stencils, disregarding all line shading, both black and white. Note that the unit 12 has detail at the edge of the linen. (This combination is similar to the leaf stencil illustrated in Figure 4.) Number the units in ink to correspond with the numbers in Figure 34.

2. Cut a piece of tracing paper to size 12½ by 4⅜ inches, and make a layout tracing. Then cut a piece of black stenciling paper to the same size and shape as the layout tracing.

3. Varnish the black paper, and when it is tacky, proceed to stencil. In stenciling the basket (1), make it very bright palegold through the center, but not so bright toward the sides, so as to give the effect of roundness. Stencil 3 in palegold, brighter through the center, fading off a bit to the sides; then, after picking up all excess gold powder, lift the stencil, and, with a clean part of the velvet, pick up the barest speck of fire powder and add the touch of fire "clouding," indicated by the line shading in Figure 34.

When stenciling the bunch of grapes, carefully observe the shading in the photograph. Also observe the shading in unit 12; a large area in the center being left black, on which 13 is placed and the bright gold touch added to the center.

The stencil for the stiles of this chair is at the bottom of Figure 38. The seat front and hand grip ornaments were completely worn off the chair, so others may be substituted.

The original chair from which the pattern is taken belongs to Miss Mary Aileen Dunne of Garden City, Long Island.

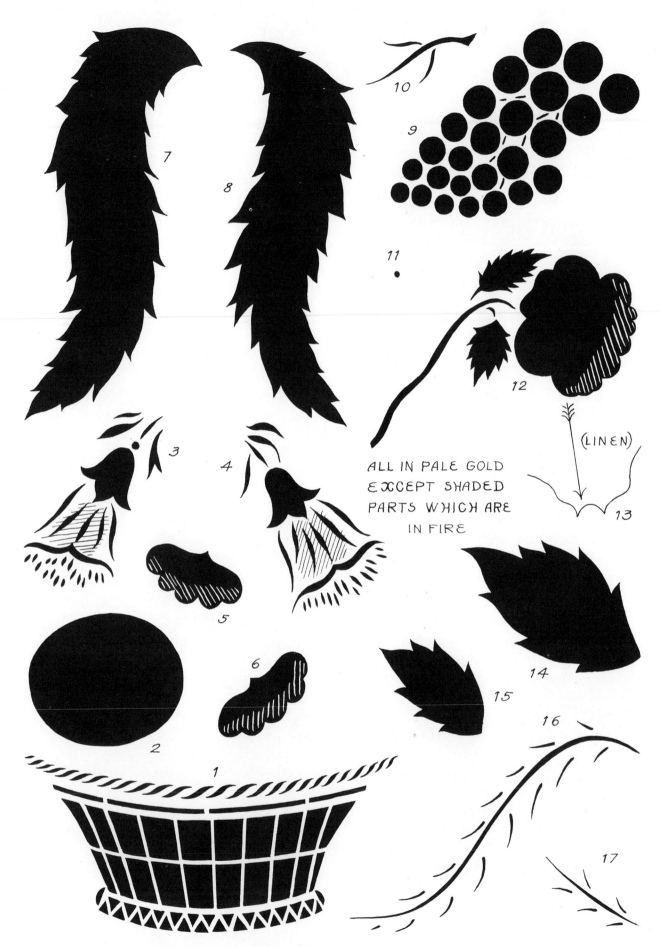

ALL IN PALE GOLD
EXCEPT SHADED
PARTS WHICH ARE
IN FIRE

(LINEN)

FIGURE 34 FRUIT BASKET CHAIR STENCILS

Boston Rocker

A copy of this pattern on black paper is made as follows:

1. Trace and cut the stencil units in Figure 35, but omit No. 1 for the time being. When you come to put this pattern on a rocker, you will probably have to alter that unit to adapt it to the ends of your slat. Meanwhile you can practice stenciling the main part of the pattern.

Number the units in ink to correspond with the numbers in Figure 35, and also write on each the bronze powders to be used.

2. Although the length of the entire slat is $23\frac{3}{8}$ inches, cut a piece of tracing paper only 13 by $4\frac{3}{4}$ inches in order to make a layout tracing for the main center design. Use the color plate as a guide, and your cut stencils on Figure 35 to trace the units. The center design from leaf tip to leaf tip actually measures $11\frac{3}{4}$ inches, and the height is $4\frac{1}{2}$ inches. Next cut a piece of black paper which may conveniently be the same size as the tracing paper.

3. Varnish the black paper, and when it is tacky, stencil the pieces in their numerical order, beginning with 2, which is brighter in the center, not so bright at the sides. The two large flowers (3) are done in silver-gold by picking up a tiny bit of gold on the velvet fingertip, and a tiny bit of silver at the same time. Lift the stencil, and picking up a touch of fire powder on a clean part of the velvet, add the tiny "cloud" of red to the centers. Set aside to dry for twenty-four hours after all the pieces have been stenciled.

4. Remove all loose powder from the pattern.

The center portions of the two large flowers are given a wash of transparent red (Alizarin Crimson with a touch of Burnt Umber). The outer portions are a paler red, to which is added a touch of transparent green. To do this, mix a puddle of red with one quill brush, and a puddle of green with another. Paint the center portion of the flowers, excluding the dots; then, picking up a little extra varnish to make a paler red, paint the outer portions, immediately adding a touch of

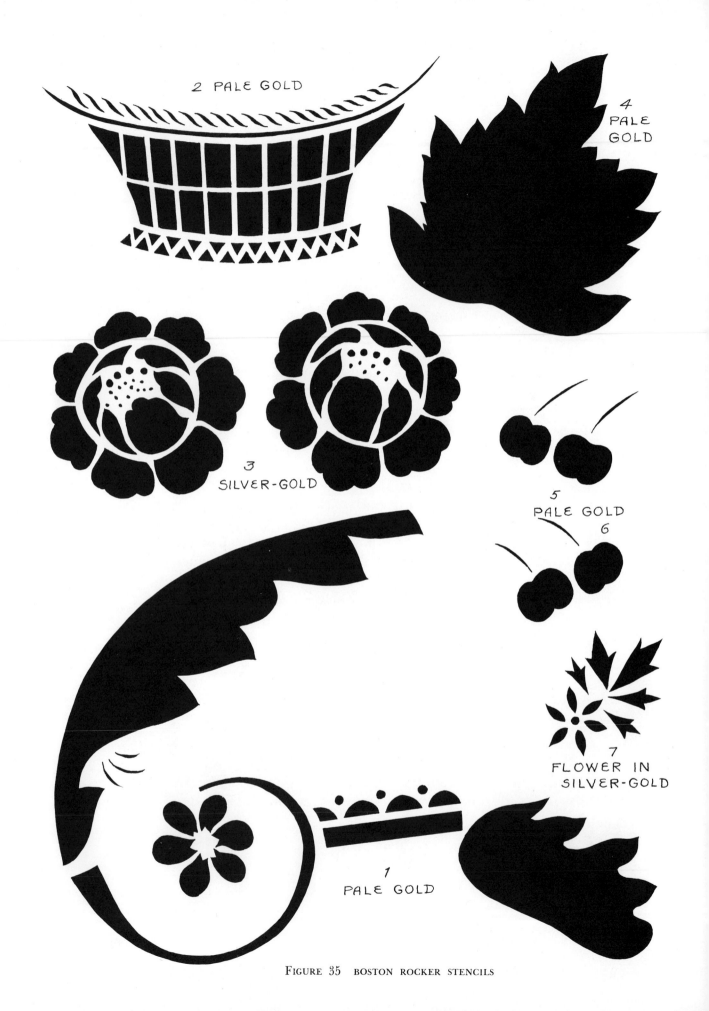

2 PALE GOLD

4 PALE GOLD

3 SILVER-GOLD

5 PALE GOLD

6

7 FLOWER IN SILVER-GOLD

1 PALE GOLD

FIGURE 35 BOSTON ROCKER STENCILS

green here and there with the green brush. But the latter should have very little green on it, or the whole thing will flood out of bounds.

The cherries are given a touch of red, blended off with a clear varnish brush. The small flower is given a wash of transparent blue, and the leaves a transparent green.

This pattern is available through the courtesy of Mrs. Roderick Dhu MacAlpine of Doswell, Va., and of the owners of the original Boston Rocker, Mr. and Mrs. Carstairs Bracey of Bracey, Va.

Eagle Clock Pattern

To make a copy of this pattern on black paper, proceed as follows:

1. Trace and cut the stencil units in Figure 36. The smaller dots in unit 14 can be punched with a hot needlepoint. Push a needle through a cork, and use the cork for a handle. Hold the needle with the point in a gas or other blue flame for a second or two; then punch two or three holes. Reheat the point and continue. When the holes are done, cut off any jagged edges of linen underneath, or lightly sandpaper them off with very fine sandpaper.

Number the pieces in ink to correspond with the numbers in the Figure, and also write on each the bronze powders to be used.

2. Cut a piece of tracing paper 13½ by 3¾ inches, and make a layout tracing of the eagle portion of the pattern. Cut a piece of black stenciling paper the same size and shape as the layout tracing. Also cut a piece of black paper 16½ by 2 inches for the pilaster design shown below the eagle portion.

3. Varnish the two pieces of black paper, and when these are tacky, proceed to stencil the units in their numerical order, using your layout tracing for the placing of the units.

The feather marks on the eagle's wings are done like shaded leaf veins, and for this purpose the X-edge on unit 4 is employed; but this time use deep gold powder. The same X-edge can be used for the leaf veins of leaf 9, but here silver powder is required. The eye of the eagle is done in pen and ink when the stenciling is dry.

Units 12, 13, 14, and 15 together comprise the design on the two upright pilasters of the clock. Unit 12 is done in palegold, after which a little fire clouding is applied to the centers of the three flowers.

The source of this material is a shelf clock owned by Mr. Richard J. Metzger, Staten Island.

136

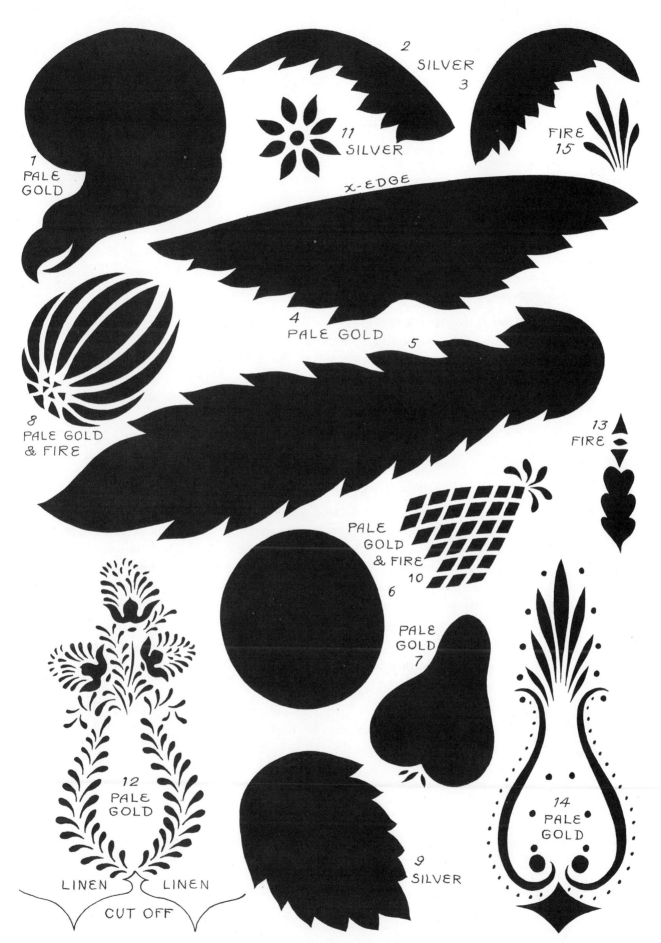

FIGURE 36 EAGLE CLOCK STENCILS

Various Furniture Stencils

It is useful to have a few extra furniture stencils on hand to fill needs that may arise. Old stenciled chairs originally had designs on the stiles (the posts on either side of the chair back), on the seat fronts, on the hand grips, and sometimes on the narrow supplementary slats. But a number of the chair patterns illustrated in other figures do not have all their accessory designs because the latter became so worn on the original chairs that they could not be copied.

Figure 37 includes an extra stile and a seat front. Figure 38 shows two seat fronts from stenciled rockers, a narrow slat, and the stile pattern from the stenciled fruit basket chair. Also included in Figure 38 are three small border patterns of two units each. Each of these borders should be traced with its two units on one piece of linen, one inch apart, and with the usual inch margin all around. They are stenciled in the same way as the chair border on the rocker, directions for which are on p. 37. The star border and the leaf border come from an old piano, the brush stroke border from a wardrobe.

In Figure 30, sections A, B, C, and X comprise a chair slat pattern taken from an original stencil in the Metropolitan Museum of Art, New York. I suggest stenciling section A first in palegold. Sections B and C might then be done in fire powder. This pattern is very suitable for a secondary slat in a two-slat chair.

The lower left-hand corner of Figure 31 shows separate units for a stile (A), a narrow chair slat (B), and a seat front (C). Note that these three are traced in the same way as unit 12, the directions for which are given on p. 126.

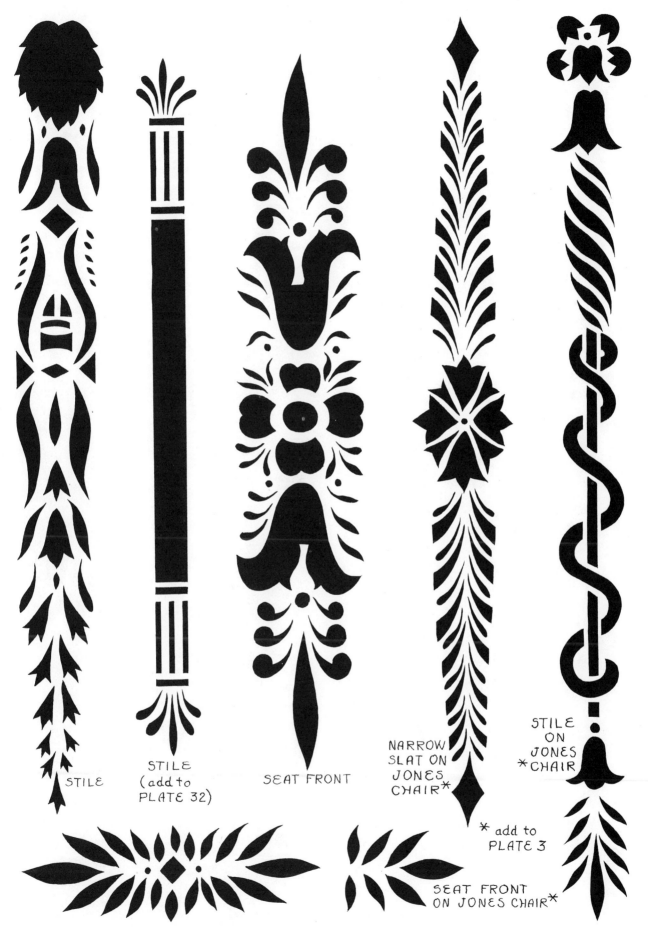

STILE

STILE
(add to
PLATE 32)

SEAT FRONT

NARROW
SLAT ON
JONES
CHAIR*

STILE
ON
JONES
*CHAIR

* add to
PLATE 3

SEAT FRONT
ON JONES CHAIR*

FIGURE 37 VARIOUS FURNITURE STENCILS

SEAT FRONT ON ROCKER

NARROW SLAT

SEAT FRONT ON ROCKER

BORDERS

STILE

BORDER

FIGURE 38 VARIOUS FURNITURE STENCILS

The Stenciled Cornice

Many beautiful decorated curtain cornices, made about 1790 to 1810, are to be found in the larger and finer old houses, and in museums. Often the designs were stenciled. This copy of the decoration on a cornice is now in the Cooper Union Museum of Arts and Decoration, New York.

This pattern is a difficult one, and should not be attempted until you have had plenty of practice in doing all the other stencil patterns.

The basic color of the cornice is a dull olive green, and the border molding and other very bright gold parts are in gold leaf. The stenciling is done in pale gold and fire bronze powders on an underpainting of black. The birds in the diamond-shaped side panels are in freehand bronze, also on a black underpainting.

It is suggested that the pattern on frosted acetate be done in sections, as the whole is too large for comfortable handling. The rectangular panel containing the main stenciled design is 33⅜ by 4⅞ inches, not including the border molding, which is ⁷⁄₁₆ inches wide. The overall dimensions of the cornice are 47 by 13 inches.

Turn to Figure 40. Trace on linen, and then cut out, the stencil units 2, 3, 4, and 5. Note that unit 4 consists of five small parts, all of which may be put on one piece of linen for convenience. Turn to Figure 41, and do the same with the units 1 to 10, and also the two large fruits in Figure 42. Number each unit in ink to correspond with the numbers in the figures, keeping those from Figure 40 in a separate envelope labelled "Basket Section." Also mark on each piece in ink the color of the bronze powder to be used.

From this point on I shall give the steps in decorating an actual cornice, but it should be understood that the stenciled sections and the birds and foliage must be practiced first on frosted acetate (*not* black stenciling paper).

141

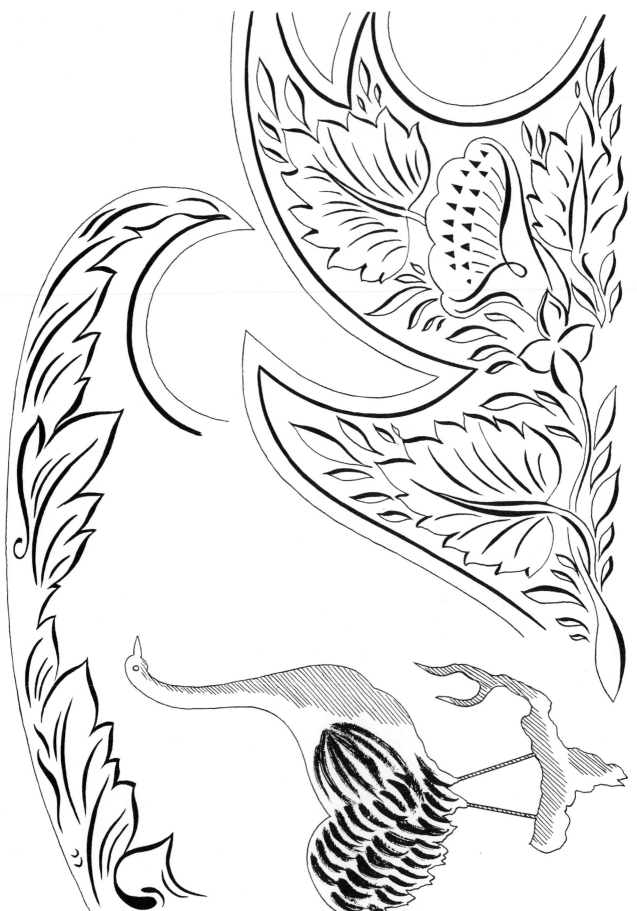

FIGURE 39 CORNICE: BIRD AND FOLIAGE

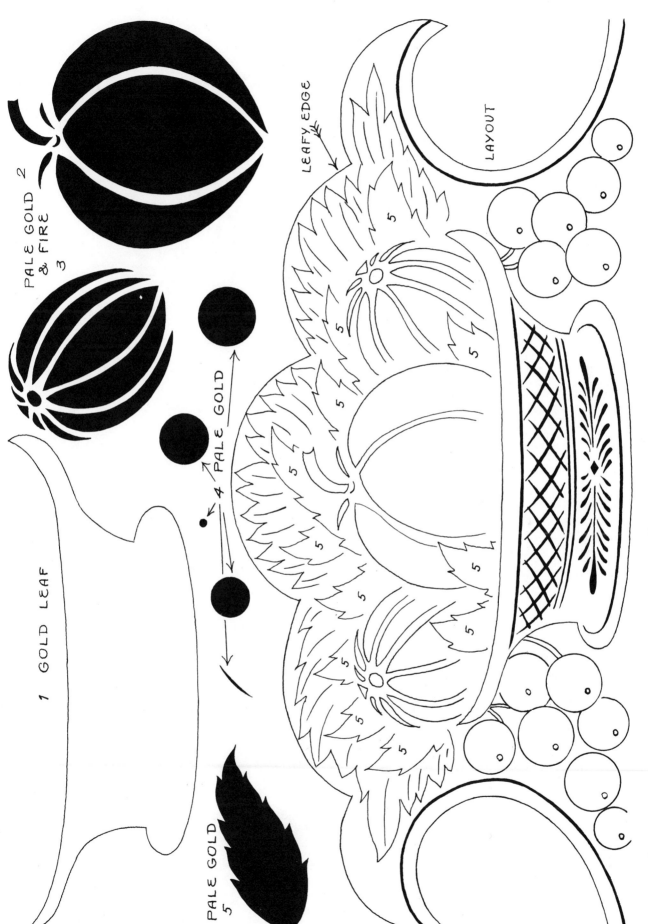

PALE GOLD 2
& FIRE
3

LEAFY EDGE

LAYOUT

4 PALE GOLD

1 GOLD LEAF

PALE GOLD
5

5 5 5 5 5 5 5 5 5 5 5 5 5

FIGURE 40 CORNICE: BASKET SECTION

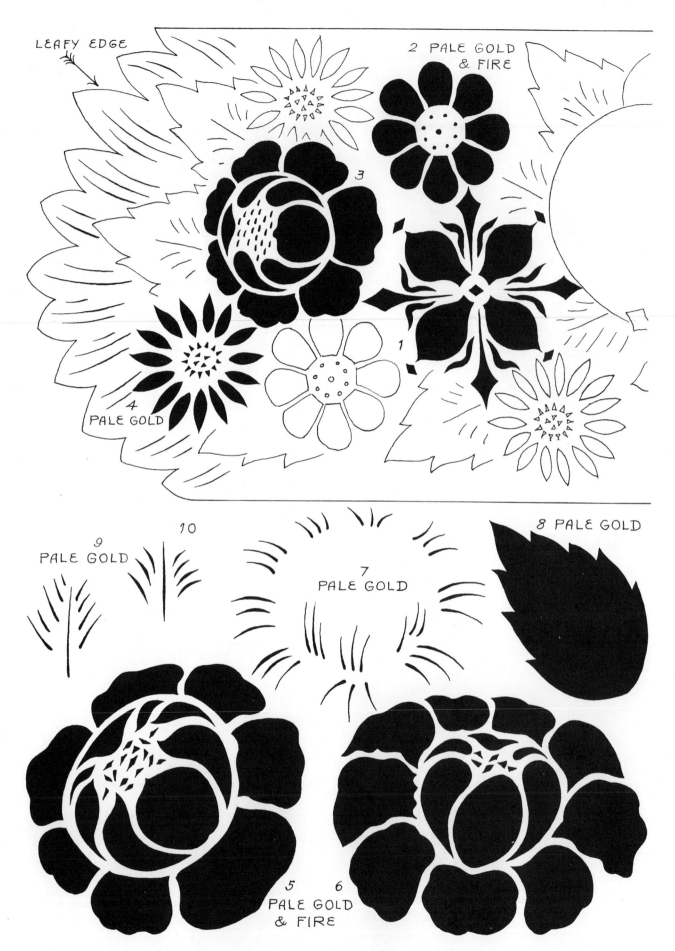

LEAFY EDGE

2 PALE GOLD
& FIRE

3

4
PALE GOLD

1

9
PALE GOLD

10

7
PALE GOLD

8 PALE GOLD

5 6
PALE GOLD
& FIRE

FIGURE 41 CORNICE: STENCILS AND PARTIAL LAYOUT

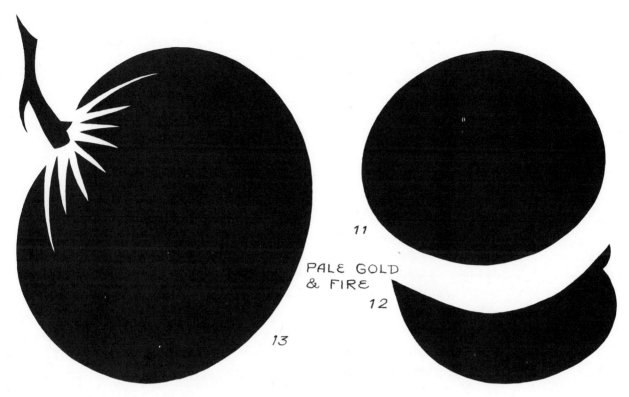

FIGURE 42 CORNICE: STENCILS

To decorate an actual cornice, proceed as follows:

1. Paint the whole cornice a dull olive green. Let it dry and harden about a month.

2. Make a tracing on tracing paper of the two sections containing leaves and flowers in Figure 39, altering them if necessary to fit your cornice; also a tracing of the basket outline (unit 1) in Figure 40. Transfer these outlines to the cornice. Then paint the areas and lay the gold leaf. Also lay gold leaf on the moldings and borders. Let this dry and thoroughly harden for a week.

3. Starting with the basket section, Figure 40, make a tracing of the outline of the area occupied by the fruits and leaves. Transfer this to the cornice. Paint the area with a thin, slightly transparent mixture of Japan Black, prepared beforehand in sufficient quantity for the job (use a very large bottle cap). Work quickly and smoothly, so covering the area that it will not be necessary to go back to touch up. The black mixture should be sufficiently thinned with varnish for it to dry with a smooth glossy black surface. Make a layout tracing.

145

When the surface is tacky, proceed to stencil the units in rotation. Where two powders are indicated in one unit, always use palegold for the brightest part, shade off quickly to fire, and finally to black. Use your layout tracing for the placing of the stencils. The gold highlight dot doesn't show much, but it is there on the shadow side of each grape. Then add the palegold on the outer leafy edge, without using any stencil. Set it aside to dry.

4. For the main stenciled section on the long horizontal panel, cut a piece of tracing paper 33⅜ by 4⅞ inches. Now trace the "leafy edge" outline (Figure 41) two and three-quarters inches in from each end, reversing the tracing paper for the right hand side. Transfer these outlines to the cornice. Then, on the same tracing paper, continue to make a layout tracing for the pattern, beginning by tracing the upper part of Figure 41; and going on to complete the stencil units in Figures 41 and 42. Take the time to do this carefully, which will make the actual stenciling much easier to do.

5. Using a thin mixture of Japan Black, begin with a large quill brush to paint the area on the cornice which is to be stenciled, starting with the leafy edge at one side; then, using a larger brush, such as a flat half-inch black bristle brush, lay the main area of paint as quickly and smoothly as possible; finish up with the quill again at the leafy edge at the other end. Work quickly and smoothly, so covering the area that it will not need any going back to touch up. Prepare a sufficient quantity of black mixture before you begin, so that it will not be necessary to stop in the middle of the painting to mix paint. It should dry with a smooth glossy black surface.

When the surface is tacky, begin stenciling with the small flowers and leaves at both ends, using units 1, 2, 3, 4, and 8. The palegold applied to the "leafy edge" is done without a stencil. Then stencil the large center flowers 5 and 6, all the time using your layout tracing for placing the units; 5 and 6 are palegold at the center, shading to fire, and with fire around the edges, leaving the surface very dark where the vein lines (7) are to go. To speed up the stenciling and to avoid scratching the surface with your finger nails when you pick up the stencils from the tacky surface, use a palette knife to life the stencils each time.

Go on to the small flowers above and below, and last of all do the large fruit units 11, 12 and 13. These are done when the surface has

146

become fairly dry, thus enabling one to get that beautiful graduated shading, fading out so that the edges of the fruits are barely discernible. Last of all, add the leaf veins 9 and 10 which not only go on the leaf 8, but also are used here and there without the leaf by way of space fillers. Set aside to dry.

6. The birds in the diamond-shaped end panels are painted in thin Japan Black. When they are somewhat drier than the ordinary tacky stage, the palegold powder is added in the places where the fine line shading appears in Figure 39, toning off quickly to black. The brush strokes on the wings and tail, indicated in black in Figure 39, are done with a spit-brush and palegold powder. Take a small quill brush, moisten it with saliva, and then lay it lengthwise on a mount of loose palegold powder, thus picking up some of the powder. With this, paint in the brush strokes on the still tacky surface. Replenish the brush with saliva and gold powder as needed. (Keep a supply of saliva on your left forefinger to re-moisten the brush—don't get the gold powder in your mouth.) Set the work aside to dry for twenty-four hours.

7. When everything is thoroughly dry, remove every speck of loose powder from the cornice. Then add the black accents on the gold leaf leaves and flower (Figure 39), the detail on the basket (Figure 40), and the veins in the "leafy edge" Figures 40 and 41). Use pen and ink for the smaller and finer strokes if you like, but Japan Black and a quill brush for the heavier accents. Set aside to dry.

It should be noted that the black veins and leaf strokes in the "leafy edge" are seen in the drawing (Figures 40 and 41), but not in the color plate where, however, they ought also to be.

8. Do any necessary touching up with the olive green background paint or the Japan Black.

Country Tinware Patterns

The earliest American colonists naturally had to import all household articles of tinware. But as time went on, they bought tinplate from England, and local tinsmiths made it into the various articles which were in demand. The first known tinsmith in this country was Shem Drowne, who started work in Boston in 1720. It cannot have been long before others were at work in Philadelphia, New York, and the larger towns.

Around 1740 or 1750 (there is some question as to the exact date) Edward Pattison started the first large-scale manufacture of tinware at Berlin, Connecticut, and he conducted a flourishing business for many years. Candlesticks, candle molds, sconces, tea caddies, lanterns, canisters, trays, pie plates, boxes for all sorts of purposes, and many other household items were produced by him. A good many of them were decorated by local artists. Pattison's business flourished until the Revolution, and was resumed after the war. Among other centers where decorated tinware was prepared were Stevens Plains, Maine; Bloomfield, Connecticut; and Greenville, New York.

Tinware was not sold only in the localities where it was made. Larger enterprises sent out traders all along the Atlantic seaboard and west to the frontier towns. The Yankee tin peddler was a well-known character, and a welcome visitor to the early settlers, bringing essential products to them in the most out-of-the-way-places.

The following group of tinware patterns, consisting of a coffee pot, large canister, bread tray, syrup jug, and coffin tray, are taken from pieces owned by the Society for the Preservation of New England Antiquities, Boston. Backgrounds for the designs were either dark asphaltum or black.

Coffee Pot

1. Paint the four large "fruits" in Japan Vermilion, disregarding the superimposed details. Then mix some Japan Green with a tiny bit of Raw Umber, and paint the areas shown in black. Wait twenty-four **hours.**

148

2. Mix a tiny bit of Burnt Umber with a lot of varnish to make a very thin transparent brown, and paint the line-shaded areas in the two lower "fruits." Don't fuss over this. Paint it and leave it; and be sure not to overload the brush. Use as few strokes as possible in the round centers. Wait twenty-four hours.

3. With a semi-transparent dark red, paint the dotted strokes. Wait twenty-four hours.

4. Mix some Japan Yellow with a little Raw Umber to make a mustard yellow, and paint the giant cross-hatching in the middle of the fruits. Each time you pick up a little mustard yellow with the quill brush, flatten the brush and paint with this flattened knife-edge, going back to the palette frequently to re-flatten the brush.

Add a little more Raw Umber to make a somewhat darker yellow, and enough varnish to give a hint of transparency, and paint the brush strokes shown by the fine cross-hatching in Figure 43. Wait twenty-four hours. This completes the pattern.

Large Canister

Make a tracing of the complete design on a piece of tracing paper (omitting all details, which can be painted in later by eye), and mount it on white cardboard. Place frosted acetate over this, and proceed to paint.

Note, however, that the white half-band which is the background of the border design of leaves and berries (see Figures 45 and 15) need not be painted on the acetate. Make a note of it, and when decorating a canister remember to superimpose the off-white half-band after the main background color is completely dry, but before tracing the leaves and berries.

1. With Japan Vermilion, paint all the flowers, buds, and berries marked V. Mix Japan Green with a touch of Burnt Umber, and paint all the parts shown solid black in Figures 44 and 45. Wait twenty-four hours.

2. With a semi-transparent dark red, paint the dotted brush strokes on the vermilion parts.

Mix some Japan Yellow with some Burnt Umber to make a mustard yellow, and paint all the cross-hatched brush strokes. Wait twenty-four hours.

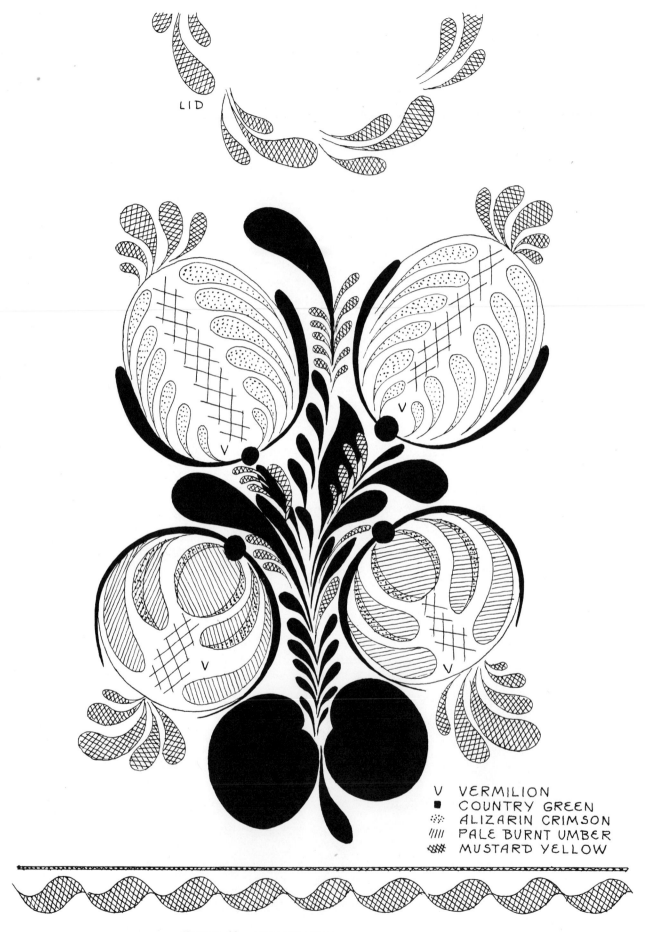

LID

V VERMILION
■ COUNTRY GREEN
⋮⋮⋮ ALIZARIN CRIMSON
//// PALE BURNT UMBER
⩩⩩ MUSTARD YELLOW

FIGURE 43 COUNTRY TINWARE: COFFEE POT

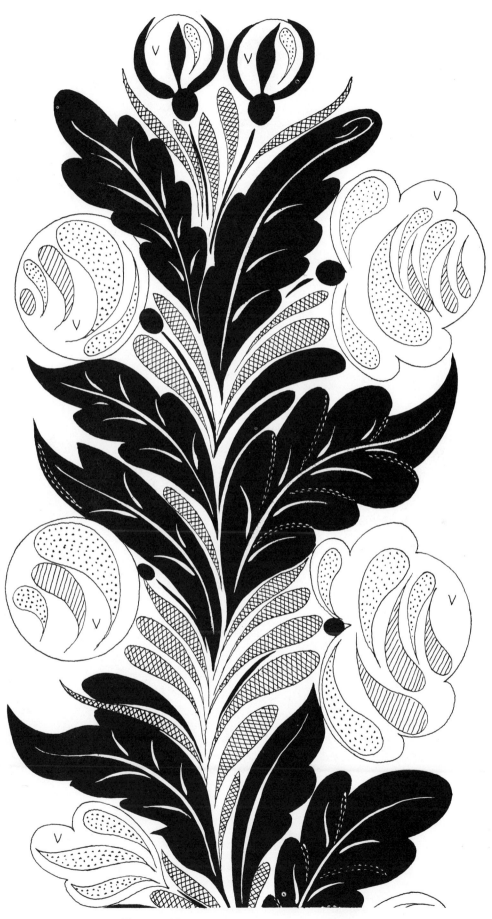

FIGURE 44 COUNTRY TINWARE: CANISTER

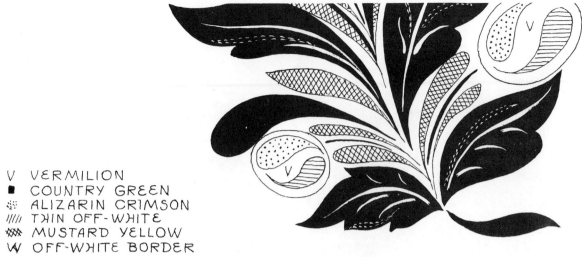

V VERMILION
■ COUNTRY GREEN
▓ ALIZARIN CRIMSON
//// THIN OFF-WHITE
▨▨ MUSTARD YELLOW
W OFF-WHITE BORDER

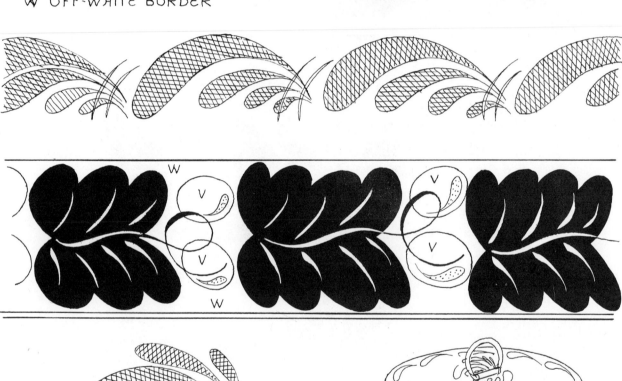

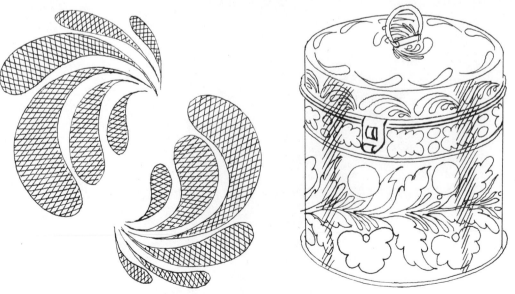

FIGURE 45 COUNTRY TINWARE: CANISTER

3. With a somewhat thin mixture of Japan Black, paint the leaf veins shown in the white (not dotted) lines in Figures 44 and 45.

With a semi-transparent off-white paint the line-shaded strokes on the flowers and buds, and the highlight strokes on the leaves shown in white dotted lines.

Syrup Jug

1. Paint the large flower and the two buds in Japan Vermilion.

With a mixture of country green, paint the strokes shown in black. Wait twenty-four hours.

2. Paint the dotted brush strokes in semi-transparent dark red. Wait twenty-four hours.

3. With a semi-transparent off-white paint the line-shaded strokes.

Mix some Japan Yellow with a little Raw Umber to make a mustard yellow, and paint the cross-hatched strokes.

Bread Tray

This is a border design on an off-white band. In decorating a bread tray, the off-white band should be painted after the background color is dry, but before tracing the design. First of all, hold a piece of tracing paper against one end panel of the bread tray, and carefully trace the outline of that area. Then place this tracing over the End Pattern on Figure 46, and draw the second curved line inward from the edge, to make the area of the off-white band. The band is slightly wider in the middle, and tapers off to the sides to meet the band on the sides of the tray. One tracing can be used for both ends of your tray. Make a similar tracing for one side of your tray, using the Side Pattern in Figure 46 as a guide.

Transfer this border area to the tray. Then paint in the off-white band, using a thin mixture of off-white to ensure a smooth surface. Let it dry at least twenty-four hours. Apply a second coat if necessary.

Put your tracings back over the patterns in Figure 46, and trace the leaves and berries, disregarding all details which can be painted in later by eye; and if necessary, adjusting the units to fit your border. Transfer the pattern to the off-white band on your tray, and proceed to paint the design.

1. Paint the berries in Japan Vermilion. Mix some Japan Green with a little Raw Umber, and paint the parts shown in black in Figure 46, but not the dots. Wait twenty-four hours.

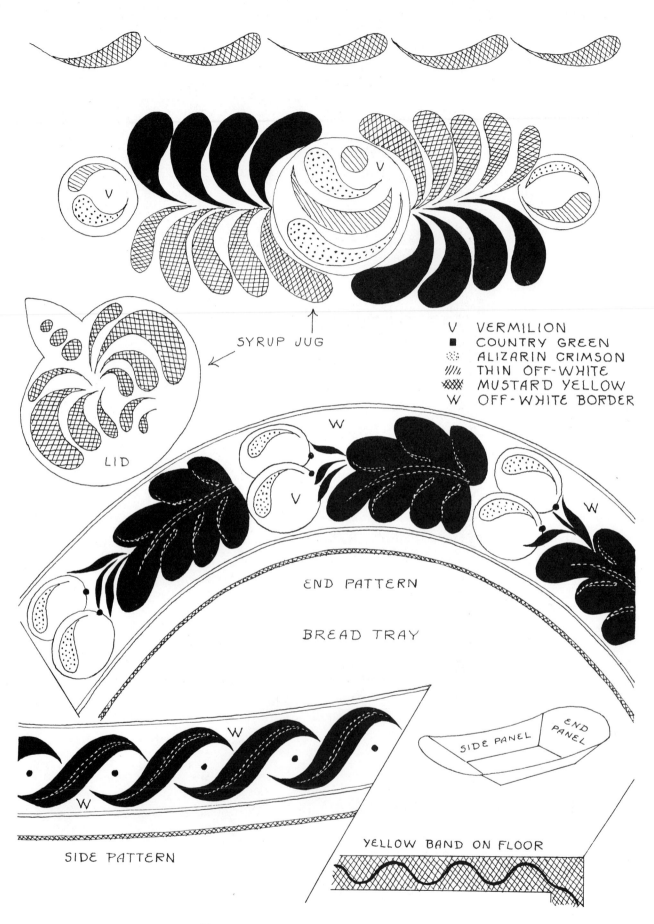

SYRUP JUG

V — VERMILION
■ — COUNTRY GREEN
⬚ — ALIZARIN CRIMSON
⫽⫽ — THIN OFF-WHITE
✕✕ — MUSTARD YELLOW
W — OFF-WHITE BORDER

LID

END PATTERN

BREAD TRAY

SIDE PATTERN

SIDE PANEL

END PANEL

YELLOW BAND ON FLOOR

FIGURE 46 COUNTRY TINWARE: SYRUP JUG AND BREAD TRAY

2. With a semi-transparent dark red, paint the dotted strokes.

Mix some Japan Yellow with some Raw Umber to make a rather dark mustard, and paint the floor border. Wait twenty-four hours.

3. Using a somewhat thin mixture of Japan Black, paint the leaf veins shown as dotted lines, and the black dots, on the ends and sides. Also paint the wavy line on the mustard floor border in black. Wait twenty-four hours.

4. Give the whole tray a coat of varnish. Wait twenty-four hours.

5. With Vermilion, and using a striping brush, stripe the edges of the broad white band with a thin stripe. Then mix some mustard yellow to match the floor border, and add the mustard stripe at the end and sides.

6. Finish the article in the usual way.

Coffin Tray

This is another border pattern on an off-white band, and it is handled similarly to the bread tray pattern just described. The floor of the coffin tray is 11 by 7 inches.

1. Paint your tray black in the usual way.

2. The off-white band on the tray starts at the point where the floor meets the sloping flange. On a piece of tracing paper, trace the floor area of your tray, and then draw a second line one inch in from the first: the area in between takes the border. Measure the width of the border with a ruler on all sides, so as to be sure it is the same width all round. Transfer the second line to the tray, and paint in the off-white band. Let it dry thoroughly.

3. Put your tracing back on to Figure 47, and trace the border motifs, disregarding all details that can be painted in later by eye. If your tray differs in size and shape, you may have to adjust the design to fit. Transfer the design to the white border on your tray.

4. With Japan Vermilion, paint the berries. Wait twenty-four hours.

5. With a mixture of country green, paint all the parts shown in black. With a mixture of Japan Yellow and a touch of Burnt Umber, paint the tiny dots shown in outline on the berries. Wait twenty-four hours.

6. With a rather thin Japan Black, paint the veins in the leaves. Wait twenty-four hours.

7. Give the tray a coat of varnish. Wait twenty-four hours.

8. With a striping brush, paint the vermilion and mustard yellow stripes, as shown in Figure 47. Wait twenty-four hours.

9. Finish the tray in the usual way.

Strawberry Box

A round cedarwood box, owned by Mrs. Vernon H. Brown, provides us with this pattern, the steps in painting which are as follows.

1. Paint the berries with Japan Vermilion. Wait twenty-four hours.

2. Mix some Alizarin Crimson and a touch of Burnt Umber to make a dark semi-transparent red, and paint one side of the berries, as shown by the line shading in Figure 47, blending off the inner edge of the red with a varnish brush. Wait twenty-four hours.

3. For the leaves and stems which are shown in black (but not for the curlicues), mix some Japan Green and a touch of Raw Umber to make a country green; with another brush, mix a lighter, yellower green by combining Japan Green, Raw Umber, and a little Japan Yellow. Deal with the leaves one at a time by painting each leaf in the darker green, and then with another brush immediately working in a little of the lighter green on the white-dotted areas which can be seen in the drawing to one side of each leaf. Wait twenty-four hours.

4. With Japan Black, paint the veins of the leaves, and the dots on the darker side of the berries. With some semi-transparent off-white, add the highlight on the berries, and on the turned-over edge of the one leaf, as shown by cross-hatching in the drawing. Wait twenty-four hours.

5. Mix some Japan Yellow and Burnt Sienna to make a warm mustard-yellow, and paint the curlicues and the dots on the lighter side of each berry.

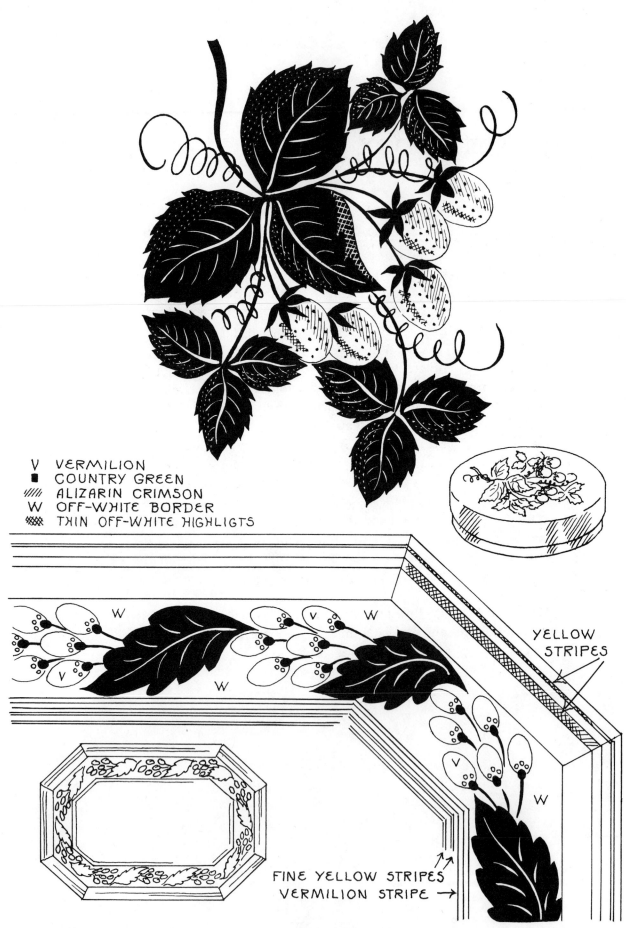

V VERMILION
■ COUNTRY GREEN
▨ ALIZARIN CRIMSON
W OFF-WHITE BORDER
▨ THIN OFF-WHITE HIGHLIGTS

YELLOW
STRIPES

FINE YELLOW STRIPES
VERMILION STRIPE

FIGURE 47 WOODEN STRAWBERRY BOX, AND COUNTRY TIN COFFIN TRAY

Japanned Highboy

Japanning has been called "the art of covering bodies by grounds of opaque colors in varnish which may then be either decorated by painting or gilding, or left in a plain state" (Robert Dossie, *Handmaid to the Arts,* 1764). It was devised as a means of imitating the beautiful and costly lacquered ware that was imported from the Orient, and which was so much admired in Europe and America.

The japanned highboy from which the patterns in Figures 48-55 have been taken is in the Metropolitan Museum of Art, New York. This handsome piece, made about 1700 of maple and pine, originated in New England, but shows the unmistakable influence of the East in its decoration.

The parts that stand out were done in gold leaf over gesso, and comprise the important or storytelling parts of the decoration. Some of these important parts are darker than the others, and these were probably given a wash or overtone of transparent Burnt Umber in some cases, and of Burnt Sienna in others. The parts that are nearly or entirely invisible were probably done in a dark gold bronze powder. All the decorations show much wear, and are so darkened and cracked that it is difficult in some places to decide exactly how they were done.

Tracings

In doing a pattern of this type, the tracings of the various parts, as well as the acetate copies, are best done separately. Then, when you come to decorate a piece of furniture of your own, you can try out various arrangements with the minimum of effort. In this connection, the boy leading the camel (Figures 53 and 54) is obviously one unit, and should be together on one tracing. Also the complete flower spray in Figure 52 should be on one tracing and in proper position, as shown in the small layout sketch. And the tip of the bird's tail in Figure 50 should be connected to the bird.

159

The corner decoration in Figure 54 is a sample of the supplementary or "fill-in" bits at the bottoms of the drawers. These were very crudely drawn and consist mostly of similar leaves and wiggly lines. It would not be worthwhile to use the space that would be required to show them all: you can easily supply your own if you need this type of "fill-in."

Patterns on Frosted Acetate

In making your acetate copies, use palegold powder for the gold leaf parts, referring always to the photograph. For the rest, use a deep gold powder, one that is much darker, so that there will be a strong contrast. In painting all stems, grasses, fine leaves, and trees, keep your work light and delicate. In painting figures, do the complete figure including the faces and hands. Later the flesh color will be painted over the gold. The superimposed details on the figures, flowers, leaves, animals, birds, buildings, vases, and other objects shown in penline in Figures 48-55 are painted in dark Burnt Umber over the gold, with a fine brush. For the detail on the camel's pack, use overtones of Burnt Umber, Burnt Sienna, and Raw Umber for contrast between the various parts.

The faces and hands were painted, but are so discolored by age that it is impossible to be sure what the original color was. I suggest mixing White, Alizarin Crimson, and Yellow Lake to make an Asiatic flesh color, subsequently adding enough varnish to make a rather thin mixture, and painting this over the gold. When this is dry, the features are detailed in dark Burnt Umber with a fine pointed brush.

Decorating a Highboy or Chest-of-Drawers

When decorating a piece of this nature, I like to put aside a room just for the purpose, where the piece can be laid on its back on the floor.

Although the background of the original was probably black, it has faded into an antique black, so if you want a really old effect, use a background of antique black (see p. 76). Assuming the black background has been properly prepared and is ready for decoration, the first step is to lay the various pieces of the finished acetate copies of the pattern in position on the upturned drawers, rearranging them as necessary. Stand off to get the effect as a whole, adding extra birds, or leaves, or trees if and where needed. First consider the placing of the gold leaf parts only; then, when these are in their proper places, consider the supplementary or dark gold powder parts.

160

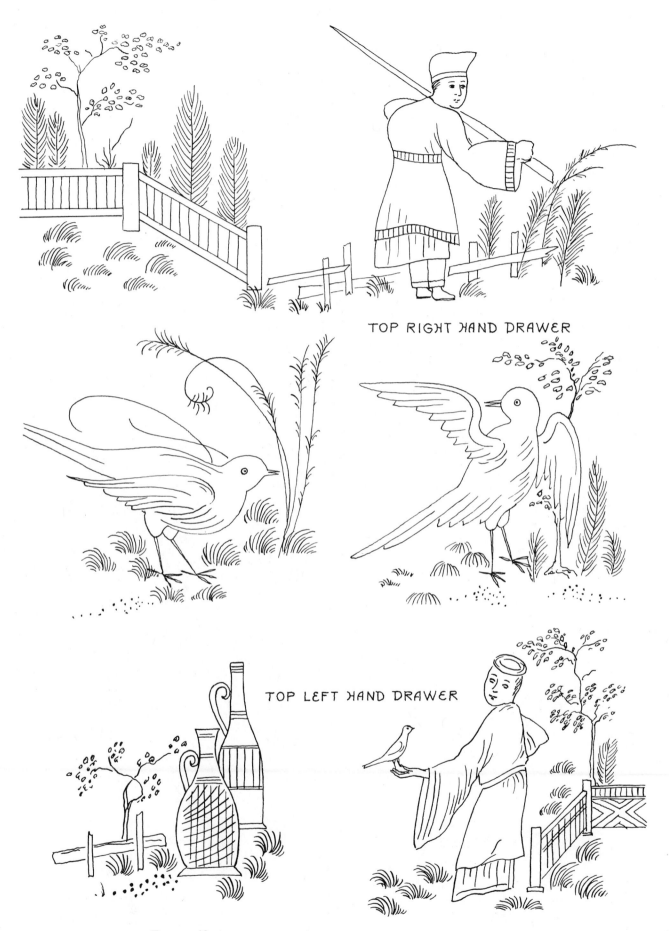

TOP RIGHT HAND DRAWER

TOP LEFT HAND DRAWER

FIGURE 48 JAPANNED HIGHBOY

FIGURE 49 JAPANNED HIGHBOY

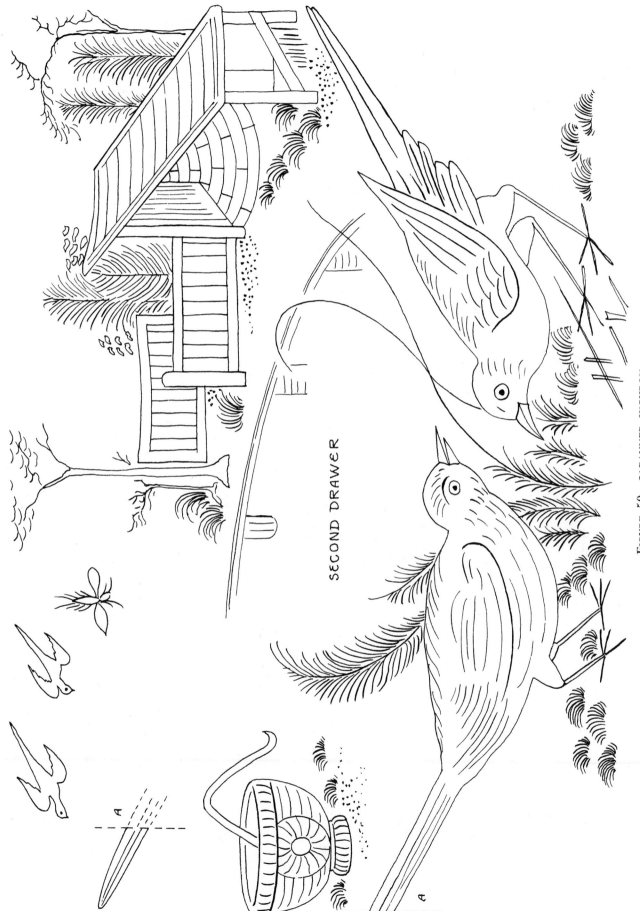

SECOND DRAWER

A

A

FIGURE 50 JAPANNED HIGHBOY

THIRD DRAWER

FIGURE 51 JAPANNED HIGHBOY

THIRD DRAWER

LAYOUT SKETCH

FIGURE 52 JAPANNED HIGHBOY

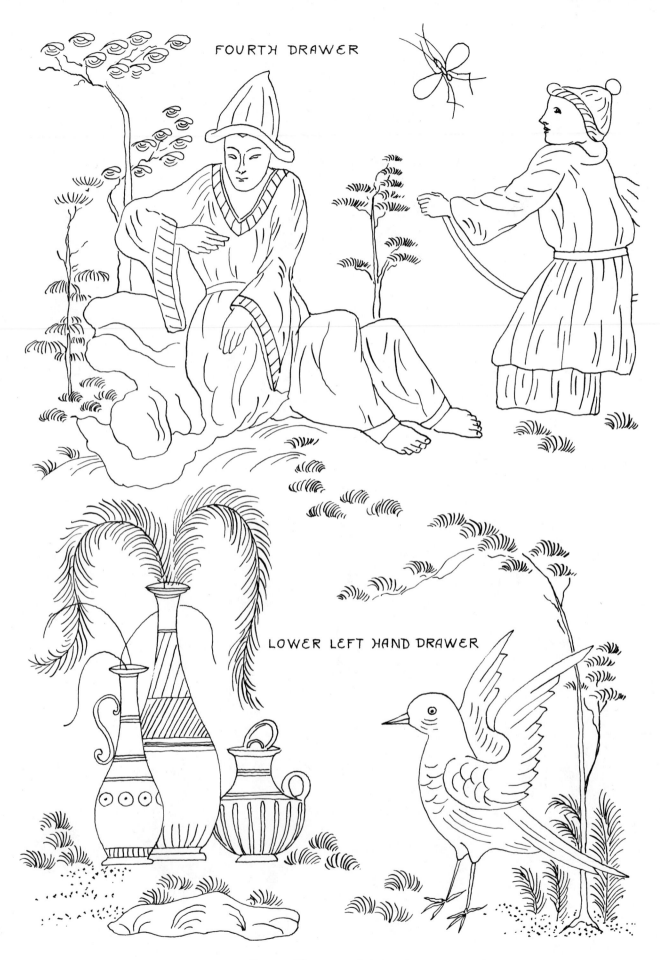

FOURTH DRAWER

LOWER LEFT HAND DRAWER

FIGURE 53 JAPANNED HIGHBOY

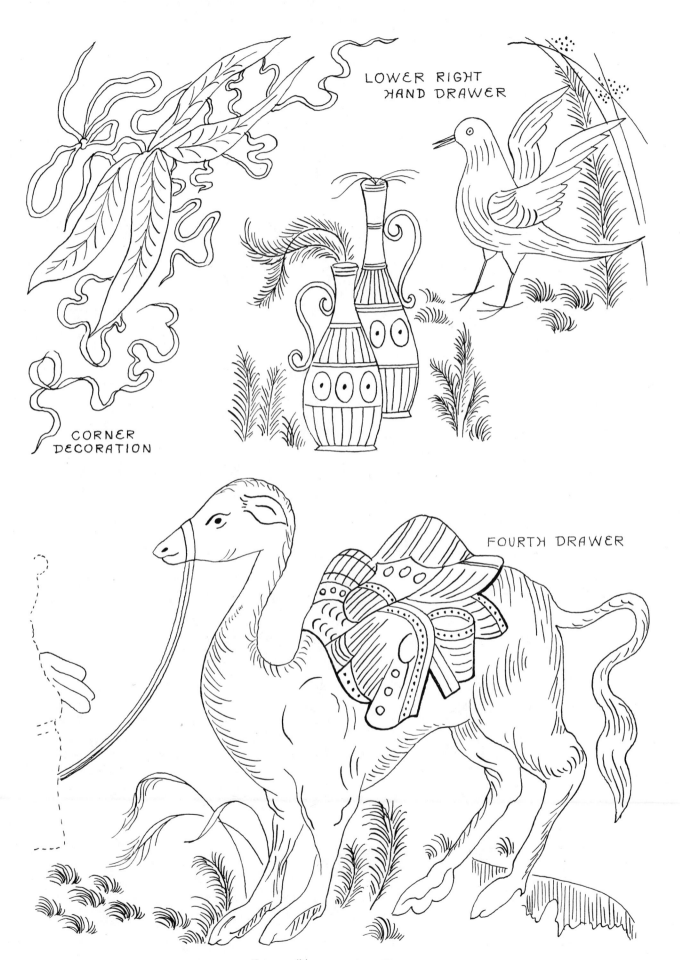

LOWER RIGHT
HAND DRAWER

CORNER
DECORATION

FOURTH DRAWER

FIGURE 54 JAPANNED HIGHBOY

FOURTH DRAWER

FIGURE 55 JAPANNED HIGHBOY

Transferring the Outline

Substitute the pencil tracings for the frosted acetate patterns, and trace the outlines of the gold leaf parts—and only the gold leaf parts: the outlines for the dark gold powder sections are traced later when you are ready to paint them.

The gold leaf parts of the design may be done over gesso (see Chapter 10) as on the original highboy, or they may be done without the gesso. The latter is just as beautiful, and, of course, requires a great deal less work. If you are not using gesso, don't forget to use whiting powder before transferring outlines.

Striping

The broad stripe around the edge of the drawers is in gold leaf. The narrow stripe inside the gold stripe is in dark gold powder.

Yellow "Fancy" Chair

For a pattern of this chair on frosted acetate, the steps required are:

1. Cut a piece of tracing paper 20 by 4 inches, and make an outline tracing of the complete slat, disregarding all superimposed details, for these can be added later by eye. Place this tracing over a white cardboard, and put a piece of frosted acetate on top. Also, trace on linen and cut one grape stencil.

2. With a thin mixture of Japan Black (add enough varnish for the black to become slightly transparent and to dry, when painted, with a glossy surface), paint the center group of fruit and two large leaves, and the group of three brush strokes marked X.

Also with a thin mixture, this time of olive green (Japan Green and Burnt Sienna) paint the two end scrolls.

When the proper tacky stage has been reached, stencil the bunch of grapes in silver powder. Before adding the bronze shading on the other fruits and the leaves of the central design, wait half an hour or an hour longer, until the surface becomes very much drier and you think it's too dry. Then apply the pale gold and fire powders as shown in the color photo. Apply *very* little at a time, starting with the brightest parts, and shading off to black; leaving a good deal of the black showing. When the end scrolls also reach that very dry stage (which will take even longer because the mixture contained artist oil color), apply the pale gold, leaving a good deal of green showing. Disregard the brown strokes which are added later over the pale gold. Let the work dry twenty-four hours.

3. Remove all loose gold powder. Mix some olive country green and paint all the green brush strokes around the fruit and leaves.

With a thin transparent mixture of Burnt Sienna, add the brush strokes on the end scrolls, blending off the edges here and there with a clear varnish brush.

170

TRANSPARENT GRAY
OLIVE GREEN
BURNT SIENNA
BLACK

END SCROLL →

FIGURE 56 YELLOW "FANCY" CHAIR

With a very thin, very transparent black, paint the broad band above and below the fruit and leaves, as indicated by the line shading in Figure 56. Set aside to dry twenty-four hours.

4. Add the black accents, the leaf veins, and the fine black stripe at top and bottom of slat. Use pen and ink for small, fine details, and quill brush and Japan Black for the larger, heavier details. This completes the pattern.

As regards the original, it is on a chair owned by Mr. and Mrs. Vernon H. Brown of New York. The background color is an antique pale yellow. The design on the seat front is similar to that in Figure 57, except that the leaves are pointed rather than rounded; and the thin gray strokes are in olive green. Striping on the chair is in black and transparent gray.

Pennsylvania Chair

Of the three sections in Figure 57, A and B were taken from an early nineteenth century Pennsylvania side chair (owned by the New York Historical Society). The main decoration is done in freehand shaded bronze with country brush strokes.

Although the background color of this chair, as it is today, appears to be a very pale yellow with a slight greenish cast, I rather think that originally it was an off-white. If I were decorating a chair with this pattern, I would start with off-white (with very little Raw Umber in the white), and count on the six finishing coats of varnish to give it a yellowish color. To achieve the slight greenish appearance, I would "antique" the first finishing coat of varnish by adding a touch of Raw Umber and the barest touch of blue to the varnish. But I would not advise attempting the blue unless you are quite an experienced decorator.

Section C in Figure 57 is from another chair, though of the same type, owned by the same Society. Both chairs, it is of interest to mention, originally belonged to a Reverend Samuel Jones, born 1737 and died 1811.

To make a copy on frosted acetate of all three patterns, proceed as follows:

1. Cut a piece of tracing paper 14 by 8 inches, and make an outline tracing of all three patterns, rejoining the separated sections D and E to the A design. Put a piece of frosted acetate over your tracing. Review the directions given for the Yellow Fancy Chair pattern on p. 170.

2. With thin Japan Black, paint all parts of the patterns that are neither dotted nor line-shaded in Figure 57. Keep looking at the color plate from time to time as you work.

When the surface has become almost dry, apply the silver, pale gold, and fire bronze powders, leaving plenty of black showing, as in the color plate. Let the work dry twenty-four hours.

3. Remove all loose powder. Then mix Japan Green, Raw Umber,

173

SEAT FRONT

A

B

C

D

E

COUNTRY GREEN
TRANSPARENT GRAY
BLACK

FIGURE 57 PENNSYLVANIA CHAIR

a touch of Japan Yellow, and a little white, making a yellowish light country green, and paint all the dotted brush strokes in Figure 57. If you were decorating a chair, you would at this stage also paint the broad green band but you would add a little more varnish to the mixture so as to get a hint of transparency in the green of the band. Let the work dry twenty-four hours.

4. Mix a little Japan Black with a lot of varnish to make a transparent gray. Try the color out on a scrap piece of acetate. Be sure not to have too much mixture on your brush or it will flood all over the place when you come to paint the pattern. If the color is not right, add more black or more varnish as the case may be. When the mixture is right, paint all the line-shaded parts in Figure 57. Allow twenty-four hours for drying.

5. Add the black veins and other details.

To Decorate a Chair

1. Apply the off-white background coats of paint.
2. Give the knobs of the spindles and the turnings of the upper part of the chair, a covering of the same pale gold lining powder that is to be used in the pattern. This is done by painting them with a thin mixture of varnish and Japan Black, and, when the surface is tacky, applying the gold powder. Let these dry twenty-four hours. Remove all loose powder.
3. Apply the decoration.
4. Varnish the whole chair in order to get a glossy surface for the striping. Allow twenty-four hours for drying.
5. With a thin, semi-transparent mixture of the same color green you used on the main slat, paint the broad stripes. Use a large striping brush. Dry for twenty-four hours.
6. Add the fine black striping (using Japan Black).

Cheese Boat

This pattern, which is done chiefly in gold leaf and freehand bronze, with some touches of stenciling, comes from a cheese boat owned by the Society for the Preservation of New England Antiquities, Boston. Section X of Figure 58 is a continuation of section B which is one of the long sides of the cheese boat, section A being the other. Section C was used on the semi-tubular ends.

The very fine leaf veins and the tiny twigs are in gold leaf, and for this kind of work it is best to use the gold-coated sheets of thin plastic sold by stationers for signing one's name in gold.

To make a pattern, proceed as follows.

1. With a mixture of Yellow Ochre and varnish, paint the areas shown in solid black in Figure 58. When the areas are tacky, lay the gold leaf as described in Chapter 9. Wait twenty-four hours.

2. Cut stencils for the four small shapes 1, 2, 3, and 4 at the lower right-hand corner of Figure 58.

3. With a thin mixture of Japan Black, paint all the remaining parts of the pattern with the exception of the tiny twigs, the flower stamens, and the butterflies' legs and feelers. When the tacky stage is reached, stencil the bodies of the butterflies with pale gold powder, using stencils 3 and 4; the suggestion of the dividing outlines of their wings by using stencil 1; and the turned-over leaf edges (all indicated by line-shading in Figure 58) by using stencil 2.

Wait another thirty minutes or so for the black surface to get still drier, and, using the palegold powder very sparingly, add the faint freehand touches of palegold indicated by the dotted areas in Figure 58 (no stencils used for this), at the same time adding touches of fire powder in the flowers and butterflies, and here and there on the stems. Leave plenty of black surface showing so that you get the overall dark effect. Wait twenty-four hours.

4. Make a pencil tracing of the fine leaf veins and twigs, the stems of the stamens, and the butterflies' legs and feelers. Place in position

176

FIGURE 58 CHEESE BOAT PATTERN

C

B

A

■ GOLD LEAF
//// PALE GOLD STENCILING

x

x

1 2 3 4

STENCILS

over the painted pattern and secure the tracing at one end with bits of masking tape. Slip the gold plastic sheet, gold side down, between your tracing and the painted pattern. With a sharp hard pencil, retrace the lines.

With a camel hair quill brush dipped in varnish, go over the fine gold lines, and let this dry for twenty-four hours. The gold lines will thus be protected when you do the finishing coats of varnish.

5. With a mixture of varnish and deep gold powder, paint the stamen heads.

Paint the details in the butterflies' wings with Burnt Umber.

When you put this decoration on an actual cheese boat, note that the striping on the long sides is done in gold leaf, as also are the "domes." This, of course, should be done at the same time as the gold leaf parts of the pattern.

Guilford Blanket Chest

This pattern is taken from an early eighteenth century painted pine blanket chest which originated in Guilford, Connecticut. It is painted in vermilion, off-white, and black on a brown stained background. The chest measures 46 inches long, 34 inches wide, and 19 inches deep. The main pattern (Figure 59) is 15 inches high in the original; the drawer pattern (Figure 60) is 7¼ inches high; and the tree on the sides of the chest is 19½ inches high. The background for this pattern might equally well be a painted brown one.

In painting the pattern, do the off-white parts first. The vase should be painted all in off-white, the decorative details in vermilion and black being done at a later stage. Use a striping brush for the long thin stems.

When the off-white parts are perfectly dry, paint the black parts, and last of all the red, which is Japan Vermilion mixed with a touch of Burnt Umber. The original chest has no striping.

CENTER

VERMILION
BLACK
OFF-WHITE

FIGURE 59 GUILFORD BLANKET CHEST

CENTER

TREE FOR SIDES OF CHEST

A

A

▨ VERMILION
■ BLACK
□ OFF-WHITE

DESIGN ON DRAWER

FIGURE 60 GUILFORD BLANKET CHEST

Index

Page numbers are given for each of the three volumes in this comprehensive edition.

184